2003

Anish Kapoor

Germano Celant

Anish Kapoor

CHARTA

General Editor
Germano Celant

Scientific Research
Anna Costantini

Research Assistant
Paolo Cecchetto

Artistic Consultant
Pandora Tabatabai Asbaghi

Graphic Design
Pierluigi Cerri
with
Ginette Caron
Stéphanie Girard

Graphic Supervisor
Gabriele Nason

Editing Supervisor
Emanuela Belloni

Editing
Anna Albano

Translation of the Text
by Germano Celant
Stephen Sartarelli

Press Office
Silvia Palombi Arte & Mostre, Milan

*First edition of this monograph was
created to celebrate the Anish Kapoor
exhibition held in November 1995 at the
Fondazione Prada in Milan.*

Cover
At the Edge of the World, 1998
photo John Riddy, London

ISBN 88-8158-178-7

Edizioni Charta
Via della Moscova, 27
20121 Milano
Tel. +39-026598098/026598200
Fax +39-026598577
e-mail: edcharta@tin.it
www.artecontemporanea.com/charta

Printed and bound in Italy

I would like to thank Jeff Dyson and Tim Shutter who have worked with me for many years and who have taken my sometimes difficult notions seriously. Nicholas Logsdail, Barbara Gladstone, Bonnie Rubenstein, Sharon Essor, Elisabeth McCrae and Susan Waxman are all due my deepest thanks. Most importantly my thanks to my dearest wife Susanne Spicale and our children Alba and Ishan without whom even less would be possible.

Anish Kapoor

Documenting in a monograph the creative evolution of an artist as complex as Anish Kapoor was an undertaking that required the help of many people, simply because of the wealth of material and scientific verification involved. First and foremost, I would like to thank Anish Kapoor whose willingness to communicate went far beyond the bounds of confidence and friendship. It would have been almost impossible for me to document his creative evolution without his constant help which made the experience most stimulating and enjoyable.

The monograph came into being thanks to the enthusiasm and energy of the Fondazione Prada in Milan, in the persons of Miuccia Prada and Patrizio Bertelli.

We would like to thank Pandora Tabatabai Asbaghi for her expertise in selecting and arranging the iconographical material, and to express our wholehearted gratitude to Pierluigi Cerri who, with Ginette Caron, created some inspired graphics.

Anna Costantini's drive and specialist knowledge contributed greatly to the scientific accuracy of the monograph. Finally, I was fortunate to have the support of Nicholas Logsdail and the Lisson Gallery, in London, as well as the collaboration of Bonnie Rubenstein. Together with Paolo Cecchetto, they gathered information and documents that made it possible to reconstruct Anish Kapoor's artistic career.

I would like to close by saying a warm thank you to Susanne, Alba and Ishan, who make up Anish's other creative, fantasy world. Thank you all very much.

Germano Celant

Contents

Artist as Sacerdos

Germano Celant

The artist has a central place in the history of culture because he has the power to give new forms to matter, endowing it with new character. His ability to produce a continuous metamorphosis of the universe, on a microcosmic but greatly symbolic scale, makes him an architect, a director, of the generative processes. His prestige stems from the creativity with which he brings to life the threads of language, that complex system in which knowing and feeling evolve. Moving between sign and symbol, the artist connects himself integrally to myth. In touch with the exemplars and archetypes of history and life, and always inventing new representations of them, he is an initiate.

The transformation of life into new images, the granting of force and energy to forms and material, takes place through a ritual, the ritual of art, which qualitatively converts the formless whole into a sacred whole. The meaning of the artist's pursuit, then, lies in his revitalization of life's origins through an activity in harmony with the cosmic and universal order of time. For Anish Kapoor, the magic of artmaking lies in continually rethinking and re-presenting the exemplary act of creating a universe. That action departs from a symbolic centre whose foundations rest in myth, and in the knowledge of the secret of life.

What is myth? The definitions are many, but essentially myth relates to the force that created the world, and that keeps the world alive through a continuous process of renewal. In Western culture, this force corresponds to the Word, or the timeless mystical sound that created the universe. Myth is sacred and myth is word—"the word that, when repeated, corresponds to ultimate power."[1]

The knowledge and interpretation of myth and word (*mythos* actually means "word" in Greek) is entrusted to the priest, the *sacerdos* (the "giver of the sacred"), who, through ritual, seeks to give unitary form to the parts of a lost meaning, and thus to bring the human closer to the divine. In his search for the lost image, the image to be rediscovered, the artist resembles the *sacerdos*. He tries to reunite what is scattered and dispersed, dried up and spent, in order once again to locate the sources of the mystical force that supports existence. His concern is the power of that force, which he wants to regenerate and re-present. The enclosures that he creates are spaces in which it can be isolated. A consecrator of materials and forms, of spaces and architectures, he sets out to reconstruct the secret of life, the heritage of the word and of the divine.

Kapoor's constructive process first consists of sanctifying a space in which the fragments of the word—*verbum* or *mythos*—can be reunited, so as to

verify this power and force through the simultaneity of the work's different elements. In *1000 Names*, 1979–80 (pp. 8–13), he seeks—as he has since his earliest mature work—to define an enclosed space, a territory, in which to isolate and reveal the energy of the sacred in all its countless denominations: *one thousand names*. The piece is a group of three-dimensional forms constituted of raw pigments of the primary colors, first red and white, later yellow and blue. Projecting out from floor and wall, these volumes evoke images—cone and mountain, half-sphere and dome, pyramid and volcano—that seem in transit between the abstract and the natural, the negative and the positive. The placement of the same configuration on the construction's different "horizons"—the floor and the wall—reveals the energetic charge, like the tip of an iceberg, in the word—or *name*—that participates in the sacred or the myth.

In *1000 Names*, Kapoor, as artist/*sacerdos*, builds towers and pyramids to unite the heavenly and earthly, the human and the divine. He attempts, then, to decipher the mystery of *elsewhere*—to reveal the magnetism of the dialogue between the complementary forces and powers of above and below, here and there, the known and the unknown. These forces yield a form-generating current that manifests the movement of life. That current's infinitude overflows the limits of any language, real or abstract. In this sense the chromatic volumes of *1000 Names* can be seen as self-sufficient and self-generating, beyond any subjection to anthropomorphism, for they are full of an extrapersonal expressiveness that stems from the mutability of both the human and the divine.

Asserts Kapoor: "with the early powder pieces, one of the things I was trying to do was to arrive at something which was as if unmade, as if self-manifest, as if there by its own volition."[2] He also says, "I've always felt that my work had to be about something else and that's what saved it. I began to evolve a reasoning, which had to do with things being partially revealed. While making the pigment pieces, it occurred to me that they form themselves out of each other. So I decided to give them a generic title, *1000 Names*, implying infinity, a thousand being a symbolic number. The pigment works sat on the floor or projected from the wall. The pigment on the floor defines the surface of the floor and the objects appear to be partially submerged, like icebergs. That seems to fit the idea of something being partially there."[3]

The conception of *1000 Names* subsists in a complex symbolic universe that revolves around the idea of the transit or passage (*in-betweenness*) from one dimension to another. The bounded room or space in which the work is

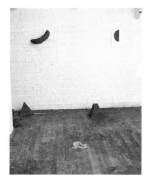

1000 Names, 1979-80

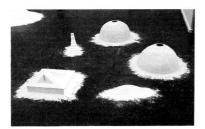
1000 Names, 1980

situated can be seen as an inner "world," and this establishes an equivalence between the microcosmic and the macrocosmic, the human and the universal. The space, then, is existential and metaphysical, individual and mystical. Its walls symbolize the world's vectors, east, west, north, and south, which, at their points of intersection, the corners, allow the meeting of the human and the superhuman. Within them, on the floor and on the wall, Kapoor's multiple forms of different-colored chromatic powder together constitute a nongeometric whole, open and free.

The grouping and the placement of these figures in such a space reflect a primordial totality, the existence of which is unconditioned and in flux. Like a small holy mountain, each entity rises from the ground to establish a harmony between earth and heaven. Each element is constructed, directly or indirectly, from a powder of pure colour, which rests on a form or supports it, creating an aureole around it.

This pigment signifies the creative force; it is a sign of life, like seed or pollen. Suggesting the birth and growth of a fruit that may assume any form or character, it suggests the mutability of life, the pressure on all subjects, spiritual and physical, to become embodied as something else. The symbology of colour is infinite, ranging from the cosmic to the spiritual, from the biological to the ethical, from the religious to the mystical. In every culture, colour restates the constant of luminous energy, of light, a recurrent motif in all articulations of metaphysics—the prime visible manifestation of the life force and of the divine. "With the early powder works I was much more concerned with the way the objects gave out light; they seem to be a source of light."[4]

In *1000 Names*, opposites and complementaries, light and dark, are reconciled not only through colour-light but through the passage between upper and lower, outer and inner, surface and subterranean—all integral parts of a work on the ground or on the wall. The horizon line on which the elements rest or from which they project is by definition a point of transition between two worlds. It is also a surface of motion: by walking on the floor, one ritually redefines the adventure of life, one's movement through the world, one's journeys, one's existential pilgrimages. In standing on the ground, the forms and volumes of pigment, besides calling attention to the poles of the known and the unknown, speak of art as growth, as a seed that develops and changes, ever susceptible to permutation. Art is seen as a living organism that mutates from embryo to maturity even while always remaining unique, whole, and integral. *1000 Names* becomes a place of the past, the present, and the future, a place where one may glimpse both

roots sinking into the ground and the ebb and flow of a wandering aerial energy in the heavens. It is a work in a state of growth, with a vitality and an intimate essence of its own. Kapoor conceives it as a metaphor for an imaginary realm that is a space of perpetual transformation.

Moreover, this constellation of fragile, tactile elements in the womb of the floor implies an antimonumental logic more in keeping with the feminine principle than with the male. Gigantism and verticalism are absent, as are pure, absolute images. Instead, Kapoor chooses an open code that avoids the univocality almost always associated with obligatory symmetry, and also with the equally obligatory sorts of asymmetry. In addition, through its free, intuitive arrangement of forms and volumes the work makes a perceptible, urgent connection with the surrounding space. This connection indicates an identification with architecture, which serves as a centre of gravity, a *cavea* or womb for the convergence of introversion and extroversion, of feminine and masculine.

The whole of *1000 Names* can thus be taken as a figure of reconciliation between diverse sexualities, the locus of an androgynous body springing from a gathering of primordial fragments: "*1000 Names* implies that the objects are part of a much bigger whole. The objects seem to be coming out of the ground or out of the wall, the powder defining a surface, implying that there is something below the surface, like an iceberg poking out of the subconscious."[5] Full of conscious and unconscious vitality, this presence lays claims to be infinite. For it posits the creative process not as an operation of abstraction or reduction (as in the Minimalist approach, which set up a rigid, functional relationship with the exhibition space and architecture) but rather as a way of respecting the existence that flows in the space, of establishing an organic, perceptible relationship with the real, without preconceptions and irrespective of genre.

What is the source of this energetic, enigmatic vision of art as sacrifice and rite, in which the artist presents himself as a *sacerdos* and the work as a tool of the evolution and transformation that will enable the individual and society to realize their unrealized potential? What sort of artistic or philosophical experience is Kapoor referring to in *1000 Names*, a hermetic, magical environment born of the *conjunctio oppositorum* of conscious and unconscious, day and night, male and female, active and passive, life and death? From what existential and creative precedents arose this need to build a bridge between opposite and complementary poles, establishing a flow of energy between art and life?

Kapoor was born in Bombay in 1954, of an Indian father and a Jewish

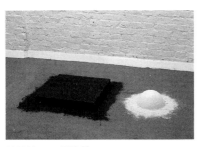

1000 Names, 1979-80

mother. After attending primary schools, he enrolled in an engineering school for six months, then, when he was about eighteen, left to devote himself to painting: "I had been painting when I was in India."[6] In 1973 he went to study in England, enrolling at Hornsey College of Art, where he remained until 1977. In 1978 he went on to postgraduate study in the sculpture department of the Chelsea School of Art.

During this period Kapoor read Carl Jung with great interest. He also met Paul Neàgu, a Rumanian artist working in Edinburgh and London who had come into contact with Joseph Beuys on the occasion of the German artist's *Celtic (Kinloch Rannoch) Scottish Symphony* project, at the Edinburgh College of Art in August 1970, and had continued to follow him up to the time of his show "The Secret Block," which toured England and Scotland in 1974. Kapoor fully acknowledges Neàgu's influence on his perception of art as a ritual, ecstatic process: "There was someone I found very important to me then, Paul Neàgu. He really had a lot to do with the way my growth as a person occurred. He was a foreigner working in this context here, that had something to do with it. He opened my eyes to the idea that making art wasn't about making more or less beautiful things and that there was some deeper purpose to it."[7]

An initial inventory of Kapoor's lexical materials can be seen in *Untitled*, 1975 (p. 5), a work executed at Hornsey. It consists of a human half-figure, half-male, half-female, drawn on the floor in white chalk and run through by a long iron rod, from which radiate a metal foot covered in chalk and a number of "rays," also in chalk and iron, which interweave with the words "male" and "female" and support simple volumetric figures such as spheres and cubes, or parts of them—angles and half-spheres, concave and convex forms. The work's visual orchestration, then, is based on a harmony of elements that coexist in the same space and have a common matrix (the body), from which they emanate like an aura of forms and materials. The force rising from the ground is absolutely physical, and its physicality is magnetic: acting like the head of a comet, it both pulls along and emits a whole constellation of sculptures.

To designate this process of the dismemberment of the individual (and social) organism in plastic visual motifs, Kapoor combines the Duchampian figuration of *Étant Donnés: 1. la chute d'eau 2. le gaz d'éclairage*, 1948–49, with the iconography and process orientation of Beuys, who in *Manresa*, 1966, exhibited a half-cross on the wall, and who made much use of iron rods and chalk in such works as *Eurasia 32. Satz der Sibirischen Symphonie*, 1969. Kapoor, however, is not interested simply in referring to iconography

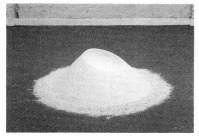

1000 Names, 1979-80

or process; rather, his attentions are focused on both artists' philosophical and alchemic obsessions. "One artist who was very important to me was Duchamp. Not the Duchamp of the readymade but the Duchamp of *The Large Glass (The Bride Stripped Bare by Her Bachelors, Even)* and *Etant Donnés*, the Duchamp of Alchemy . . . a perfect kind of oppositeness. I made quite a lot of work that had to do with this polarity."[8]

Attempting to probe Kapoor's metaphor of a body on the ground, which also acts as the source of elements that break away from it to rise toward the heavens, one may identify a dialectic between a stable element—the prison of this androgyne's individuality, however absolute that individuality is—and a volatile one: the divine, the sacred, which is both separated from and connected to the body by the bar of rays. Kapoor tends to emphasize connection. He wants to abolish difference—he wants material's errant force to contain both the sacred and the human. Rift is transformed into fusion, the body becoming a shining star around which instantaneous radiations of molecules gather to become form and volume— "the body being the central theme, the body being the vessel, in which the transformation takes place."[9] In the *Untitled* of 1975, however, the problem is still one of separation, so much so that the body is as much a centrifugal force as a centripetal one. While it supports the work's materials and forms, it is equally penetrated by them in its symbolic orifices; it is not yet a glorious body fused into a total unity, cut from a sacred, ritual self-sufficiency, as in *1000 Names* (pp. 24–25).

The incompleteness of the transition is expressed in the figure's androgyny, and in the fact that it is only half drawn in, not fully realized. But this figure is on the road to completion, and is combined with a recognizable, literally weighty bodily presence: the metal foot, metaphor for a slow, ponderous advance toward the final outcome. *Untitled* of 1975 is a pivotal work in Kapoor's gradual definition of art as a casting off of one's own identity in favor of a golden, numinous state, in which the body is transformed into a lymph of the Tree of Life, and of Art.

In the articulation of this *Untitled*, the drawing of the androgyne becomes an archetypal image of the human psyche. The androgyne appears as the primordial unity predating the separation of the genders, the "double" whole in which all opposites converge. Its presence as a white shadow on the floor represents the life-breath—the "rays" as breaths—that will eventually give rise to Kapoor's later vocabulary of forms and materials: cube, sphere, chalk, powdered pigment. His work will thrive on the dialogue between spirit and matter, above and below, masculine and

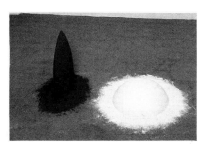

1000 Names, 1979-80

Untitled, 1977

Untitled, 1976

feminine, for it is in *duality* that the energy of transformation and evolution lies. Only from the double can the centrifugal power of being arise, the infinite dance of an art that proclaims itself as self-generating, impulsive, mobile, and open to secret and enigma. In *Untitled* Kapoor illuminates a holistic vision based on an osmosis between self-impregnating opposites, an interrelationship of inside and outside, superficial and subterranean, conscious and unconscious. This vision will continue to take shape in *To Reflect an Intimate Part of the Red*, 1981 (pp. 50–53), *Mother as a Mountain*, 1985 (p. 78), *Here and There*, 1987 (pp. 165–67), *The Healing of St. Thomas*, 1989 (p. 117), *Void Field*, 1989, and *When I Am Pregnant*, 1992 (pp. 165–67).

At the centre of all Kapoor's art lies the pregnancy of the absent body—shadow, aura, and void. Renouncing the fullness and completeness of sculpture and painting, he seeks a mirror-state in which the artist becomes a nomad, the protagonist of "mnemic migrations"[10] among the formal and material languages with which he asserts a presence in the world. ("I am a painter who is a sculptor," says Kapoor.[11]) The notion of cutting the body into fragments of matter, of reducing it to a simple expression of the symbolic, underscores the constant presence of an *interval* marking the passage between material and immaterial, between mobility and immobility. The figures in the world of the body's transmutation are memories of the idea of the flame-body, in which the human being is accepted as a residual figure.

In *Table of Dreams*, 1976, the idea of the body's absence, indirectly harking back to the "unspoken voices" of Brancusi's table, is accompanied by the energetic physical presence of a sculpture halfway between soft and hard, between flesh and object. In this drama of laceration and flux, however, there is a yearning for a primordial cohesion. This confusion is overcome in *Untitled*, 1977 (pp. 2–3), a sort of vulval enclosure or screen made of painted cloth held up by poles, and functioning as both a construction and a site of ceremony; and also in another untitled work of the same year, a chair occupied by a vaginal metal container, and surrounded by and connected to white-painted poles surmounted by spheres of cloth made solid with plaster.

Both works delimit a space (in order to bring it back to life), as much with their ceremonial poles as with the soft bed of Mother Earth—the natural-fibre cotton cloth. This enclosed inner space of salvation invokes the isolation required of the initiate. At the same time, it is also a wedding chamber, an open room, decorated with branches and flowers, in which the

couple settles down on a rude bed to create a third being. A Duchampian itinerary returns in another *Untitled* of 1977, in which a dark-colored tent separates two worlds while also suggesting a visual bridge between them. On one side an object of steel and chalk rises from the ground; from it radiates a line of linkage, exceeding the limits of the tent. On the other side is a platform, also standing on the ground, on which rest a mirror and some soft instruments. The joining of these two universes of hard and soft, masculine and feminine, is enhanced by the deafening noise of a kind of mechanical metronome that beats a stick against the ground, turning sound into an alchemic coagulant.

Aside from their repeated echo of Duchamp's *Large Glass*, and of the Jungian idea of the ritual encounter and "internal marriage" of male and female as a fundamental process of the human condition,[12] the configurations of these works express Kapoor's desire to arrive at a formal middle-ground between the meanings of the body and of its absence, between stasis and potential activity. This ground is to be achieved through abstract forms and soft volumes that are no longer representations of transformation, evolution, life, and growth, but rather are simply paradigms of the construction and unveiling of the inner state of a being in the world. In this series of untitled works, Kapoor is concerned with a casting off of the body, a progress from the fullness of physical and tactile energy typical of *arte povera* to the emptiness of metaphysical vertigo. Plunging into his materials as so many pneumas nourishing life, he begins to pose the question of art as infinite growth, as in *1000 Names*. His evolution along this path finds another confirmation in recent art: the "environments" of Paul Thek, whose *Procession in Honor of Aesthetic Progress: Object to Theoretically Wear, Carry, Pull, or Wave*, 1968, and *Stag in the Boat*, 1971–72, provided considerable iconographic and poetic inspiration for Kapoor's early works. "I was very interested at the time in Paul Thek. His is a sad story but he was a marvellous artist. I never saw one [of his environments] for real then, only in art magazines, but I think what was important about them to me was that they were deeply ritualized situations."[13]

In *Anthropomorphic Ritual*, 1977, a group of airy configurations float in the void, rising like birds, or fantastical creatures with strange wings and beaks, from a womb of painted cloth. Images of flight subtending a birth, and separated from the earthly, vulval bed, they are in direct spiritual contact with the heavens. In the guise of fragments and disparate forms, there emerges from the organ's slit a full image (or word) that spills over to the

Anthropomorphic Ritual, 1977

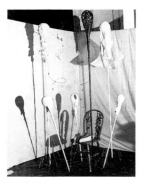

Untitled, 1977

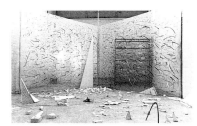

Untitled Installation, 1978

outside as visual energy. Out of the open body comes a colored swarm of light, ascending objects heading out into space. They rise up in search of a landscape in which to settle.

Another untitled work of 1977, on the other hand, is a physical realization of the idea of a descent into a context: here the forms aspire to land on earth, once they have found a territory to house them. Suspended from a wire, figures of colored fabric loom, as if about to land, over a painted surface, again vulval in form, that is also occupied and cluttered with other objects. Here and in *Anthropomorphic Ritual*, Kapoor once again establishes a balance or duality between opposite yet mutually attractive elements. Maintaining the dialectic between divine and human, spiritual and physical, angelic and satanic, he makes forms fly and at the same time descend. He maintains a cyclical vision that rests on the meeting of earth and ether, low and high, dust and air. The archetype of the glorious body is transformed through the dialectical relationship between the volatile and the stable. This transformation coincides with a release of free imagistic energy, but, at the same time, also corresponds to a reabsorption and freezing of the surround. If the power of the images is to circulate freely and unobstructed, the territorial web must become compact, enclosed, so as to attract these liberated objects, figures, fragments, and forms. An opening requires a closing, a fullness wants a void, the limitless demands a limit.

In 1978, before completing his studies at the Chelsea School of Art, Kapoor created an untitled installation in his studio that marked a moment of transition from his early work to the more mature *1000 Names*. The piece was made up of fragments of chalk, electric motors, silks, and Jackson Pollock-like strokes on two large transparent screens that divided the room, filtering a view of several stands on which stood small spheres. Every plane of the room from floor to walls was penetrated by a constellation of two- and three-dimensional signs, an aggregation that took full and uninterrupted possession of the space. It was as though secretions and humors originating in the body had found a mode of total, almost cosmic respiration, magical and enigmatic, forming a full, self-contained universe. Between 1975 and 1978, a wellspring of energy and art had led to the transmutation of the figure of the androgyne into a sensual organ capable of granting colored forms and figures their freedom and access to the air. In *Untitled*, 1978–79, this energy generates a proliferation of images so rich as to fill up an entire *alveus* or space. Here all opposites coexist: dispersion and accumulation, surface and volume, solidity and transparency, colour and material, mobile and immobile, geometric and organic, low and high,

gesture and plan, order and anarchy, fullness and emptiness. One melts into the other, merging in a disconnected agglomerate that strives to reconstitute itself as a higher unity. Objects on the ground, like signs on the wall and floor, present themselves as metaphors of a multidirectional force. A terrific ebullition begins to register the fits and starts of a body in a state of fusion, transmuted into base matter but tending to become *One*. As in the alchemic tradition of *solve et coagula*, art is the vehicle of a renewed energy the purpose of which is to transform the elementary body, which underlies works from the *Untitled* of 1975 to that of 1978–79, into a supreme, sublime body, as in *1000 Names*. The metamorphic journey is complete, and the material distilled can now shine within itself in celebration of both the sacred and the profane, the divine and the human.

The Garden of Origins

The pure image, unscathed by the act of coming into being, is an extreme experience. Kapoor identified it in 1979, on a return visit to India, where he discovered primary colour in its raw state. In its perfect alloy, this material corresponded to his search for an absolute metaphysical language—a language capable of melding together in unity the parts of the glorious body, which is composed of superior fragments that together solidify the multiple complexity of the universe.

Using this powdered pigment, Kapoor succeeds, in *1000 Names*, in transforming symbol into reality, in rendering metaphors of light and creation as physicalized events, integrating their polarities. "What I did discover in India was a material," he says.[14] Aside from material, however, Indian culture also provided him with a confirmation of his poetic and philosophical orientation: "I hadn't realized that the direction I had been working in was already there. I was only there for a month or so, but it was a real affirmation of my being . . . The whole of the Indian outlook on life is about opposite forces. One thing I was fascinated by were the little shrines and temples by the roadside, which are all over India, and are specifically orientated towards this dualistic vision."[15] In India, moreover, the transformation of every gesture or act into a sacred serial rite helped Kapoor to reclaim for himself an infinite, virtual procedure—*1000 Names* inaugurated a ceremony of chromatic and formal reinvention and expansion that would last until 1985—and to understand the destiny of his art: "I do not want to make sculpture about form—it doesn't really interest me. I wish to make sculpture about belief, or about passion, about experience that is outside of material concern."[16]

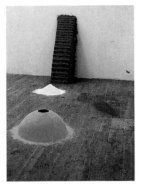

1000 Names, 1979-80

xx

In the culture of Kapoor's origins, the numinous permeates all reality; in the Hindu cosmogony, gods such as Shiva are omnipresent. And the wall decorations in Indian temples are inscribed within a philosophical vision of the fecundity and abundance of the regenerative spirit. Kapoor's return to these origins confirmed his desire to identify art with a transformative will that, floating between painting and sculpture, rises up in the world to permeate every order of object and landscape: "I think I am a painter who is a sculptor."[17]

The *substantia* of the painting-sculptures that would result is pure pigment, which, despite its optical weight as dense colour, has a soft, ethereal quality that makes the features and contours of volume and form nebulous. It dissolves considerations of the real and emphasizes the power of light, which becomes a shimmering, a vibration, that allows the forms to float in space like Monet's waterlilies, or to dissolve in a rarefied atmosphere, as in a Turner landscape. The works are full but vaporous, like red, white, and yellow dandelions erupting from the floor, producing a visual vortex that swallows up the gaze. Being formed by the purest of powder, the contours of each element become labile, the surfaces vulnerable, changeable, indefinite.

By transforming sculpture into a restless vibrant mass, an unstable, fragile object, Kapoor makes his own contribution toward moving beyond the disagreeable rigidity and absolutism of Minimal art. He situates himself in a kind of symbolic and procedural syntony with *arte povera*, and with Land art from Jannis Kounellis to Robert Smithson, enriching their vocabulary of sensorial and sensual data. First of all, his vibrant, seductive images, which invite one to draw close and touch, throw the visual closure of a Donald Judd or a Dan Flavin into crisis. The technologically produced surfaces of those artists' works offer crystalline or metallic skins. Kapoor instead presents an unstable, porous epidermis, fragmented and permeable, seeming both to float upon and to compose the sculpture's forms and volumes, which themselves seem to float in space.

Kapoor's desire is to enter the thing itself. For in the esoteric tradition, art is an image that approaches completeness but does not reach it. It must always be perceived as integrated with something beyond its self-presentation. In *1000 Names*, then, colour defines form but does not resolve it. It slowly makes one recognize its existence, but the aureole that surrounds it also demonstrates its contingency and ephemerality. The quest for the sacred is expressed in the pilgrimage or journey toward the wellsprings of sight.

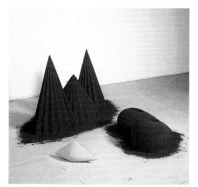

As if to Celebrate I Discovered a Mountain Blooming with Red Flowers, 1981

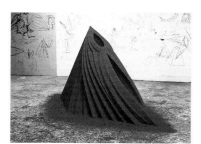

Mother as a Mountain, 1985

Colour offers one route toward understanding the shape of the power and energy that inform the universe. It cannot, however, tolerate any absolute definition, but must obey the laws of the movement and flow of life. Aspiring to connect with that process of compression and expansion, the pigments of *1000 Names* amass like unstable entities, breathing with the earth. Their pulverization, their mixing of earth and air, allows each object to situate itself at the juncture between the physical and the metaphysical, the measurable and the immeasurable, matter and spirit. Finally the brightness, the impetuous, elusive fibrillation of the individual red, yellow, and blue—the latter of an intensity recalling Yves Klein's cosmic sensibility—have a powerful sense of purity, showing that they belong to the realm of pure Idea: art as the epiphany of the Sublime.

Closed within the perimeter of its energy charge, subject to the law of the "symbolic," *1000 Names* embodies the advent of a "mindscape" and of a "soulscape."[18] It presents itself as the ceremony of an illumination of life and creativity. The colors foreground their own allegorical quality: in Kapoor's personal symbology, red becomes a symbol of masculinity and the generative, white refers to virginity and the feminine, and yellow corresponds to desire (the passional, solar part of red). At the same time, Kapoor's self-renewing forms become vehicles of a *theatrum chemicum* in which one rediscovers the buried archetypes that will revitalize the continuity between culture and life.

The first version of *1000 Names*, exhibited in 1980 in the Paris studio of the sculptor Patrice Alexandre, consisted of objects made directly of red and white pigment. This was followed by a show at the Coracle Press in London, in which Kapoor broadened his vocabulary of forms and colors while preserving the impact of an arrangement that fills a space to the point of transforming it into an energy field. Other permutations and modifications followed, the essence and variety of the work being in a constant state of enrichment between 1981 and 1985.

At the same time that he continued to work on ephemeral installations, Kapoor also began to broaden the iconography of his petrified, primordial landscapes. In 1981 he created *As If to Celebrate I Discovered a Mountain Blooming with Red Flowers* (p. 55), *To Reflect an Intimate Part of the Red* (pp. 50–53), and *Part of Red* (pp. 45–49). For their forms, these works employ pure figures such as the sphere and the parallelepiped, and they assume a more articulated iconography than the earlier works did–from stair and mountain to dome and enclosure. It is here that Kapoor's colors are first enriched with the addition of blue. Also, in both the number of

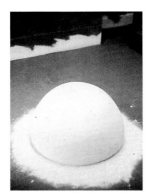

1000 Names, 1980

their elements and the spaces they delimit, the groupings in these works are simpler and more contained than the earlier ensembles; the visual areas they describe fall under one's gaze more easily. Unlike *1000 Names*, they no longer immerse one in an archipelago of forms and colors, instead confronting one with a sculptural presence.

In essence, the figures that start to emerge in 1981 recall the symbology of the works of 1975–79. They too present hemispheric cavities and oval or roundish constructions that evoke the female body, as though Kapoor, after his intense self-discovery of 1979 steeped in a variety of cultural stratifications, wanted to reintroduce fragments of the unconscious and to point to profound, unexpressed meanings. These works present the dome as an absolute symbol of the whole as sacred enclosure and uterus, locus of the feminine and the Great Mother, inexhaustible reservoir of psychic and erotic energy, source and origin of all becoming, all evolution. Other spatial archetypes, from stairs to mountains, recall ascensional—male—dynamics, as well as the desire for flight, the aspiration to transcendence, and the constellations of the psyche. Even the perception of landscape changes: "I began to be very interested in the whole idea of landscape; what is formalistic landscape, what is the energized idea of external space, which is the equivalent to the energized idea of internal space, one of the most important areas is the garden. I began to look at very reduced gardens, of course sand gardens, but perhaps the most important influence was from Persian carpets."[19]

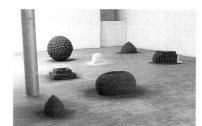

1000 Names, 1979-80

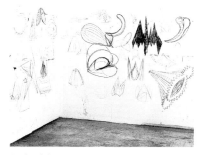

Study of the artist, 1985

If in *1000 Names* the rhythm of change was relentless, unceasingly living, breathing, and passing through successions of different moments corresponding to new situations, here it contracts nearly to the point of petrifaction. The morphological transformations of the *natural* matrix that permeates *As If to Celebrate I Discovered a Mountain Blooming with Red Flowers* are such as to make this group of "mountains" seem crystallized, as much by their abstract, geometrical formalization as by their concentration at the centre of the space. The work refers to a haiku, and reflects a Zen vision of the world, but the sense of reawakening induced by its Duchampian, Eastern play of words is more important. In this sense *As If to Celebrate . . .* should be confronted as a further questioning of art.

For Kapoor, art cannot be immutable, cannot continue to produce the same *names*. It must *reawaken*. His effort in these works is to rouse his painting/sculpture from the effect of gravity that threatened to submerge it in *1000 Names* and to rediscover an iconic spontaneity based on the light of *living* images. The 1982 works *Red in the Centre* (pp. 60–63) and *White*

XXIII

Sand, Red Millet, Many Flowers (p. 59), and the 1983 *Six Secret Places* (pp. 74–75), break out of any metaphysical schema of forms and materials and return to the capturing of a recognizable image, or at least a "figural" one. These configurations rising from the ground reflect a pulsing unconscious magma. The objects and forms seem to arise out of a subconscious imagery stratified in time, out of the artist's memory of his cultural, natural, and artistic roots. There are images of fire, of the body and of plants that manage to come together in symbolic unities of from five to seven elements. The works point to Kapoor's interest in memory, and in the freight of images that spring from history and culture.

In the sculptural experiments of 1981 and after, which run parallel to the variants of *1000 Names*, the need to master memory as a subjective reflection on one's own existence—as, in this case, an Indian-born artist active on the international scene—is of central importance. In particular, the theme of myth as testimony to a material, social, and spiritual life, a theme of Eastern origin, leads Kapoor slowly, until 1985, to choose and to live out an iconography that is ever more naturalistic: "Increasingly what is important is not looking at and reading myths as an observer, but *living* them, seeing connections with myths after the fact, so that one enters into those psychological states and ways of being that have made those myths."[20]

The deciphering of these natural images continues to lie in combinations of opposites: high and low, damp and dry, mortal and immortal, raw and cooked, perishable and permanent. This coupling of antinomies both carries on Kapoor's chosen discussion of dualities and enriches it with a naturalistic symbolism that is global and universal in nature: "Binary oppositions are the fundamental elements of the human condition. Capturing the void in matter is one way of creating drama, of placing the scene in a physically and psychologically clear language, in the sense that every form is either concave or convex. The materials used in Indian art can be perishable, such as bread, rice, and clay, or durable, such as stone and precious metals."[21]

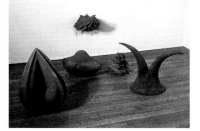

Red in the Centre, 1982

The struggle against time passes through the peace and quiet of the Oriental garden, a sanctuary of the memory of nature. The combination of sand and rock, moss and shrub, in these gardens symbolizes the perfect, balanced union of the elements of the universe. Kapoor looks at the gardens as he would at Oriental carpets, which reflect the "garden of heaven,"[22] and which consist of elements that coexist according to an "organic geometry and become an image of the earthly reflection of the heavenly state."[23] Intended as a place of ceremony, the Oriental garden is the site of powerful

sensory impressions that put us in touch with cosmic energies. Kapoor therefore takes it as a "place of power,"[24] so much so that he considers his objects of powdered colour "functionaries of a garden."[25]

The image of the garden moves between the toils of agriculture and the pleasures of Eden, and is defined by a relationship of continuity and transfer between nature and culture. It is a "third nature,"[26] then—a figure that mirrors the androgyne. Kapoor recognizes the garden as a site for the kind of grafting and reconciliation of opposites that presides over his art. A place of both natural and artificial form, it is a laboratory in which they find an alchemic compatibility, can manifest a mutual sympathy, and thus achieve a circular, mythic mimesis. Myth returns in the reverberation of the images that take shape in *To Reflect an Intimate Part of the Red*, *White Sand, Red Millet, Many Flowers*, and *Red in the Centre*, and also in *Three*, 1982. These works evoke secret relations between vegetal forms and figures such as berries, seeds, leaves, fruits, and roots, as if the primary emulsion of the cubes and spheres in *1000 Names* were turning into a growth of organisms whose image mapped the artist's knowledge.

Colour remains central. The forms are arranged without hierarchy, but the group is organic, "almost fruitily organic,"[27] in character. The agglomerations become accumulations of naturistic travel notes, as if the garden functioned like an atlas, charting the gnosiological paths of the world. The forms Kapoor dreams up assume bizarre connotations, abandoning all reference to Minimalist reduction, for "they are going in the direction of the symbolic landscape."[28]

Like *To Reflect an Intimate Part of the Red*, *Part of the Red*, 1981, sets red at its centre. That colour is flanked by yellow, its erotic complement, and by blue, which, anchoring it to earth like a root, expresses the immaterial underground. The figures' iconography ranges from stairs and knots to fruit and seeds, suggesting the potentially infinite multiplication and range of this chromatic kernel, and bringing it to flower. Rising up impetuously, the forms also turn inward, exulting in their corollas, their living interior cavities. They propagate a *vivification* that transforms them into sensitive cells, the particles of a nervous system that branches out into the whole space: "Bodies keep coming into this internal landscape."[29]

In *White Sand, Red Millet, Many Flowers*, the efflorescence of the forms leads to an irradiation of points and protuberances that suggest shapes ranging from breasts to mountains. Creating a spell, an aura, not only of colour but of form, they give the object a seductive intimacy. In both this work and *To Reflect an Intimate Part of the Red*, the arrangements of

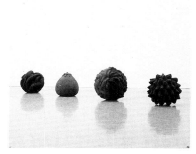

The Chant of Blue, 1983

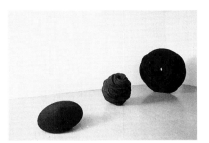

Hole and Vessel, 1983

elements refer strongly to their own depths. They call increasing attention to their curved, half-blossomed appearance, ardent and sensual, as if wishing to internalize, protect, and isolate themselves. In 1982 the vegetal objects and body parts become more resolved, growing and separating from the ground to become autonomous fruits, without any aureoles. The figure still refers inward, and no longer opens outward by dissolving into powder. Instead of breaking apart on the ground, it closes in on itself like some new being.

As the iconography broadens, the figures take on a solar quality, hot and dry. They even sometimes seem burned black—cold and raw, as close to death as to life. "The emphasis," according to Kapoor, "has shifted to the objects themselves so that they become like idols or 'objects of power.'"[30] A protuberance jutting from the wall emphasizes the organic quality of language—the tongue, a characteristic of the Indian figurative tradition, particularly in reference to the goddess Kali, to whom Kapoor seems to be referring in the pyramid of breasts in *White Sand, Red Millet, Many Flowers*. Everywhere there is the same search for a life force, mystical and physical, universal and personal, which must be constantly illuminated so that it will not die out. This probing of different symbologies reevokes the power of female blackness (the woman who is reincarnated in the underworld, who is the world's life force), which appears in the pyramid in *White Sand, Red Millet, Many Flowers* and also in the subsequent *Black Earth*, 1983 (pp. 68–69). It is as if this woman were being given back a long-repressed, buried voice: "As a man there's a feminine part to me, that's the creative and mysterious part."[31]

In every religion, the usual medium of communication between earth and heaven is the sacrificial rite. This contact, however, can assume different forms. In *1000 Names* made in 1982 (p. 57), and suggesting a sort of bud, seed, or heart, or some other internal organ, the material used is sky-blue-painted mud. This "heavy" work seems to deny the possibility of direct access to the divine—of any kind of contact with the divine that is more than symbolic. It signifies both renunciation and a joining of opposites—thus another "marriage." Kapoor's works from 1982 speak of fertility and the coming together of the sexes. The mediation no longer takes place vertically, from the earth to the heavens, but horizontally, like the attraction between women and men.

This earthly, carnal intercourse through mud, a material that unites the female principle (earth) and the male dynamic principle (water), has more than pleasure as its object: it also joins together diverse family groups, often

held together by the magic number five, a sign of union and perfection. We see this in *Part of the Red*, *To Reflect an Intimate Part of the Red*, *Red in the Centre*, and *Full*, 1983. These ensembles seem to reflect a mystical vision of the earth as an *alveus* capable of spontaneously yielding its fruits and harvests of love and nourishment. In antiquity, between the woman as furrow and the man as cultivator, beautiful fruits were once produced. Demetre and Devi, the goddesses of agriculture and the woods, protected human union and preserved seed in the womb.

Kapoor's iconography in these works is strongly sexual. In *In Search of the Mountain*, 1985, and a version of *1000 Names* from the same year, for example, his symbols become phallic and vaginal—yet they simultaneously assume absolute geometrical forms, arriving at an excess of "geometric figuration" that makes them seem rigid and cold. Despite this involution, however, which seems to bar the possibility of creation, the works nevertheless give rise to another idea of creativity (or maternity): that of the womb as vessel and locus of natural growth (as in *Mother as a Mountain*), and of darkness and the void as the zero point of creation, where the name and the word are reborn. "Let's think of the first person who made a pot. I feel that it was almost certainly a woman. Let us say that she went to the riverside and found a lump of clay and was able, with a few subtle movements of her hands, to transform it into a pot. What has happened is that the clay is completely changed. It is now a pot. It has a new function, a new purpose and—what's most important—a new name. The ability to give a new name is, in a way, this act of transformation."[32]

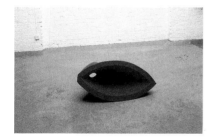

The Pot is a God I, 1985

The polished hardness of *Pot is a God* and *Pot for Her*, 1985 (p. 71), is the result of a refinement and crystallization of the dryness of epidermal sensuality in favor of a visceral sensuality. As the locus—the feminine locus—of mystery and enigma, the place where the wonders and secrets of all metamorphosis converge, place of the unmanifest and the unknown, the vessel is the *absolute* space. That void—wellspring and abyss, maelstrom and fullness of being—is presented as the maximum of unknown intensity. Furthermore, by depriving his objects of the chromatic vibrancy previously conferred on them by powdered colour, and creating openings and cuts in them, as in *Place*, 1985 (p. 79), Kapoor upsets the object's defensive perimeters, dissolving its texture and weight and making it transparent and luminous. This loss of solidity enables him to lay bare the object's interiority: "I have always engaged with interiority, that which is inside . . . Interiority has become evident, whereas with the early work it was implied."[33] With *Here and There* and *I* in 1987 and *Wound* in 1988 (p. 85),

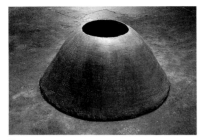
Shrine, 1987

the concept and vision of interiority become a kind of zero point that precedes form and colour, but that implies every possible formal universe. Here Kapoor begins to think of emptiness and darkness as moving toward fullness. He moves from abstraction to concreteness, not the other way round. Emptiness becomes a concrete language through which creation reverses its process, does not come into the light but goes toward the shadows into which all worlds ultimately fall.

The Architecture of the Self

For Kapoor, the passage from emptiness to fullness must be physicalized in material. At the same time, if this material is to convey emptiness, it must be dematerialized. To maintain the presence of this dematerialized material, Kapoor needs a substance not airy or light but dense and heavy, hard and solid: stone. Interiority must clash with a hostile, crystallized tumescence, must descend deep inside it to take possession of its *spirit*, and to find there an *elsewhere* in which metaphysics is part of natural existence. This journey into the underside of things is a continuation of Kapoor's search to contain, within a vessel, a unity based on the duality between the ego and the nonego, the inside and the outside, spirit and matter. The artistic ceremony that Kapoor begins in 1987 continues the myth of oppositional dyads changing places by spilling over into each other, so that the negative becomes positive, full becomes empty, heavy becomes light.

The belief that the infinite is the other side of the finite is fully formulated in *I*, a large limestone boulder carved out inside to form a cavity. A hole above the cavity allows one a view into it—a view into a deep blue. The visual experience is of looking at a nucleus of solid rock with a black circle on top, which, as one approaches, turns into an orifice, an opening onto a dark abyss. Similar to this, though with greater bodily emphasis, is the dialectic between inside and outside in *Wound*, 1985, where the stone is "wounded" and displays a pair of open red lips to the viewer's gaze. Both works carry on the artist's concern with the mechanism of life as a play of antagonistic poles, like Eros and Thanatos. In the one, nature displays the dual condition of presence and absence, wholeness and nothingness; in the other, nature shows that the inert—stone—can be reanimated, rediscovering a lost spiritual and fleshly potency.

The immersion in the dark chasm of infinite blue, like that in the red lips in which every principle of life, pure and impure, collects and coagulates, demonstrates the continuity in Kapoor's surrender to the metamorphic flux of material in the body and of the body in material. "I seem to be moving

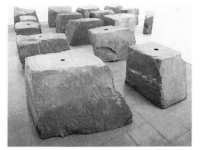

Void Field, 1989

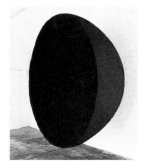

Madonna, 1989-90

from light to darkness. I think I know why that is. One of the things that has always had a very strong pull for me has been what I might call a matriarchal view of creativity, of energy. It seems to me that that is towards darkness, perhaps toward the womb. . . Darkness is formless."[34]

Whether sculpture has a frontal individuality, as in *I*, or a fleshly presence, as in *Blood Stone*, 1988 (p. 91), stone, like mud, transforms it into a "real landscape"[35] rather than a "mindscape"—a labyrinth of forms and materials in which one loses oneself in order to find oneself (*1000 Names*)—or a magic or ritual circle releasing energy from its centre (*Part of the Red*). It becomes instead a cosmic solidification, a great being asserting itself by its imposing presence. The very verticality and weightiness of the stones, hollowed out and charged inside with blue or red, presuppose a permanence that symbolically underlies their relative immortality, as compared to the impermanence of the arrangements of raw pigment. On the other hand, the works' scale is now of a human dimension and status: "An essential issue in my work is that the scale always relates to the body. In the pigment works from 1979 to 1983, a sense of place was generated between the objects. This place has now moved inside the object so it has been necessary to change the scale. The place within is a mind/body space. A shrine for one person."[36]

Contemplation means not only venturing and losing oneself along the unknown, mysterious path formed by a constellation of enigmatic and natural, esoteric and corporeal figures, as in *1000 Names*; it also implies confronting a *solidified* spirit, a *solidified* infinity, which can no longer be rarefied. The use of stone confirms this need to recognize the *real* equivalence between mortality and immortality, and the need to crystallize the sacred instead of dissolving it. In the history of religion, the greatest manifestations of the sacred have been lithic, from the Semitic bethels and the Arabian Kaaba to the black stone of Anatolia to Mithras, the Indo-Iranian lithic light. In the legend of Deucalion and Pyrrha, even the human is symbolized by stone. For all these reasons, one might say that stone is the path from the human to the divine. In *I*, the individual meets his destiny as something crude and heavy as well as sublime and redeemed; he comes up against his double, the I, who reclaims the body as a vehicle of the unknown. He is driven to awaken and to test himself against a thick wall erected between himself and the void, which swallows and devours all. This nothingness or void can arouse a mixture of fear and awe. As a boundary, it is close to dream and hallucination, to ecstasy and trance—so much so that in *Earth*, 1991, and *Descent into Limbo*, 1992, it will present

itself as an opening between light and darkness, an orifice in which human beings can lose themselves and fall. "Void is really a state within. It has a lot to do with fear, in Oedipal terms, but more so with darkness. There is nothing so black as the black within. No blackness is as black as that. I am aware of the phenomenological presence of the void works but I am also aware that phenomenological experience on its own is insufficient. I find myself coming back to the idea of narrative without storytelling, to that which allows one to bring in psychology, fear, death and love in as direct a way as possible. This void is not something which is of no utterance. It is a potential space, not a non-space."[37]

Seen in psychological terms, this is the dichotomy and the antithesis between the two planes of consciousness and unconsciousness. It reflects an awareness of the tangle of forces inside one, by which one is possessed. At the same time, the interval, the *in-betweenness*, that in earlier work held constellations of objects together is for the first time sucked inside. In a rising progression, the light that illuminated and penetrated the sculptures from 1983 to 1986, through a kind of mysterious metempsychosis, is transformed into darkness.

If one considers that behind these transformations stands the human individual—the *I*, who moves about in nature—then one can say that the initiation has reached its maturity. In both light and shadow, the subject has succeeded in recapturing the face of the divine. Having eliminated that separation, which is given in the passage through the very door of life itself—the maternal, sexual orifice—the human can now declare himself born: *Adam*, 1988–89. Following the recapture of *I* we see a crystallization of a higher illumination in which the human can be reintegrated, completing a kind of crossing that involves him down to his innermost fibers: *At the Hub of Things*, 1987, the first half-sphere in fibreglass, covered in dense Prussian blue pigment. This work begins the series of "Voids," which include *Madonna*, 1989–90 (pp. 114–15), whose monumental and architectural proportions (it is three meters in diameter) make it loom over anyone who approaches, the three elements of *Untitled*, 1990, and *Eyes Turned Inward*, 1993 (pp. 158–59). To allow for the epiphanic reabsorption of the human by the divine, these works turn the void outward. The enormous mass of blue, and the object's concave shape, create a kind of vertical abyss, capturing energy and pulling in the observer's gaze, if not his entire body.

The idea is "to make an object which is not an object, to make a hole in the space, to make something which actually does not exist."[38] Even more, the

Installation, 1989; Angel, 1989;
Void Field, 1989

XXX

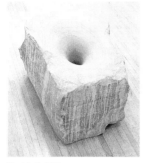

Untitled, 1993

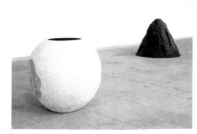

Untitled, 1991; Mountain, 1991

extraordinary appearance, loved and feared, of a piece of the void, at once finite and infinite, reactivates the symbolic contact between inside and outside, earth and heaven, male and female, active and passive, conceptual and physical, thus renewing the process of knowing. "The neophyte can, in this manner, have an effect on this unstable universe of powers that are outside him and inside him. The symbol, for him, is like a magical, irresistible entrance into that amorphous, tumultuous tangle of forces. [By means of] the symbol he enchains them, dominates and dissolves them; [by means of] the symbol he gives form to the infinite possibilities lying at the bottom of his unconscious, the unexpressed fears, the primordial impulses, the ancient passions."[39]

The plunge into the depths entails losing oneself, or experiencing a "sensual uncertainty."[40] One is also aware of being pulled into the magical vortex of an energy mass. "I have always felt drawn," says Kapoor, "towards some notion of fear in a very visual sense, towards sensations of falling, of being pulled inwards, of losing one's sense of self."[41] In the end one finds oneself transformed, or evolved. Getting lost in the purifying blue, which concretizes body and spirit, thus enables one to recapture an *elsewhere* that is in continual motion: "Colour is a real transformer. It changes things very directly . . . Recently I have tended to work more with space, with conditioning the space in such a way as to bring about different states of being. I see different works in terms of different states of being."[42] The earth is the dance floor for a wealth of I's performing the mythic dance, bearers of spirit moving according to a frantic rhythm. No two beings are alike; each has his own inimitable identity, each is a psychophysical quantum, each projects outside himself a life or body drawn from the cosmic reservoir, from the void and nothingness that surround us.

Void Field, an installation of sixteen large stones, identifies both the I and the world as they quantically occupy the same field. Between them the work finds a continuity of existence in which the distinction between organic and inorganic is false, because each is merely a different aspect of the same phenomenon. In both Western science and Eastern thought, opposites are polar; but in *Void Field*, Kapoor attempts instead to render in physical terms a field in which the I and the world move through the same space. It is a place in which the distinction between mass and void, one and many, heaven and earth, is inadmissible: "*Void Field* is a work in which this kind of binary opposition that I've always been juggling with seemed to place itself in some very clear way. It's a work about mass, about weight, about volume and then at the same time seems to be weightless, volumeless,

ephemeral; it's really turning stone into sky. The darkness inside the stones is the darkness of black night, the darkness of sky."[43]

More than just a crowd of distinct individuals, *Void Field* can be seen as an urban aggregate, a segment of city modeled in stone, and made up of monuments conceived as solid domes resting on stone flooring. It is a suggestive image, transforming the sky into a solid architecture through whose openings there shines a celestial light, luminous and mysterious. And if such a thing can be conceived, then the sky can become stone: "Once I made *Void Field*, this earth into the sky, it occurred to me that it would be wonderful to attempt the opposite . . . In *Void Field* we have the earth containing the sky, earth outside, sky within. To do the opposite was to have earth within, sky without. I just painted some stones . . . And . . . they became bits of sky. They became weightless and in a sense effortless."[44] The work in question is *Angel*, 1989 (pp. 104–109), a series of slabs of slate covered in blue pigment and arranged freely about the floor.

Angel, a further step toward the desired union of opposites, expresses a yearning for a mutual reappropriation between heaven and earth, a step in which the purity of the immaterial becomes material. The fluidity of air is solidified, translated into the surfaces and limits of a volume. At the same time, the texture and weight of stone begin to flow, to move like a cloud or stream. The intangible becomes tangible, once again possessed in the name of the esoteric desire for absolute fusion and the reabsorption of differences.

In its transmutation of energy, *Angel* is the counterpart to *Void Field*. Both deal with the transfiguration that leads to the sublime, and to the ecstasy (if not the hallucination), beyond all individual faiths, in which the celestial breath solidifies. Furthermore, *Void Field* and *Angel* represent a kind of duality. They are poles of shadow and light that imply each other, like two sides of the same coin. Together they make up a further whole, affirming that there is no such thing as a sure identity, enclosed in the comforting shell of a definition. One thing is always ready to spill over illusory into another and assume its outward appearance: "Notions about illusion are quite central. This is where I have a curious overlap with painting in that the space of painting is the space of illusion. I seem to be making sculpture about the space beyond, illusory space."[45]

In this dialectic between painting and sculpture, colour too assumes dual and complementary meanings. It may be affirmative and present, when laid over stone, or it may be absent and ethereal, when hidden inside stone. In terms of modern art history, the chromatic element of *Angel* and *Void Field*

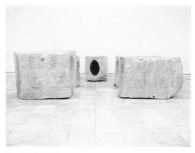

Untitled, 1990

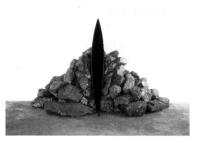

Black Fire, 1990

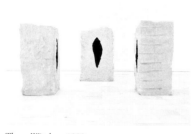

Three Witches, 1990

is an architectural crystallization of the sublime transparency that runs through painting from Barnett Newman and Mark Rothko to Yves Klein and Robert Ryman. If painters like these work on refining colour, Kapoor for his part works on petrifying it, in a kind of condensation of its astral, spiritual quality. His aim is to find the point of cohesion that will stabilize this suspended aggregate of opposites. Art serves him as the alchemic fire, purifying and regenerating so as to crystallize knowledge itself in stone. The crossing of this limit—the paradigm of light spilling over into matter—brings Kapoor's work close to the loftiest experience of holiness. It does not allow him to forget the opposition between male and female, however. Thus even at the height of his concretization of the divine—in *Angel*—he also reaffirms the power of sexual dualism, in iconographically intense, frontal works such as *Black Fire*, 1990, and *It Is Man*, 1989–90 (p. 111). Immersion in the chasm of the body, male and female, is a way of descending in order to come back up, of plunging into the swell of flesh in order to find the light. *The Healing of St. Thomas* consists of an opening or wound of red pigment set at eye level in the wall. At the same time, however, it alludes to the doubt and redemption of Saint Thomas, realized in the transition, through a touch of the hand, from skepticism about the Resurrection to belief: "The metaphorical language is that he reaches out to touch what is apparently an illusion only to find reality. The eye and the hand need each other. Once he has touched the wound, a kind of healing takes place in Thomas. He is healed of his doubt."[46]

One could say that the juxtaposition of images (*Angel* corresponding to *Dragon*, 1992, pp. 138–41), as well as reflecting a paradigm of East and West (*Pillar of Light* corresponding to *In the Presence of the Form*, both 1991, in a dialogue between male and female), is a way for Kapoor to show that art too proceeds by antitheses and opposites. To find its light again, it must immerse itself in the flood of pure and impure, high and low, the spiritual and the sensual. So, having crystallized the heavens through colour, Kapoor achieves a further linguistic shift by trying to define light and dark without using any colour whatsoever. From the incised slab of slate in *Tomb*, 1989 (p. 113), and the vortex carved into limestone in *Oblivion*, 1994 (p. 182–83), to the hollow in the floor in *Black Stones, Human Bones*, 1993 (p. 175), and the stratifications of light in *Bright Mountain*, 1993, the artist devotes himself to the experience of emptiness and fullness, darkness and light, through pure materials alone—-limestone and sandstone, sanded and polished. He wants to capture the stone's inner power, which he considers an element not of stasis but of potential action.

The Healing of St. Thomas, 1989-90

Limestone originates in water, a mobile, liquid element. Susceptible to evaporation, water can be transformed into air, which is itself open to further metamorphoses, one of these being fire. Kapoor's choice of limestone thus encompasses the possibility of a flux among the four elements of traditional cosmology: earth, air, fire, and water. Participating in the language of esoterism and initiation, Kapoor's limestone works reflect the perceptible processes of becoming, as they proceed, from within, from light to darkness—as we see in the seven elements of *Untitled*, 1990 (pp. 124–27), and in the great block of Kilkenny limestone in *Untitled*, 1994–95 (p. 191).

Just as mud can be shaped into an endless variety of forms and images, the potential of stone is infinite, even while this medium is never amorphous. Among its possibilities is the construction of an architectonic identity through the shimmering of light, as in the great cathedrals (*Pillar of Light*, 1991). The column of light is the ideal axis linking the dwelling place to the heavens, and architecture is a metaphor of construction, as of the self. In such works as *The Healing of St. Thomas* (p. 117) and *Endless Column*, 1992 (p. 143), both the carnal and the divine, in the form of colour and stone, undergo a further transition: they find light and darkness in the components of architecture. These works openly declare their function as supports; indeed they constitute or appear in walls and ceilings. In *The Healing of St. Thomas* the bloody orifice exposes the wall's "interior space," its carnality: "The body is a building, the self is another shell . . . the idea of architecture is an image of the self."[47] In *Endless Column*, on the other hand, vaporous, fragile red pigment becomes a supporting structure, an "endless column" (Brancusi) that seems capable of passing through the entire building and up into the sky.

Just as in ancient Greek tradition the columns of Hercules marked the confines of the known world, one might say that architecture is a metaphor for approaching darkness and the unknown, a way of knowing them. In 1992, then, Kapoor "becomes" an architect. Two projects from that year—*Building for Void* (pp. 144–49) and *Descent into Limbo* (pp. 154–55)—consist of constructions, one cylindrical and one cubical, in which the interiors make historical and esoteric allusions to light and darkness, conscious and unconscious, fullness and emptiness. In assuming this role, of course, Kapoor always keeps in mind the mysteries and secret rituals of the temple architects, their goal being the integration of architecture into the pure cosmos of the divine.

Building for Void is a cylindrical cement edifice, fifteen meters high,

designed in collaboration with David Connor for Expo '92 in Seville. From
the outside it looks like a geometrical vortex about to screw itself into the
ground. Inside, openings in the floor and ceiling give respectively onto
darkness and light. These two moments—created below by digging a cavity
into the floor and covering it in blue, and above by piercing the building's
perimeter—express a death and an ascension, a stasis and a motion, the
calm of the underground world and the dynamism of the heavenly.

Descent into Limbo, created for Documenta IX in Kassel, Germany, is also a
concrete structure, this one six meters by six meters by six meters. If
Building for Void posits architecture as possessing the luminosity and happy
mastery of antithetical yet complementary energies, here architecture
becomes dark and terrifying, due to the presence, in the centre of this great
cube, of a large orifice opening onto a huge circular void, three meters in
diameter. There is the illusion of a flat blue surface on the floor, but as one
approaches, one realizes the sensation of standing at the edge of a precipice.
The bottom is invisible, as though a fall might be infinite and eternal:
Limbo. The effect creates an enormous tension, as though the earth's crust
had ceased to exist and beneath it there was only an immense void, an
absolute darkness.

In this dramatic ritual of entering a solid-looking concrete block, accessible
only through a small door, one experiences a passage typical of the
procedures of alchemy—a movement from a theatrical moment to a
triumphal one. Forcing the building's opening and plunging into the space
on one's way to the edge of a great void, the dark vortex of the unknown,
one feels physically and psychologically alive. One has penetrated and been
embraced by the magnetic force of an unknown energy. Submitting to it,
one reacquires a sense of one's finitude through the experience of infinity:
"The void has many presences. Its presence as fear is towards the loss of
self, from a nonobject to a nonself. The idea of being somehow consumed
by the object, or in the nonobject, in the body, in the cave, in the womb. I
have always been drawn to a notion of fear, towards a sensation of vertigo,
of falling, of being pulled inwards. This is a notion of the sublime which
reverses the picture of union with light. This is an inversion, a sort of
turning-inside-out. This is a vision of darkness. Fear is darkness of which
the eye is uncertain, toward which the hand turns in hope of contact and in
which only the imagination has the possibility of escape."[48]

The ordeal of the void, of limbo, is a necessary precondition to gaining
mastery over nothingness and the self. It occurs through a dramatic
experience of the breath, the unknown fearsome word, that rises up from

The Earth, 1991

the earth. Emptiness is at the centre of this experience, in the place where the visitor is supposed to be; while fullness is on the periphery, on the verge of engulfment in the central vortex. *Horror vacui* is transformed into invigorating, active power. The work offers yet another way to take in the vital breath of the womb of the sacred and the numinous. Finally, the infinity that yawns before one's eyes is carved out as a circle. Implying absoluteness and totality, it is a form that alludes to heaven and earth, and to all that is complete and harmonious. But the circle is also the uterus, the holy enclosure, locus of the Great Mother, primary element of creation and reproduction. Like an overturned dome, it represents the pregnant maternal womb of the earth. Inside, *Descent into Limbo* is feminine, a condition of intimate space; outside, it is masculine, a rigid, aggressive construction. House and uterus, architecture and maternity, are isomorphic; they express the meeting of the sexes.

In its Apollonian clarity, *When I Am Pregnant* (pp. 165–67), a relief swelling from the wall in an image of maternity, overcomes the ancient conflicts between the sexes to express a cohesive energy, a power capable of inaugurating life. For Kapoor, the blending of architecture and nature is above all a metaphor of the desire for a fusion of male and female. "Every man carries with him the eternal image of woman, not the image of this or that particular woman, but a definite feminine image. This image is fundamentally unconscious, an hereditary factor of primordial origin engraved in the living organic system of the man, an 'imprint' or 'archetype' of all the ancestral experiences of the female."[49] Finally, pregnancy recalls the primordial experience of movement in amniotic space, as part of a whole as yet unknown. A space of pain and joy, of frantic spasms, of severing and separation, it leads to a harrowing identity: the dawn of life. *When I Am Pregnant* falls into an intermediate realm not entirely defined by either spirit or matter, for the body precedes the spirit and the spirit cannot exist independently of the body. The swelling of the wall, then, is an energetic expansion of material to ensure the existence of spirit. It is a transition between the action of the passions and the full wholeness of life. At once modest and immodest about existence, it uncovers a sweet nakedness, the nakedness of nature in her most unexpected, surprising aspect.

He who is about to be born is in a state of transition: he will literally come out on the other side. Having emerged from the void, he will exist in the pure power of fullness. He will emerge as a temporarily kindled energy in a journey between life and death, between physical and metaphysical,

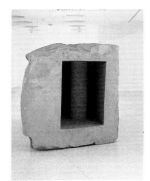

Pillar of Light, 1991

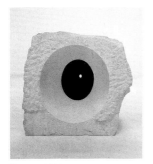

Passage, 1993

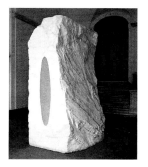

Untitled, 1994

between conscious and unconscious, "back to proto-existence which is always surprising, always new."[50]

At the source of all birth and beginnings there is light. And Kapoor's work begins to realize the primacy of light in 1995, when the series of "Voids" — with their silent sedimentation of darkness, of the unknown, the interior, the indistinct and mysterious — are followed by works like *Turning the World Inside Out*, 1995 (pp. 206–207), and *Turning the World Upside Down*, 1995 (pp. 204–205), which return toward clarity and luminosity, toward the visible and the definite.

Here the viewer is confronted not with uncertainty, with something ungraspable, as in works from *1000 Names*, 1979–80, to *Void Field*, 1989, but with an identity like a mirror. Thus *Turning the World Inside Out* gathers its surroundings into itself, including the observer's own gaze and body. Its exterior contains and conveys a panoramic vision of the space and of the everyday life around it, even while its interior is void.

Manifesting both itself and the world outside it, this twofold being both produces and re-produces, both offers itself to our gaze and hides within that gaze, forever surrendering itself yet forever fleeing. Compared to the darkness, total yet apparently definable, of the void works from *At the Hub of Things*, 1987, to *Descent into Limbo*, 1992, the luminous *Turning the World Inside Out* defines a whole that is fleeting because it is eternally divided between interior and exterior, between hiding and reflecting, between motion and immobility. Similarly, *Turning the World Upside Down* is an ensemble in which opposites try to reconcile and meet without either contradicting each other or losing themselves in each other. Rather, they live out the vicissitudes of a dialectical existence in which the sublime coexists with the everyday, the object is affirmed in its environment, fullness is reflected in emptiness, the real lives in harmony with the abstract. Something happens in the void, and this something eludes our grasp, for it does not really coincide with one thing or another, one space or another, one position or another. If, in the series *White Dark*, 1994–95, the correspondence between inner void and outer void makes all presence interchangeable, and affirms neither space over the other, *Turning the World Inside Out* expresses the same indefiniteness and indeterminacy of presence, in that it changes constantly, like a vortex, as it reflects light. The unexpected leap it proposes is no longer into the nothingness of darkness but into light. It gathers the secret forces of the reflective power of art, which can absorb all as well as dissolve all. To live through the experience it offers is to submit to the ordeal of loss that underlies and animates the void,

Untitled, 1995

embodying the enigma that every truth is born and then dies, is accessible and inaccessible, lived and created.

Capturing the force of life, as vortex, as eruption, is the essence of art and art in turn, through the principle of opposites, triggers the reading of life. This is the alchemy of creation.

The flow of Kapoor's visual thought continually resorts to an alchemical principle whereby the profound energy, infinite and unknown, that commands sight and perception becomes crystallized. In this way the artist plunges his work in an abyss of uncontrollable, unsurpassible essence, perpetual stimulus to the search for the unknown. This immersion in the limitless realm of sensation, which in Kapoor's works oscillates between color and forms, materials and volumes, gives rise to an upheaval that can be likened to a "turning of the world upside down." Here material, having lost its fixity, finds a new connection with immateriality, presenting itself as though perpetually, limitlessly activated. While the pre-1994 sculptures tended to reconstruct a limited reality, the image that Kapoor introduces in *Turning the World Upside Down*, 1995, is instead a spherical configuration that combines a maximum concentration and specularity of art to the point of erasing all boundaries. To look inside is, in fact, to trigger the disappearance and disintegration of the known world of objects — to negate the fixity of appearances which are afflicted by matter, and reveal an image that devours. Here we are in the realm of the unlimited, the infinite, a kind of vortex that engulfs and annuls things, a reflection that breaks and overturns the discontinuity of being, enabling it to attain an absolute purity and perfection. The energy that unfolds at the core of this art is linked to the abyss gaping in its depths, which are capable of revealing a blinding, elusive outerness. This, however, might reverse itself in an extroversion arising not from the removal of space, such as that occasioned by the spherical cavity, but from the externalization of the three-dimensional concavity that leads to *Turning the World Inside Out*, 1995. Here the volume reveals the world but contains a secret inside itself: the hollow enables Kapoor to maintain a dialectic between inside and outside. The sculpture externalizes and reflects reality and at the same time devours it, but also maintains an axis mundi, an omphalos or umbilicus that breaks free from the locus, or presents itself as a central figure foregrounding the enigma of the void and nothingness. In *Turning the World Inside Out II*, 1995 (pp. 210–211, 213), the eternal indeterminacy of the appearance of the unknown and the obscure, integrated into the floor and architecture of the exhibition space, becomes a figure floating on the boundary between being

and non-being. Its brilliance penetrates the opacity of the natural material and points to a totalizing vortex at the center of the world. It is an abyss of light and energy sunk into the floor, emerging from the surrounding surface and in sucking everything. It is the culmination of an upheaval for Kapoor in which he succeeds in symbolizing the essence of sight and perception as place, space and image. The work is a synthesis of arrival and departure, of inside and outside, a center of attention and irradiation of a distinct, unforgettable place. The state of tense wakefulness of *Turning the World Inside Out*, 1995, is then transformed into a total sphere in *Turning the World Upside Down III*, 1996 (pp. 228–229), as though Kapoor wanted to cast a final, ultimate spell. Here the relationship between cavity and concavity triggers a maximum concentration. The sphere succeeds in catalyzing the surrounding environment in both an inward- moving and outward-moving direction. With its outside and inside it empowers a highly effective double fulcrum, concretized in the total liberation of place. It becomes a nucleus, a center echoing the mutual embrace of art and reality — a plunge into the vortex of the image, where all mediation is annulled in favor of a single fusion. In this respect the embrace becomes almost mystical, since the work manages to reveal the spirit of its creator, to display his resources and to give expression to a profound plan that conveys everything into the flux of perception. It thus becomes clear why Kapoor, in 1996-97, decided to test himself with the overwhelming power of sacred and ritual places. First in the Kunst-Station St. Peter, 1996, in Cologne, Germany, and then in the Mausoleum am Dom, 1997, Graz, the artist confronts the task of conducting a dialogue with the superhuman maelstrom of religious architecture. In Cologne, he seeks to dissolve its barriers, while in Graz he attempts to gauge the insuppressible difference between the sacred and the profane. In the first *Untitled*, 1996 (p. 214), he does not renounce the fascination of the spatial and ritual Other, seeking to internalize it through specular, convex forms. In the second *Untitled*, 1997 (p. 231), he asserts himself through a separate unity, charged with golden reflections and objective autonomy in order to underscore the primordial independence of the visual and formal impulse, which he presents intact in all its radiating power. Both works reveal a tendency to sublimation; they both approach a sacred scale, as though the art wished in his work to make an ontological leap, something equivalent to the creation of an absolute continuum. The boundary disappears, and sculpture enters an inexhaustible dimension. Its visual and energetic infinitude unfolds as the sustenance of things; it becomes a synthesis between the limit and the limitless, coinciding

Untitled, 1995

with the very process of becoming. The immaterial, ideal tone of the sculpture is accentuated by the refinement of the materials and techniques. The suggestive power of alabaster, like that of stainless steel, triggers a passage from the physical to the non-physical, from the opaque to the reflective, from the dark to the luminous, multiplying the modes of sublimation and dialogue between materials and forms. By always starting from a nucleus and its centripetal and centrifugal forces, Kapoor continues to produce distilled works that express a uniqueness of purity and strength, mediated through different, contrasting expressive modes, such as rough and smooth, transparent and opaque. His 1997 *Untitled* series in alabaster codifies a vascillation of material that manages to absorb and/or release luminosity through the secret crux of the pure form, carved into the primitive block. The same thing occurs in the reappearance of color in the 1997 *Untitled* series in felt. Here reappear the magic of the chromatic sensibility, the inner necessity of a soft material, and the fortuity of the weight and the fall, typical of the works of 1979–84. And in them an obscure desire for reconciliation with the organic whole of the world is reasserted. Thus, after creating extreme works expressing absoluteness and infinitude, neutrality and inexhaustibility, the artist has liberated the "volatility" of chromatic pigmentation that had marked his early works, and has gone back to confronting the aleatory nature, the sexual and tactile immersion that are indices of another universe. With *At the Edge of the World*, 1998 (pp. 259–263), the evocation of an "other universe" reaches its culmination. A ponderous tool of incantation, the work creates a magical space that creates a complete metamorphosis of the place. It signals a change in direction, a universal, atmospheric exigency, where what is at stake is not only vision, but the entire body. Under the enormous red dome, the observer performs an almost mystical dive into the space, liberating his psycho-corporeal aggregate. He enters a coagulative potentiality that animates things and places, architecture and life. Kapoor is here is approaching a sensibility of infinity. And even though he never attains his ultimate goal, he seeks to capture its multiplicity, its "mother force," whose emotional power drives him to transcend limited individualities and present once again a continuum between the power of art and the goals of life.

Translation from the Italian by Stephen Sartarelli

1. Gerardus van der Leeuw, *Phenomenology of Religion*, Italian trans. *Fenomenologia della religione*, Turin 1975.
2. Anish Kapoor, quoted in Constance Lewallen, "Anish Kapoor," interview, *View* VII no. 4, San Francisco 1991.
3. Kapoor, quoted in Ameena Meer, "Anish Kapoor," *Bomb* (Winter 1989–90).
4. Kapoor, quoted in Lewellen.
5. Ibid.
6. Kapoor, quoted in Douglas Maxwell, "Anish Kapoor," *Art Monthly*, London (May 1990), p.6.
7. Ibid., p. 6.
8. Ibid., p. 7.
9. Kapoor, in an unpublished interview with Germano Celant, London, July 1995.
10. See Lynne Cooke, "Mnemic Migrations," in *Anish Kapoor*, exhibition catalogue (Oslo: Kunstnernes Hus, 1986). Cooke's essay is the first scholarly contribution to the analysis and study of the works of Kapoor between the years 1975 and 1981.
11. Kapoor, quoted in Maxwell, p. 9.
12. "Concerning Jung, I read books with illustrations from the complete works, like *Psychology and Alchemy*, *Alchemical Studies*, *Symbols of Transformation*." Kapoor, in the interview with Celant.
13. Kapoor, quoted in Maxwell, p. 7.
14. Kapoor, quoted in Lewallen.
15. Kapoor, quoted in Maxwell, p. 7.
16. Kapoor, in Michael Newman, *Objects and Figures: New Sculpture in Britain*, exhibition catalogue (Edinburgh: Fruitmarket Gallery, 1982).
17. Kapoor, quoted in Maxwell, p. 8.
18. Ibid.
19. Kapoor, in the interview with Celant.
20. Kapoor, quoted in Marco Livingstone, *Anish Kapoor: Feeling into Form*, exhibition catalogue (Liverpool: Walker Art Gallery, and Lyon: Le Nouveau Musée, 1983), p. 23.
21. Kapoor, quoted in Caroline Smulders, "*Anish Kapoor vers la dématérialisation de l'objet*," *Art Press*, Paris (November 1989): 18.
22. Kapoor, in the interview with Celant.
23. Ibid.
24. Kapoor, quoted in Livingstone, p. 15.
25. Ibid.
26. See Alessandro Rinaldi, "La ricerca della 'terza natura,'" in *Natura e Artificio*, ed. Marcello Fagiolo (Rome: Officina Edizioni, 1979), pp. 154–75.
27. Kapoor, in the interview with Celant.
28. Ibid.
29. Ibid.
30. Kapoor, quoted in Livingstone, p. 12.
31. Ibid., p. 23.
32. Ibid., p. 27
33. Kapoor, quoted in Lewallen.
34. Ibid., p. 16.
35. Kapoor, in the interview with Celant.
36. Kapoor, quoted in Marjorie Allthorpe-Guyton, "Mostly Hidden," in *Anish Kapoor*, exhibition catalogue (London: British Council for the XLIV Venice Biennale, May 1990), p. 50.
37. Ibid., p. 45.
38. Kapoor, quoted in Lewallen, p. 16.
39. G. Tucci, *Teoria e pratica del Mandala* (Rome: Ubaldini, 1969), p. 36.
40. Kapoor, quoted in Claire Farrow, "Anish Kapoor, Theatre of Lightness, Space and Intimacy," *Art and Design*, London, no. 33, 1993 p. 53.
41. Ibid.
42. Ibid.
43. Kapoor, quoted in Lewallen, p. 21.
44. Ibid.
45. Kapoor, quoted in Allthorpe-Guyton, p. 46.
46. Kapoor, in "Homi Bhabha and Anish Kapoor, a Conversation," in *Anish Kapoor*, exhibition catalogue (Tel Aviv: Tel Aviv Museum of Art, 1993), p. 62.
47. Kapoor, in the interview with Celant.
48. Ibid.
49. C.G. Jung, *Word and Image* (Princeton: at the University Press, 1983), p. 226.
50. Kapoor, in "Homi Bhabha and Anish Kapoor," p. 60.

Works

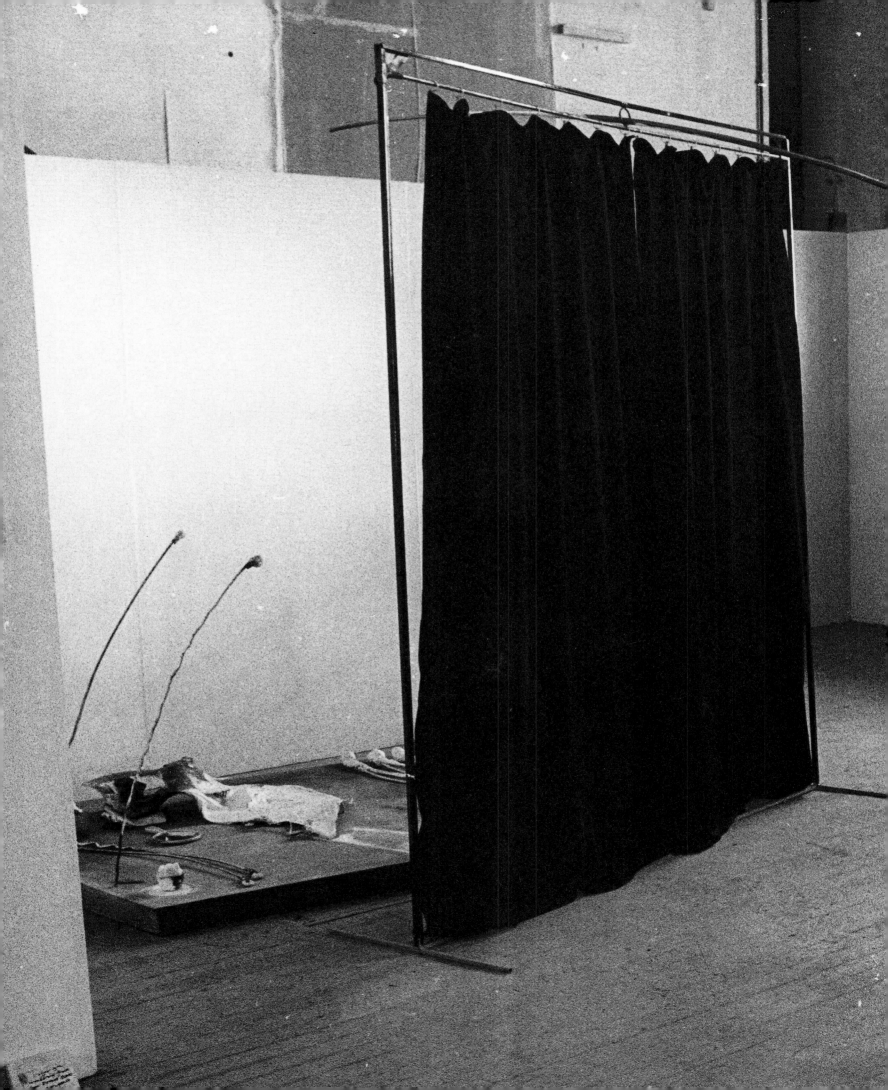

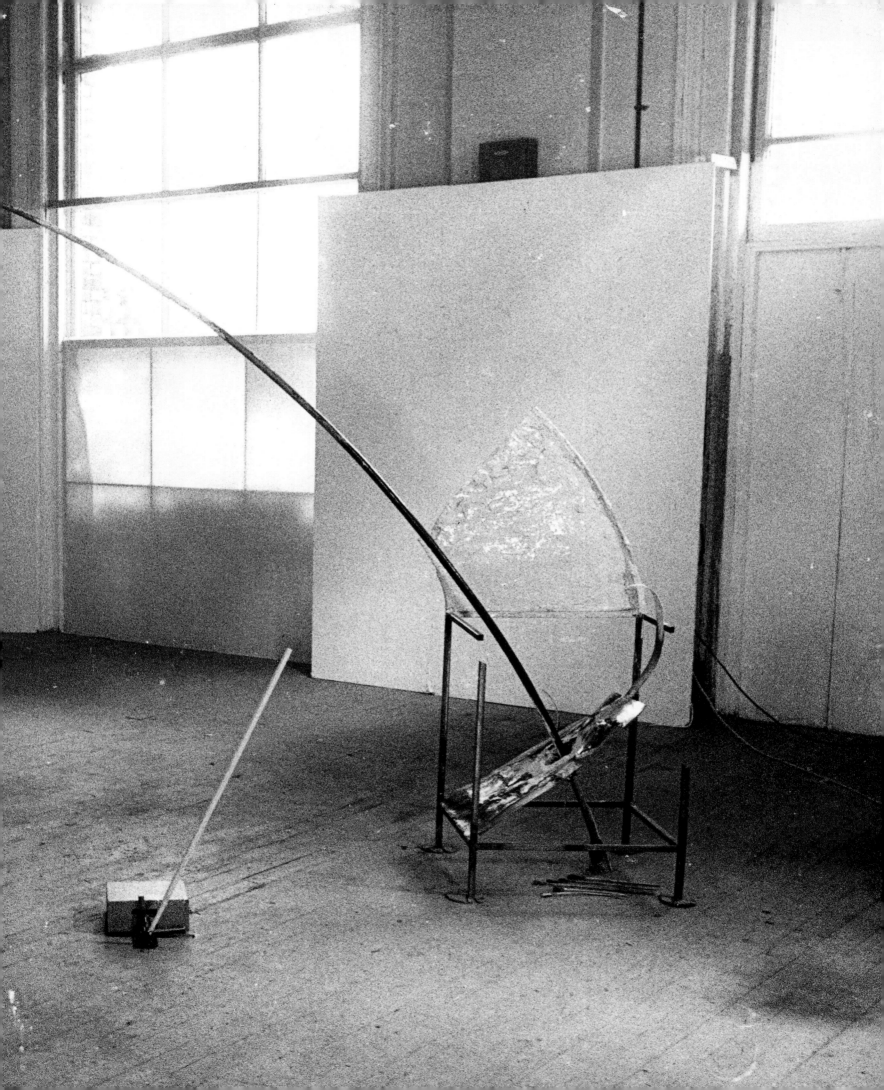

4

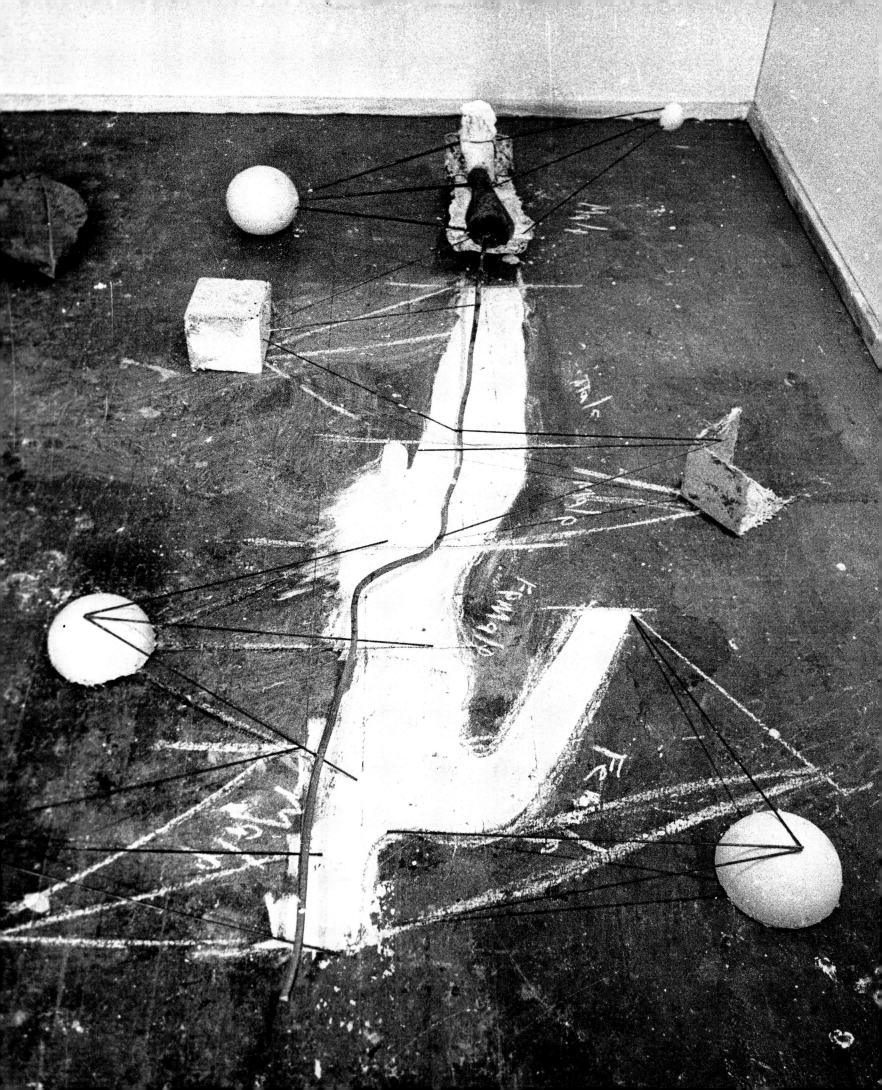

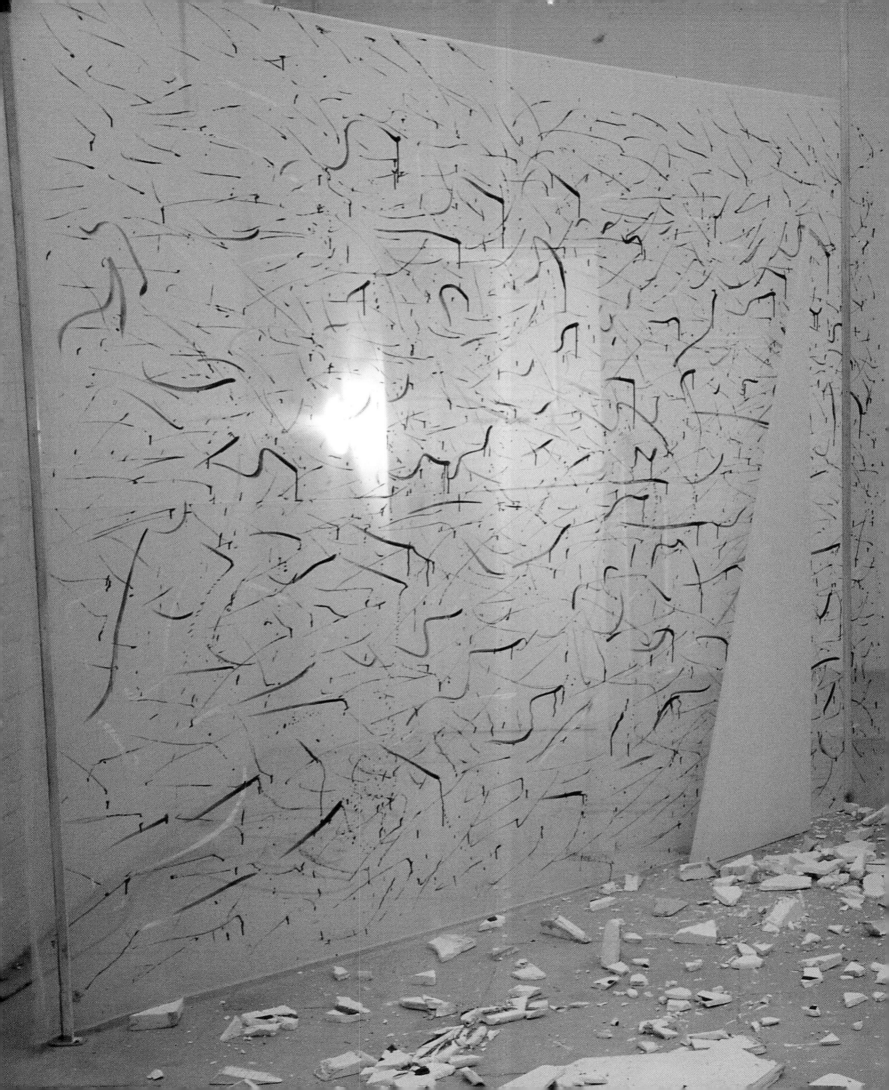

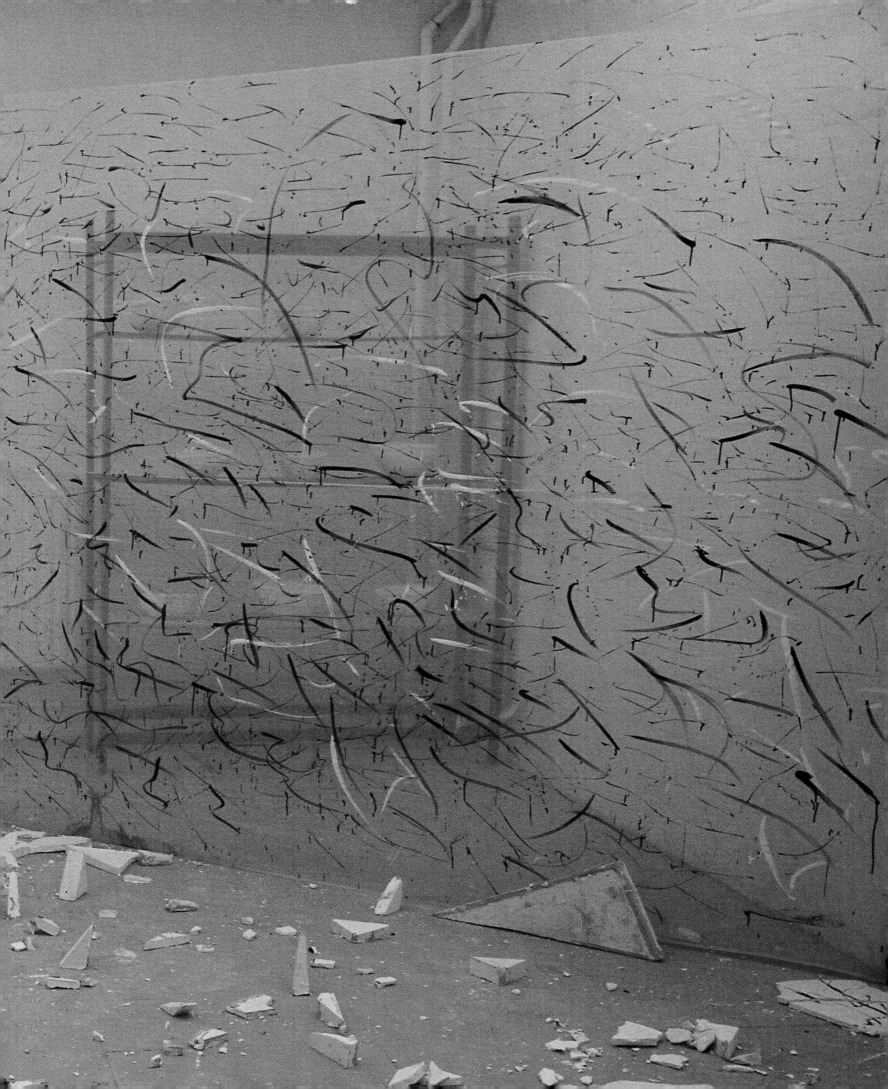

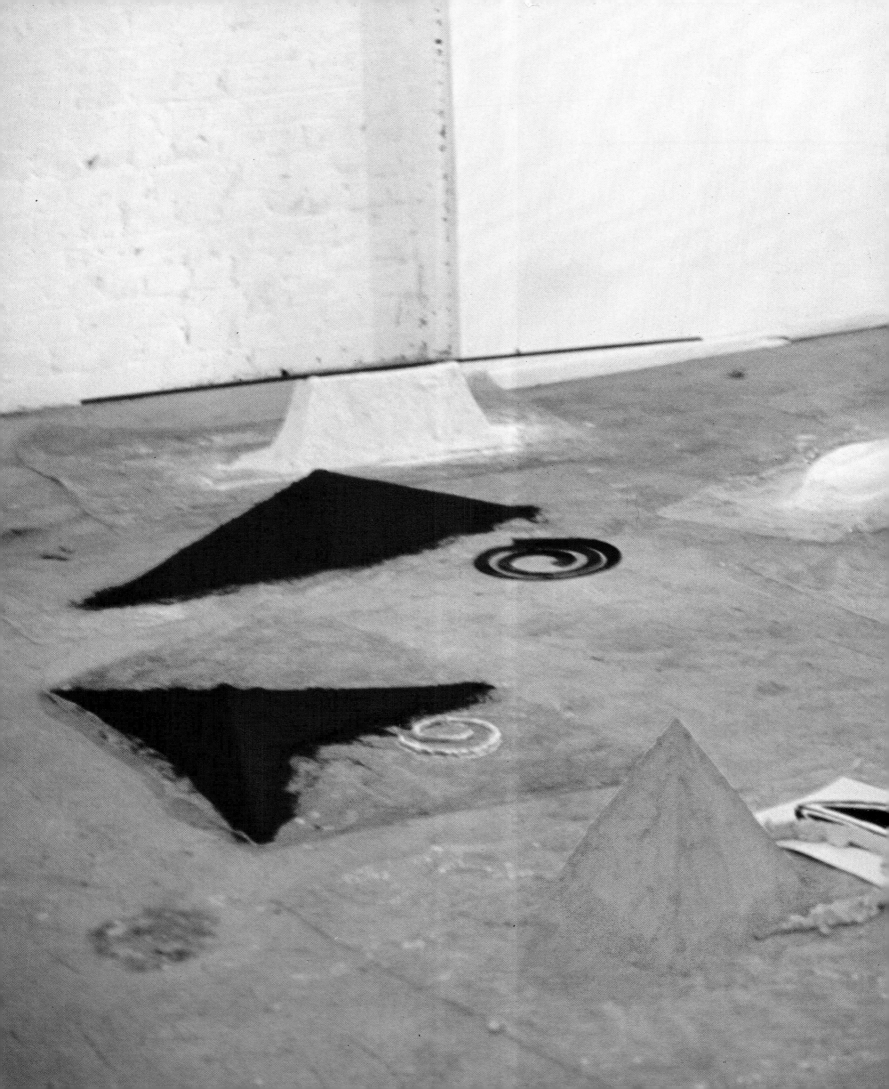

12

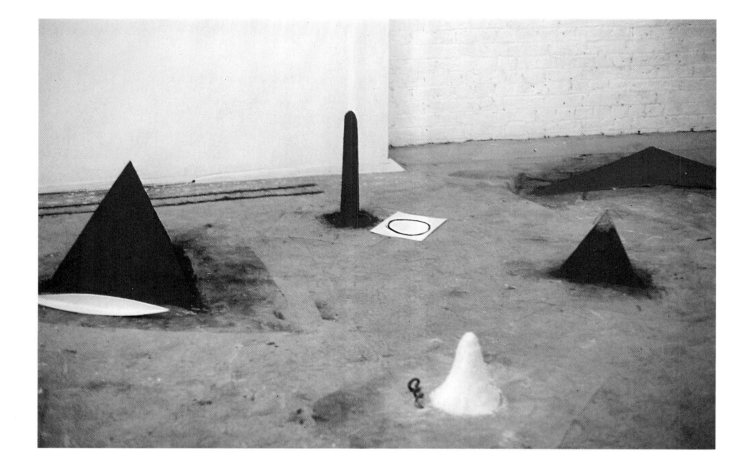

11

1000 Names, 1979-80

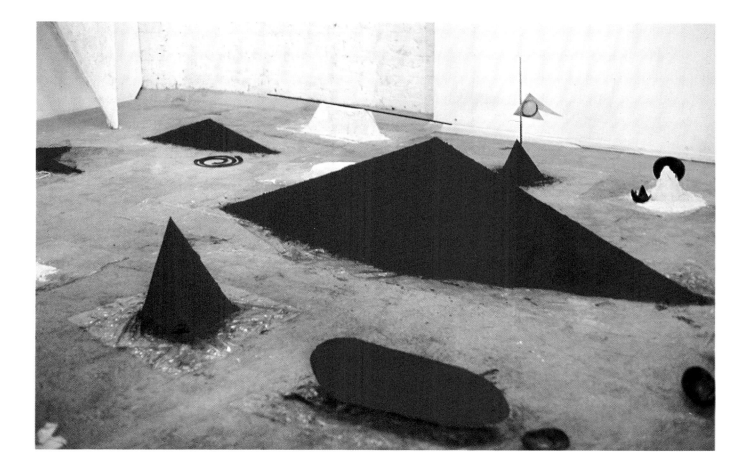

10

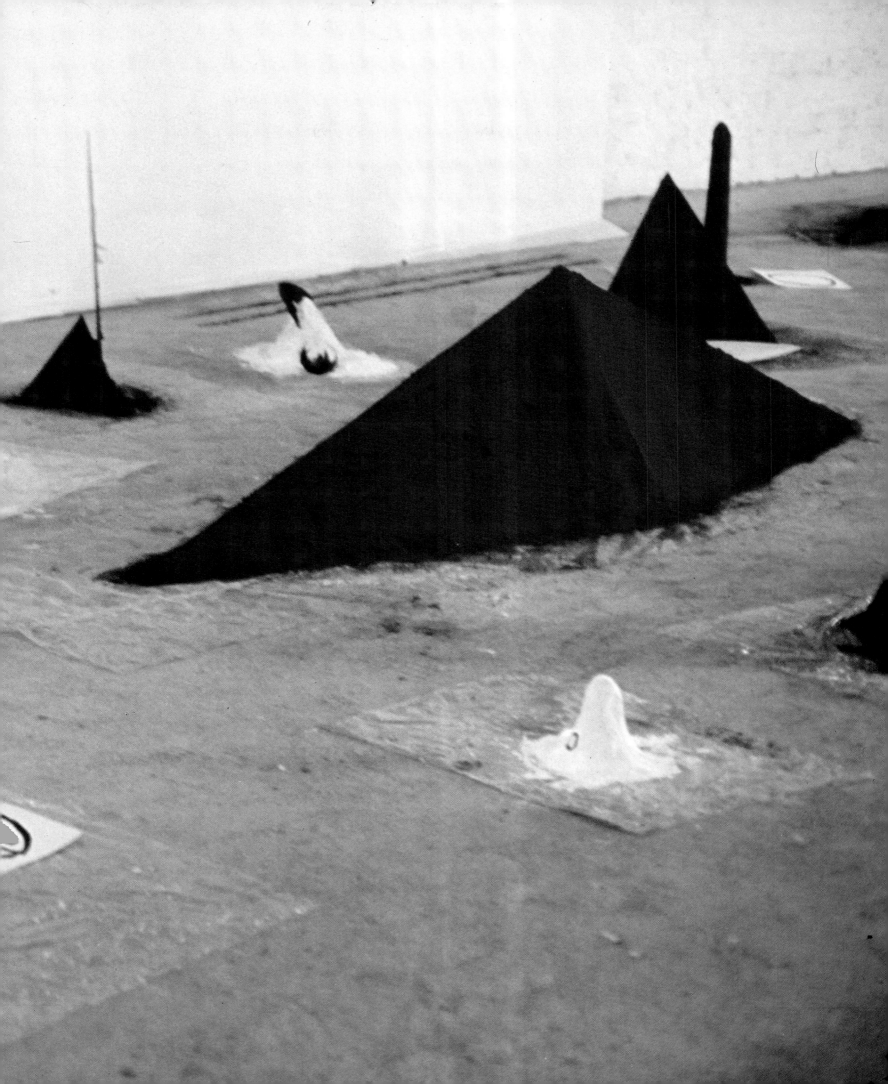

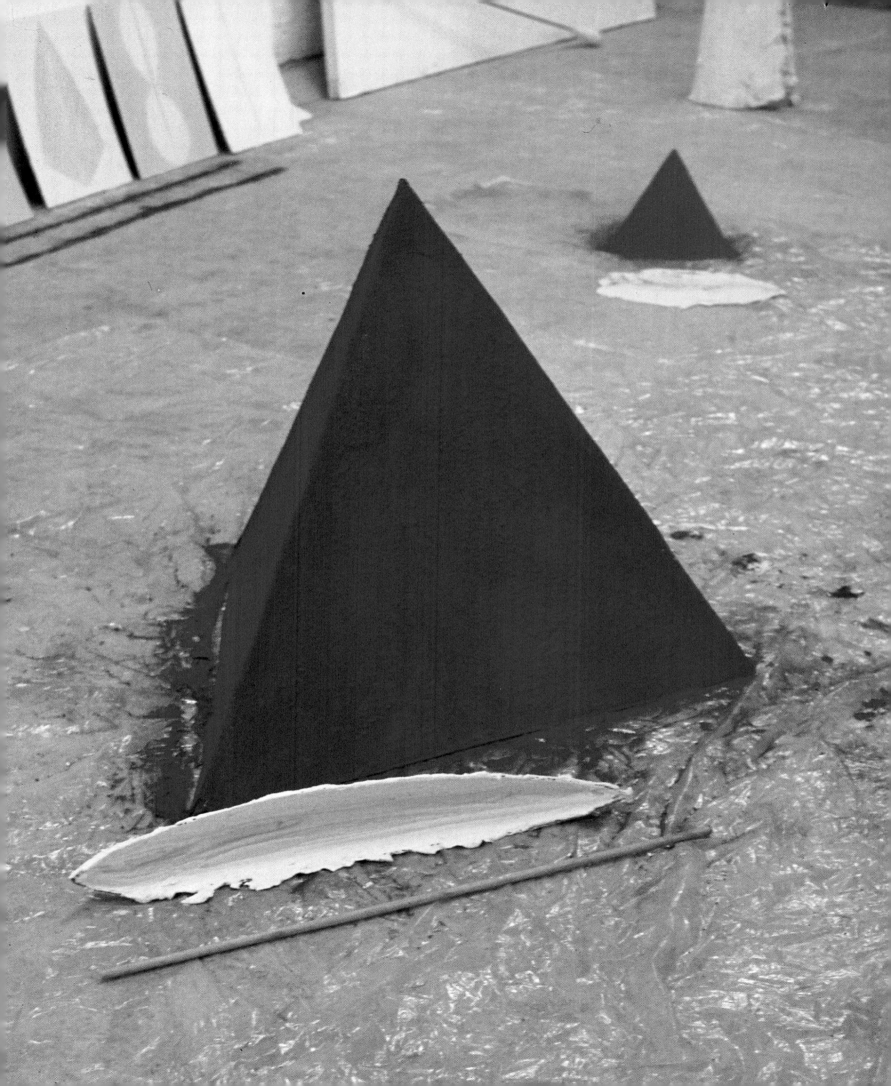

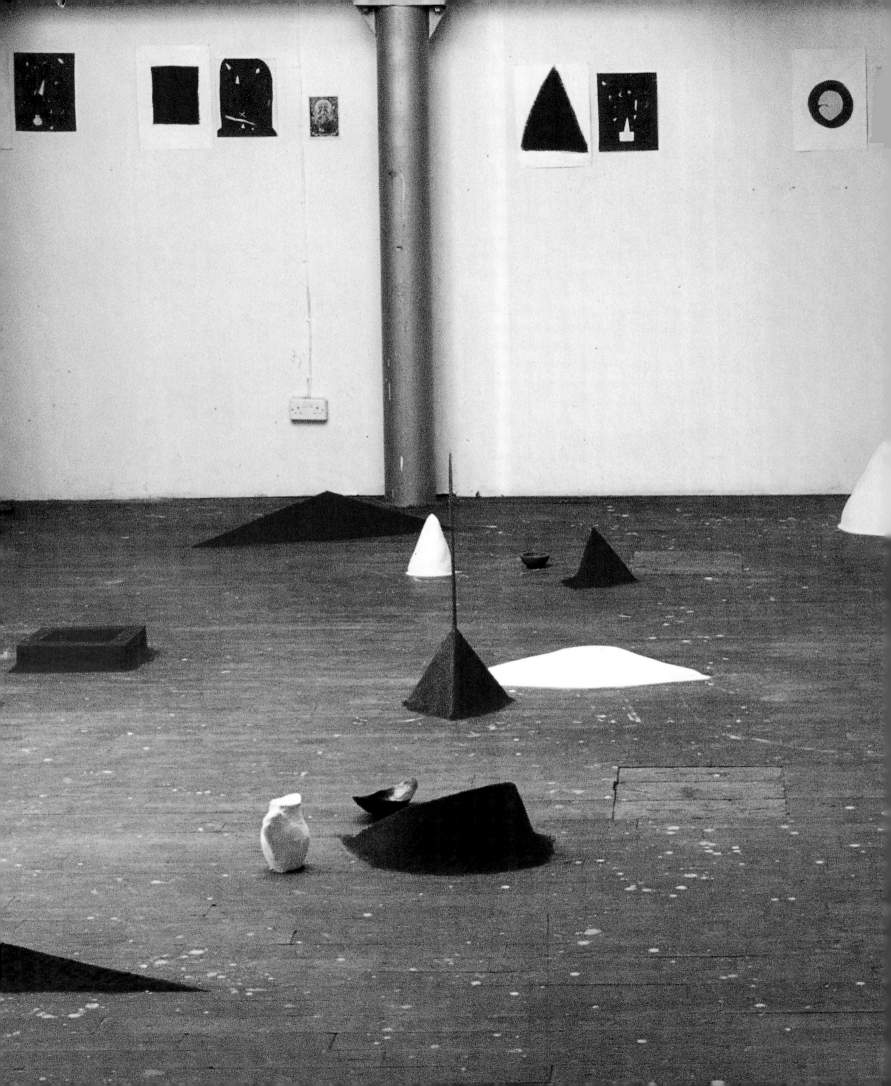

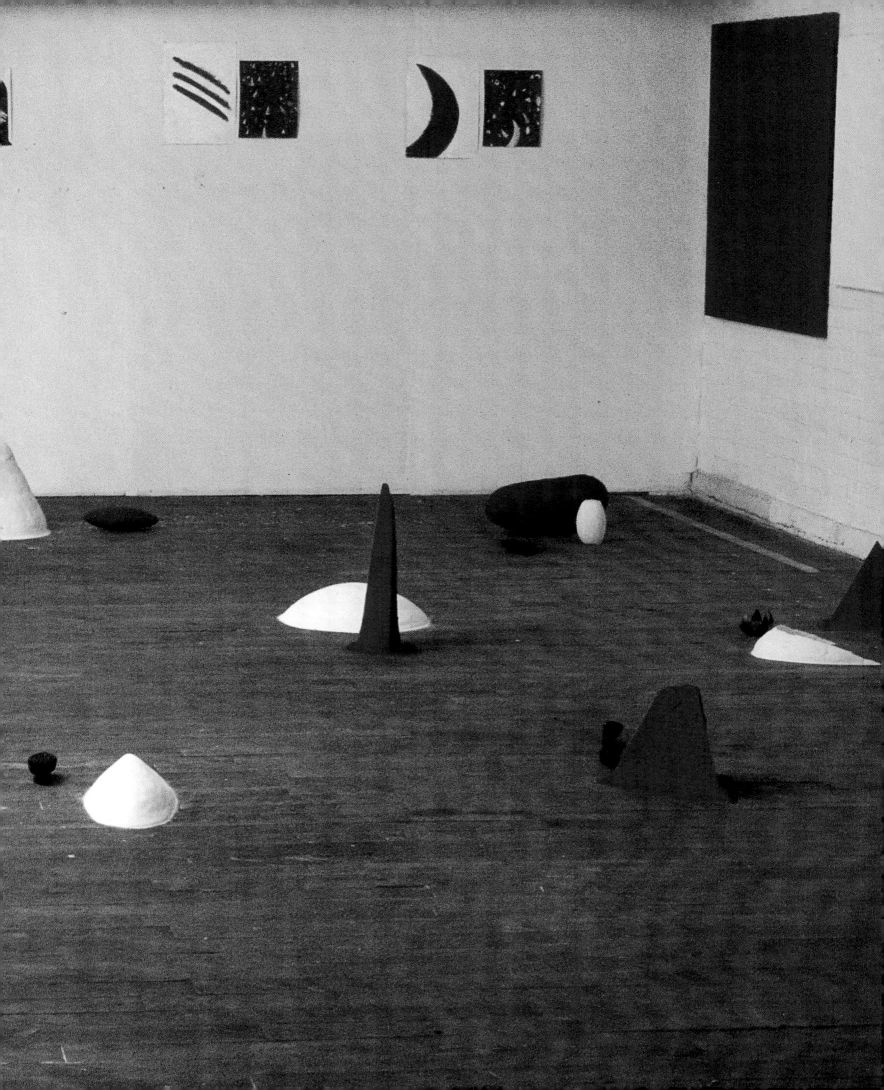

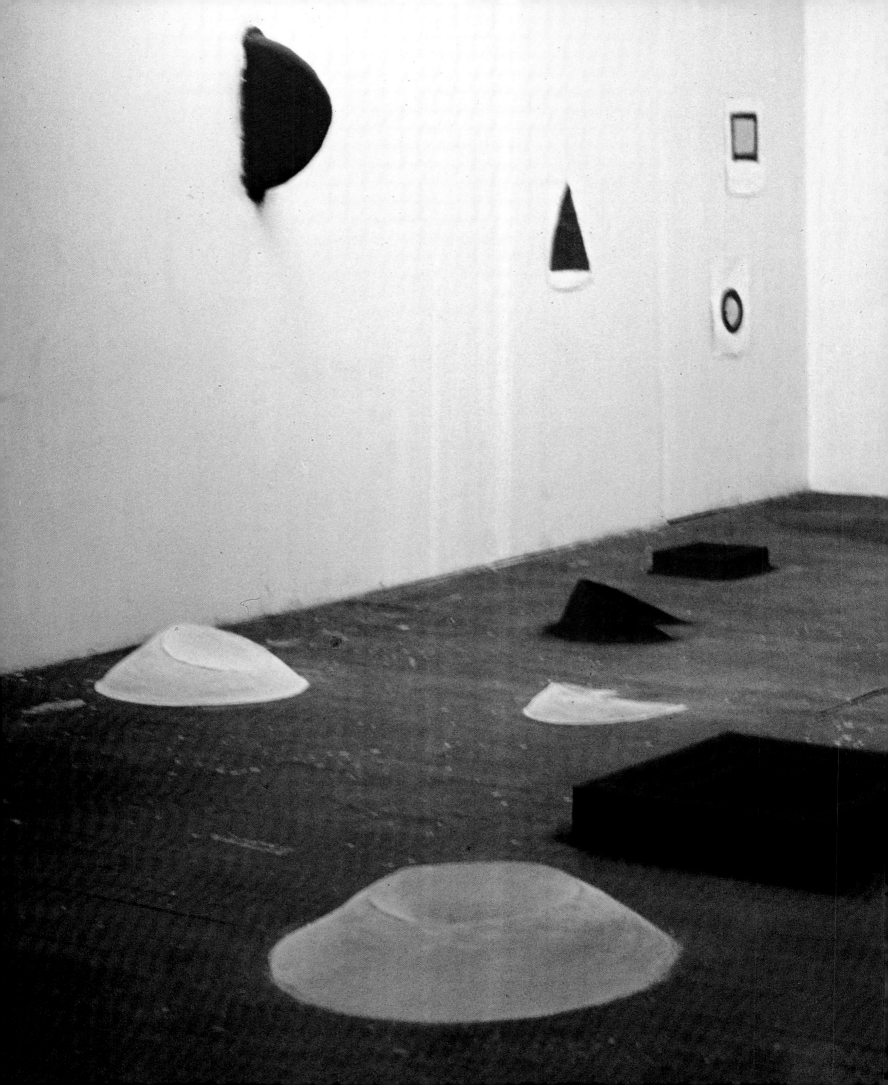

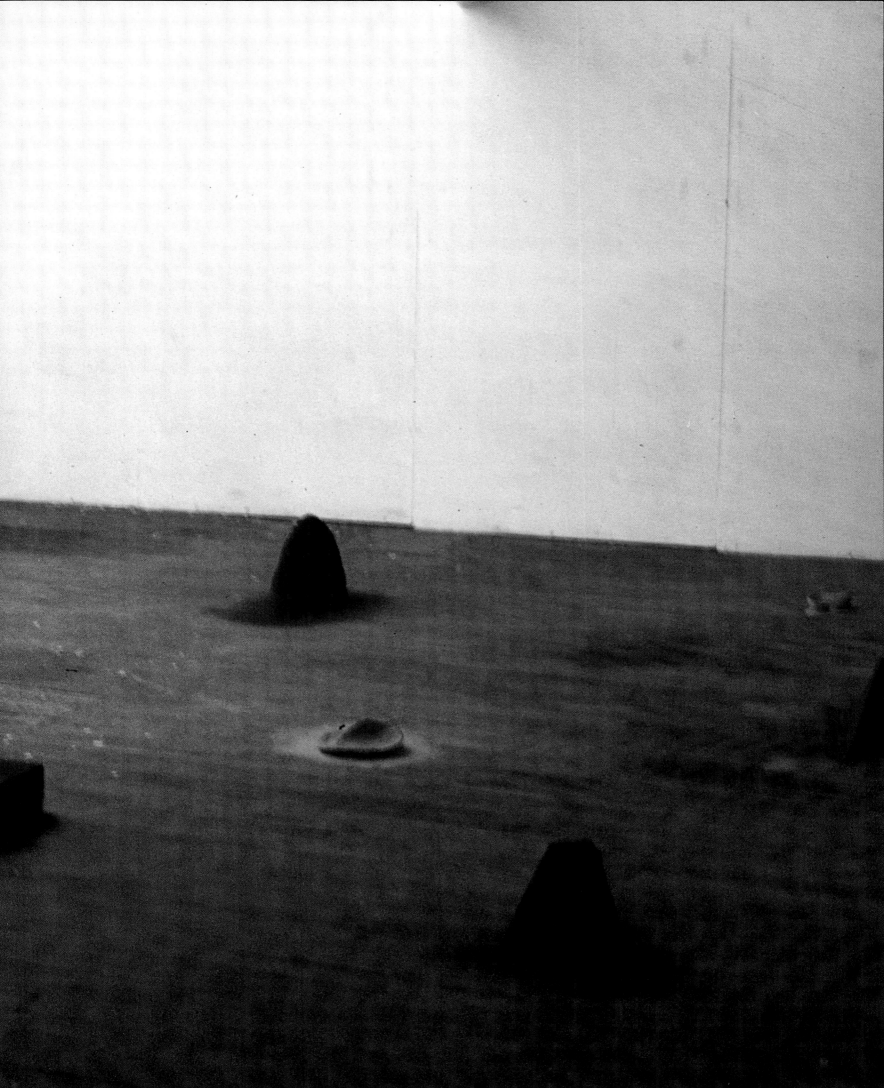

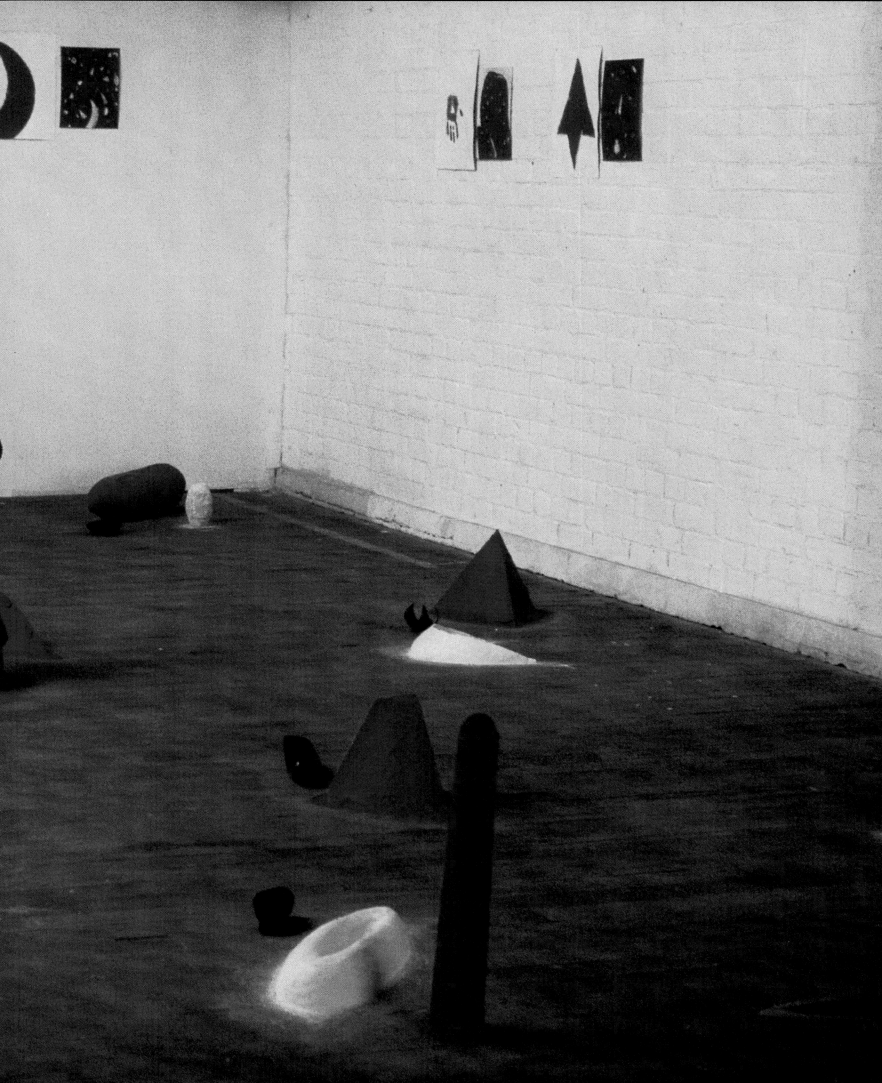

22

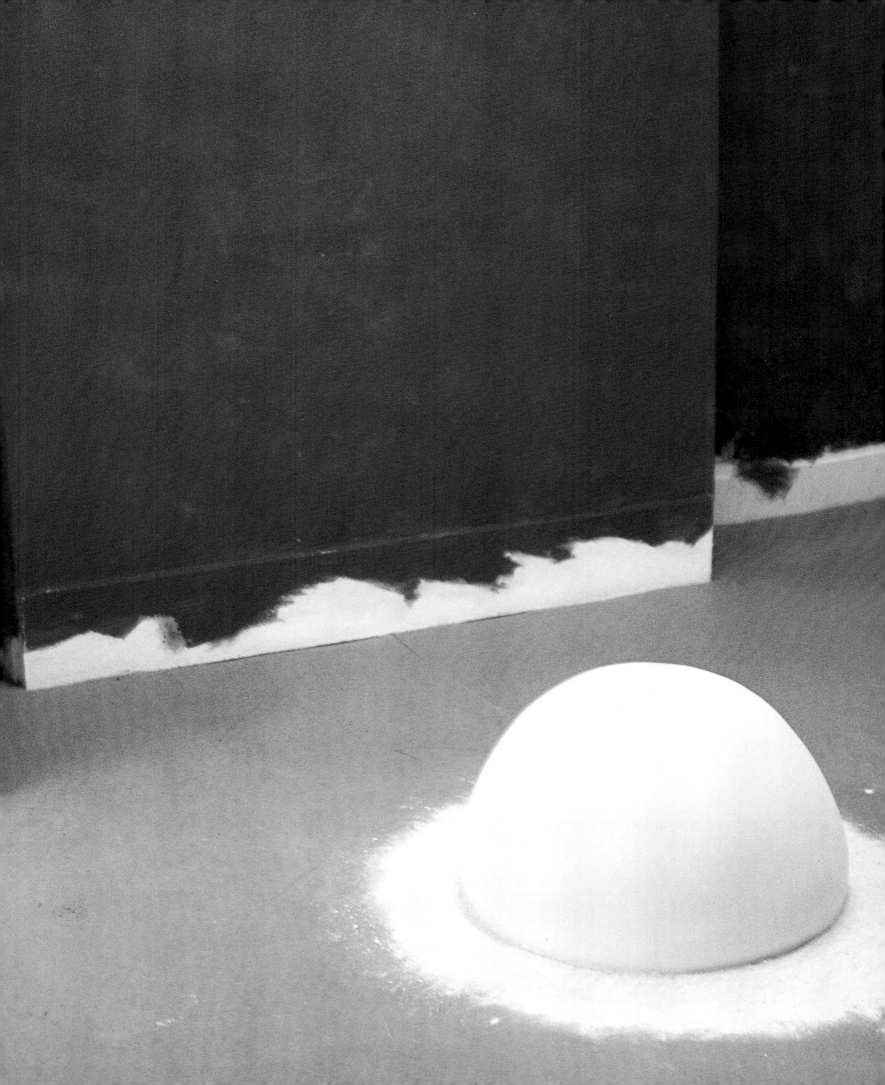

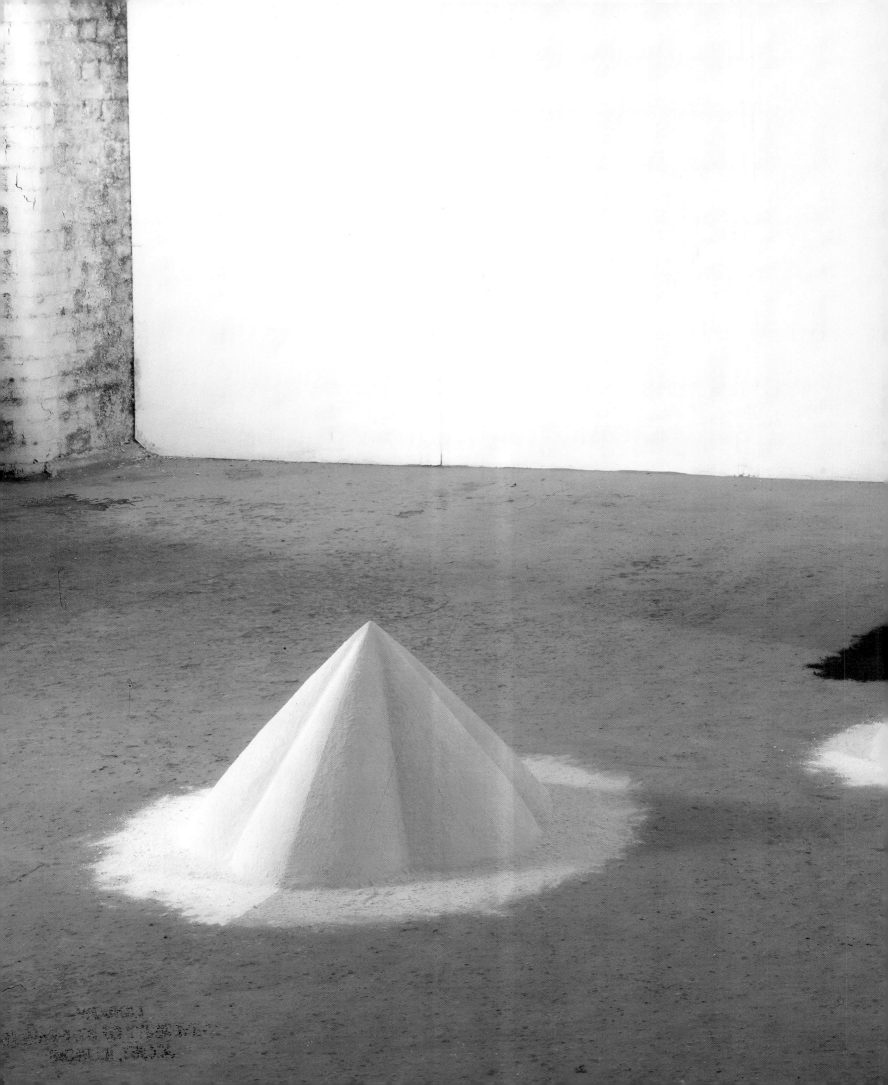

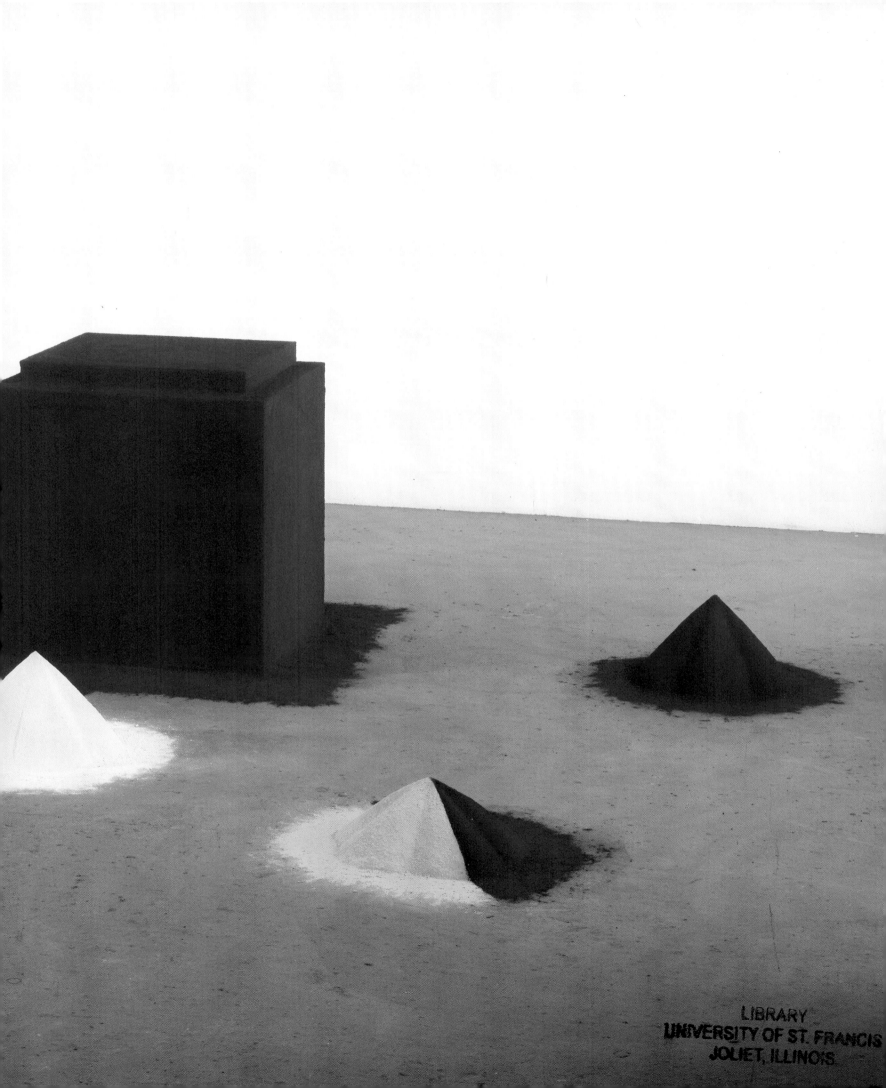

26

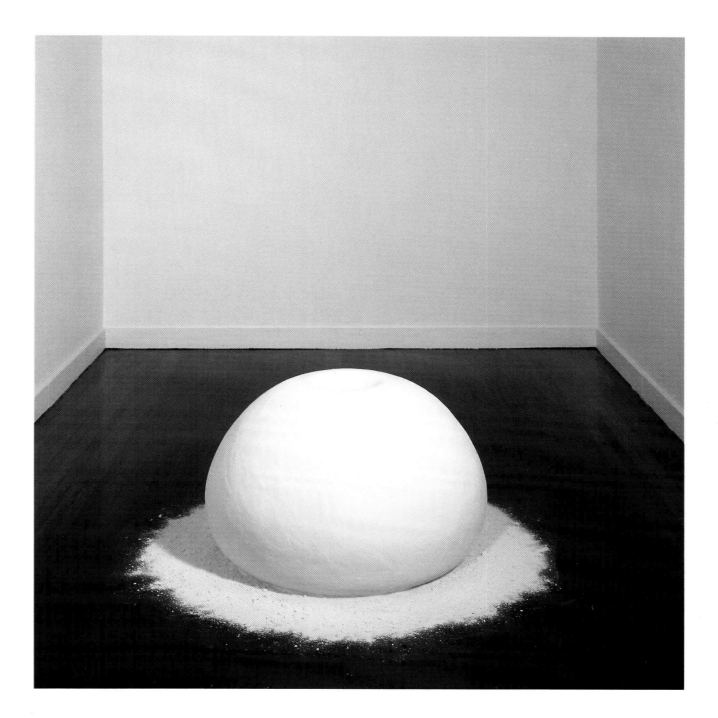

1000 Names, 1980

28

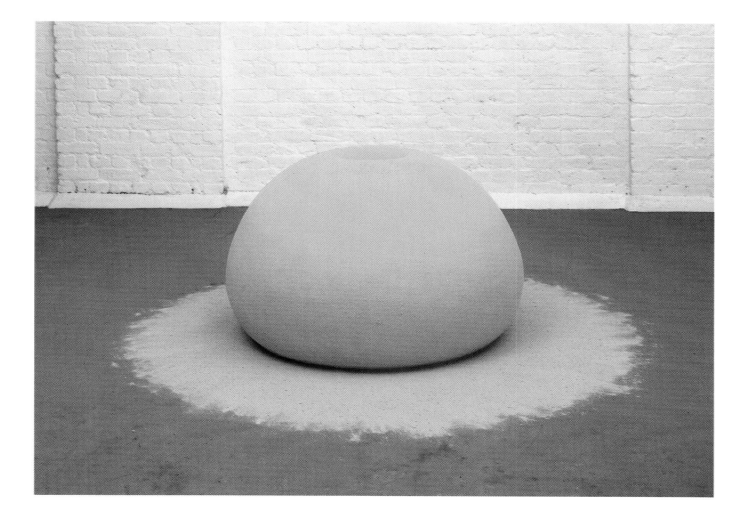

1000 Names, 1980-81

1000 Names, 1981

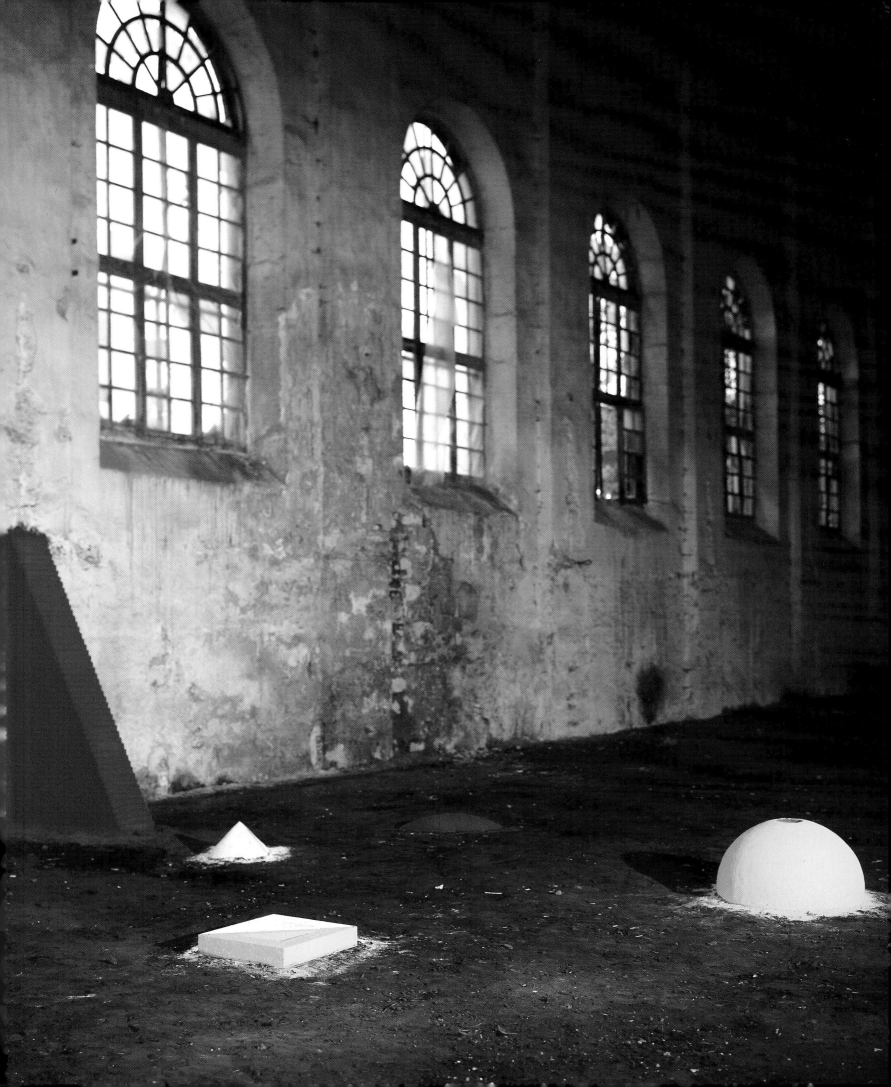

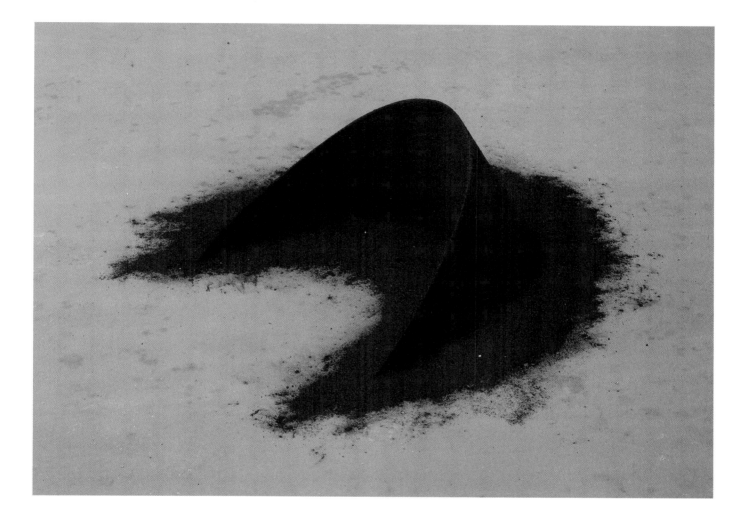

33

1000 Names, 1979-80

34

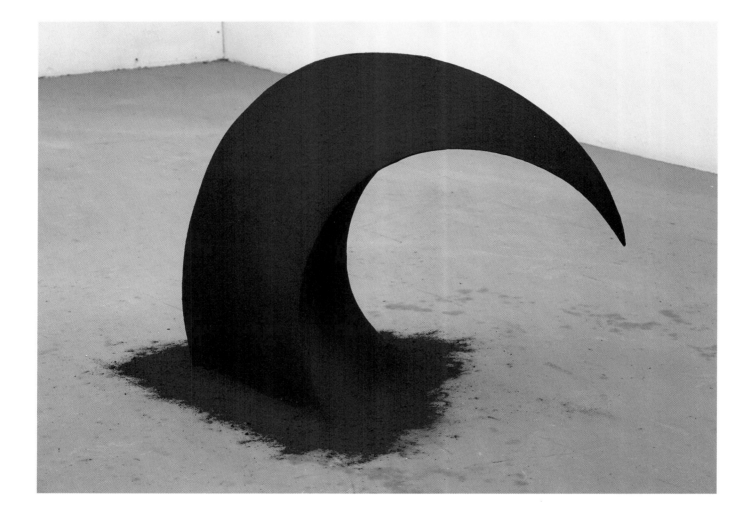

1000 Names, 1979-80

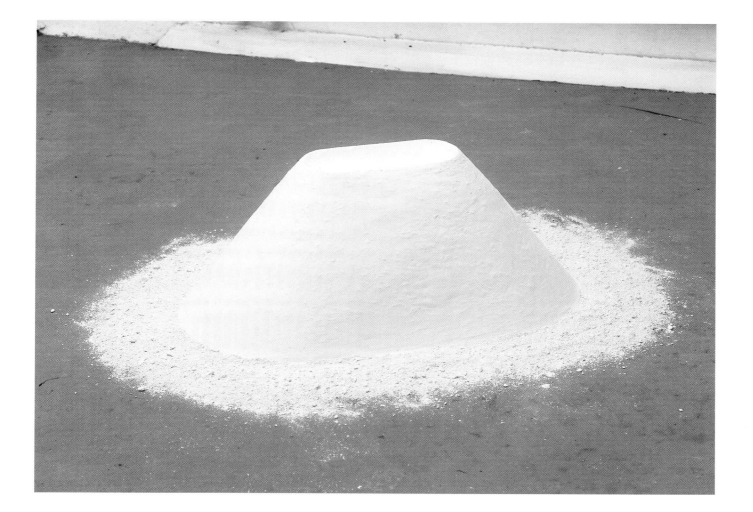

1000 Names, 1979-80

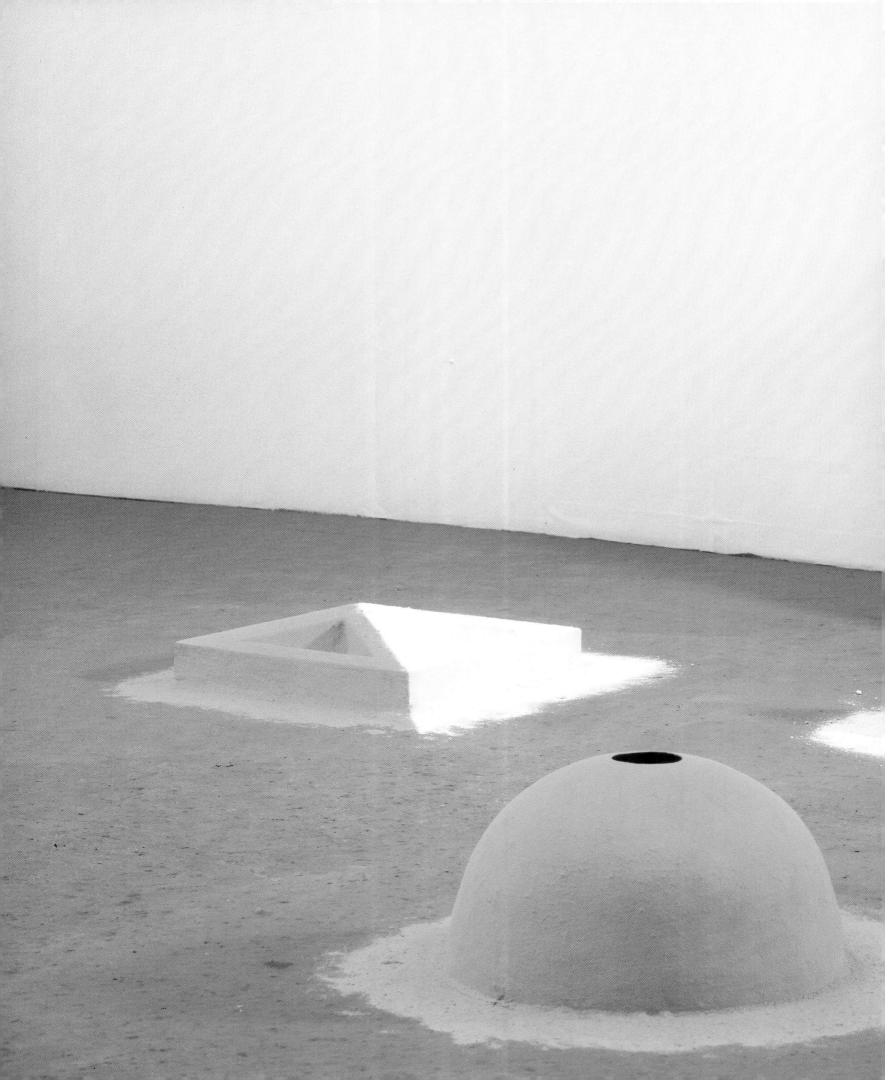

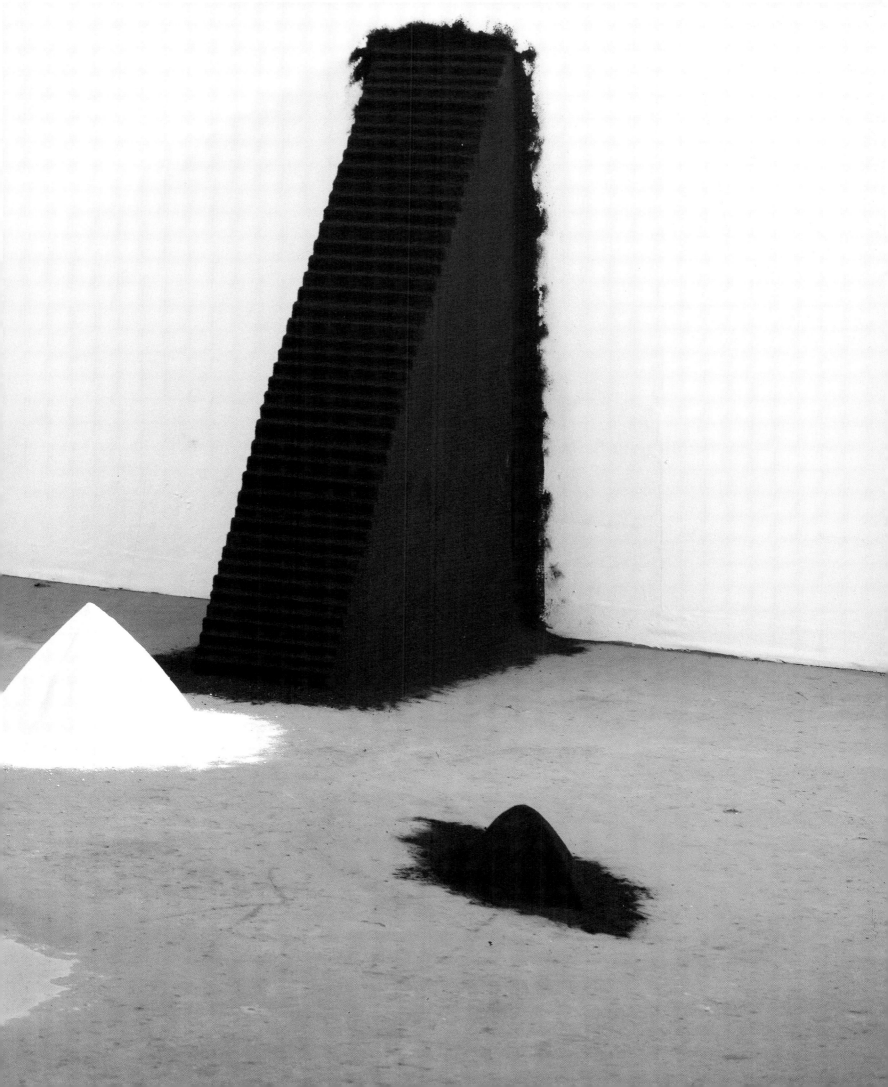

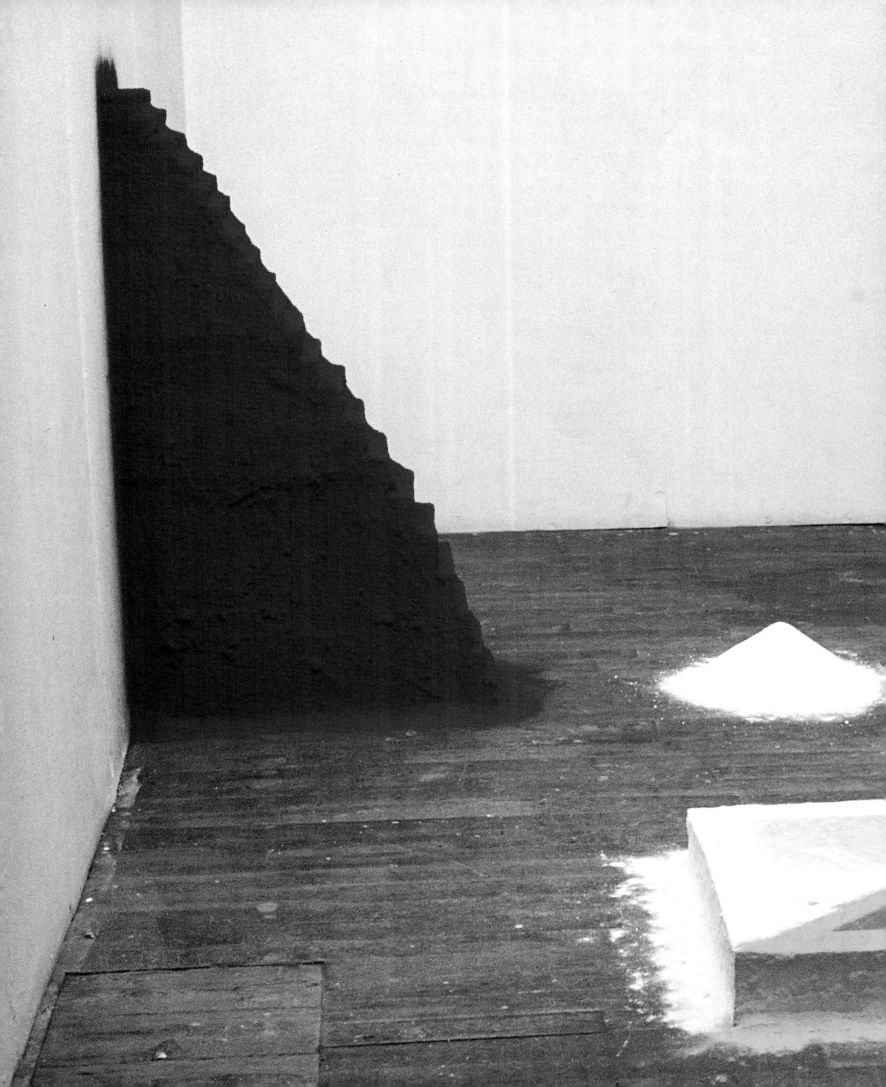

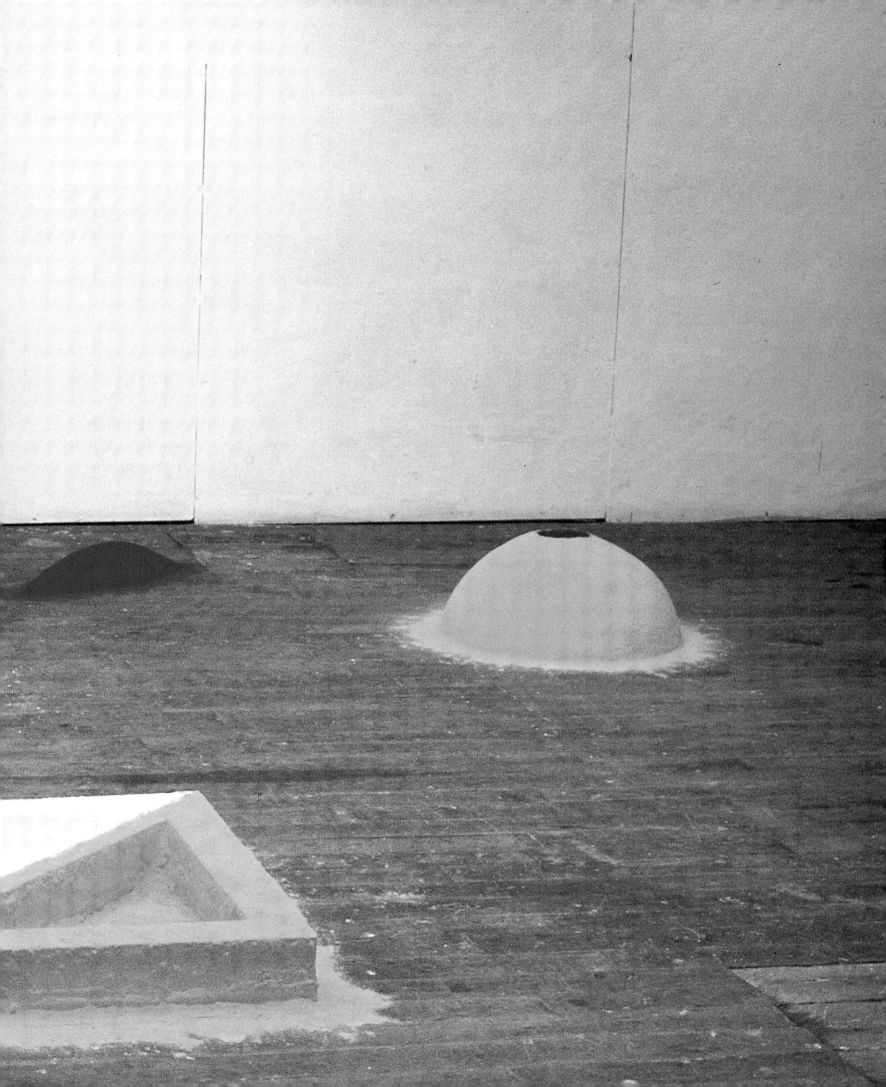

40

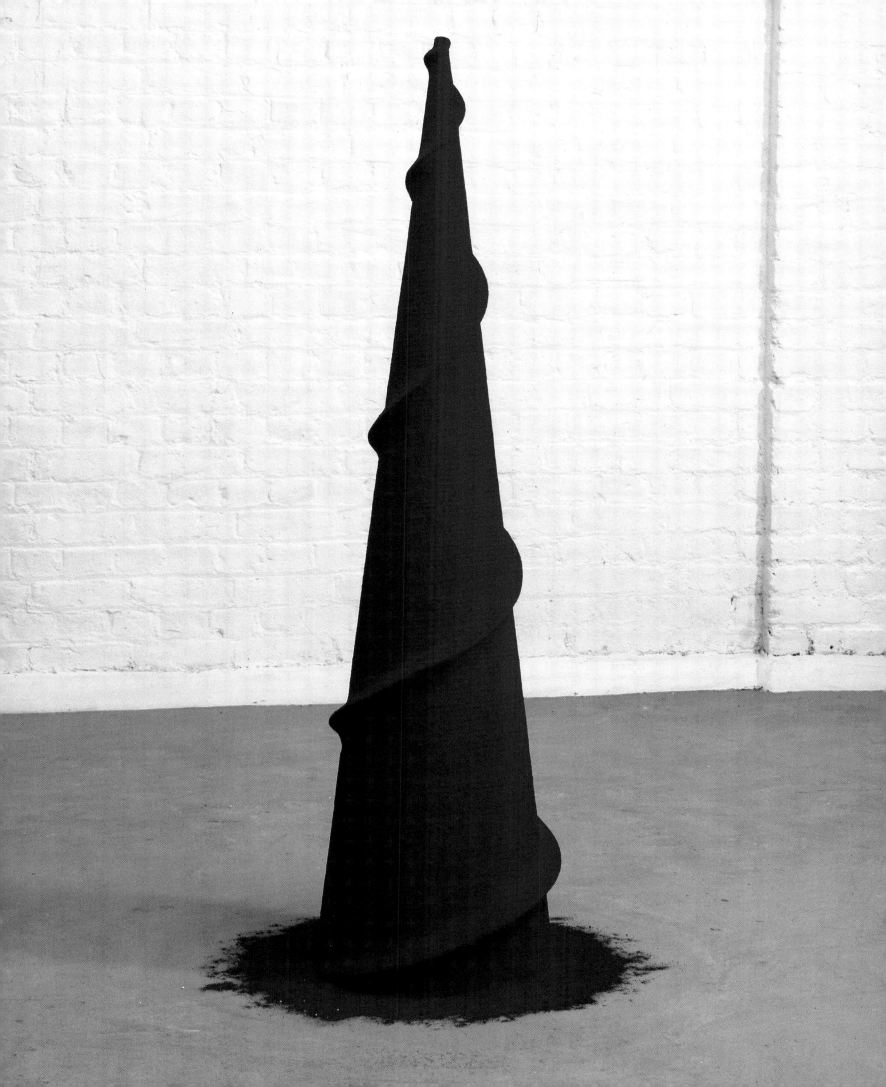

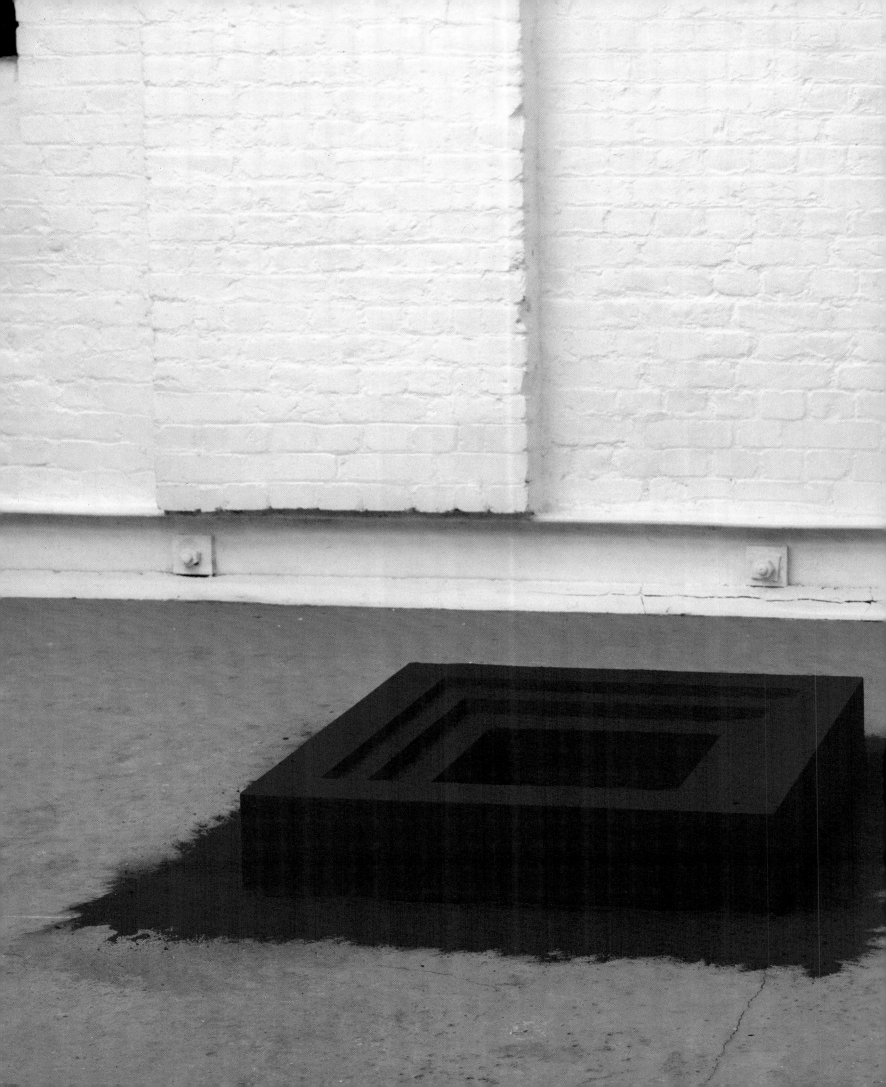

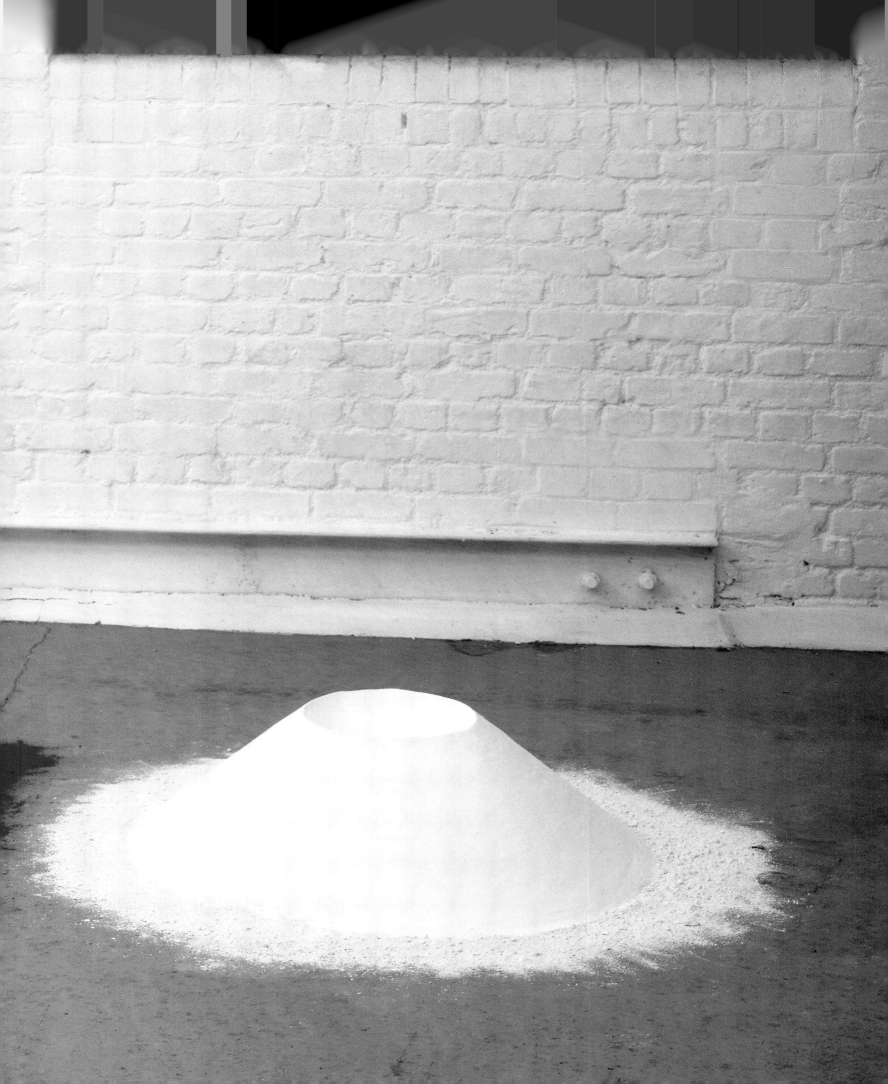

44

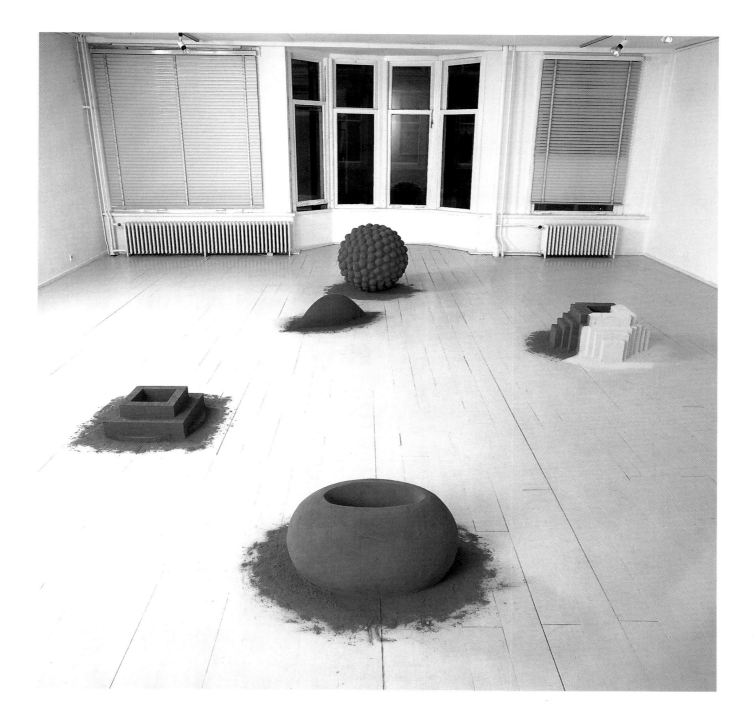

45

Part of the Red, 1981

46

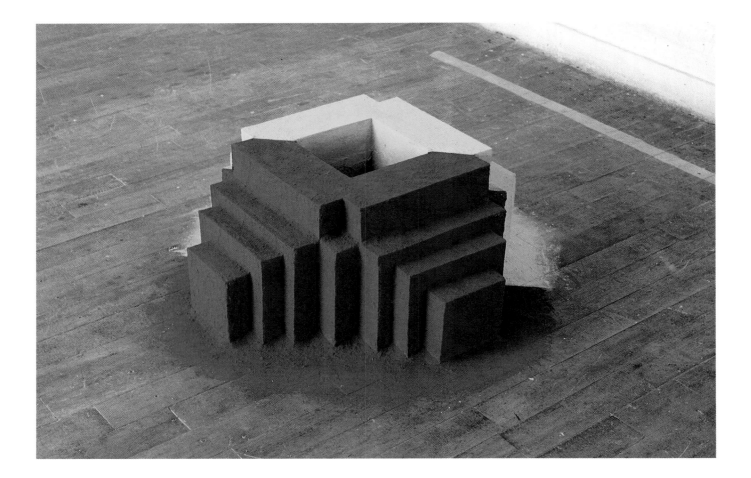

Part of the Red, 1981

Part of the Red, 1981

48

Part of the Red, 1981

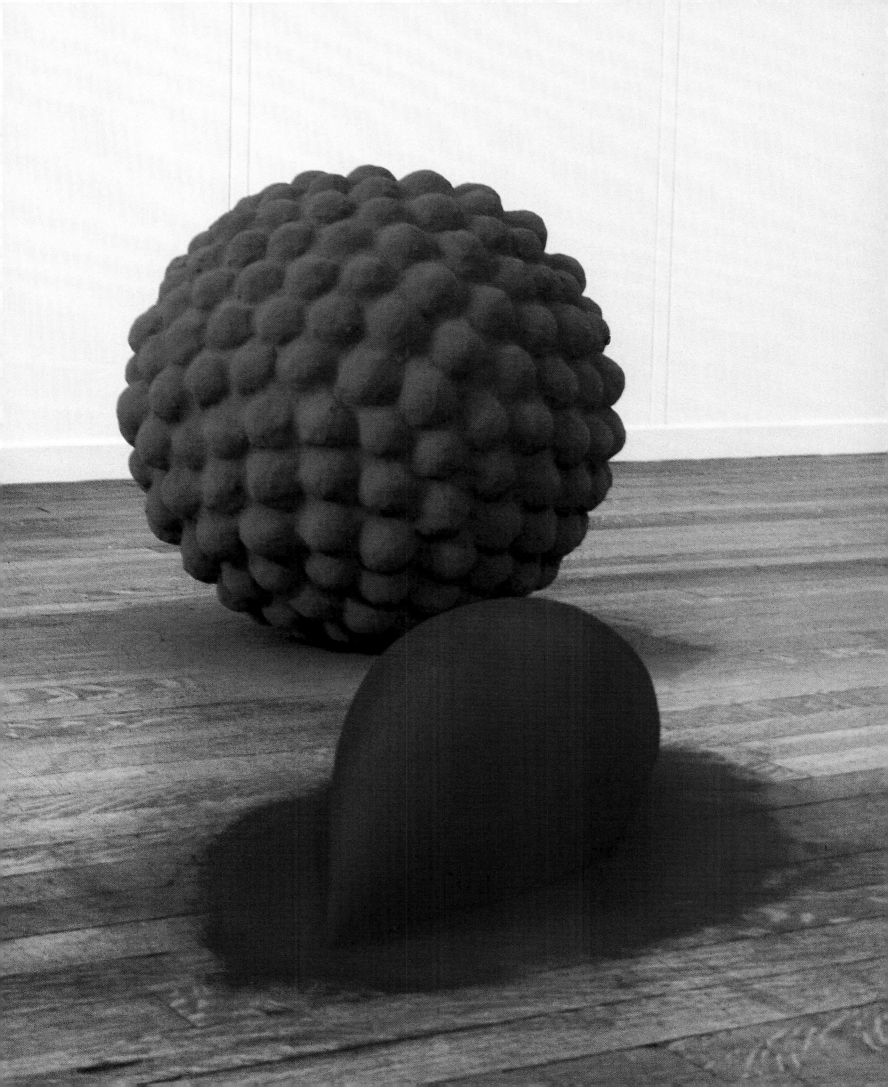

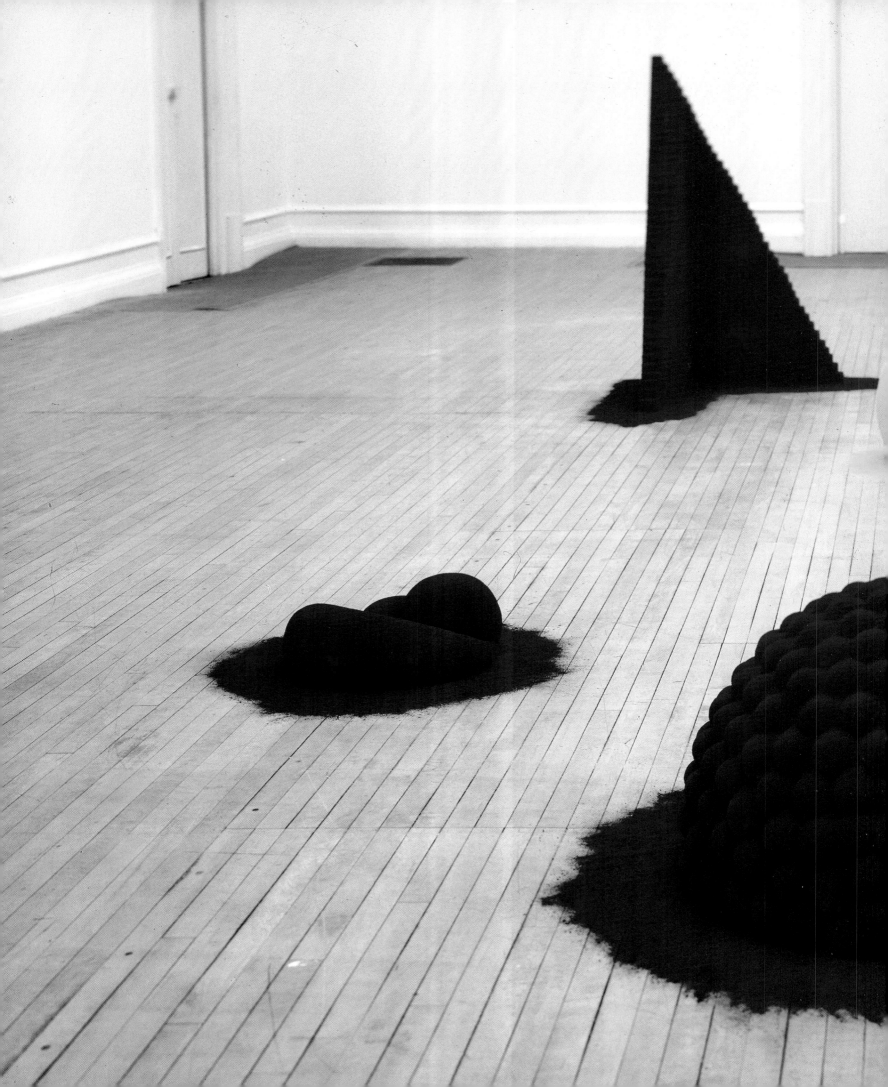

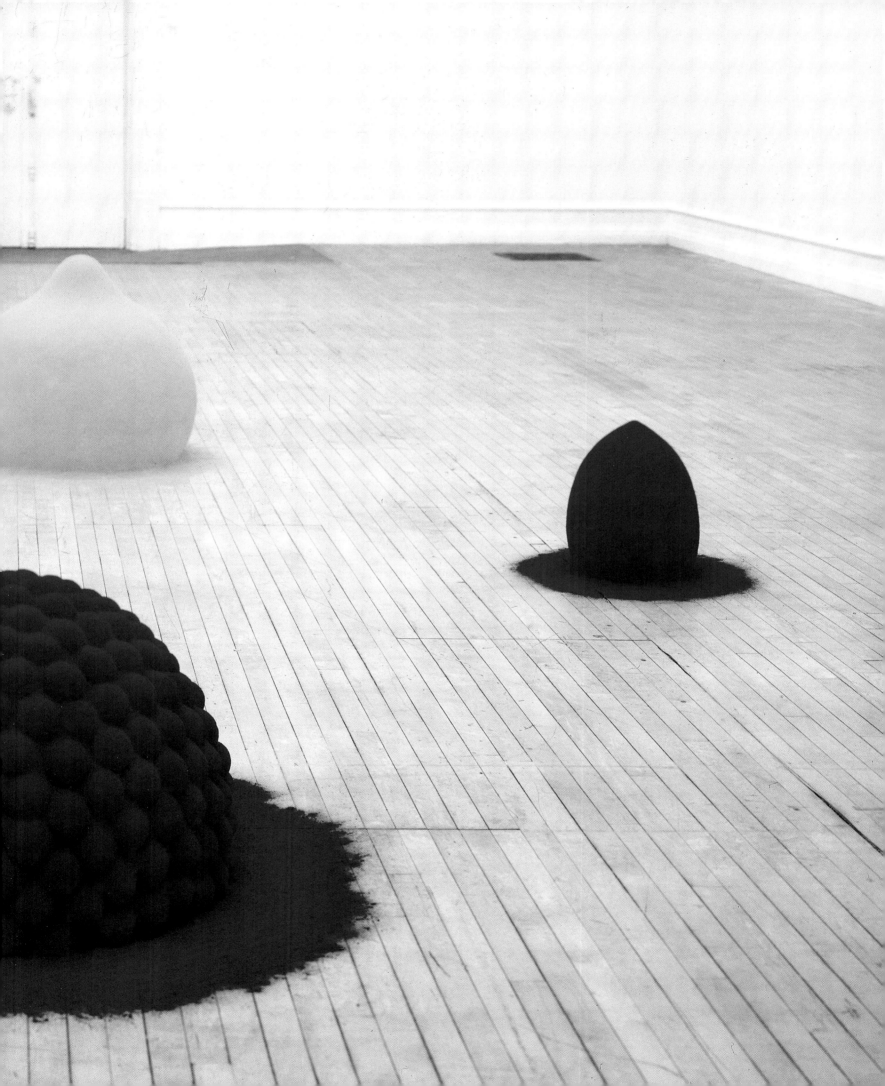

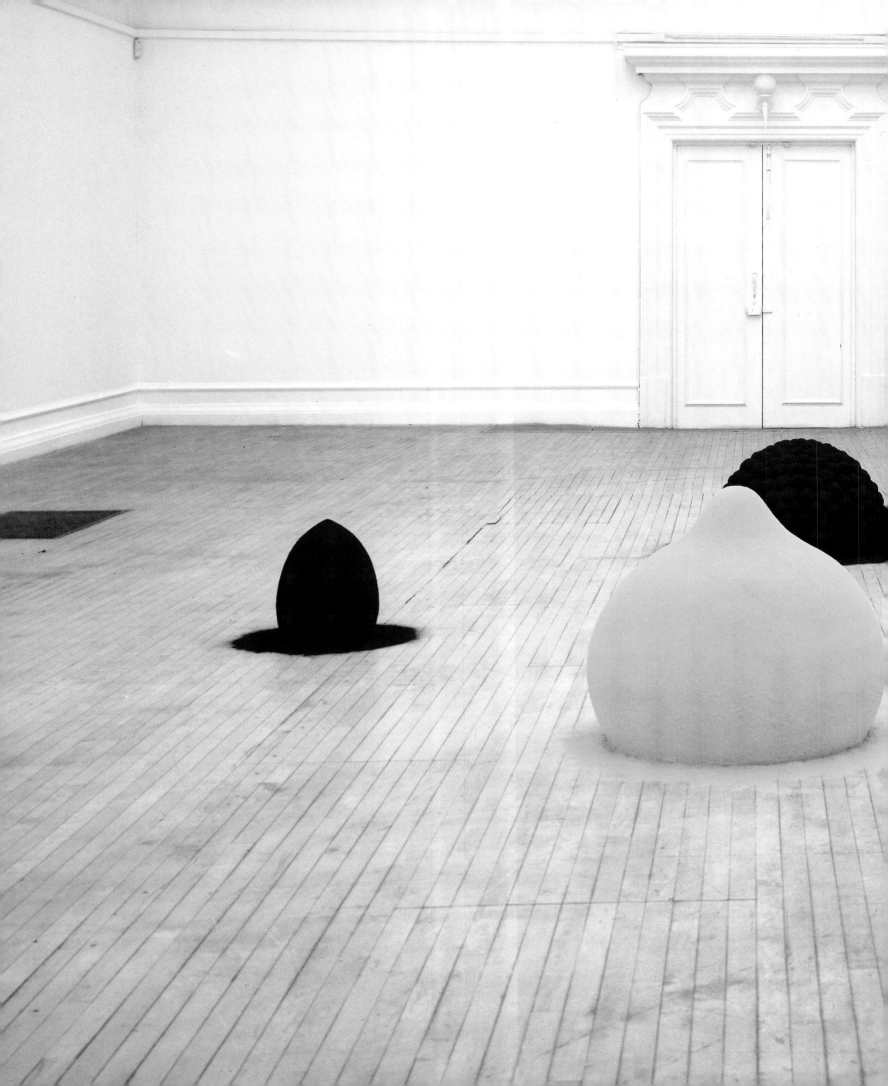

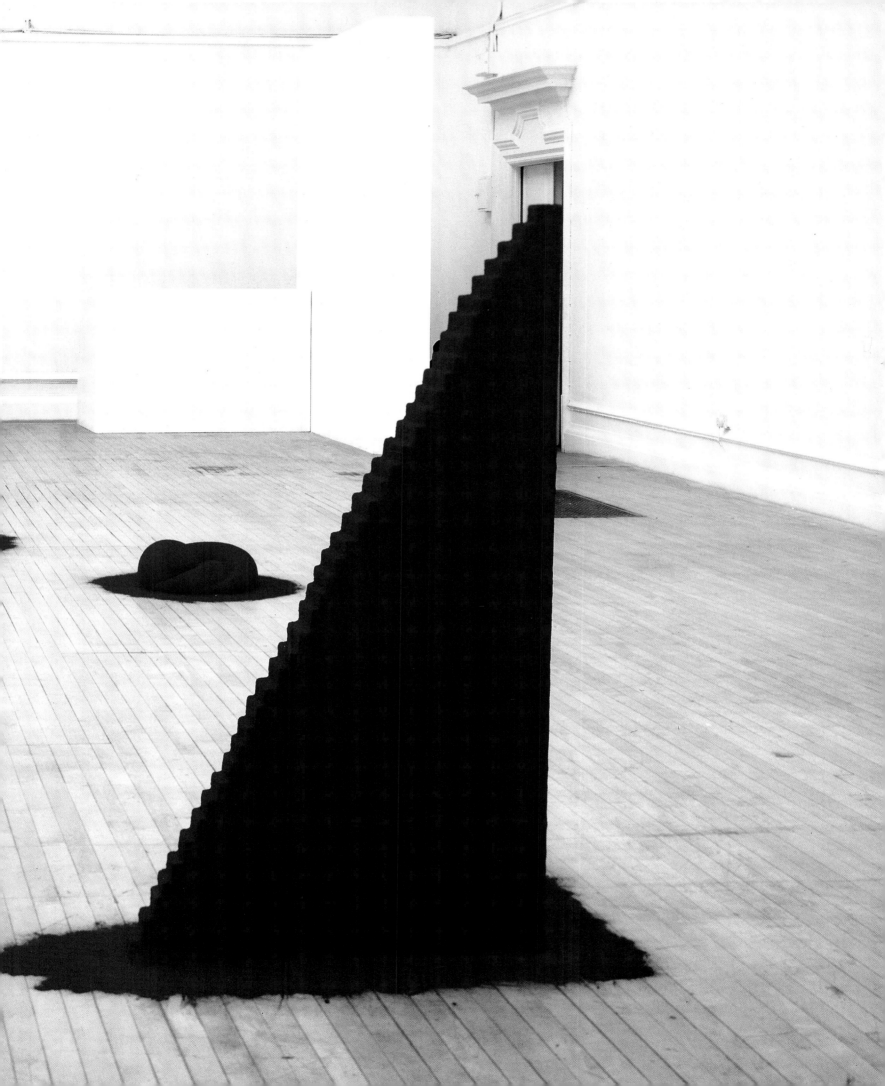

p. 50-51, 52-53
To Reflect an Intimate Part of the Red, 1981

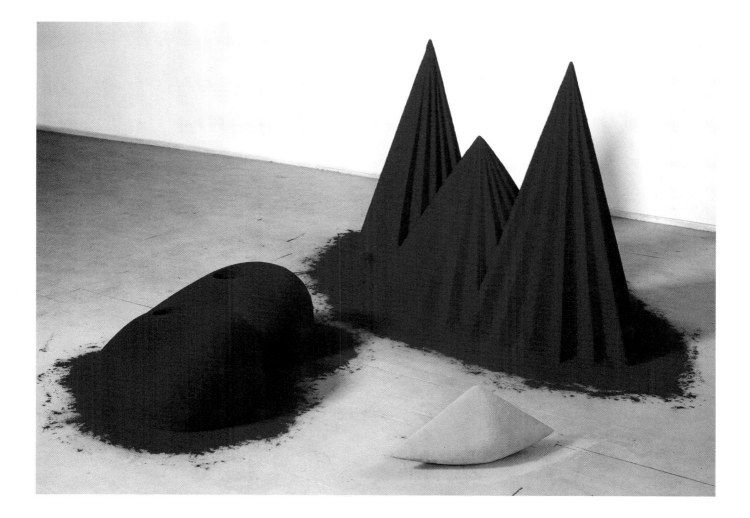

As if to Celebrate I Discovered a Mountain
Blooming with Red Flowers, 1981

56

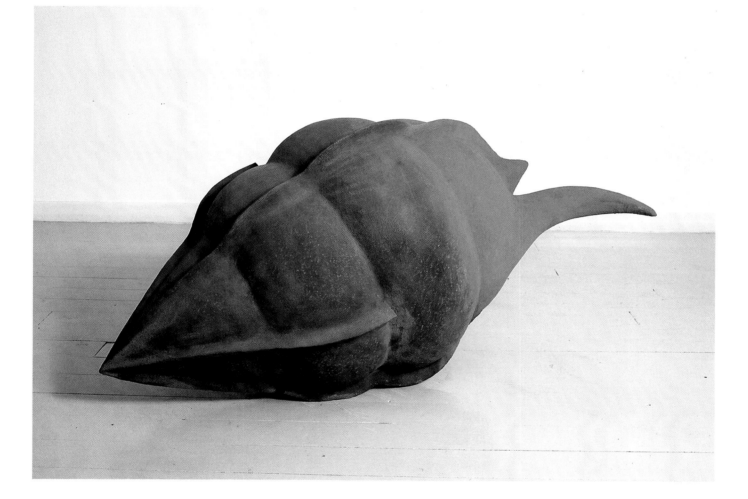

1000 Names, 1982

58

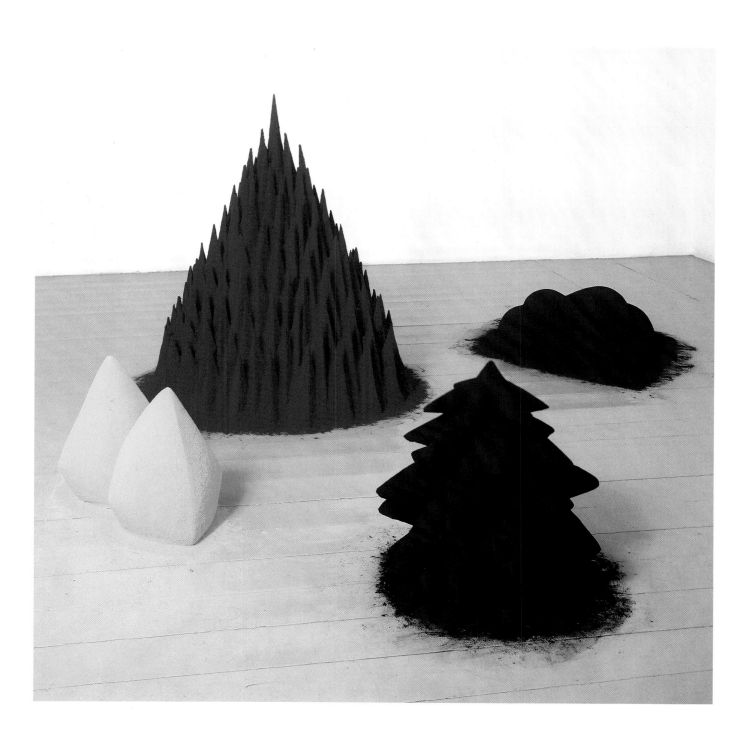

White Sand, Red Millet, Many Flowers, 1982

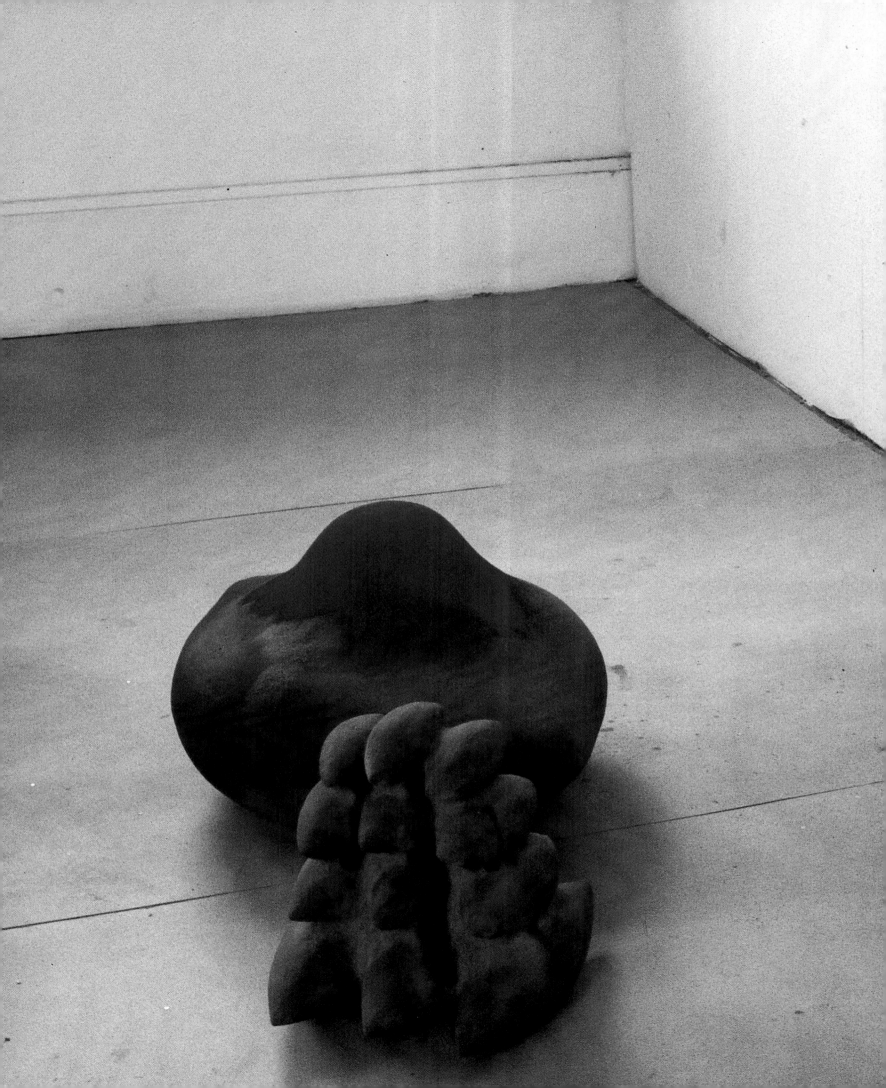

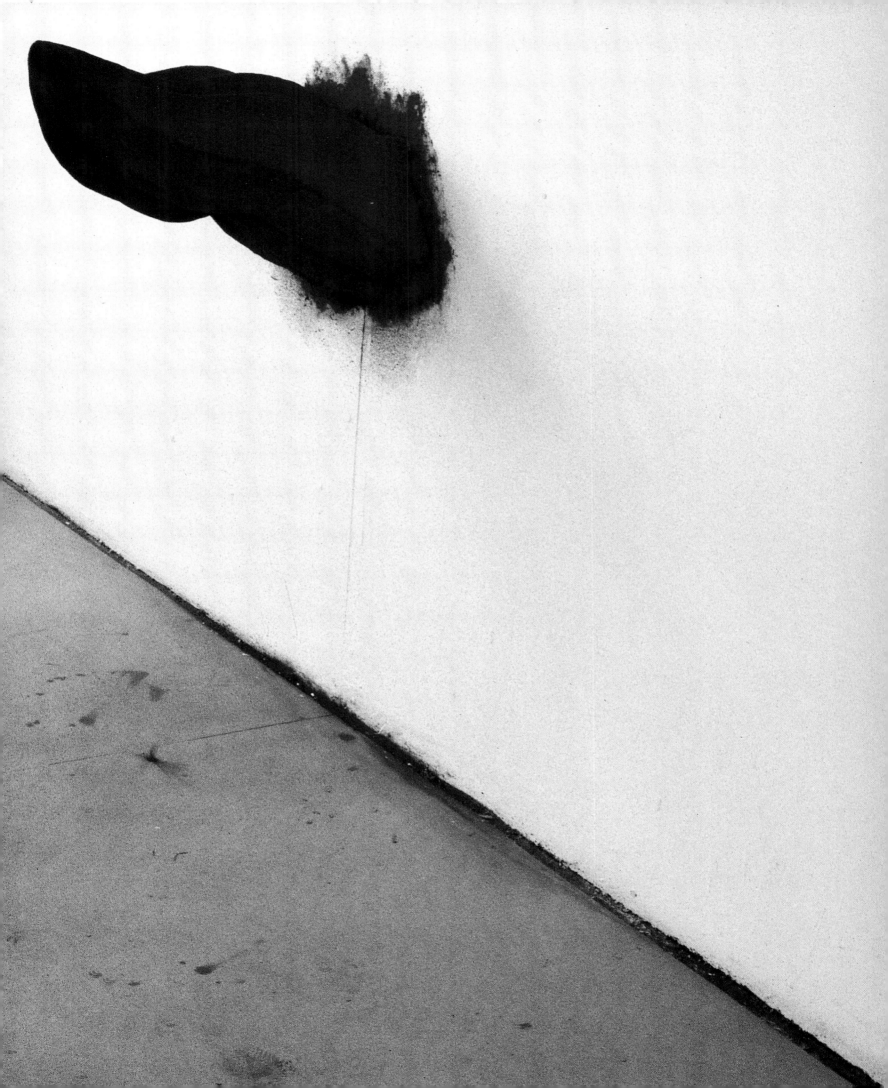

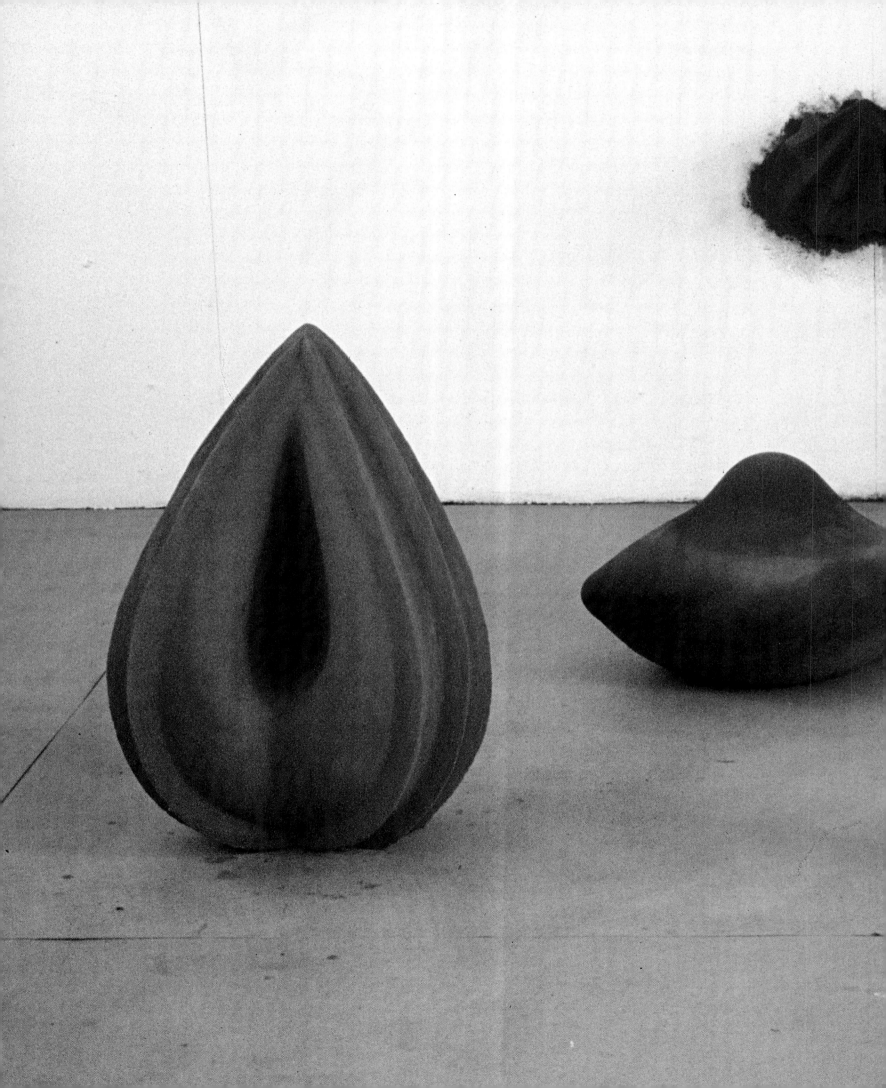

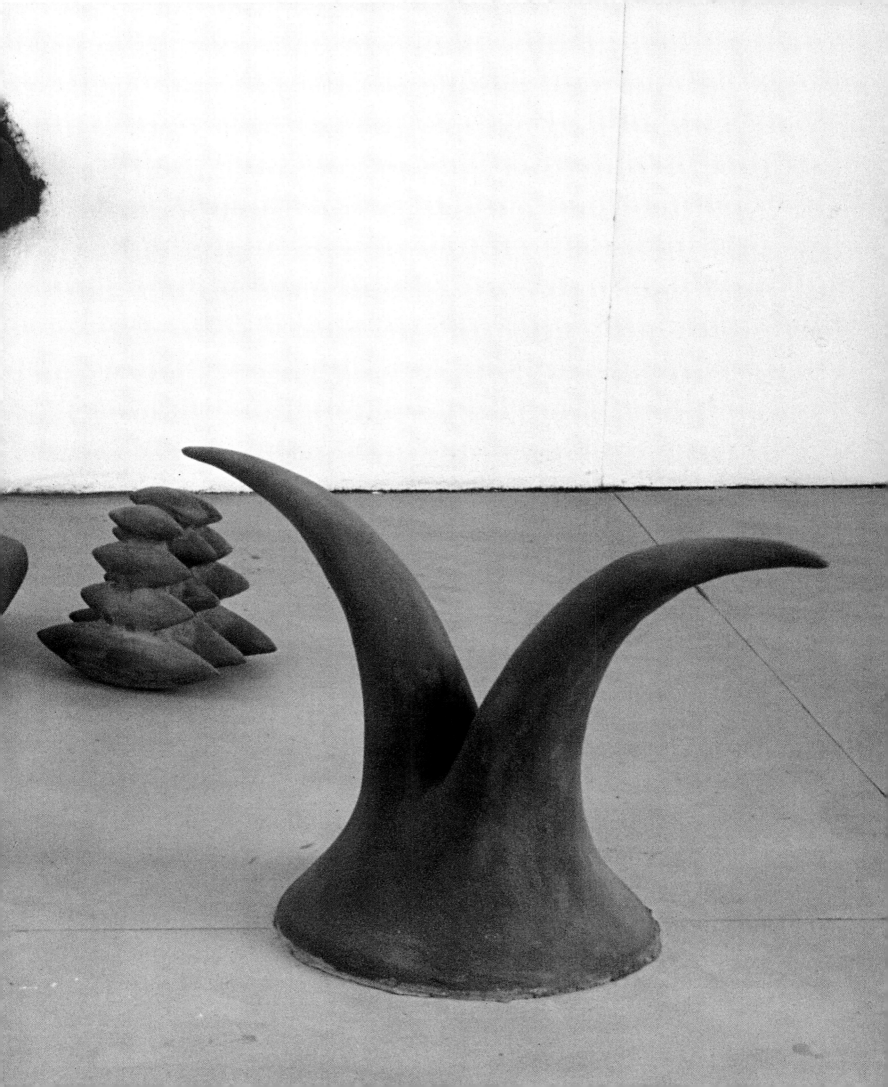

p. 60-61, 62-63
Red in the Centre, 1982

1000 Names, 1982

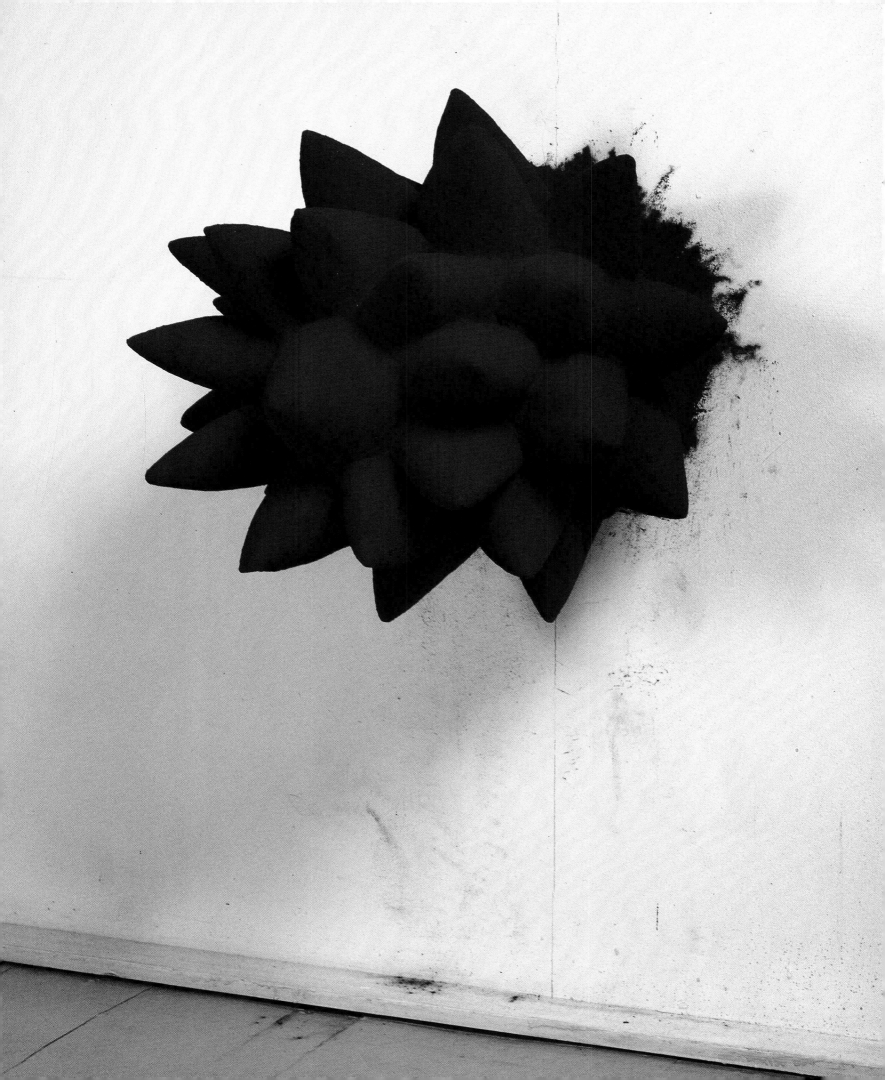

66

Untitled, 1983

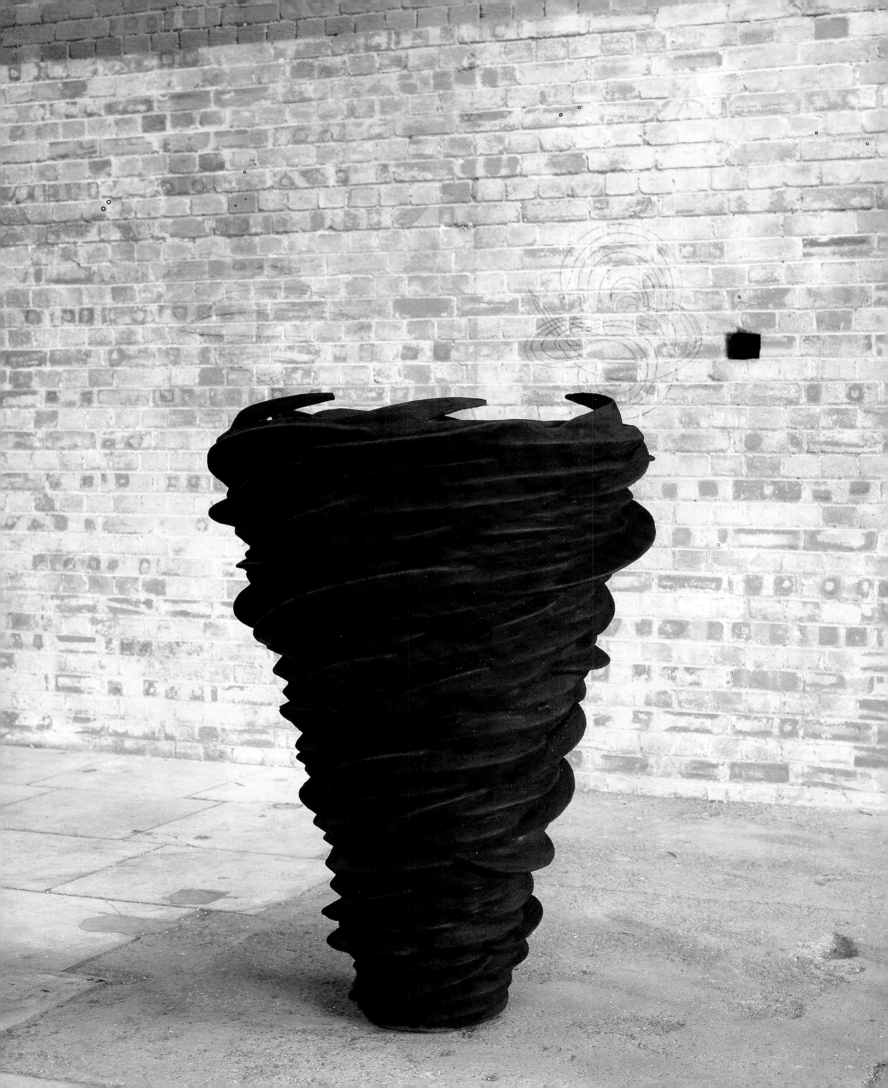

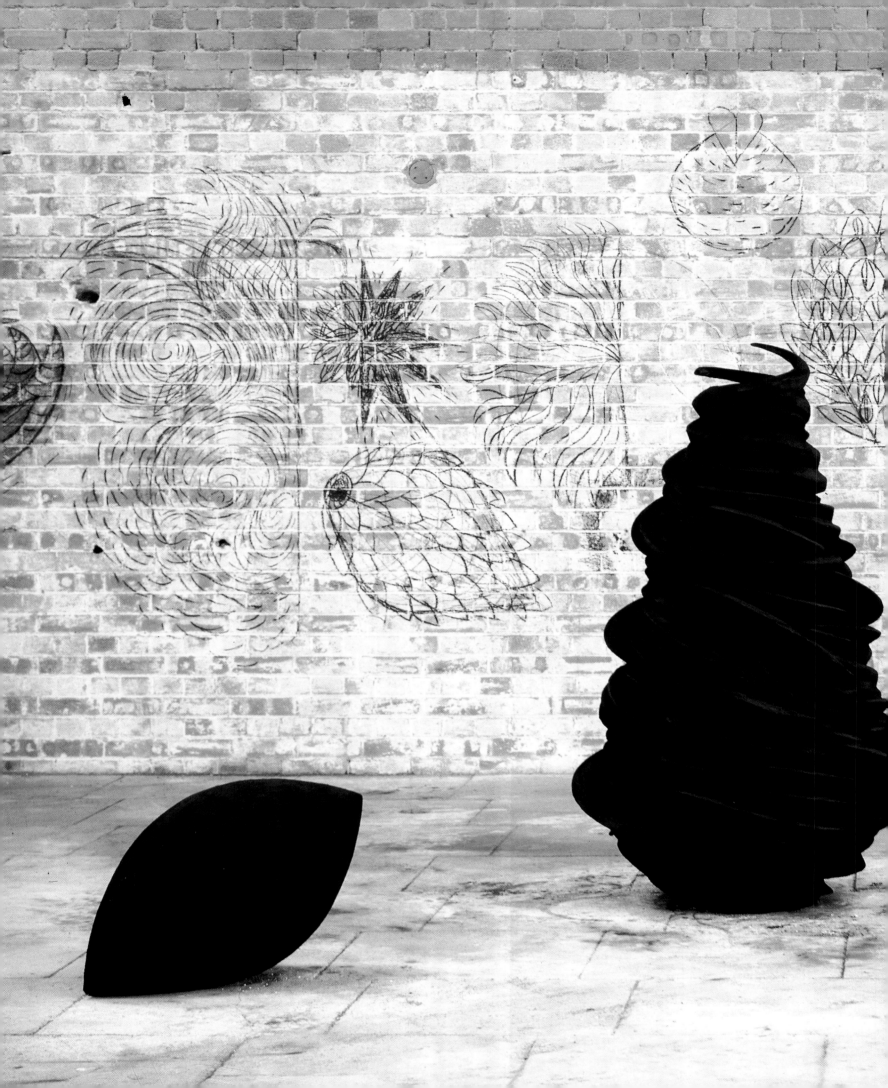

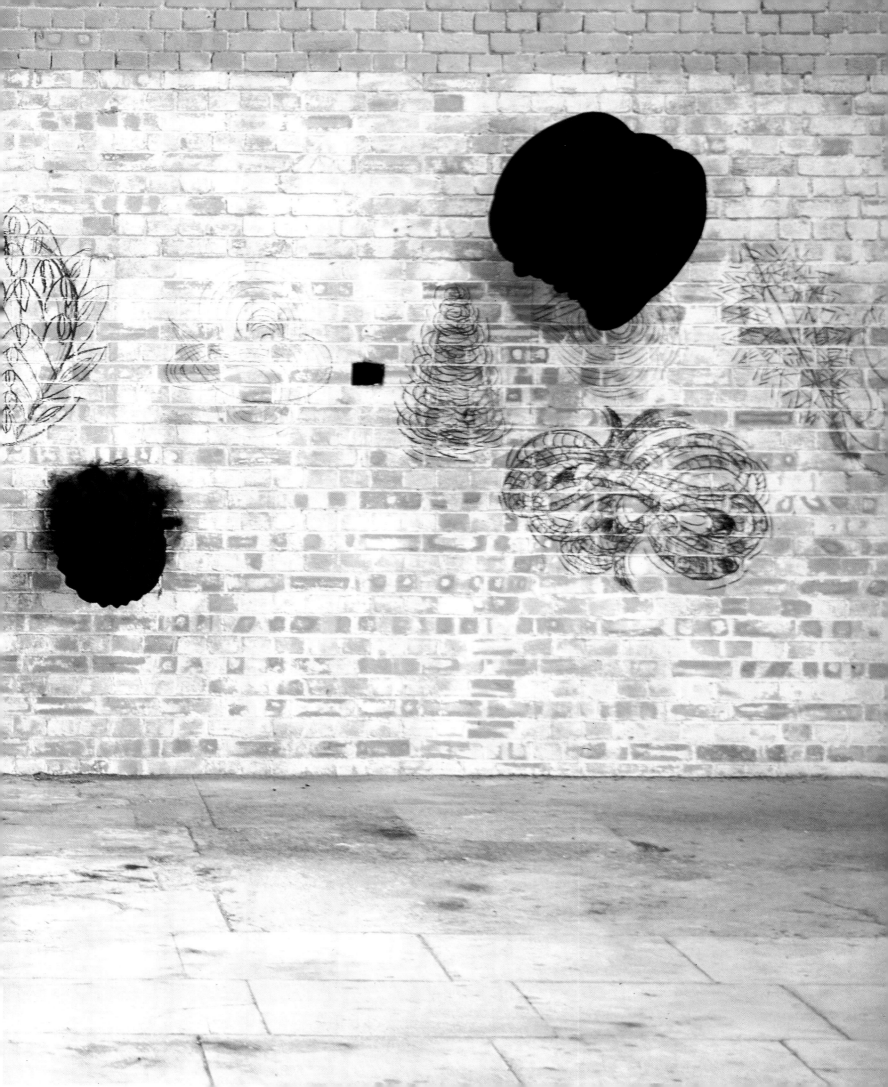

70

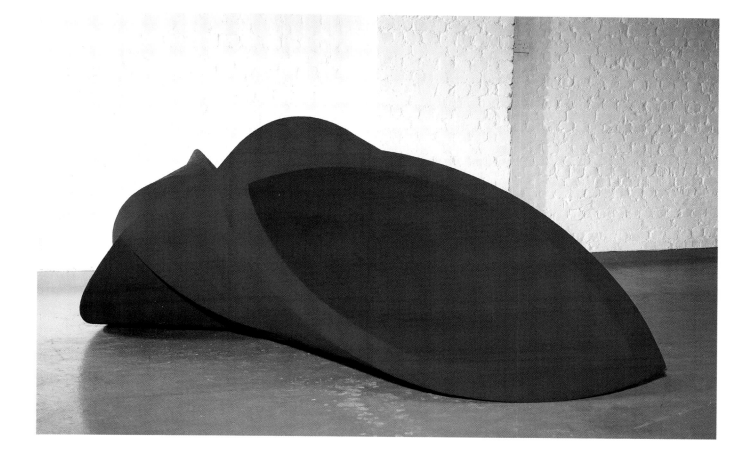

Pot for Her, 1985

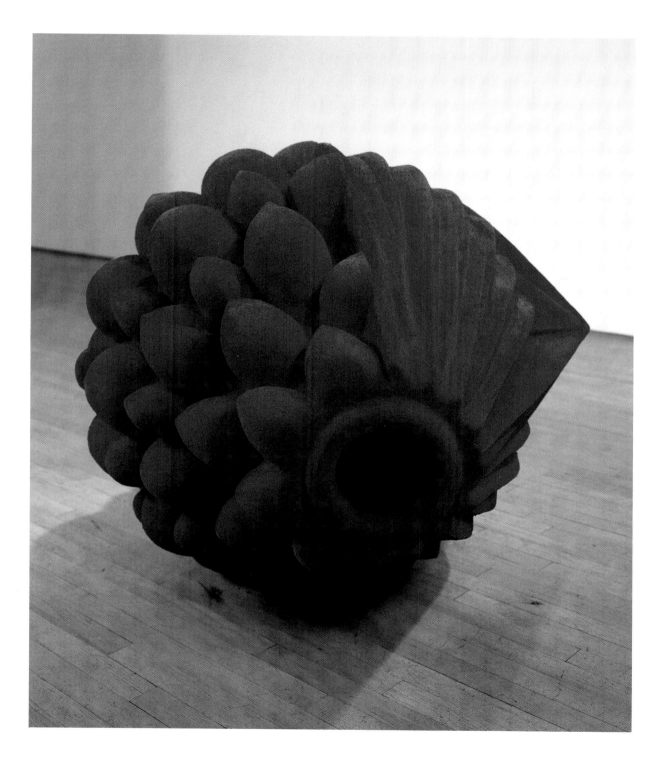

Hole and Vessel II, 1984

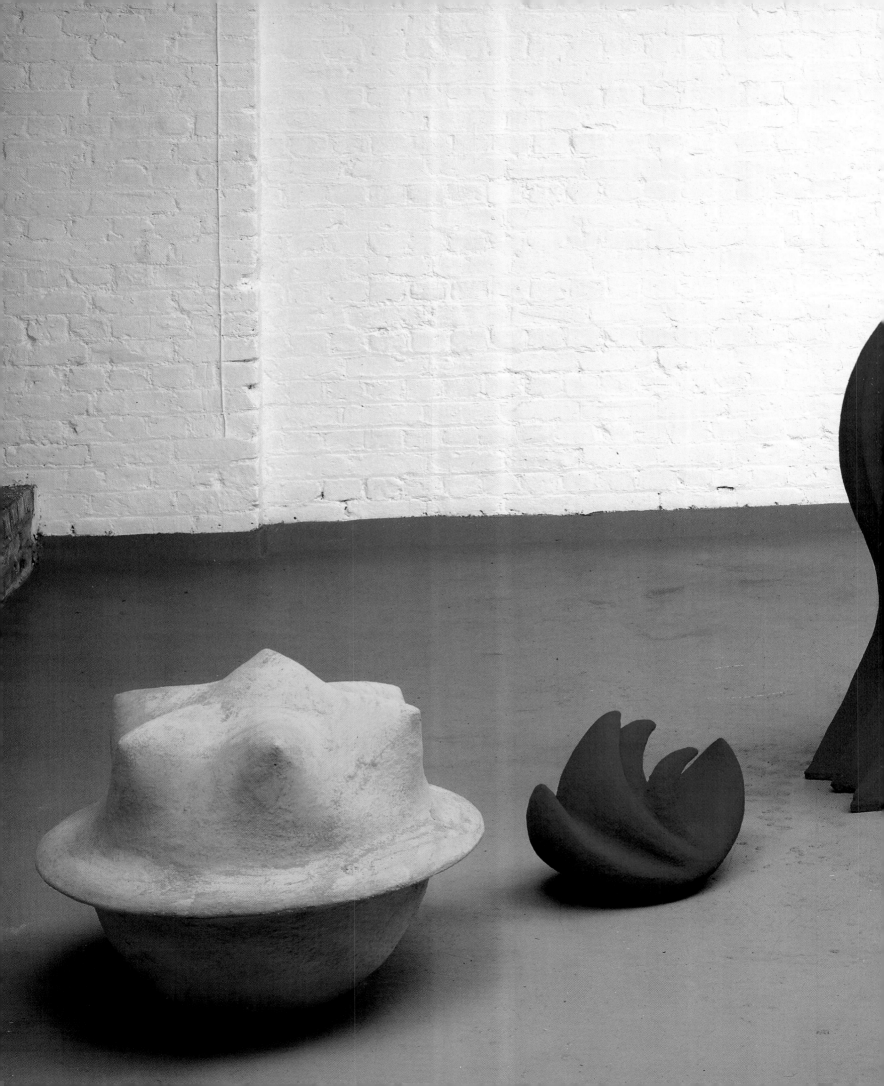

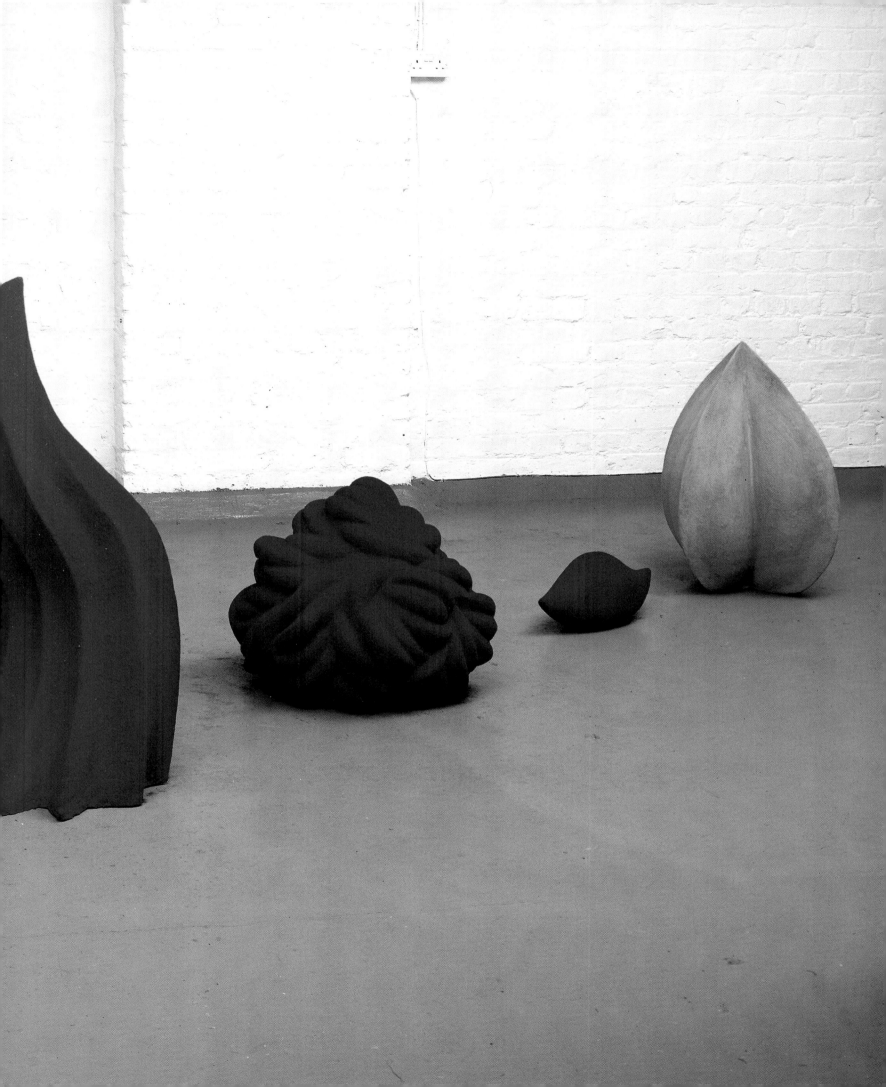

76

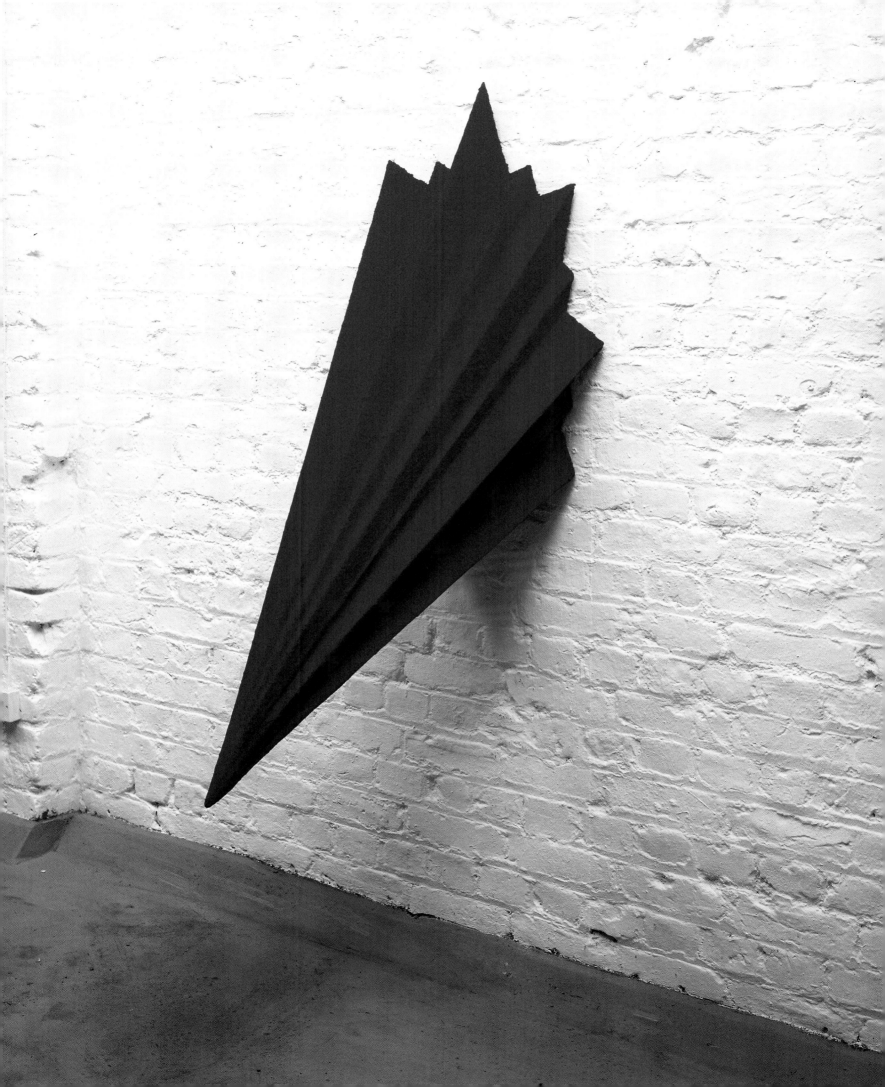

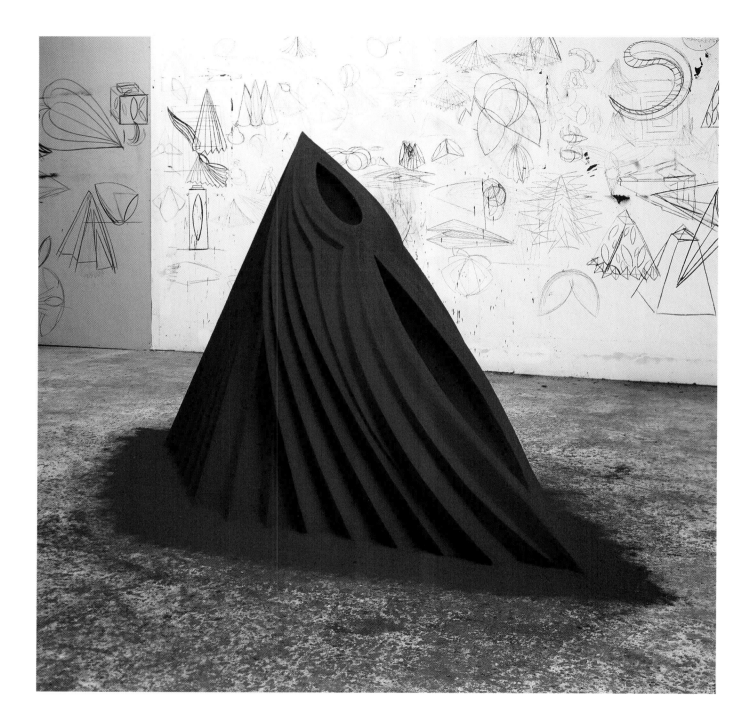

78

Mother as a Mountain, 1985

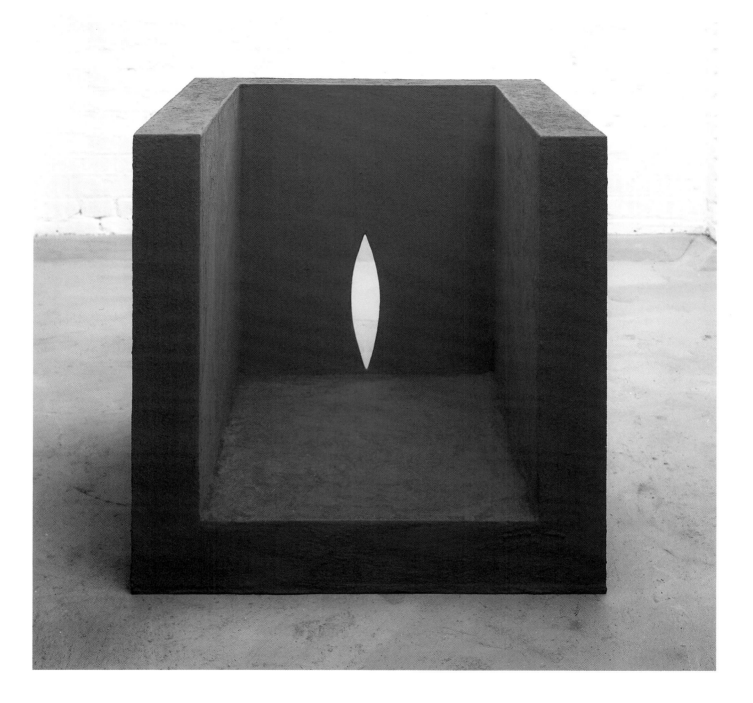

Place, 1985

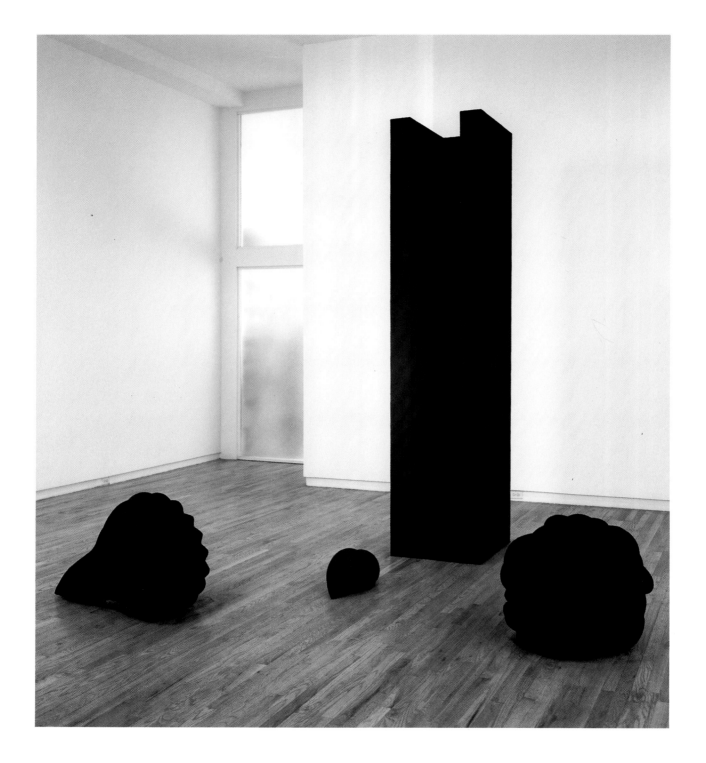

Dark, 1986

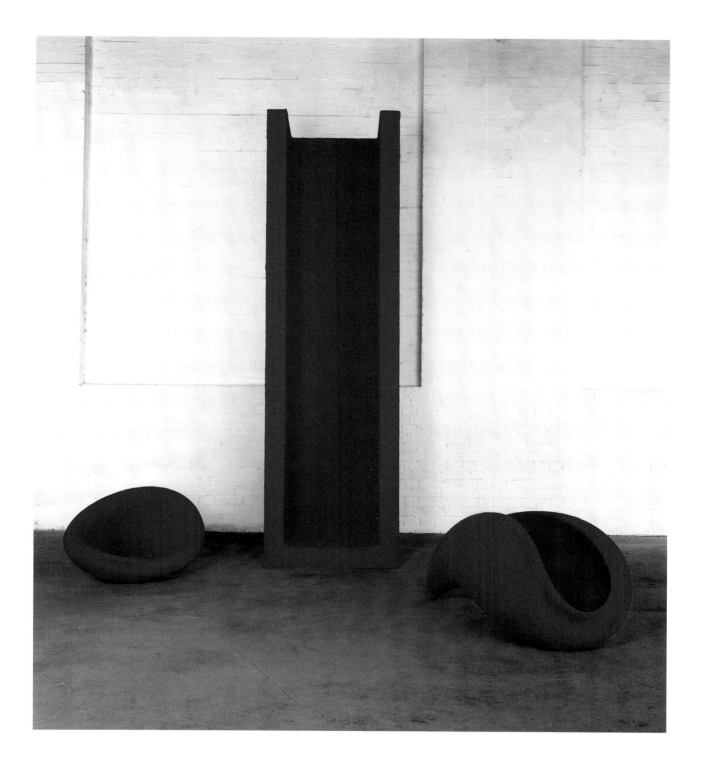

Untitled, 1986

82

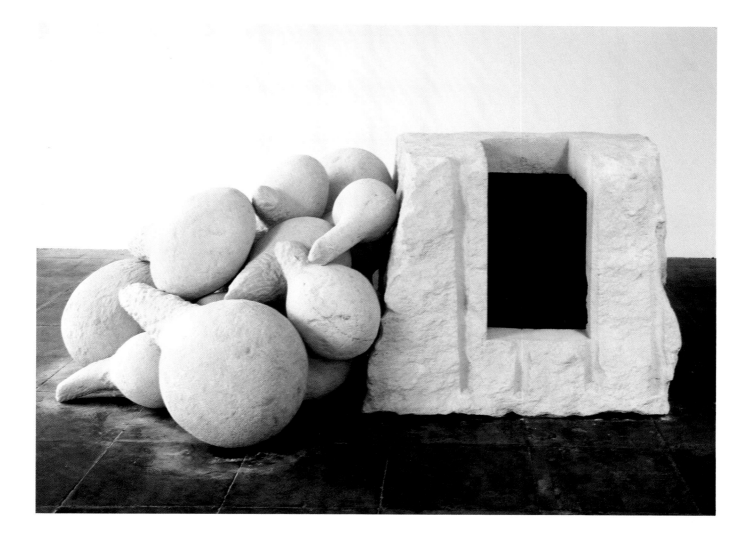

83

Here and There, 1987

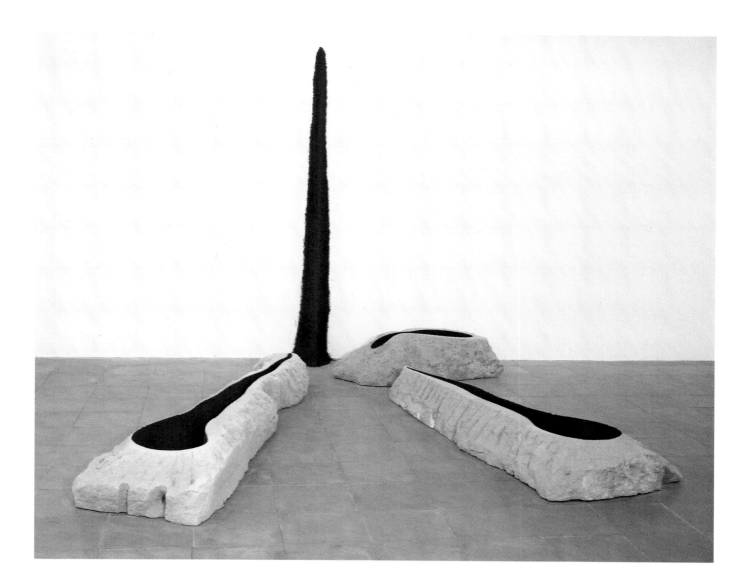

Wound, 1988

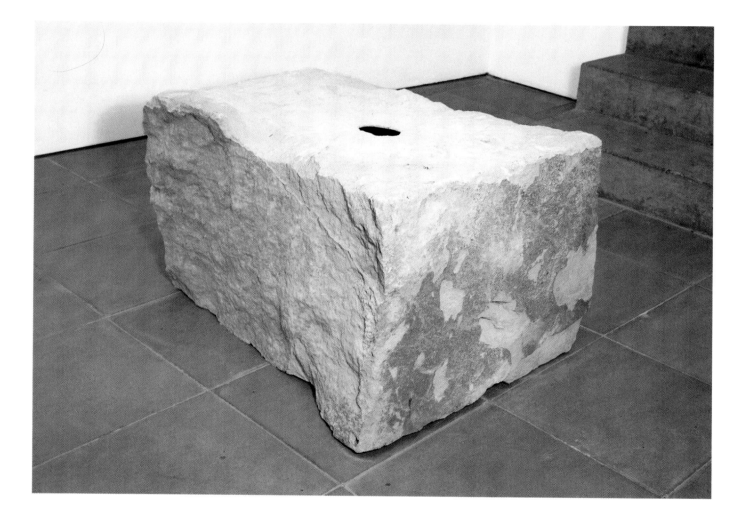

I, 1987

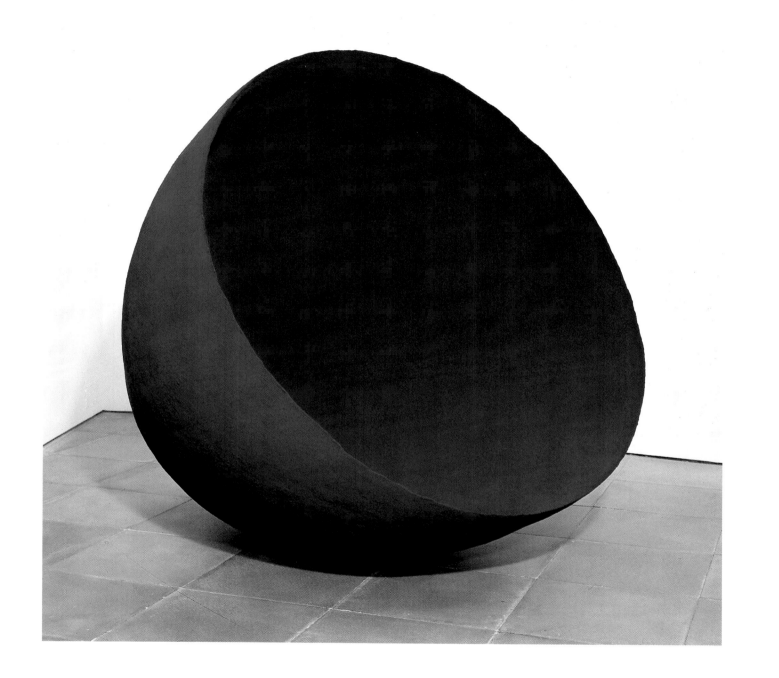

At the Hub of Things, 1987

Blood Stone, 1988

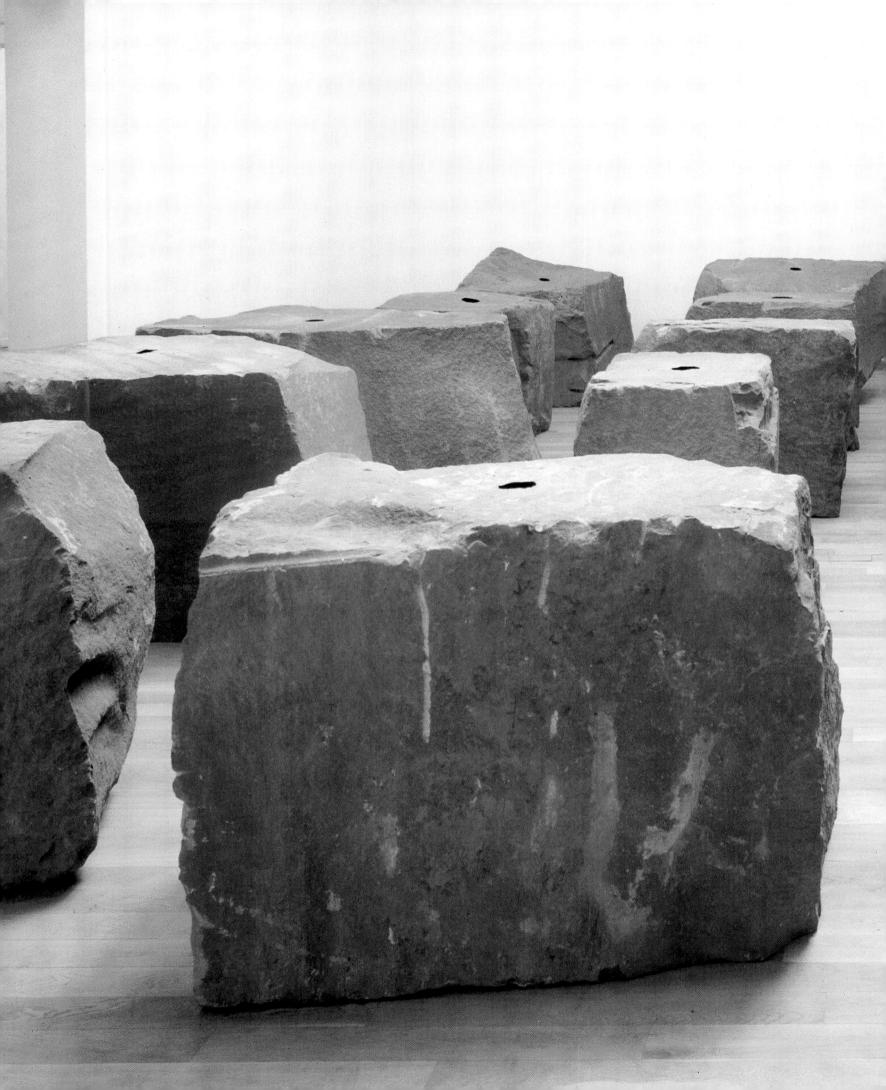

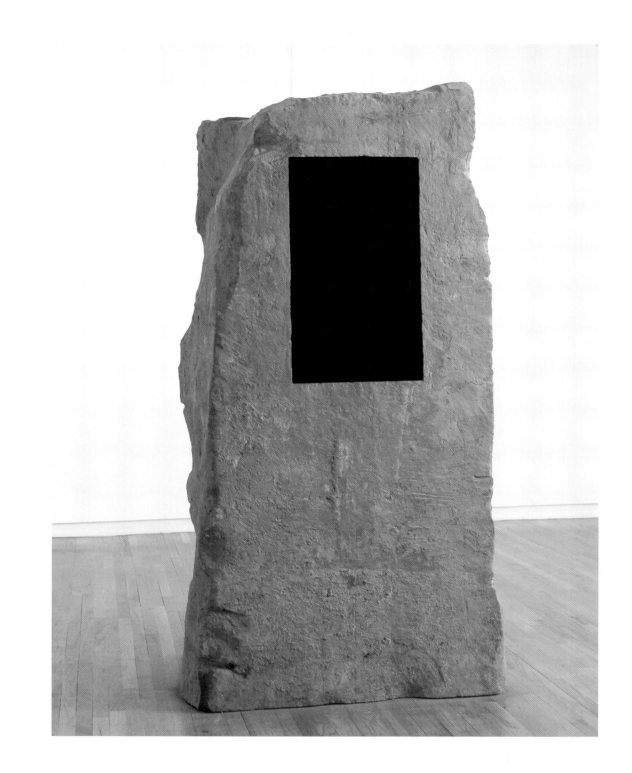

Adam, 1988-89

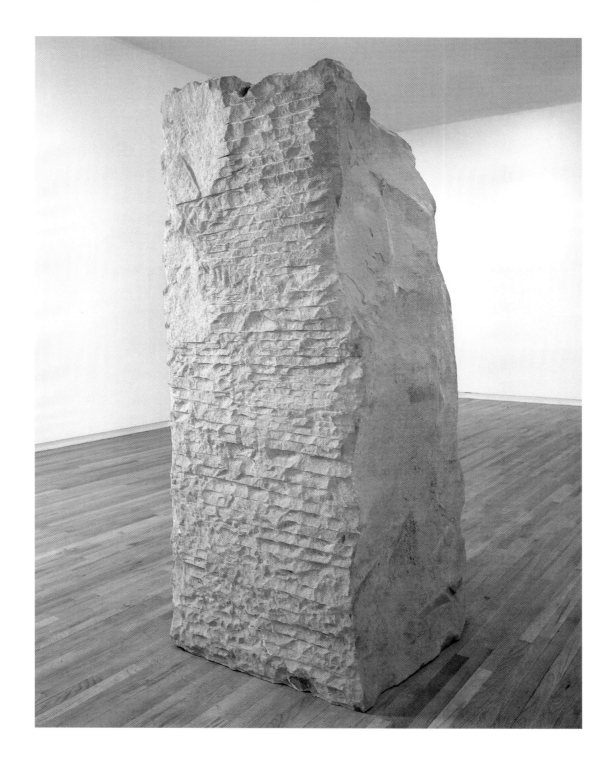

Adam, 1988-89

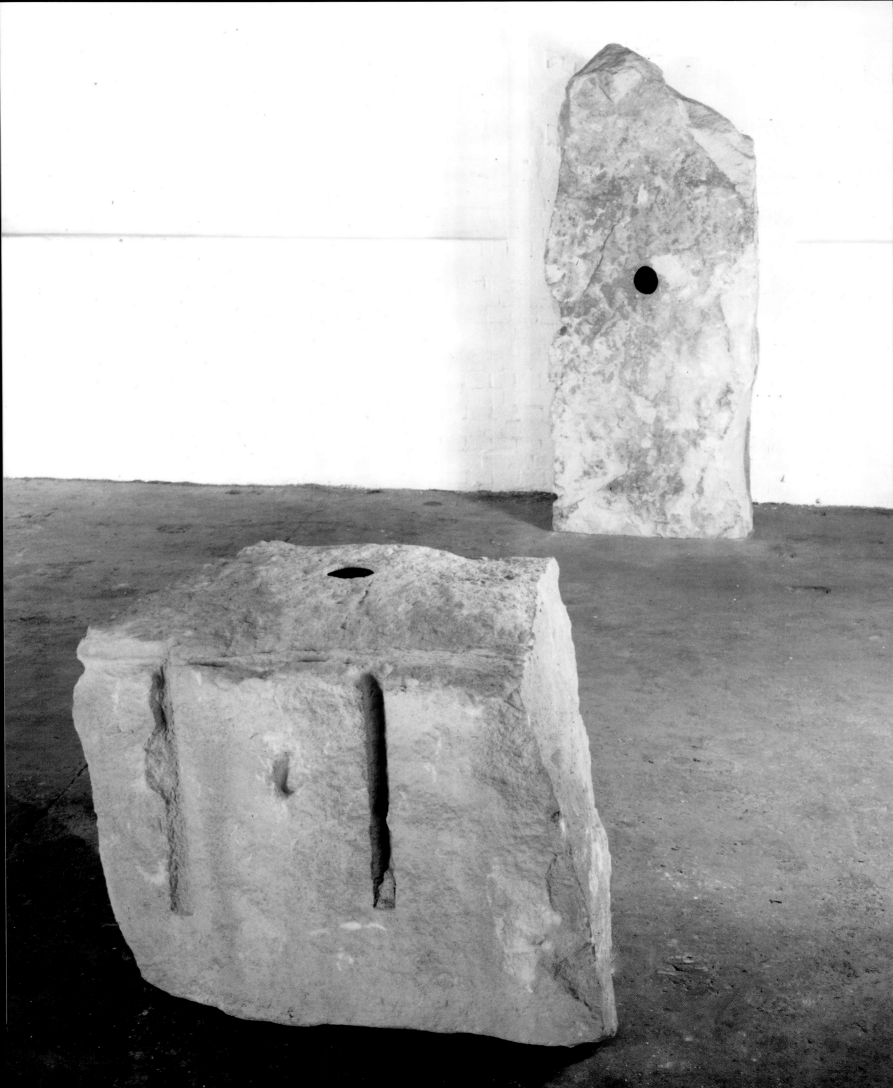

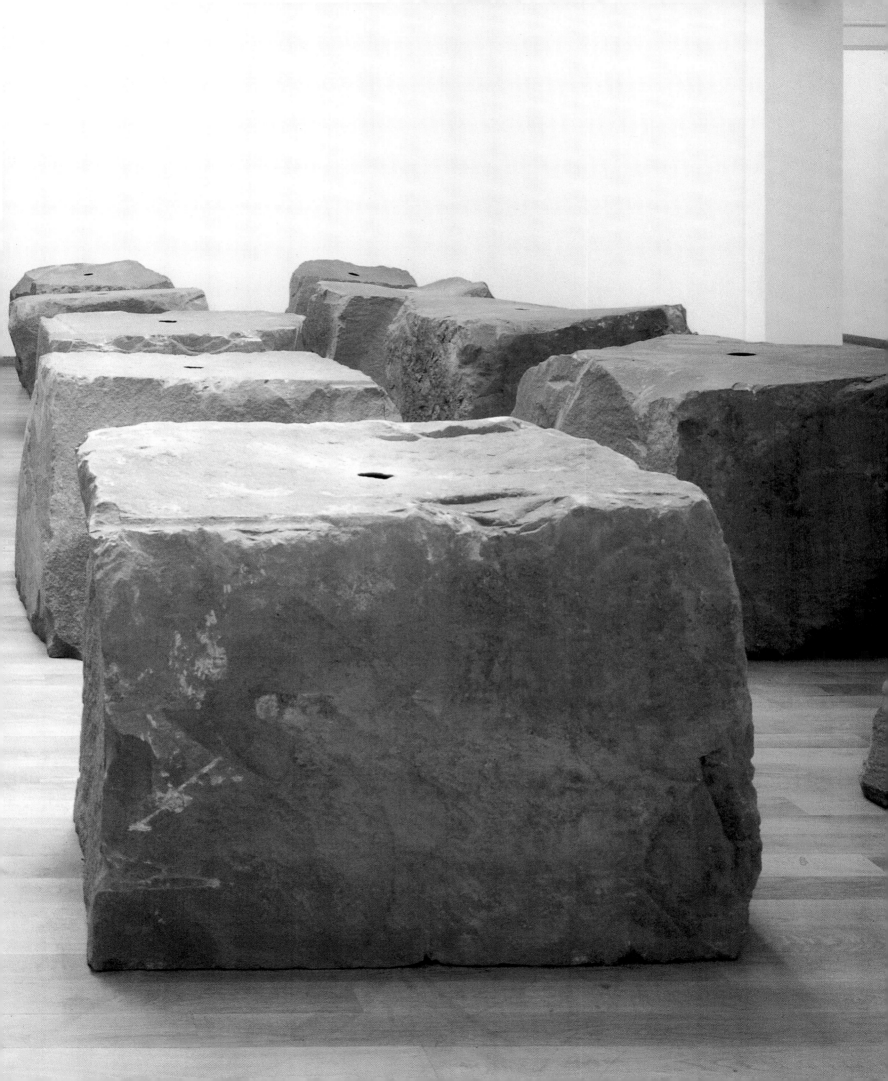

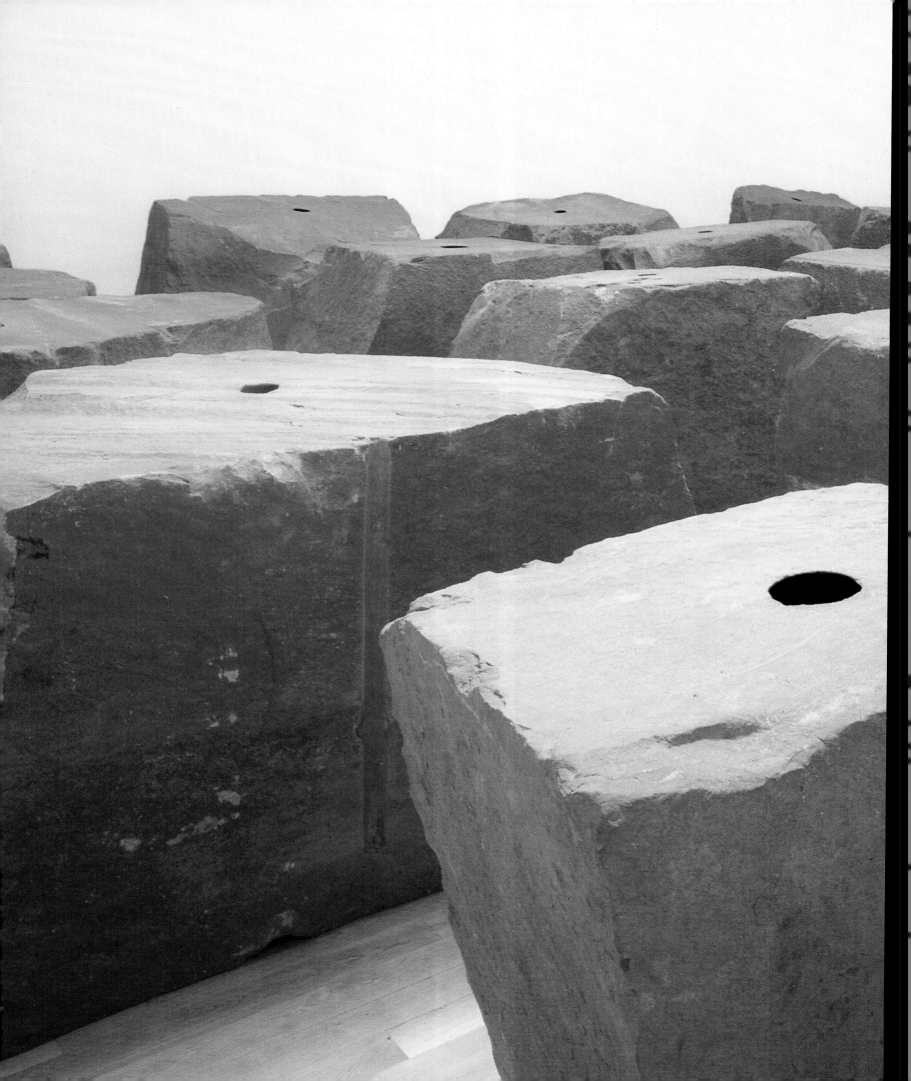

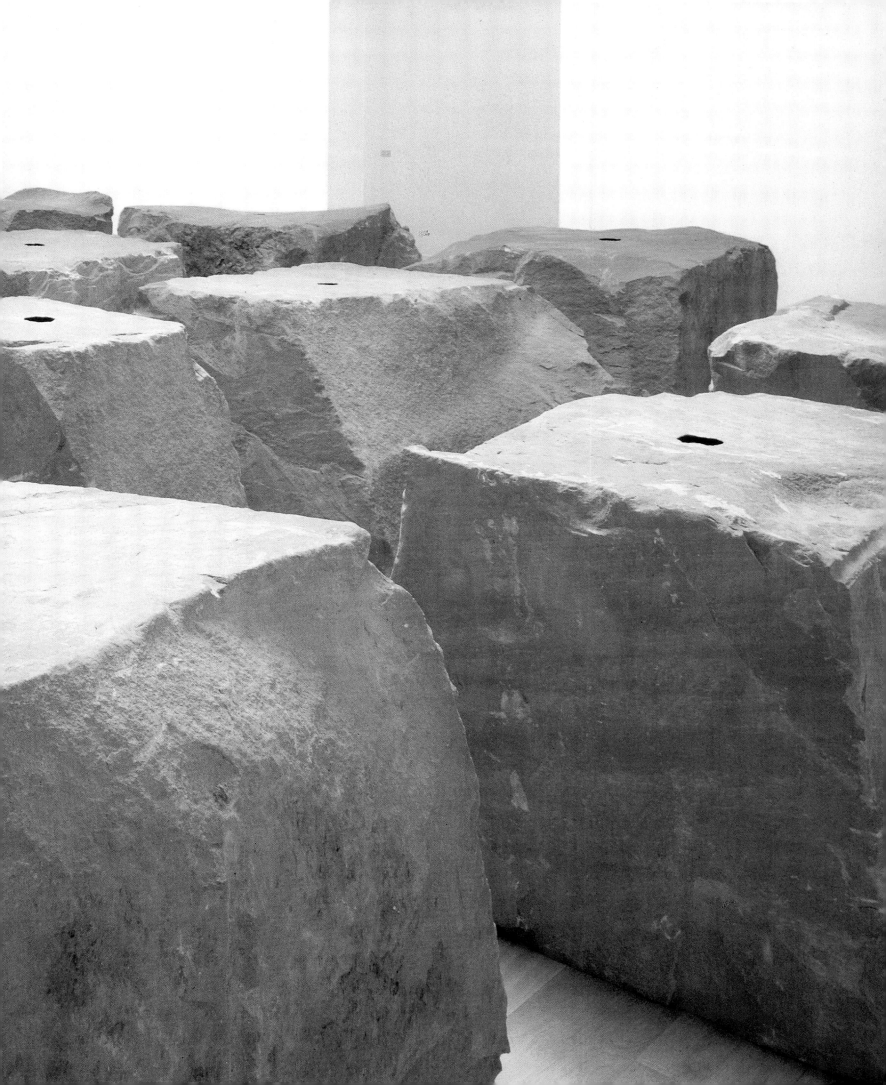

98

Void Field, 1989

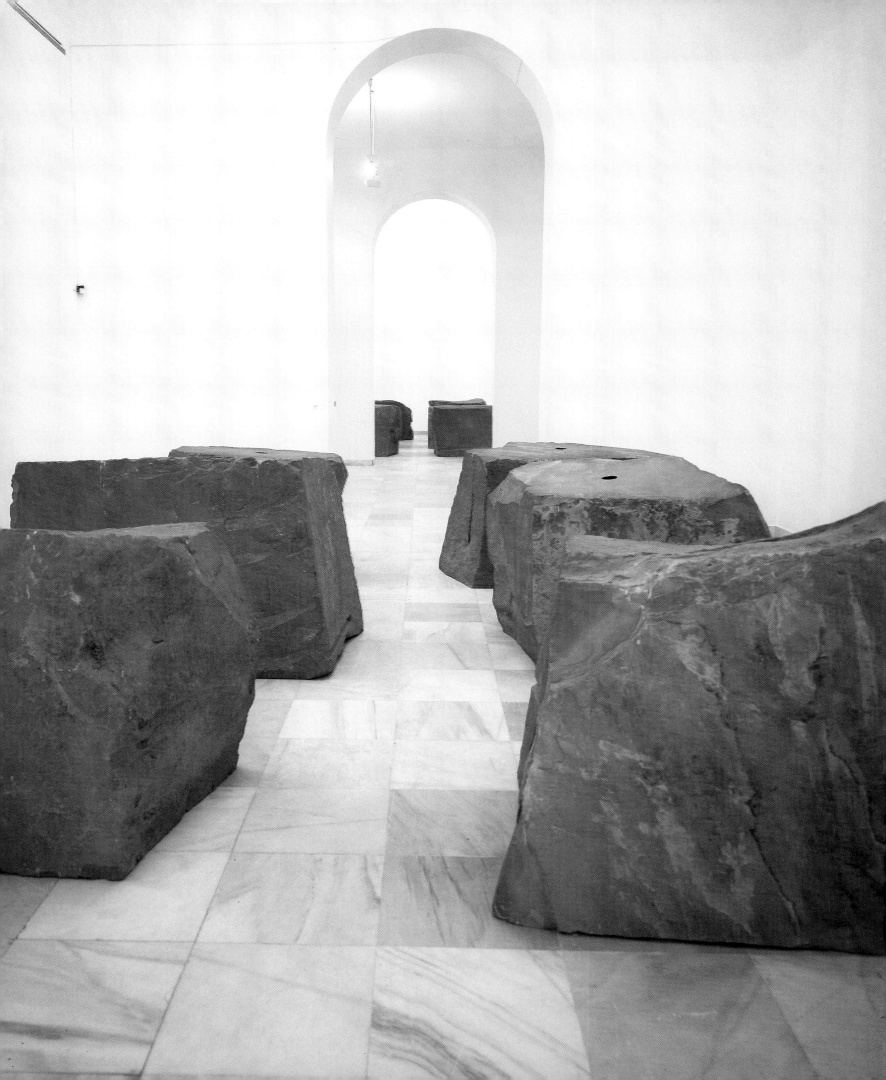

100

Void Field, 1989

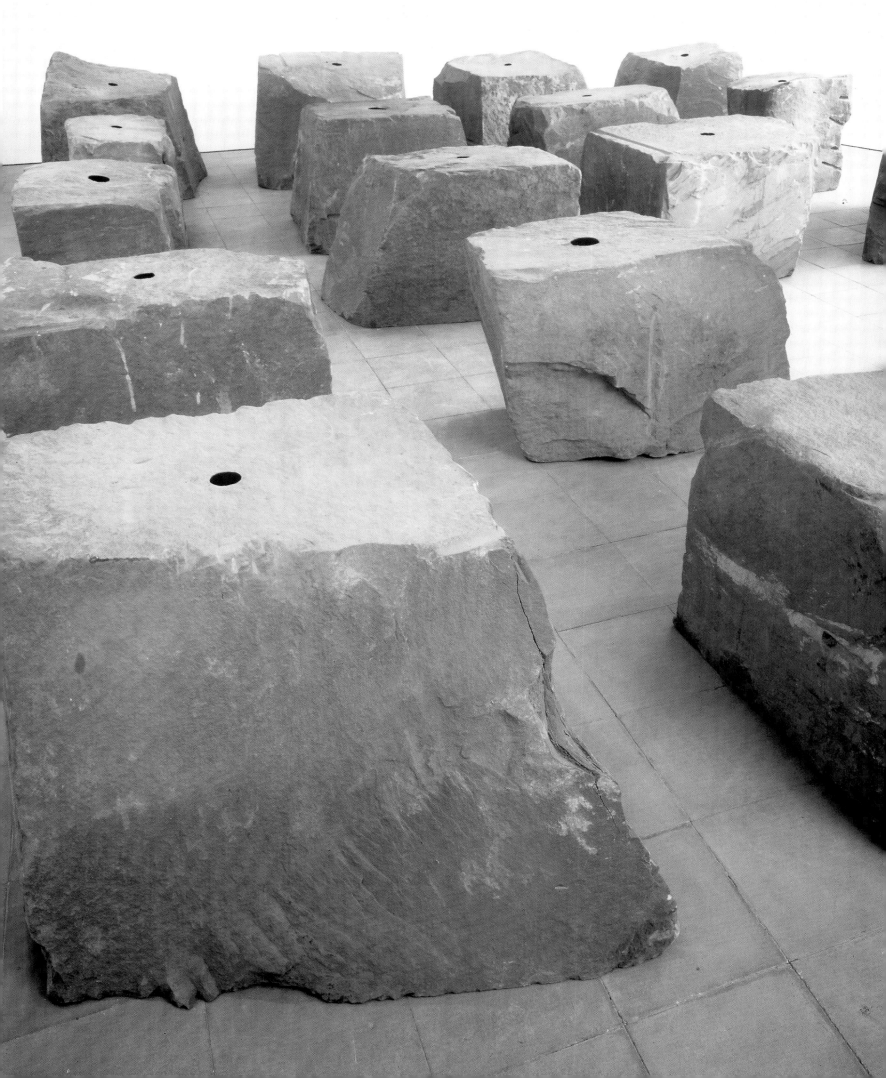

Void Field, 1989

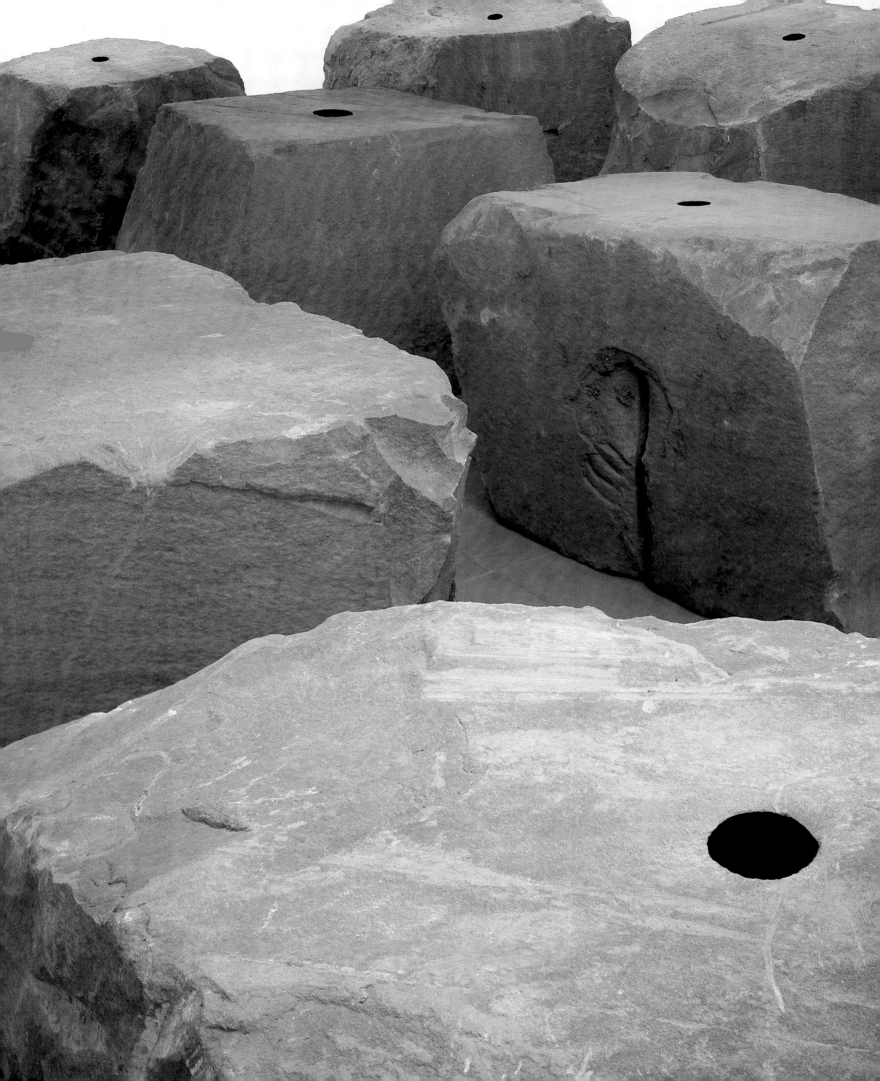

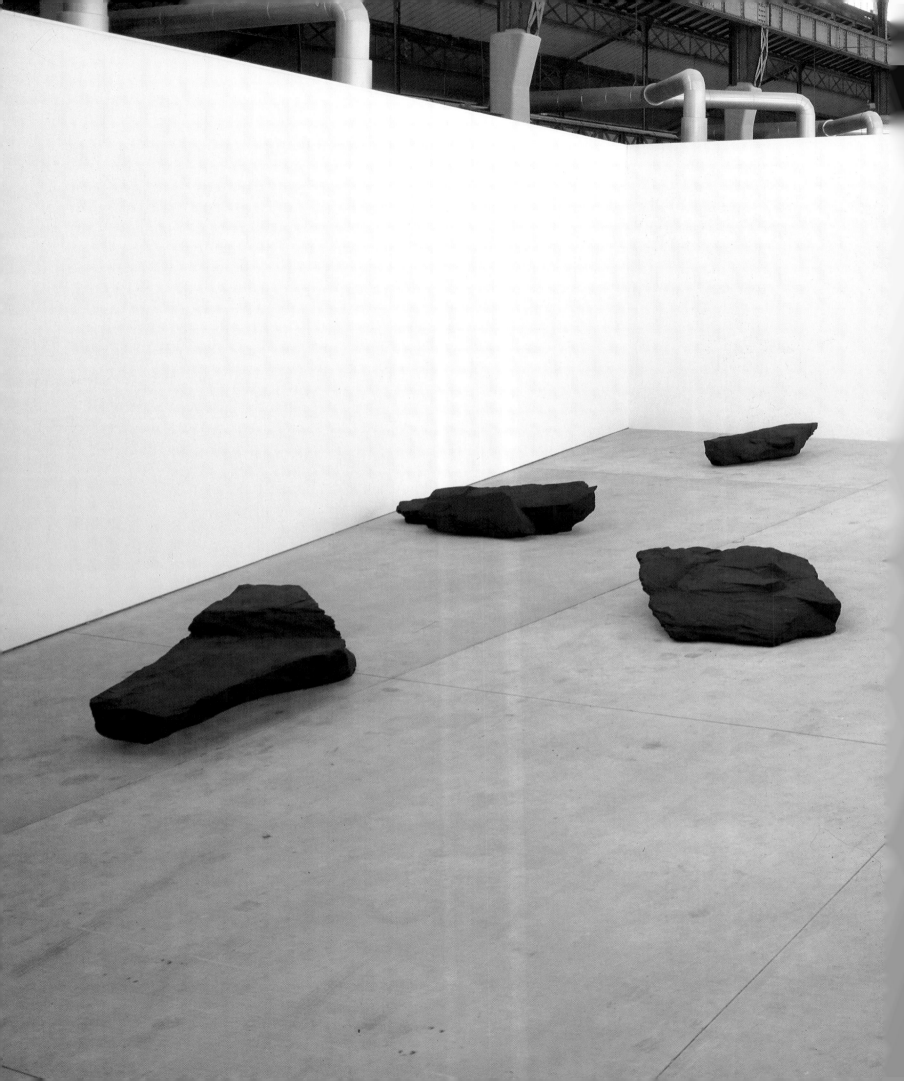

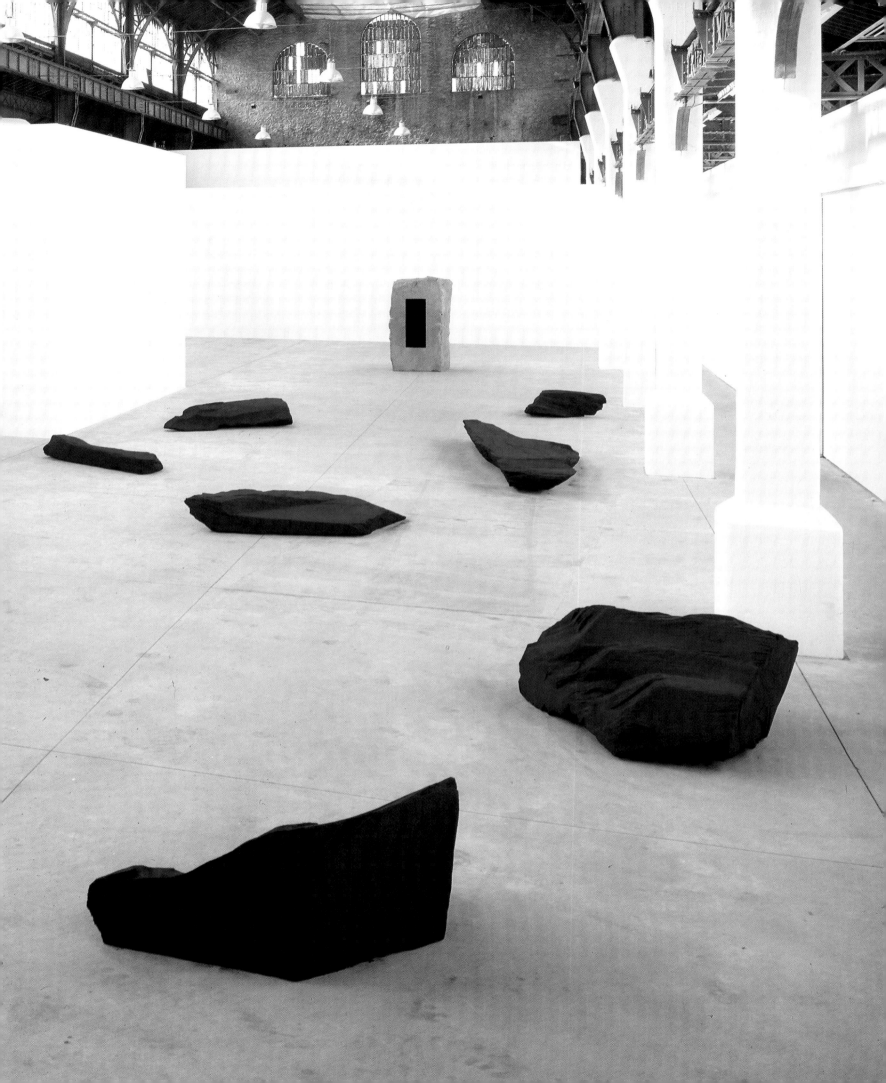

106

p. 104-105
Angel, 1990
It is Man, 1989

Angel, 1990
It is Man, 1989

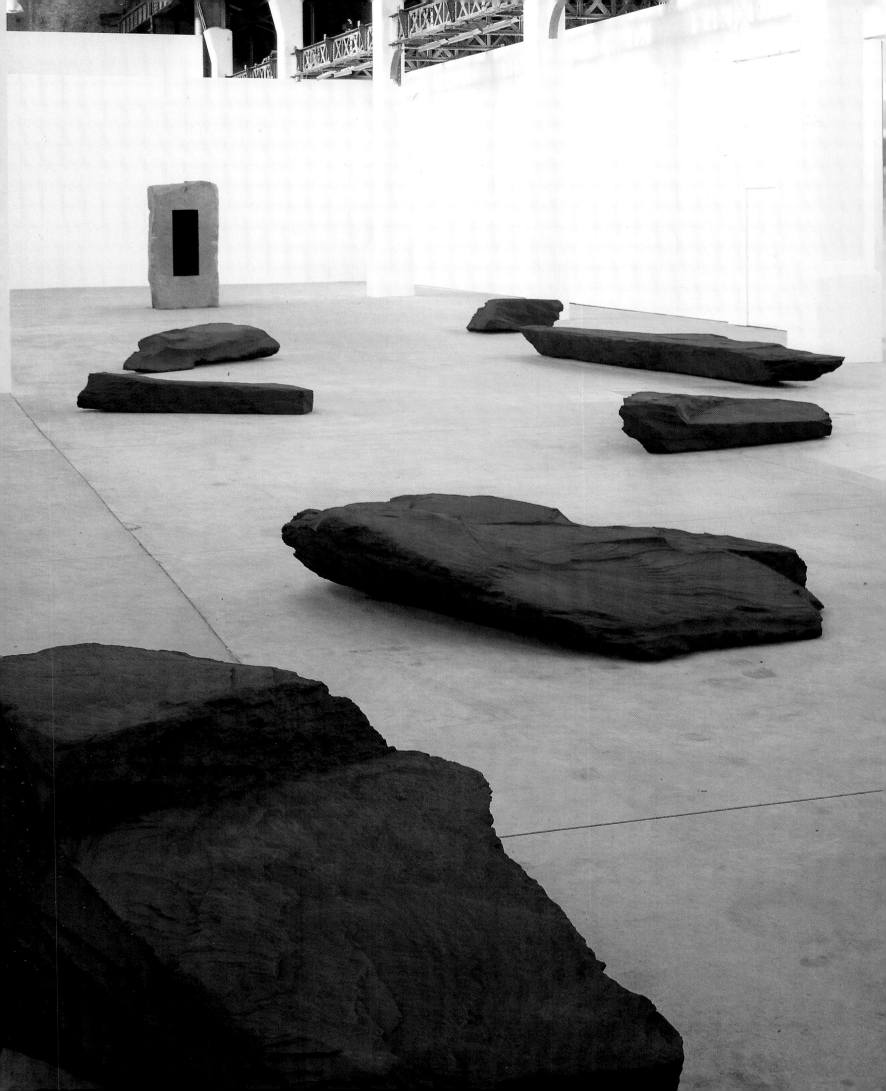

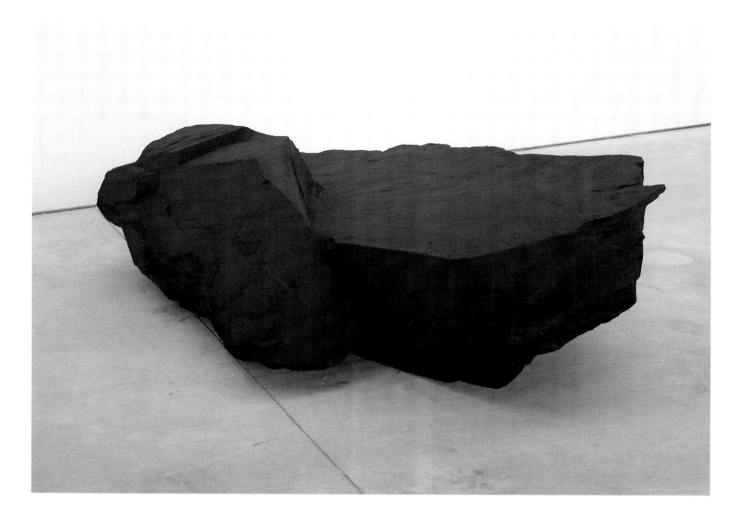

Angel, 1990

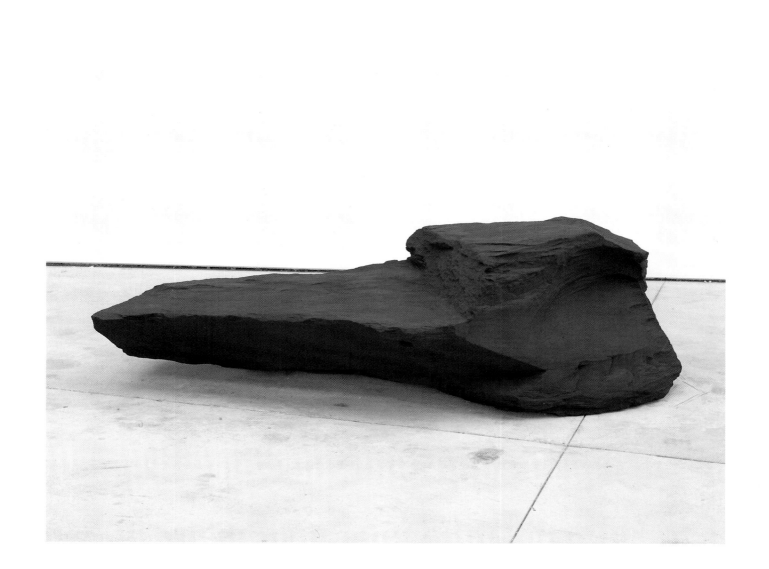

Angel, 1990

0

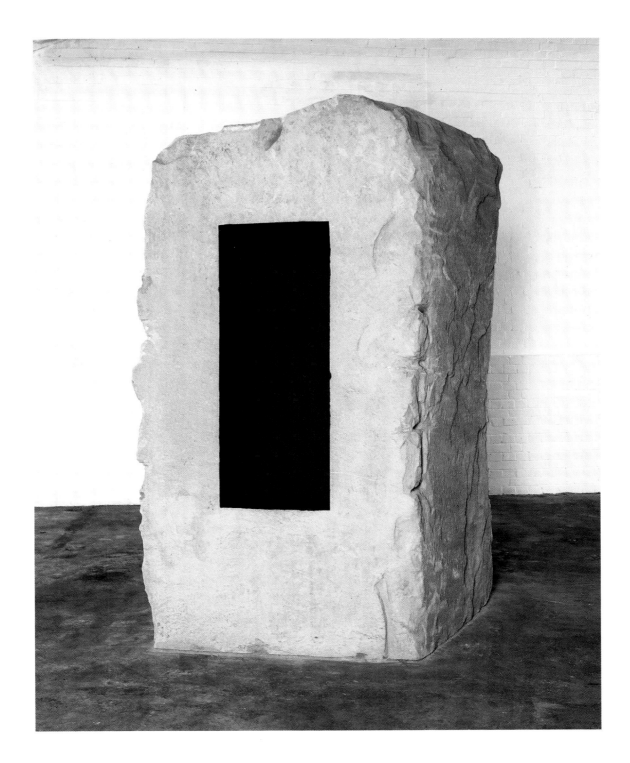

It is Man, 1989-90

Tomb, 1989

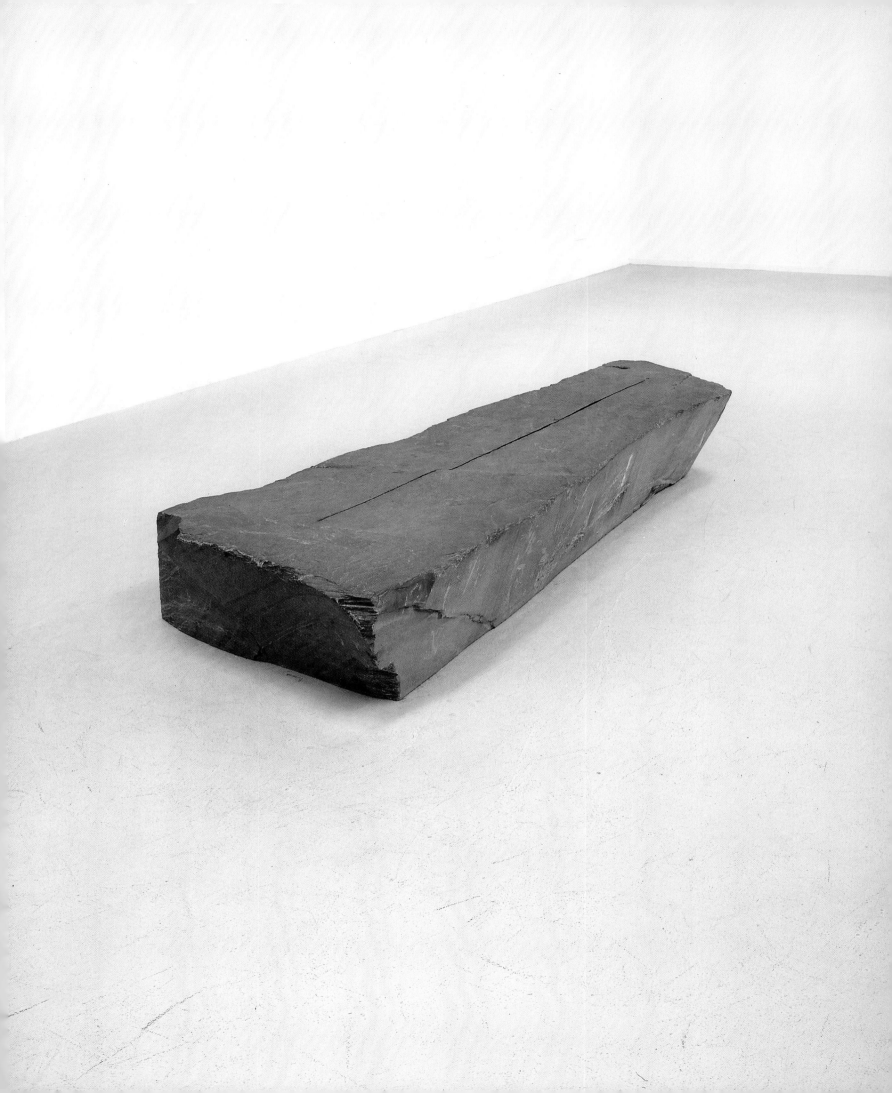

114

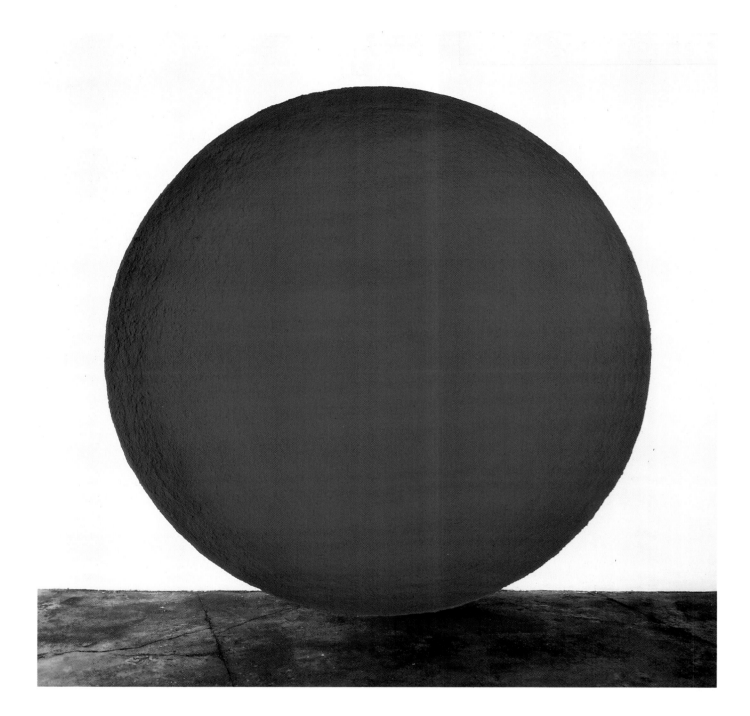

Madonna, 1989-90

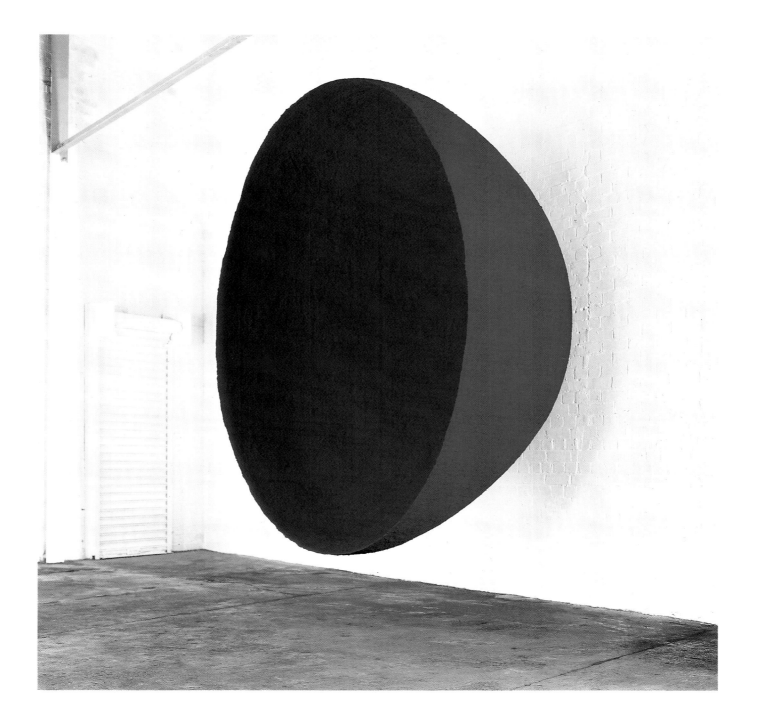

Madonna, 1989-90

116

The Healing of St. Thomas, 1989

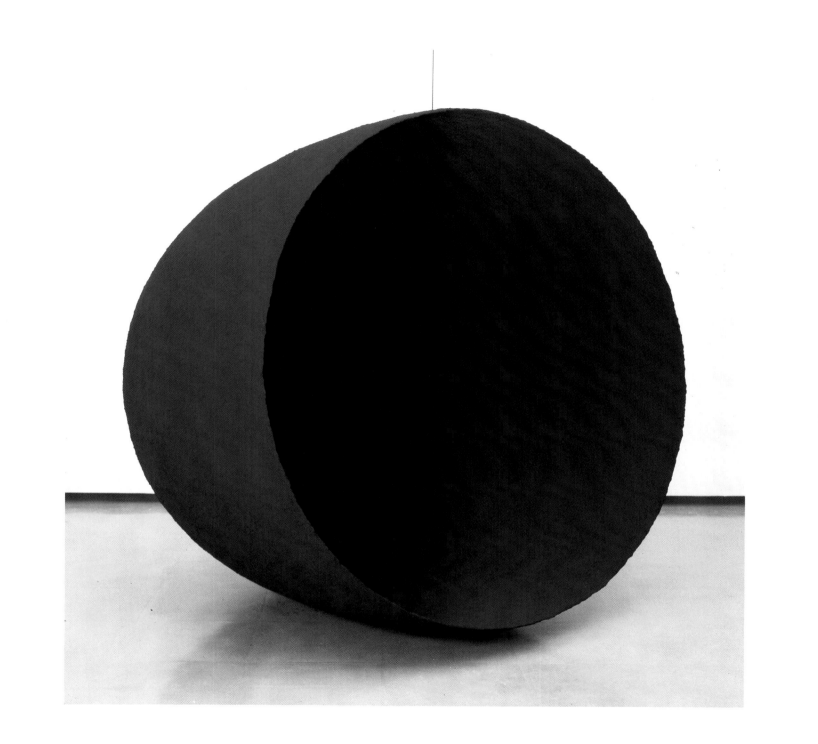

Mother as a Void, 1989-90

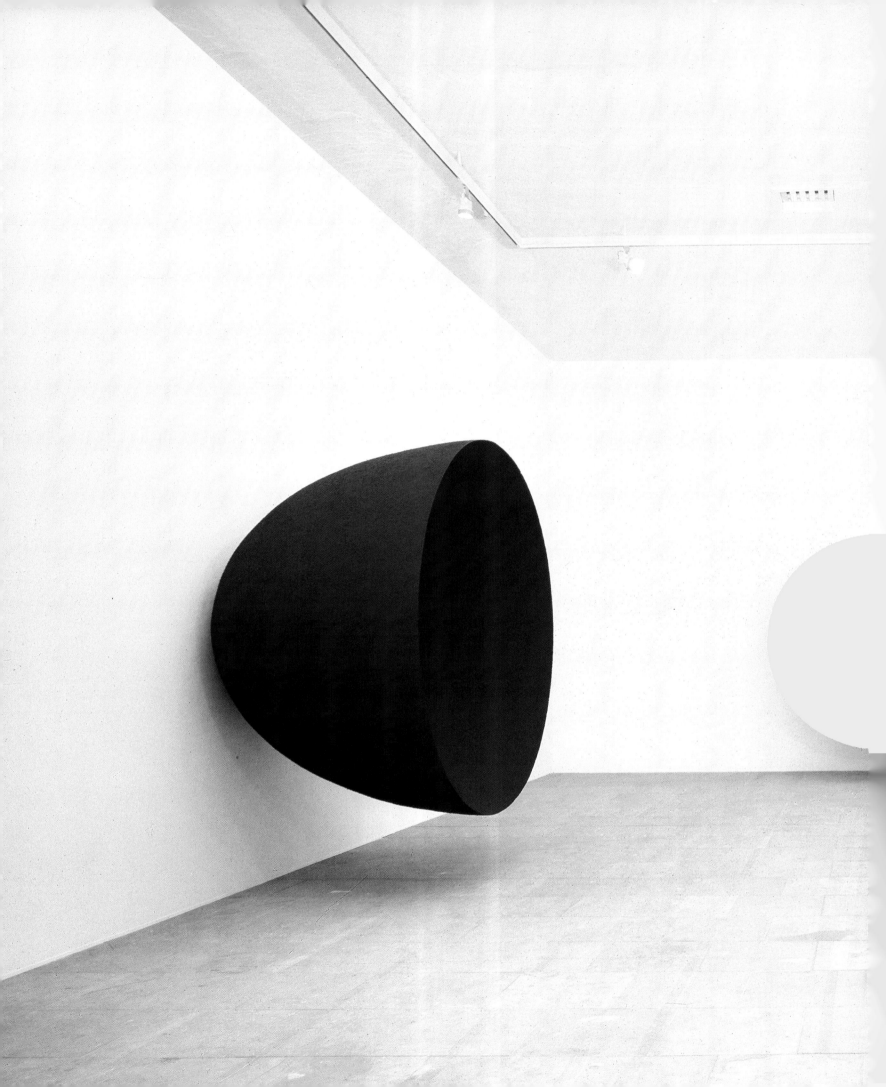

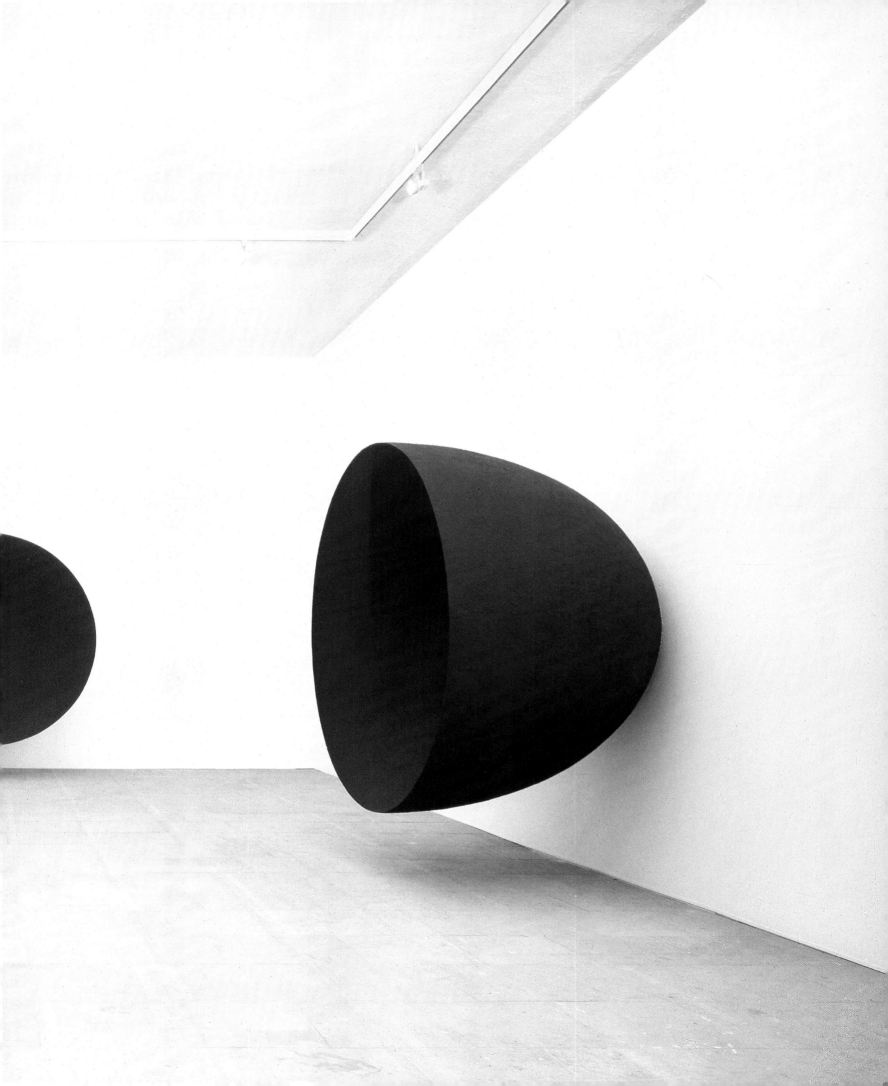

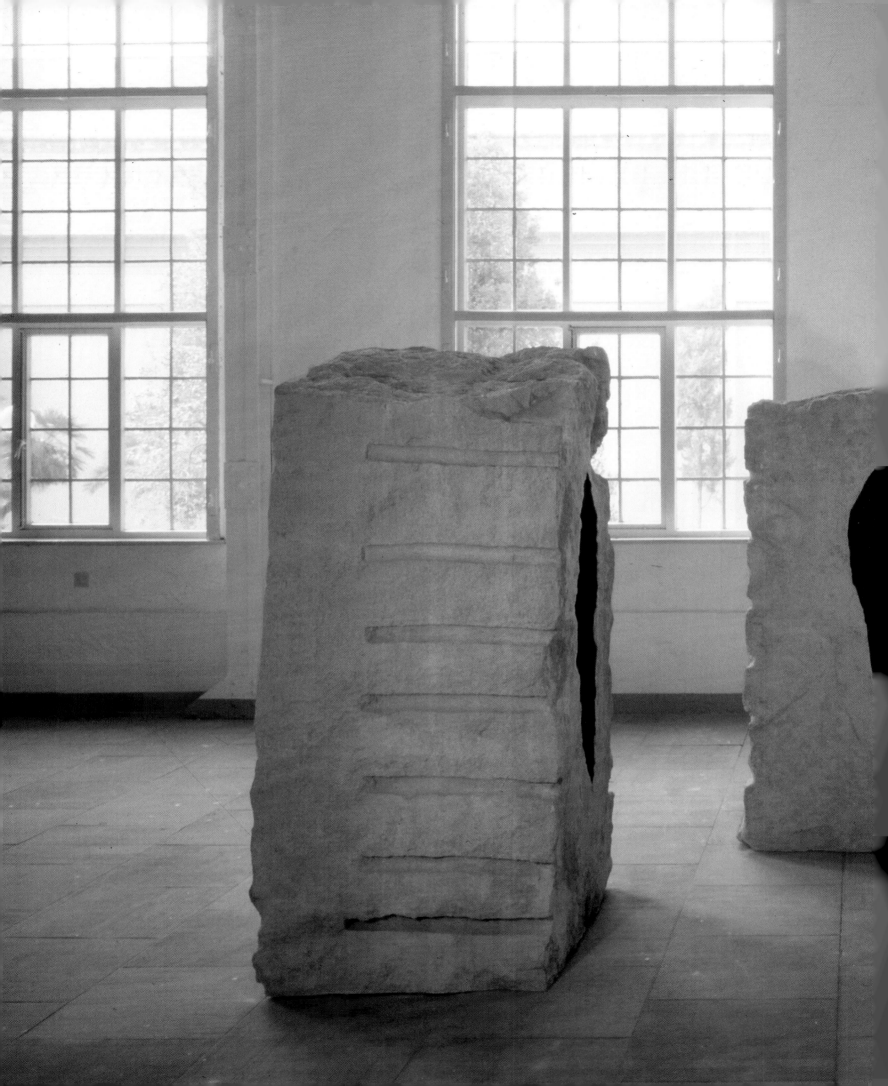

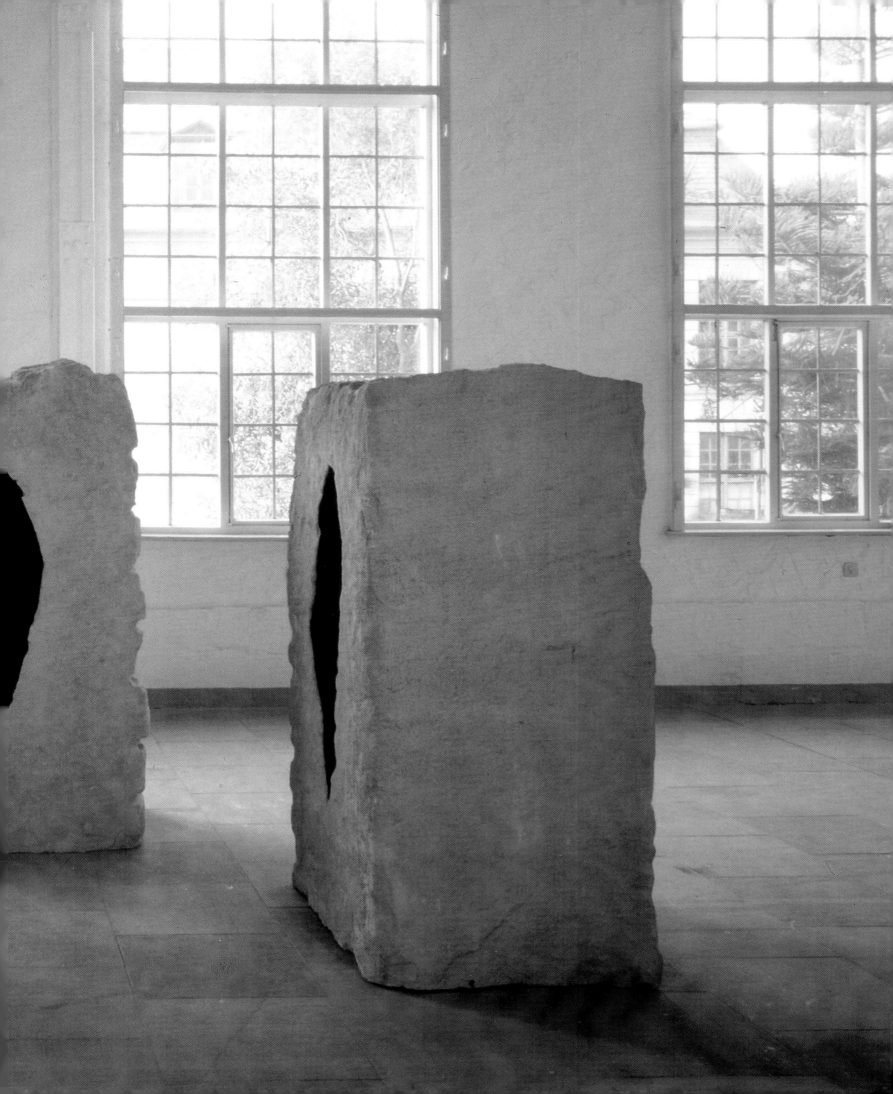

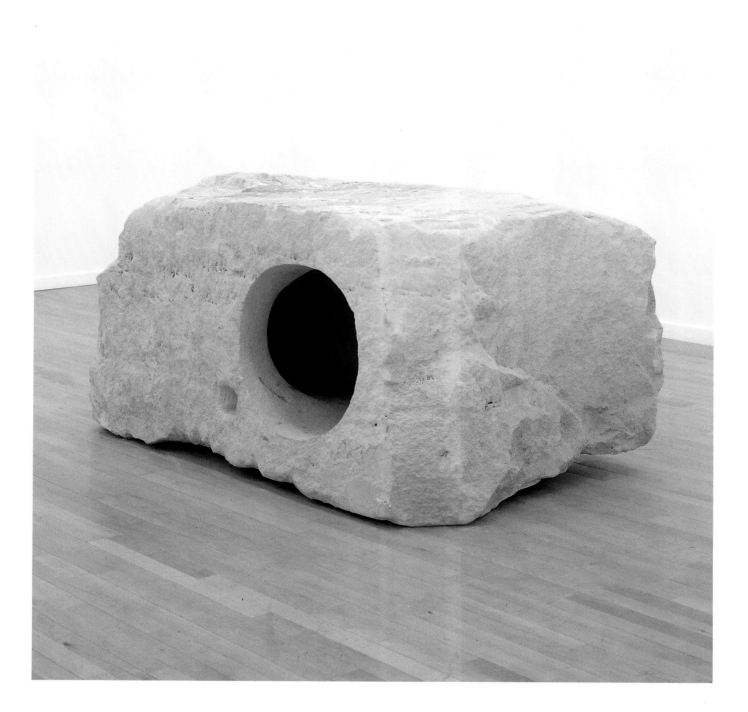

124

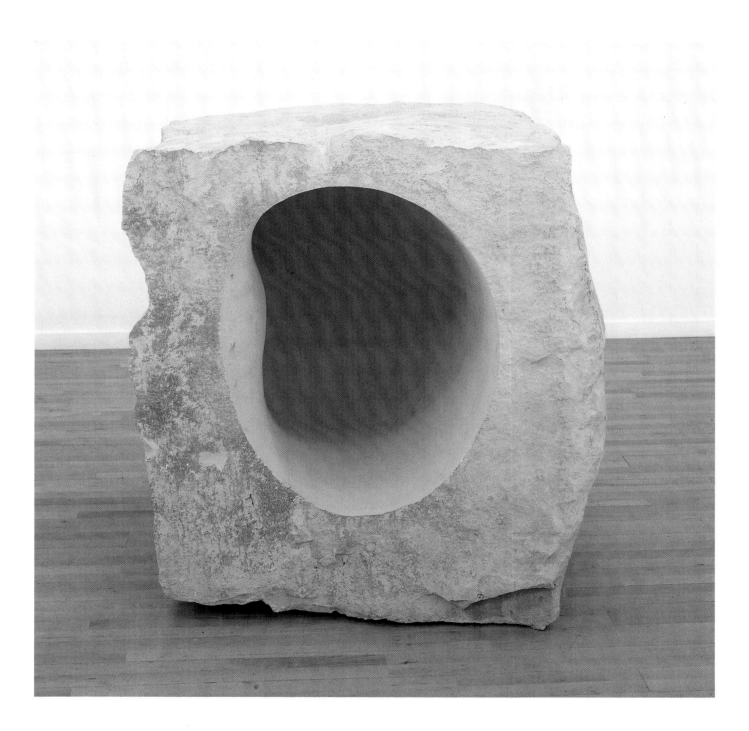

125

Untitled, 1990

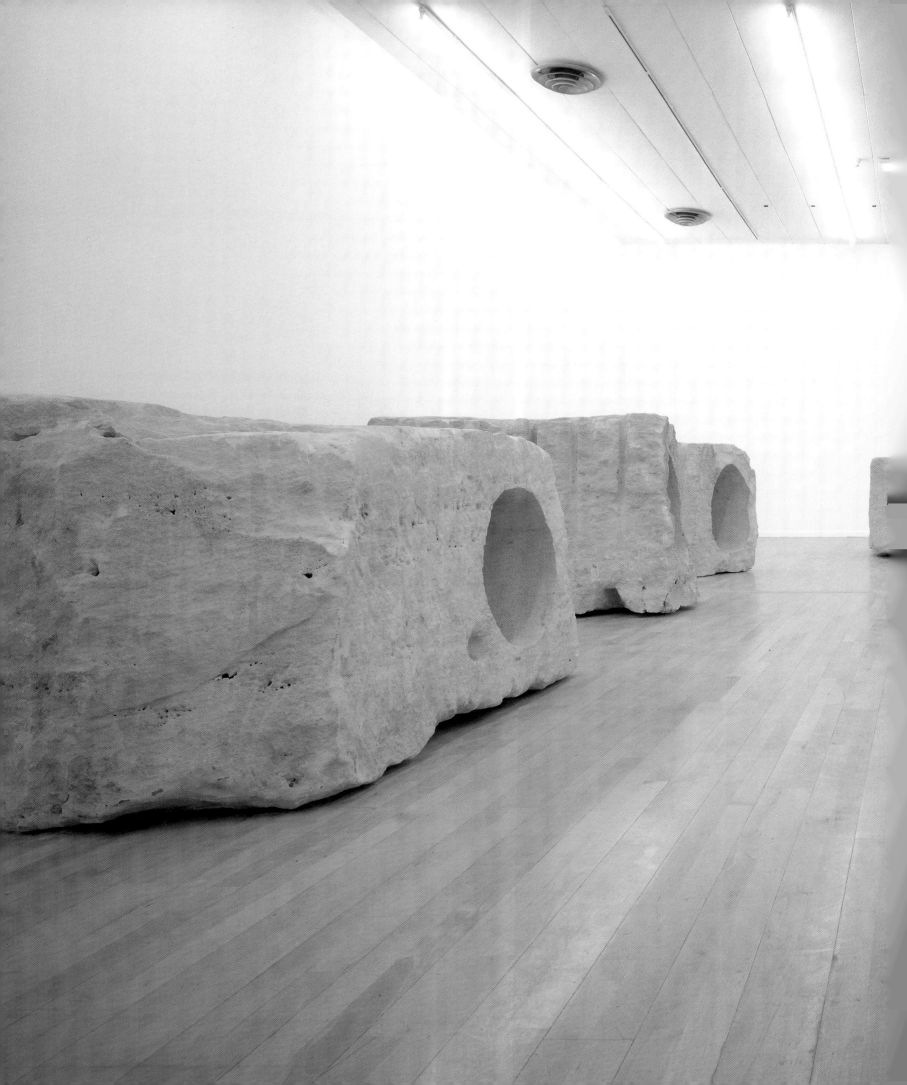

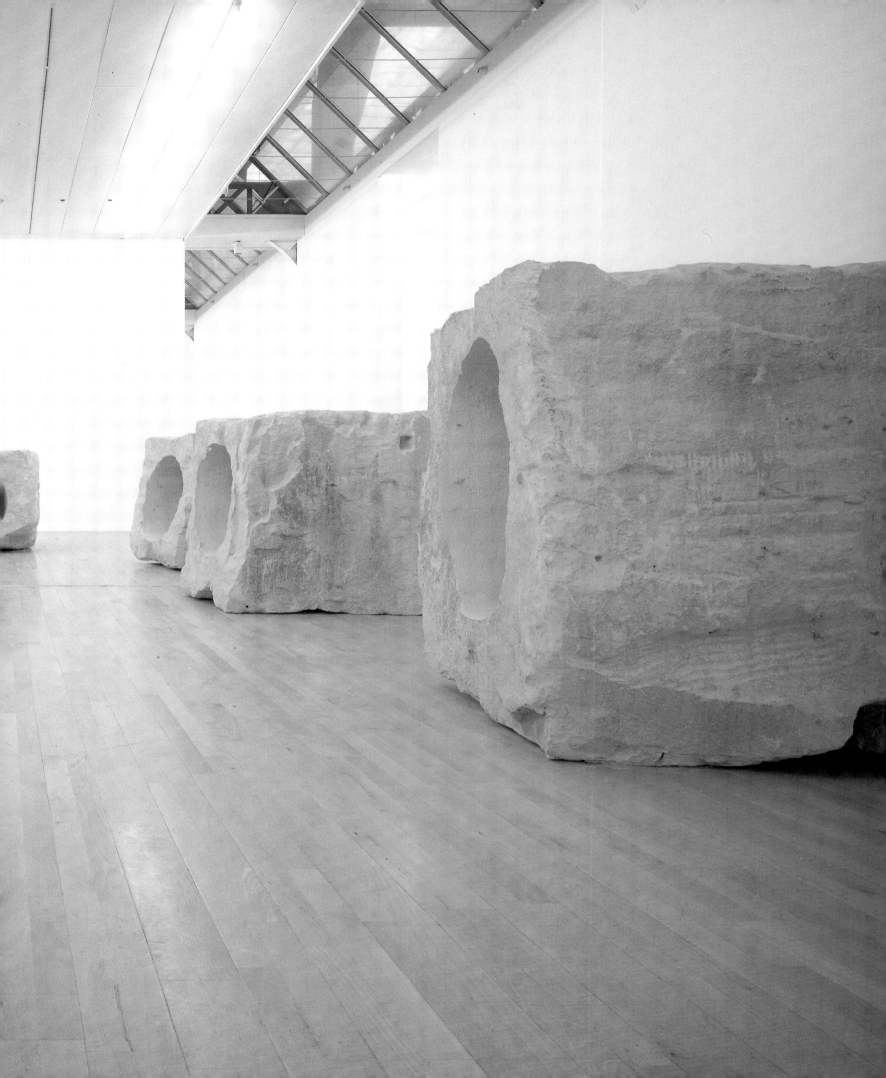

128

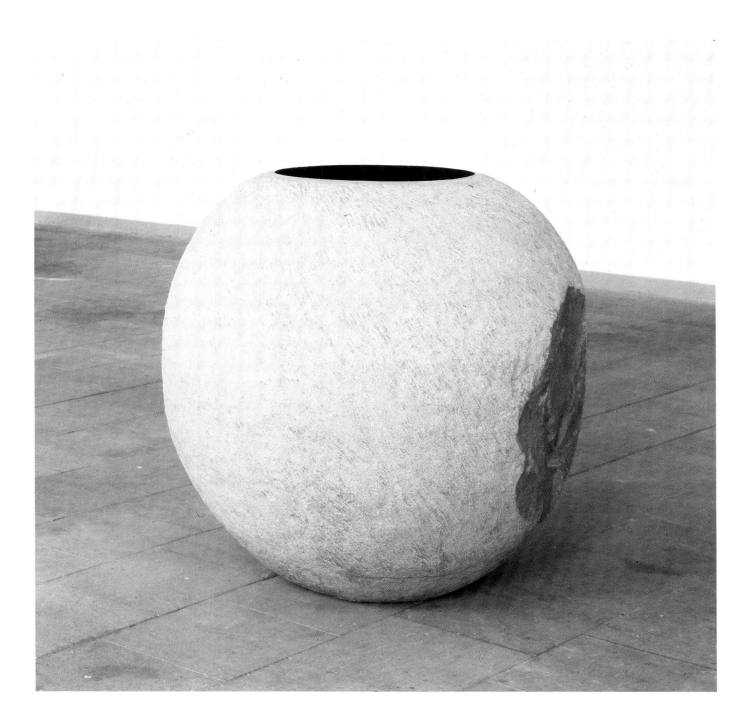

129

Pot, 1991

The Earth, 1991

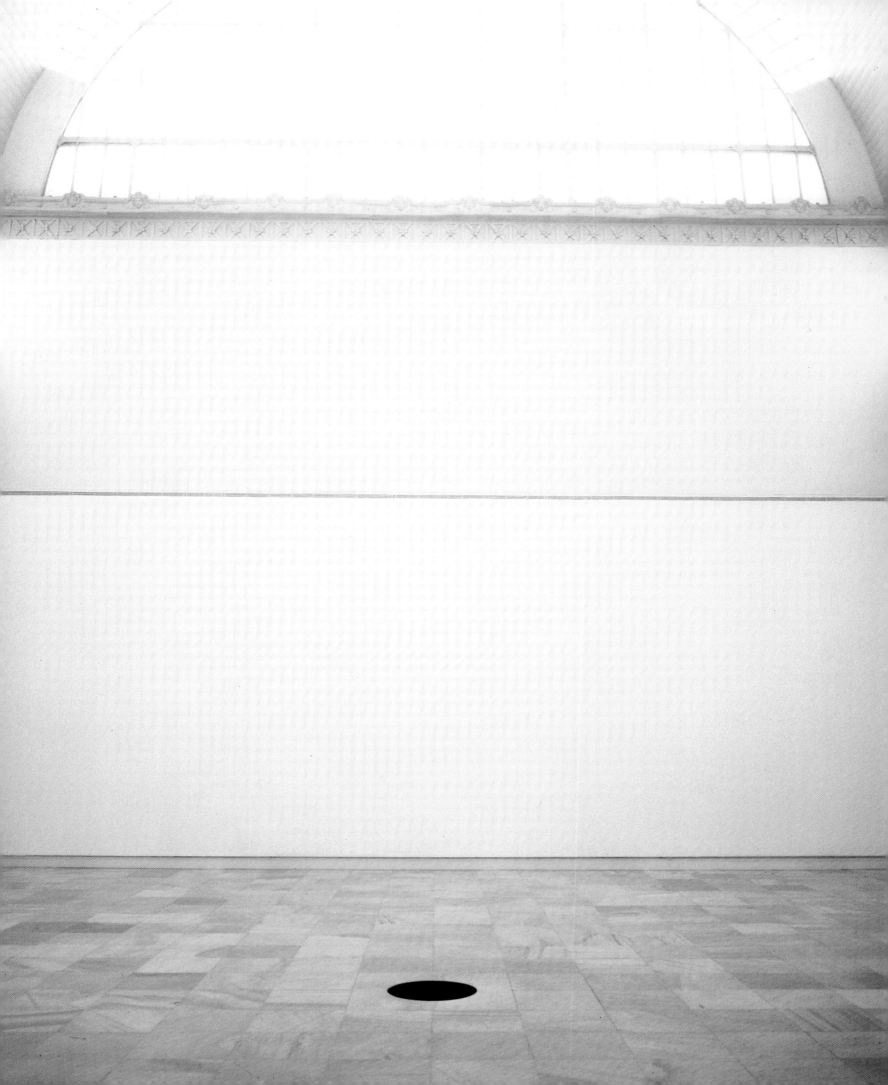

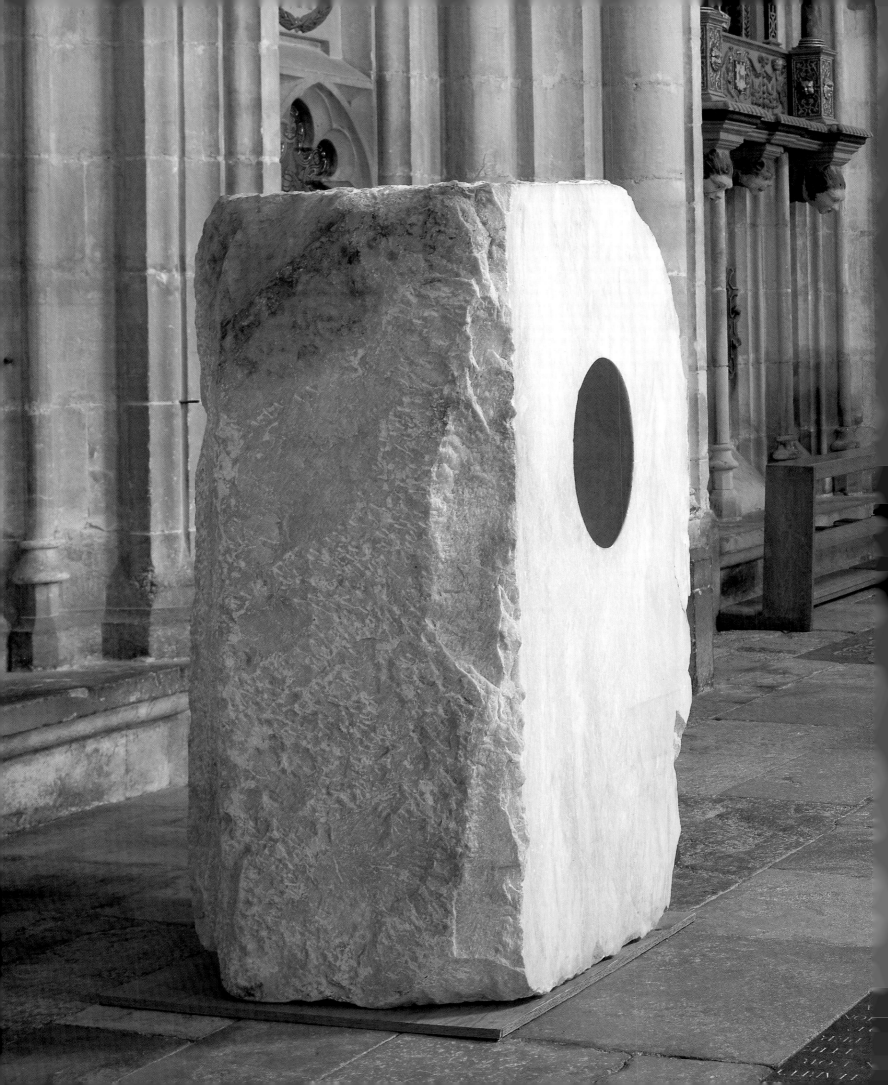

134

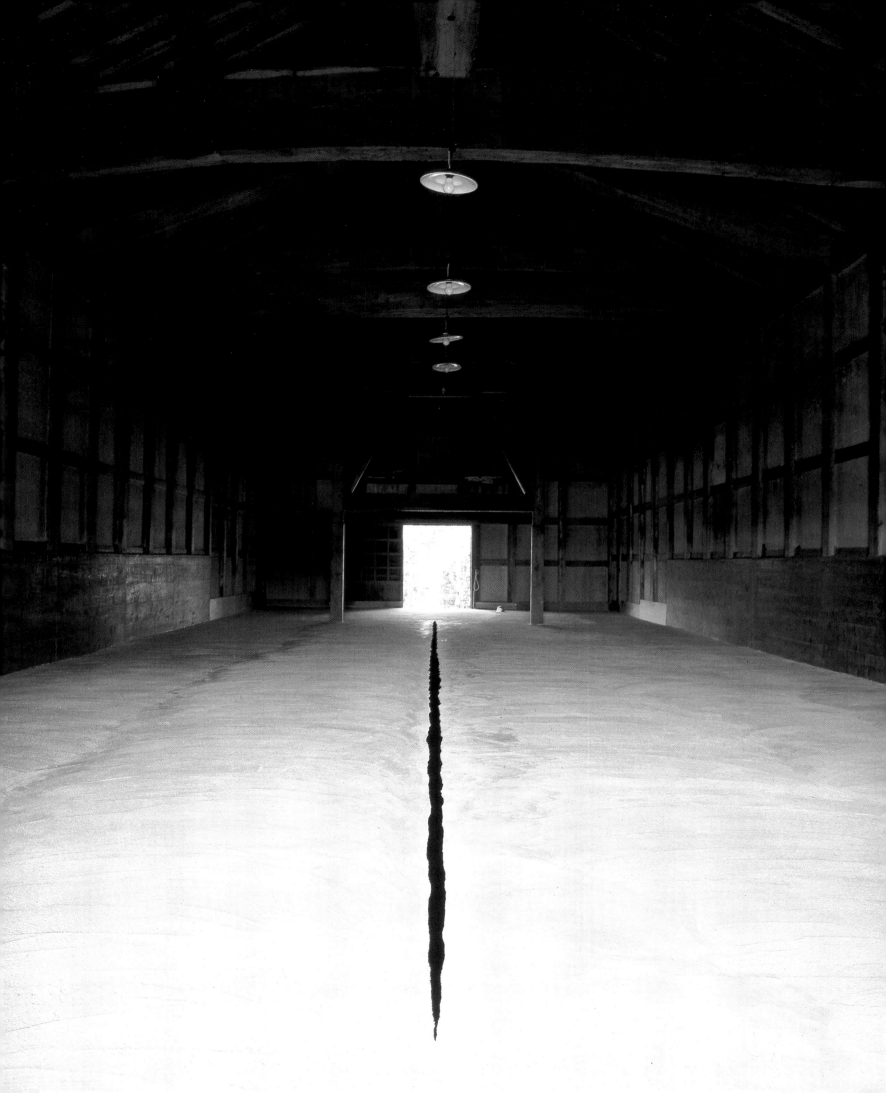

136

Untitled Installation, 1991

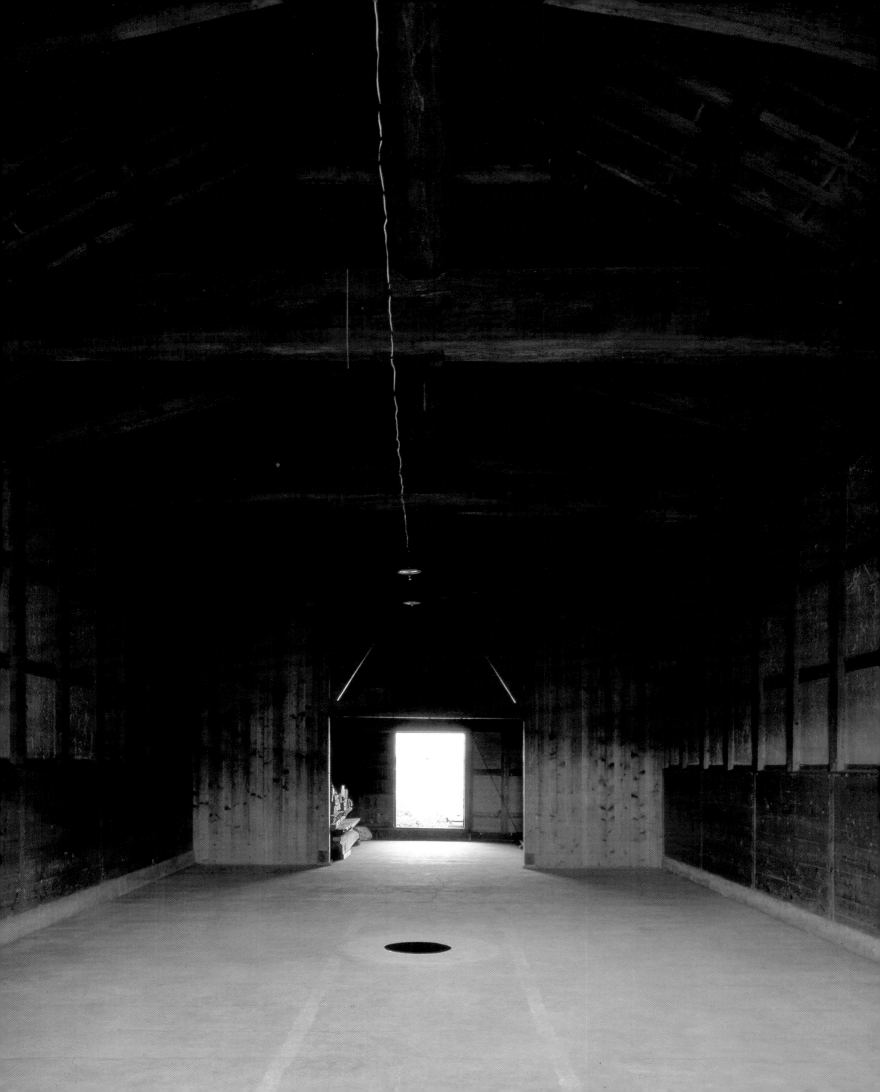

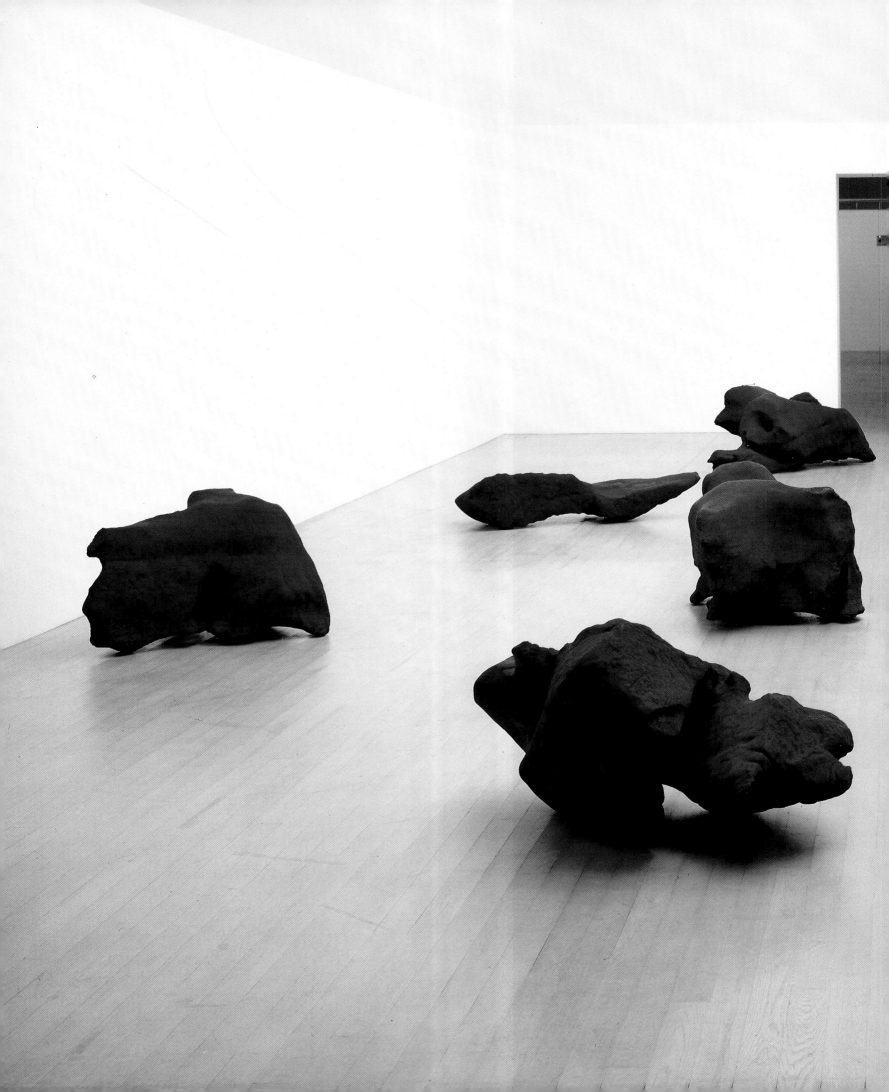

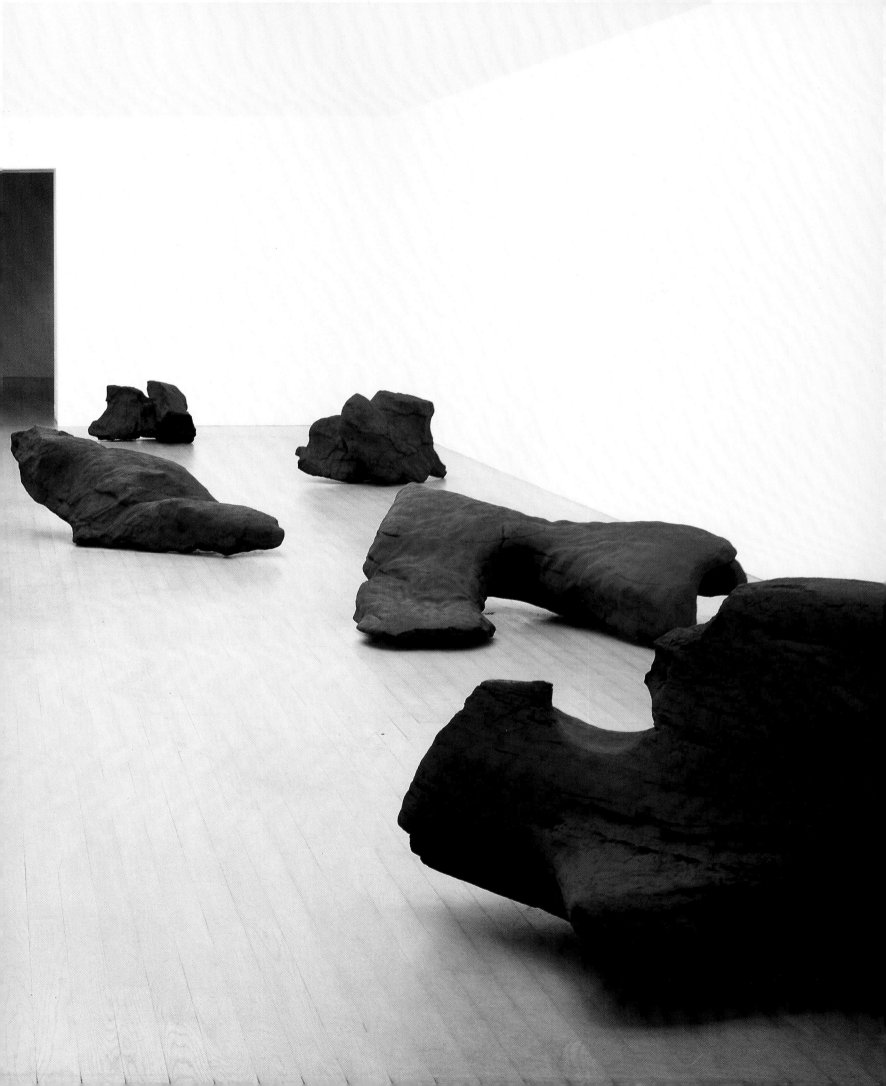

140

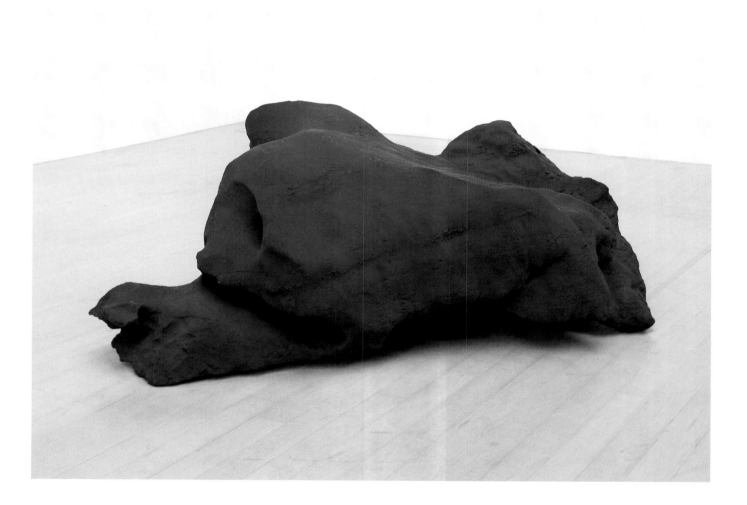

Dragon, 1992

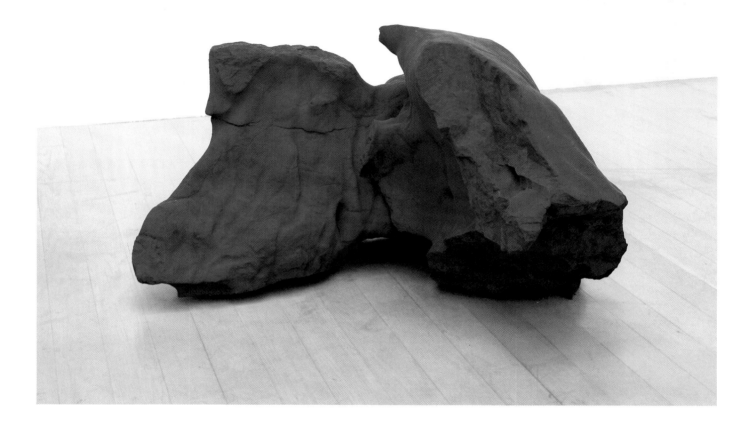

Dragon, 1992

142

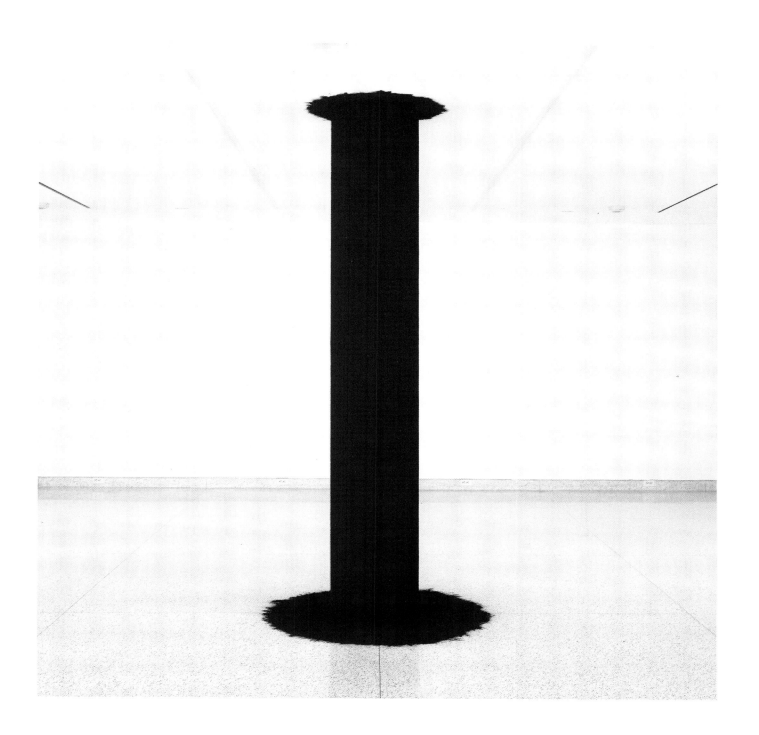

Endless Column, 1992

144

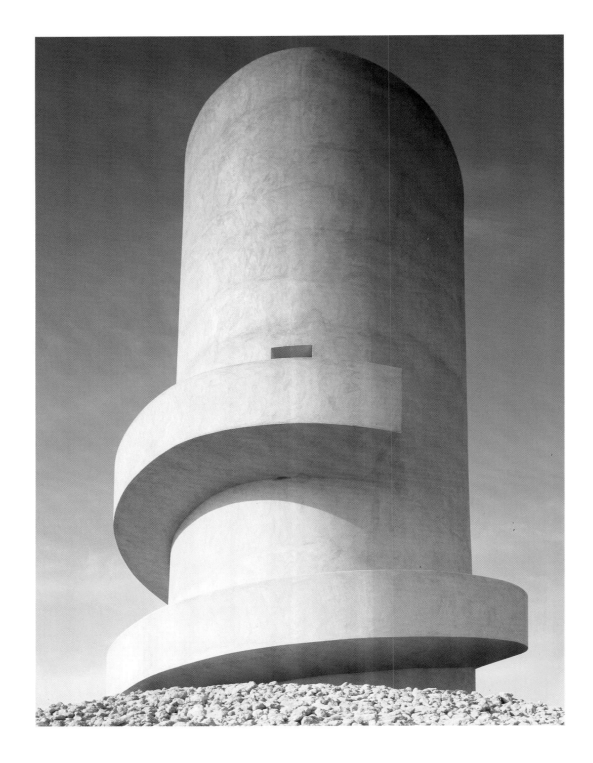

Building for a Void, 1992

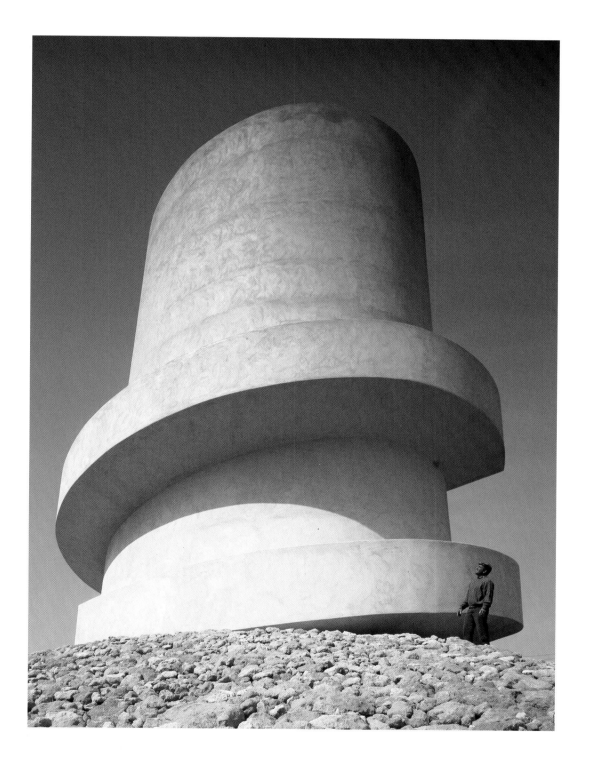

Building for a Void, 1992

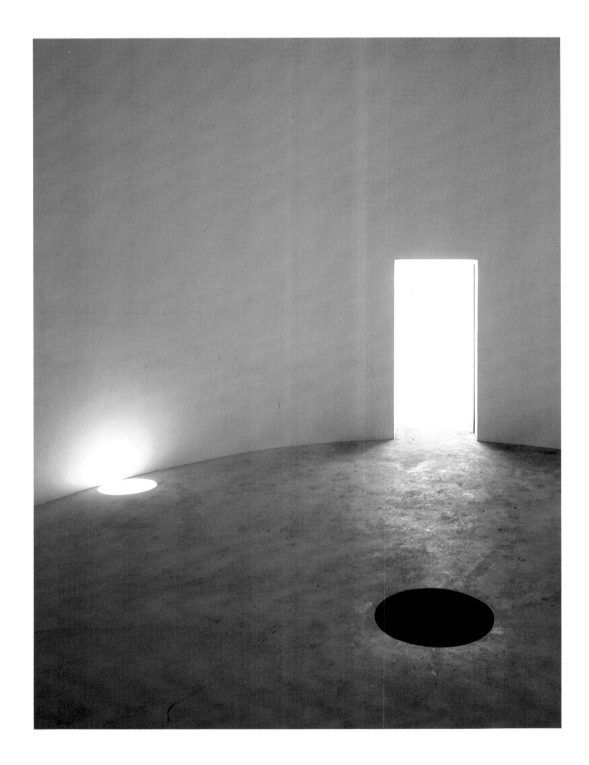

Building for a Void, 1992

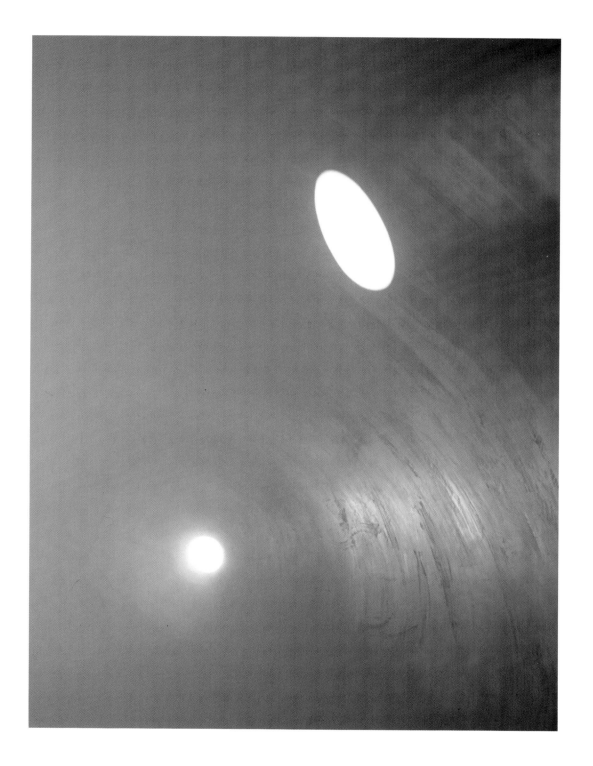

Building for a Void, 1992

148

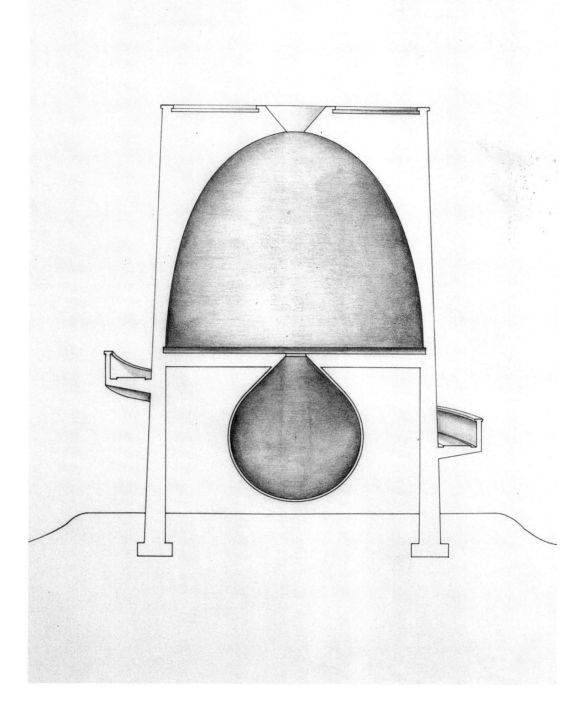

Building for a Void, 1992

Building for a Void, 1992

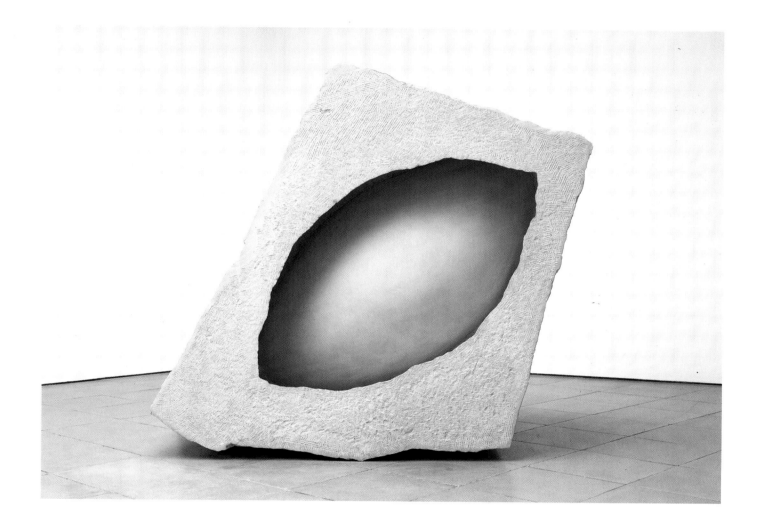

151

In the Presence of Form II, 1993

152

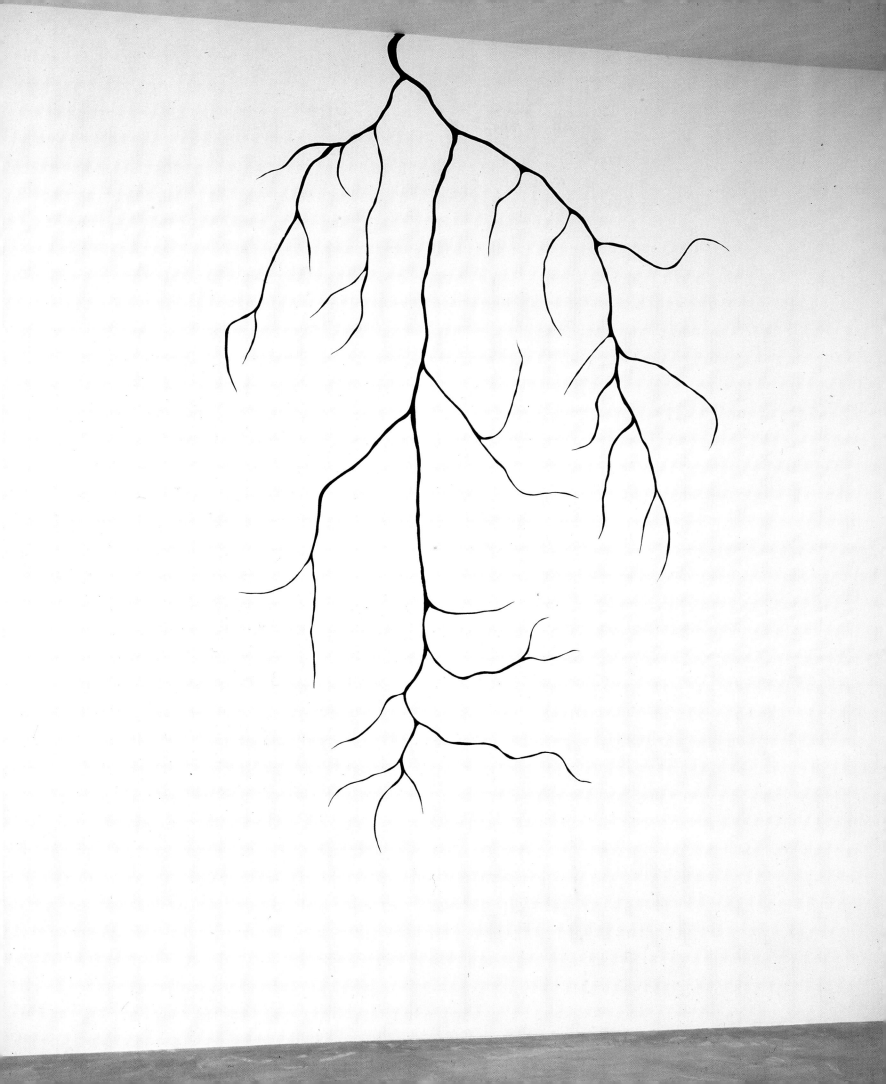

154

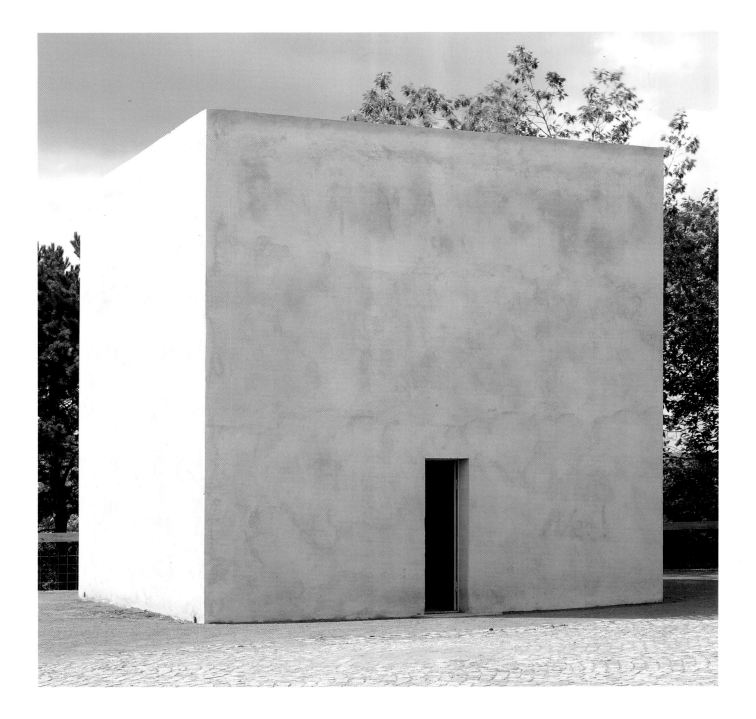

Descent into Limbo, 1992

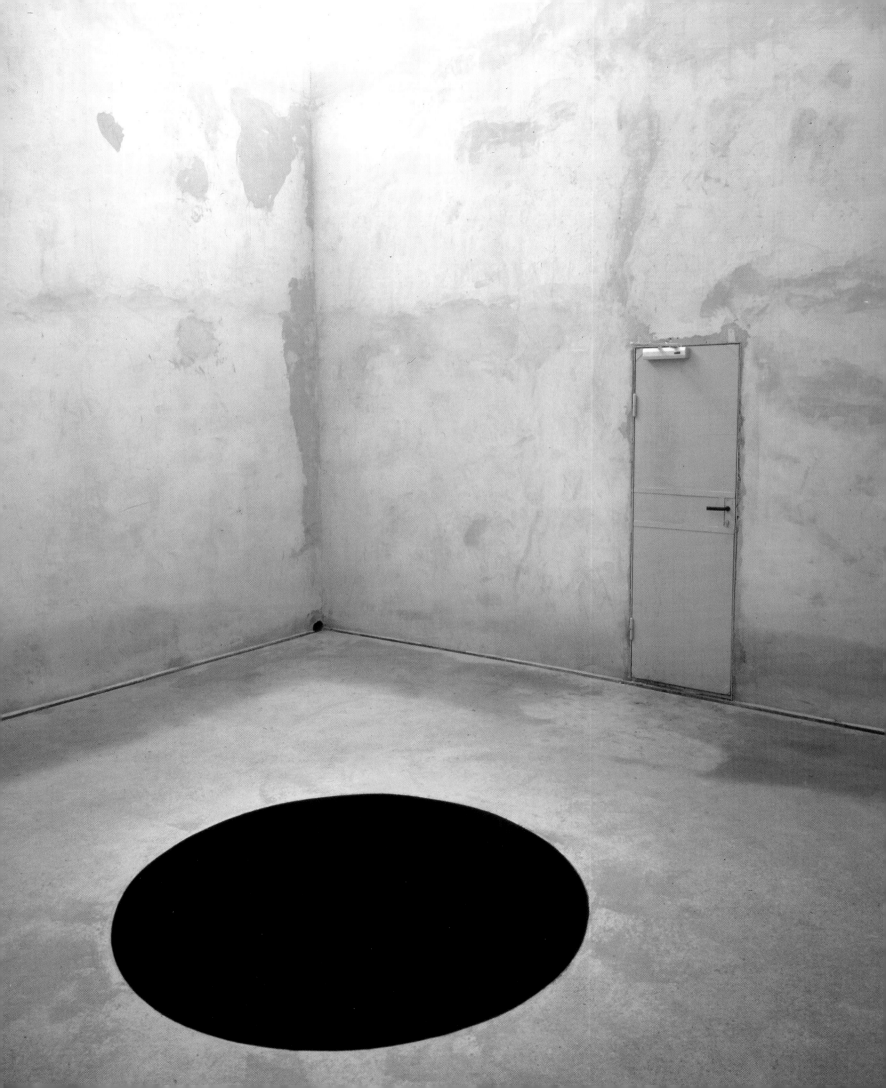

Untitled, 1993

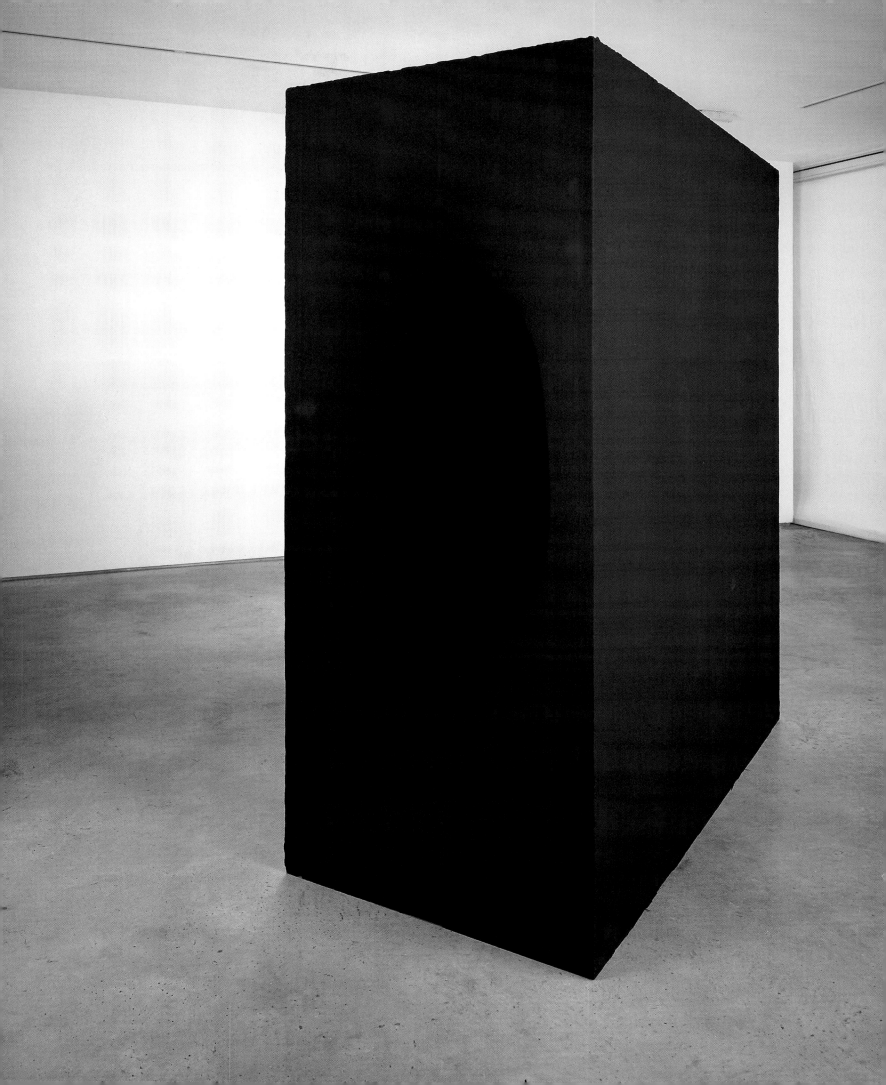

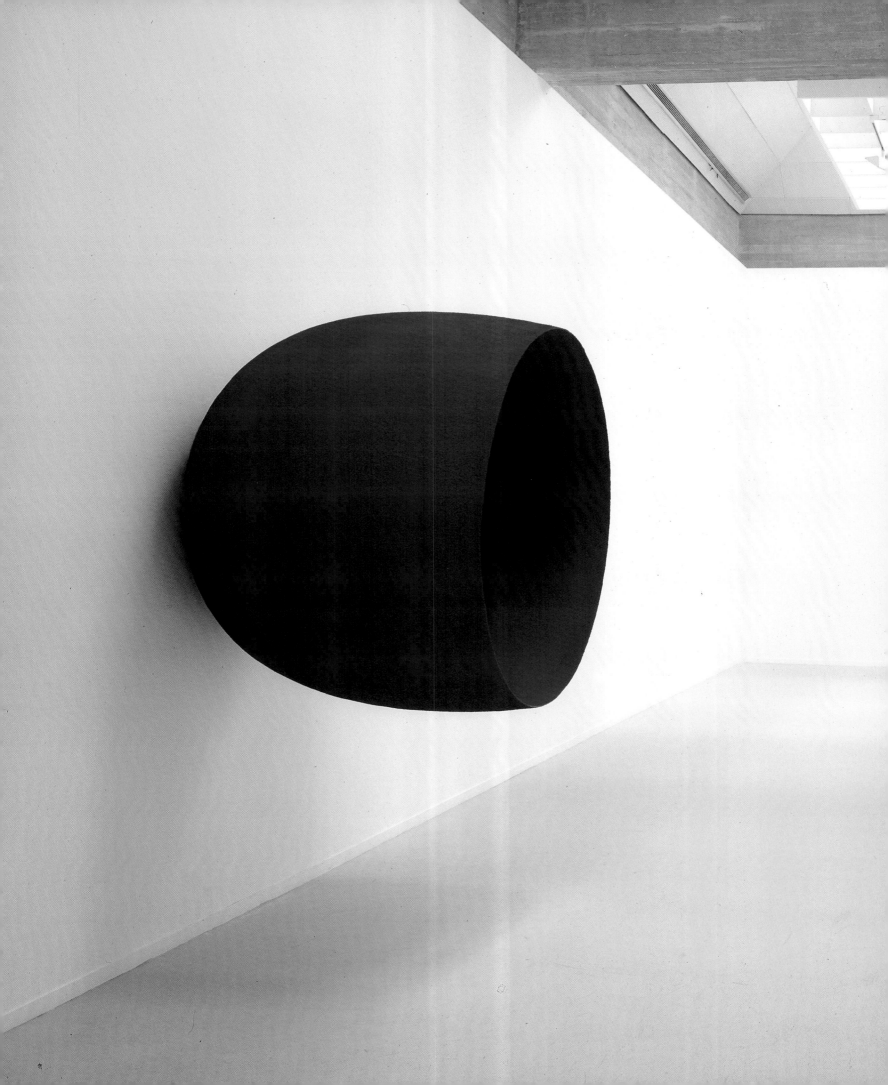

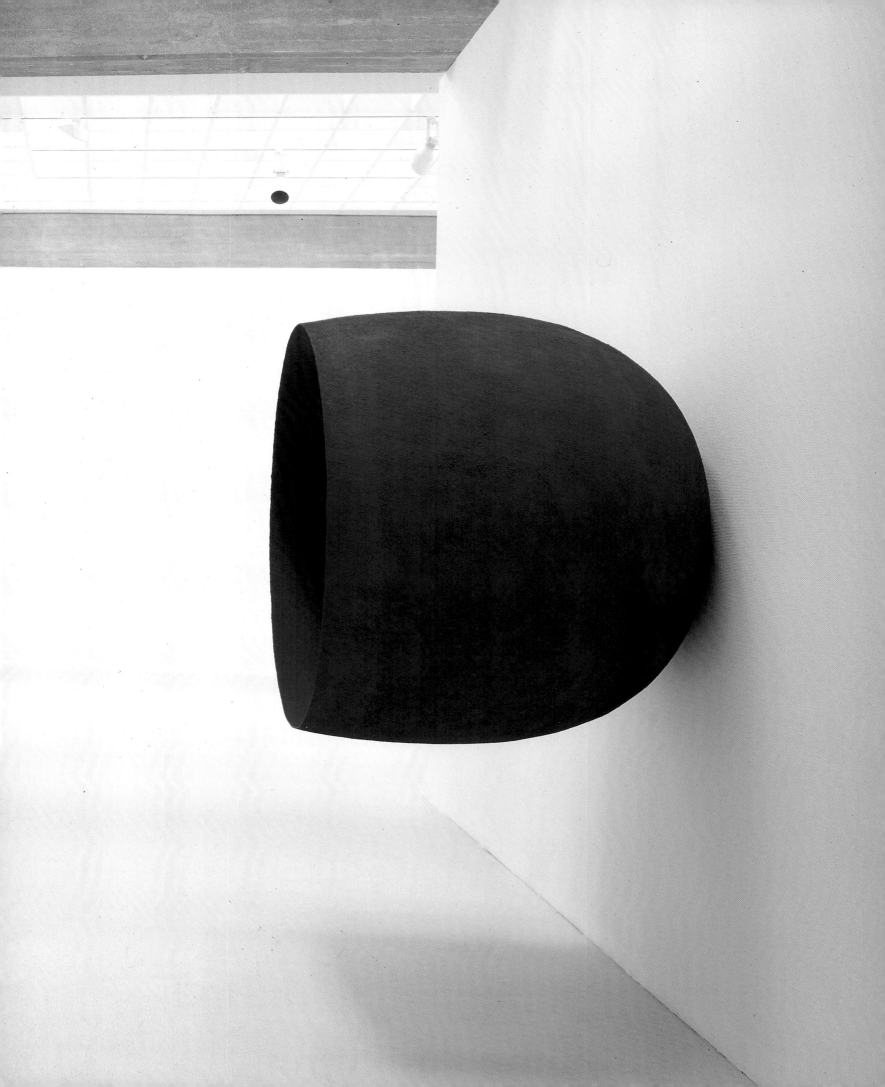

160

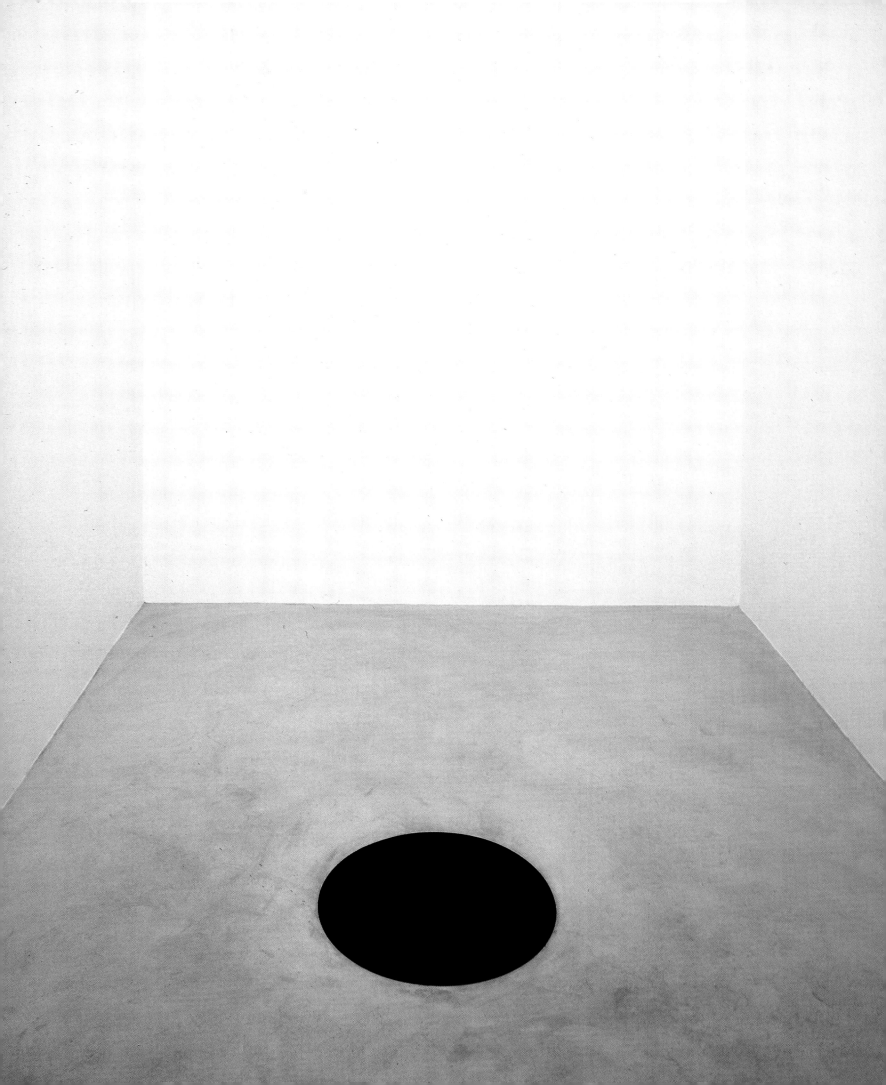

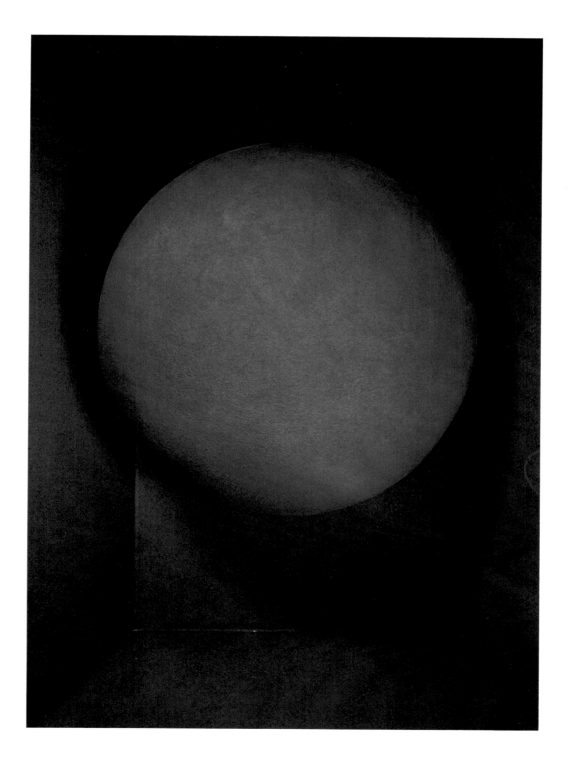

Untitled, 1992

When I am Pregnant, 1992

When I am Pregnant, 1992

When I am Pregnant, 1992

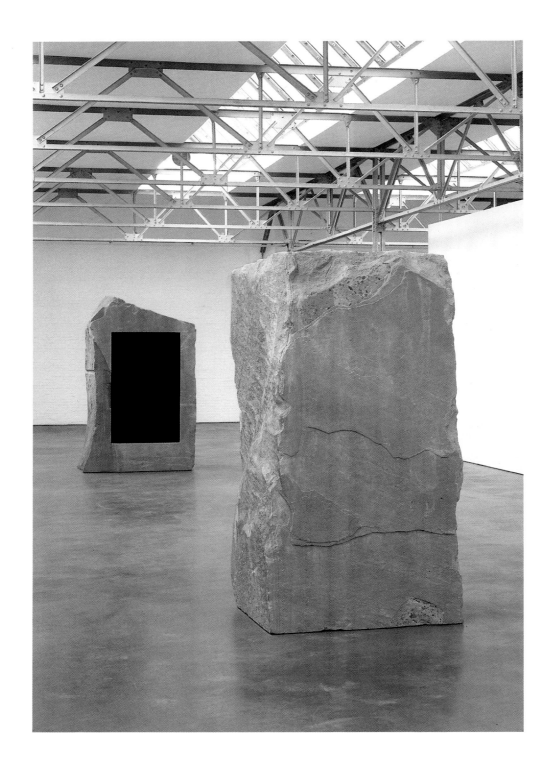

Untitled, 1992

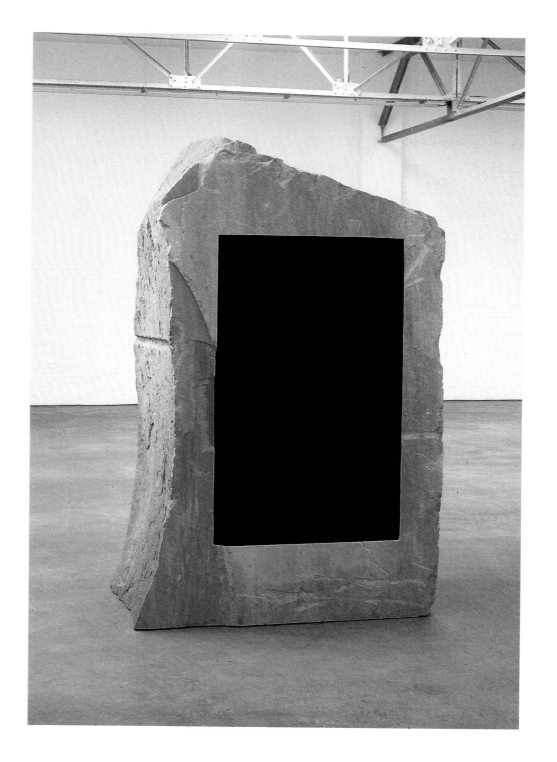

Untitled, 1992

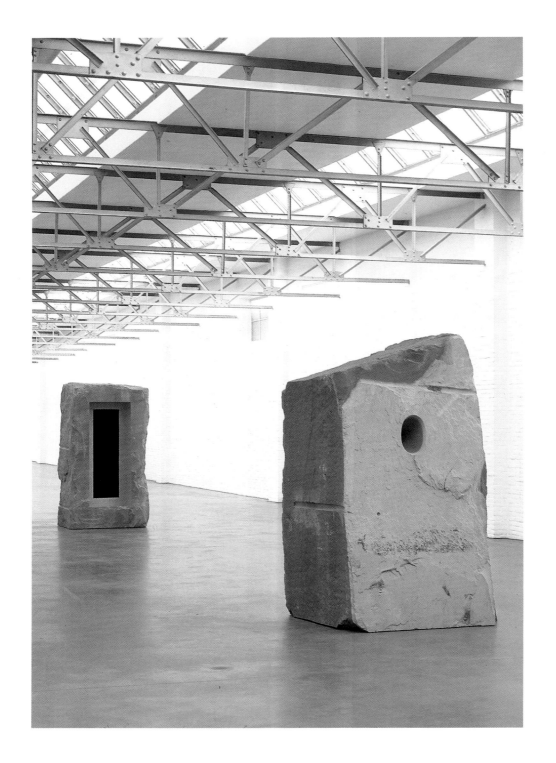

Untitled, 1992

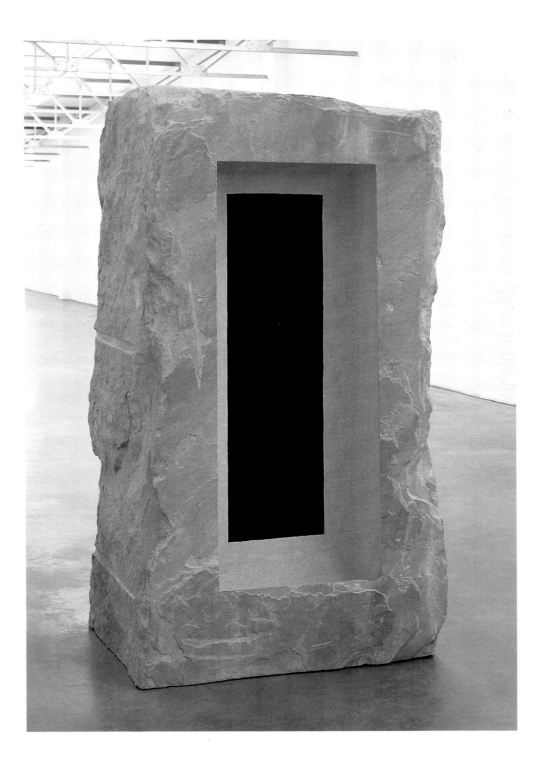

Untitled, 1992

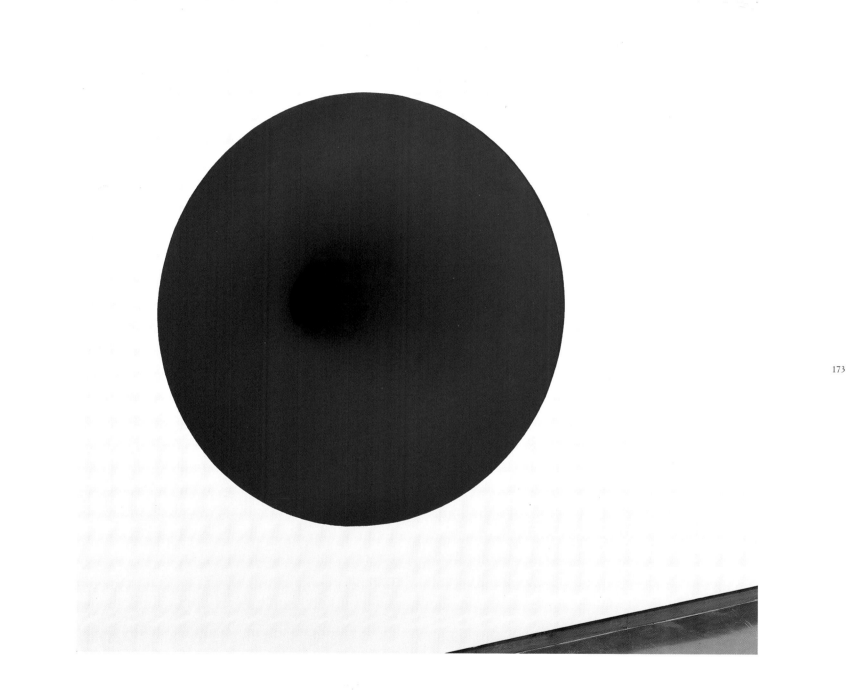

173

Untitled, 1993

174

Black Stones, Human Bones, 1993

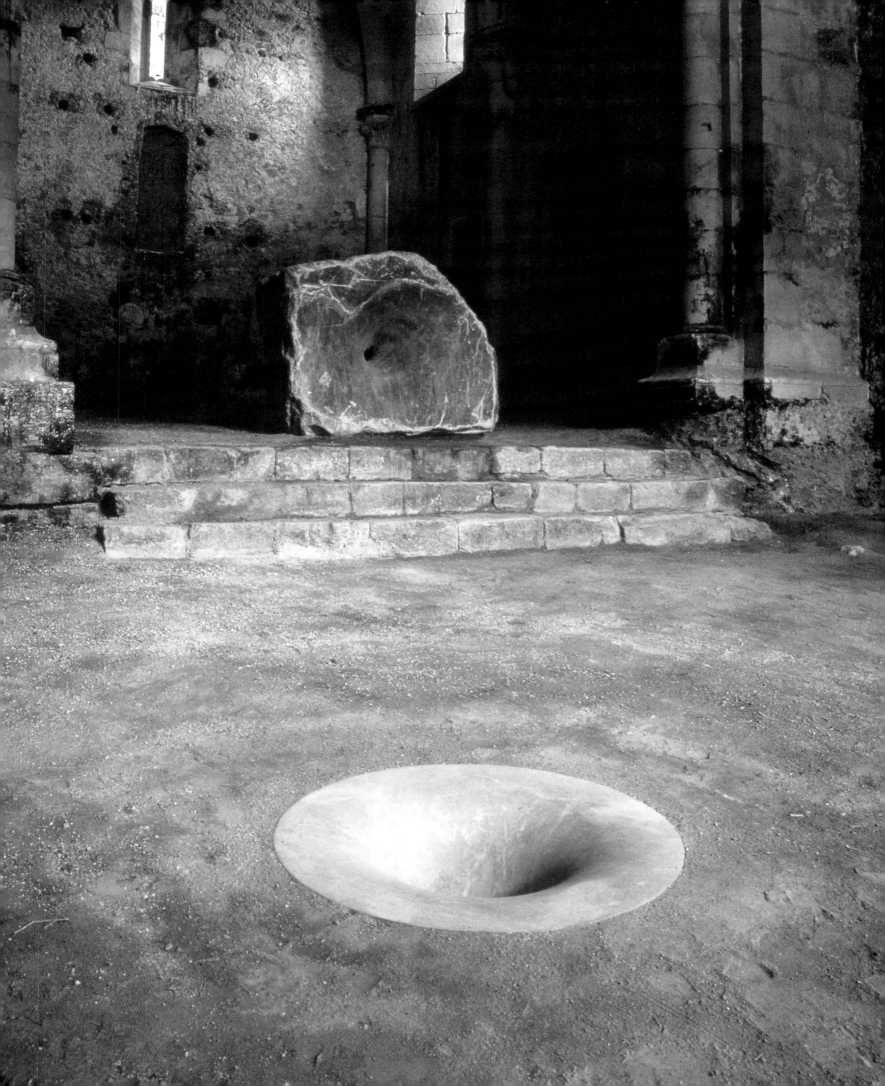

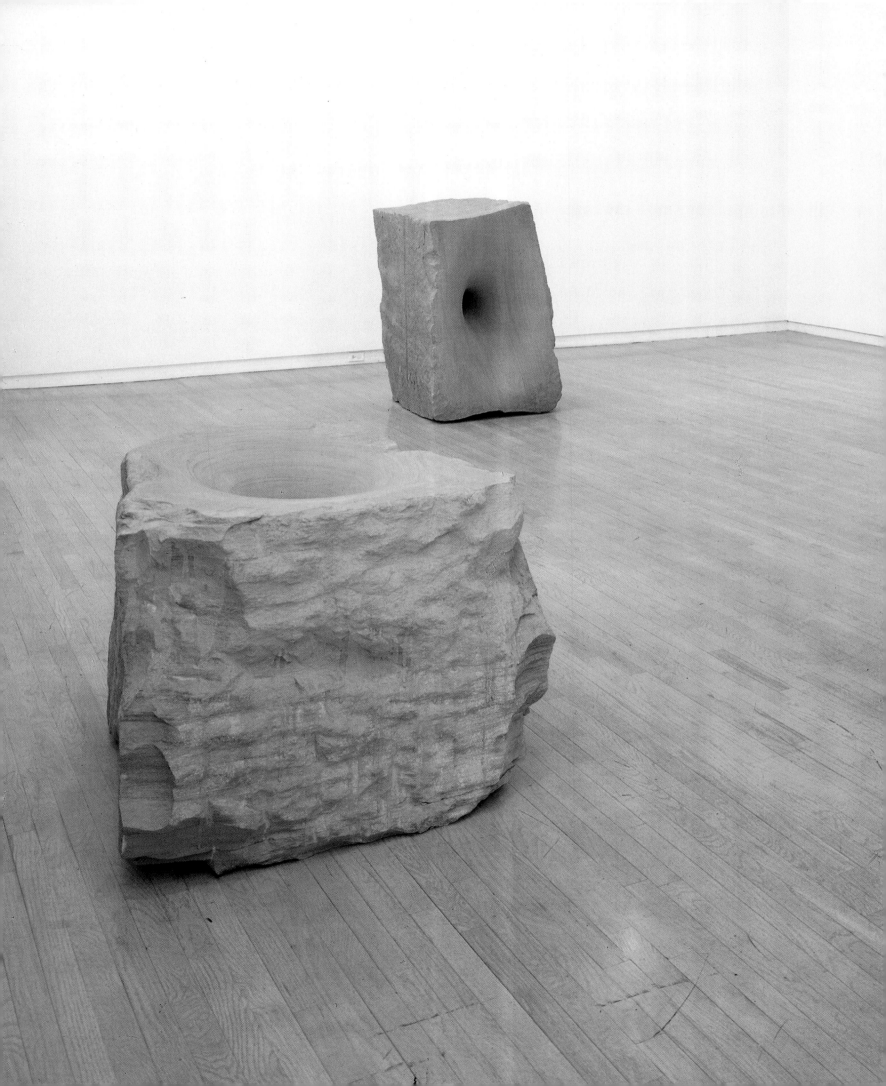

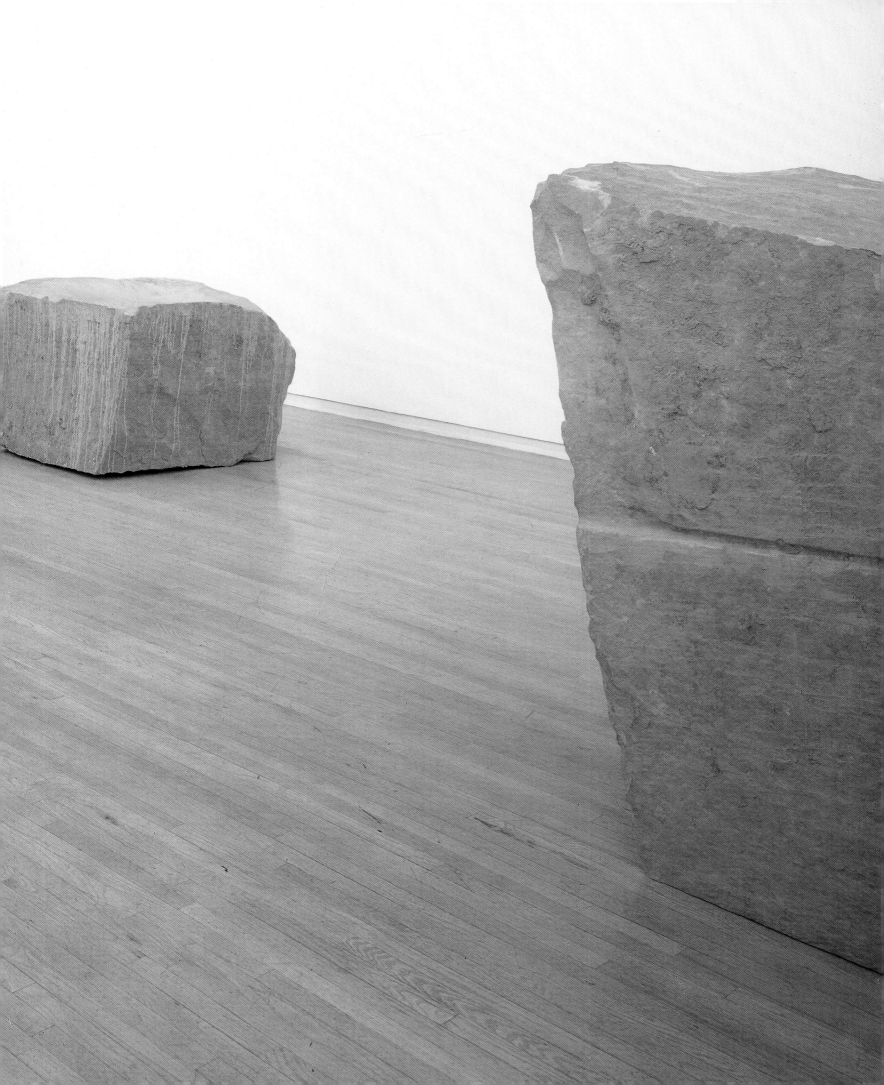

178

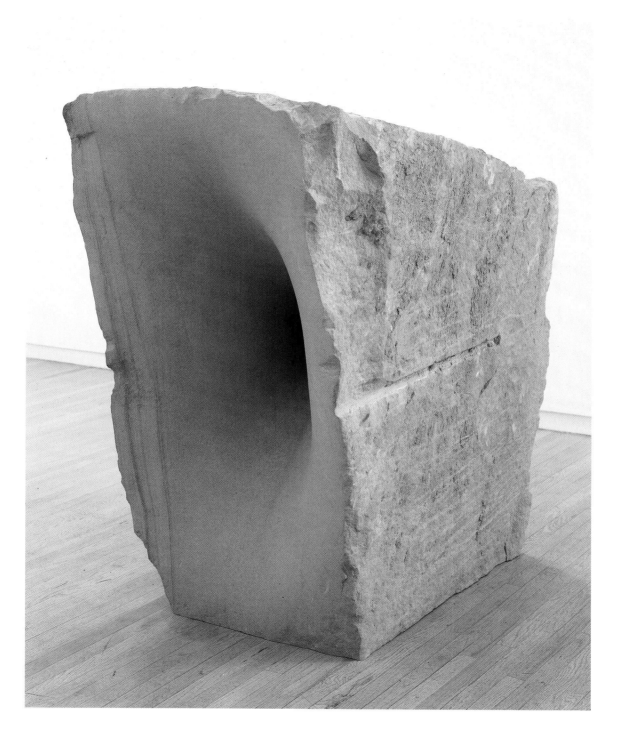

179

Untitled, 1993

My Body Your Body, 1993

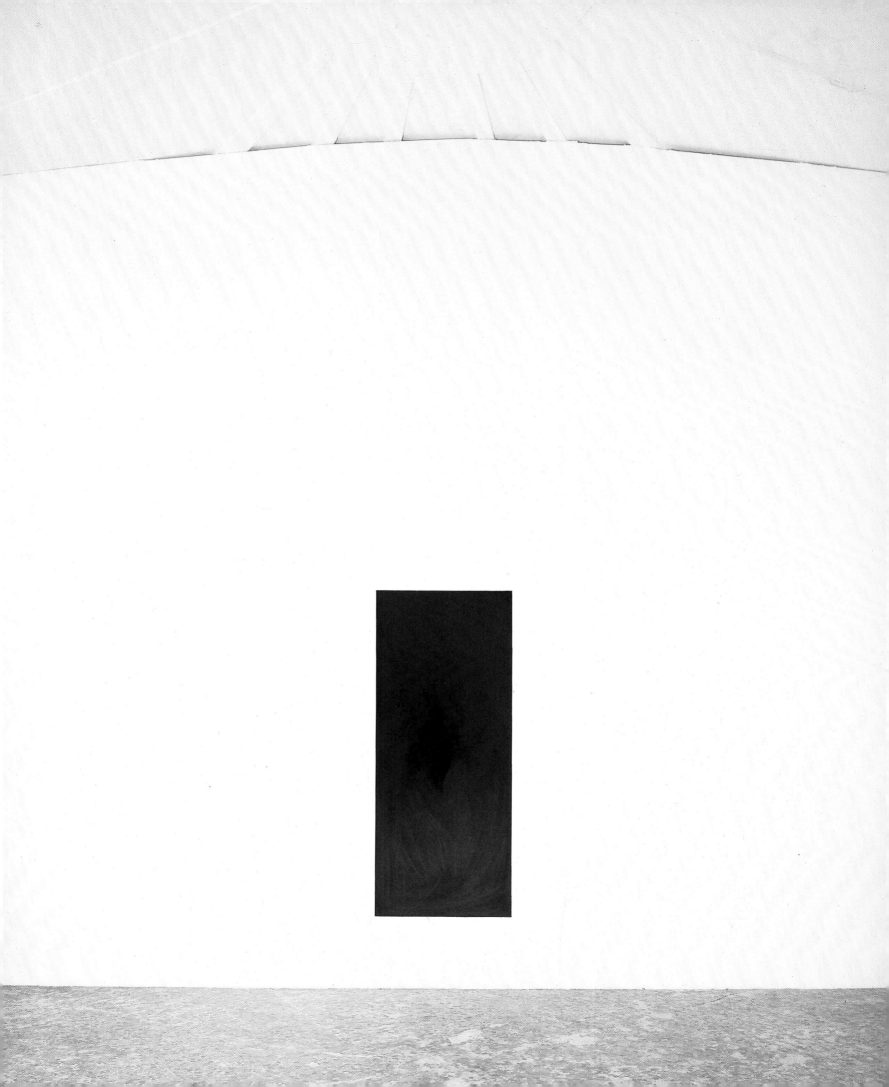

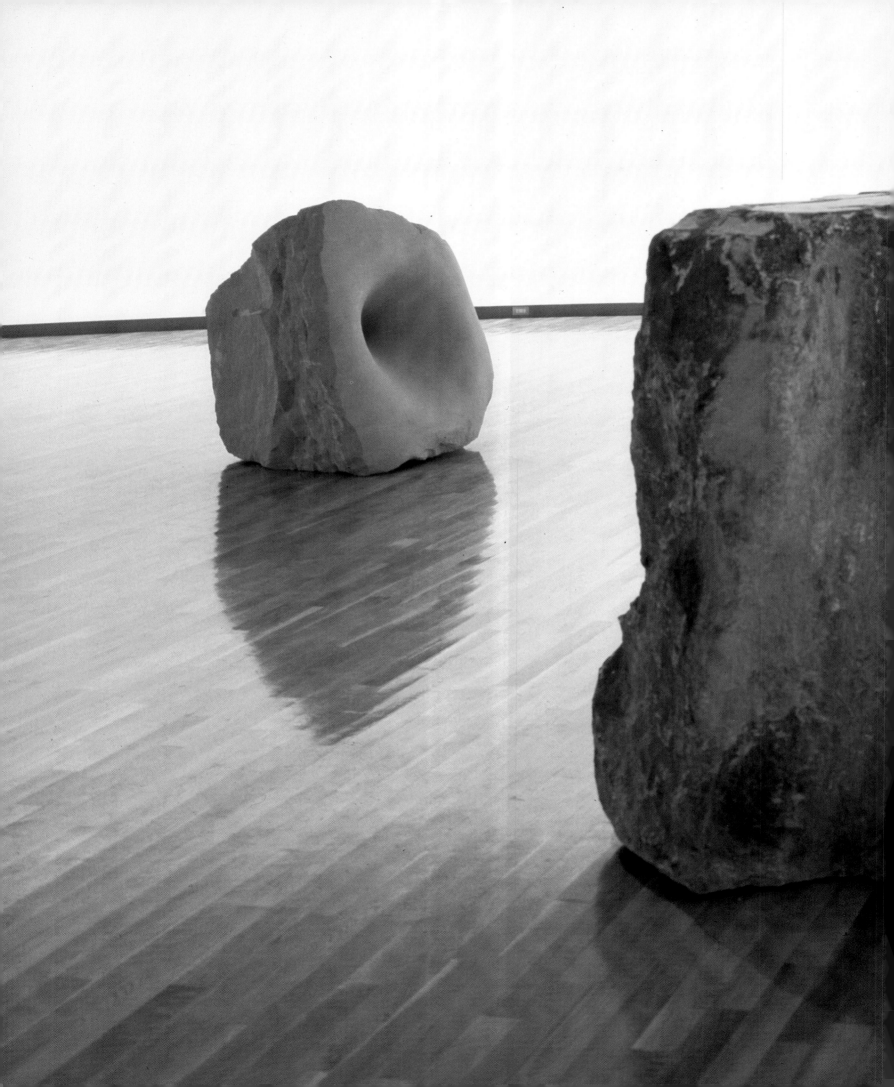

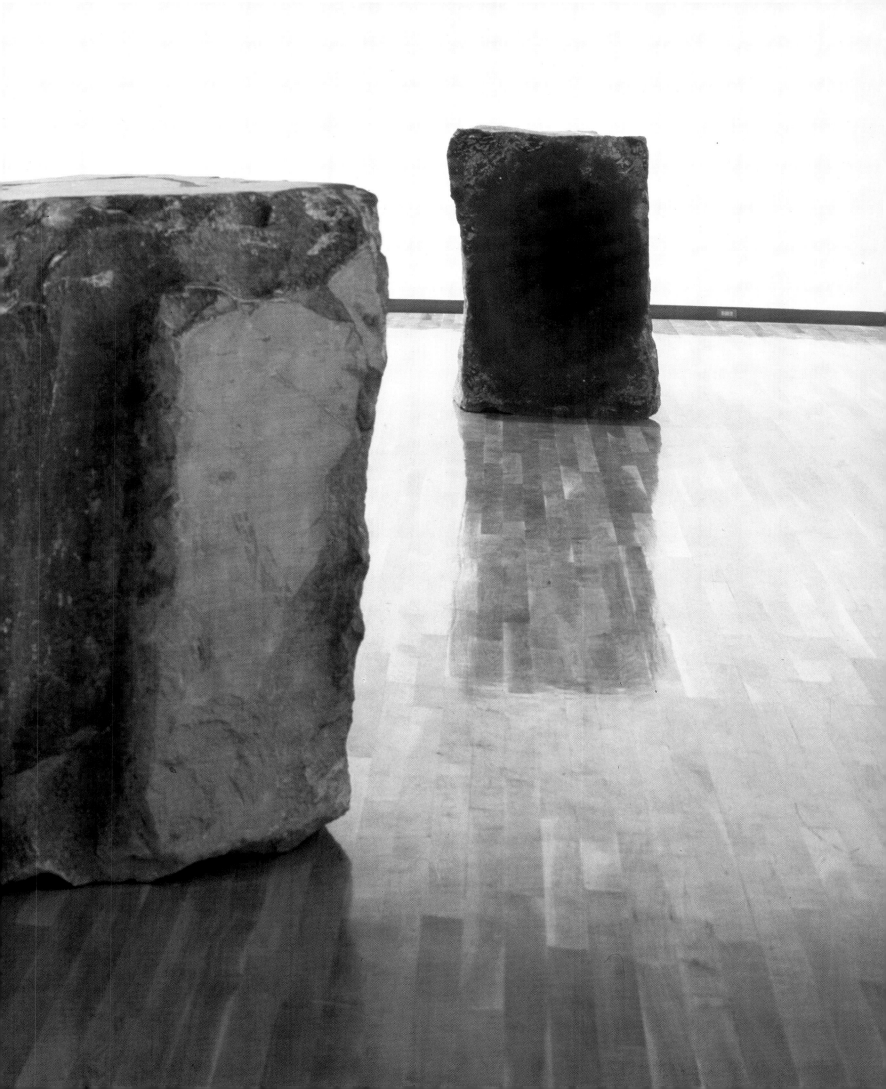

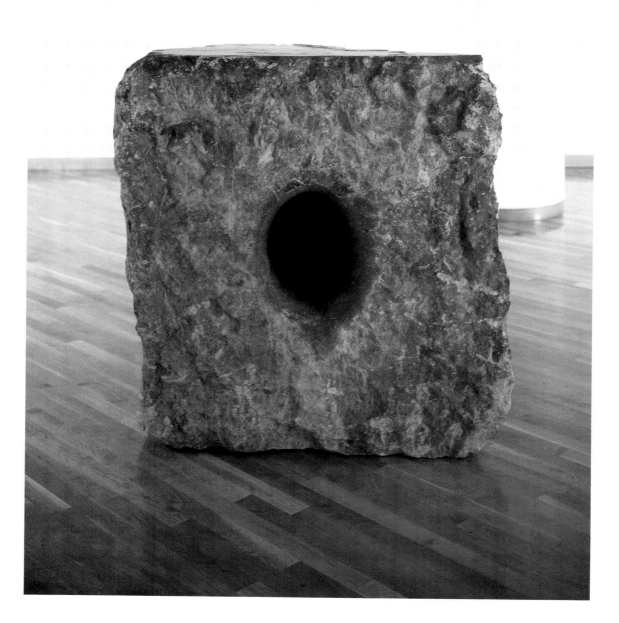

Oblivion, 1994

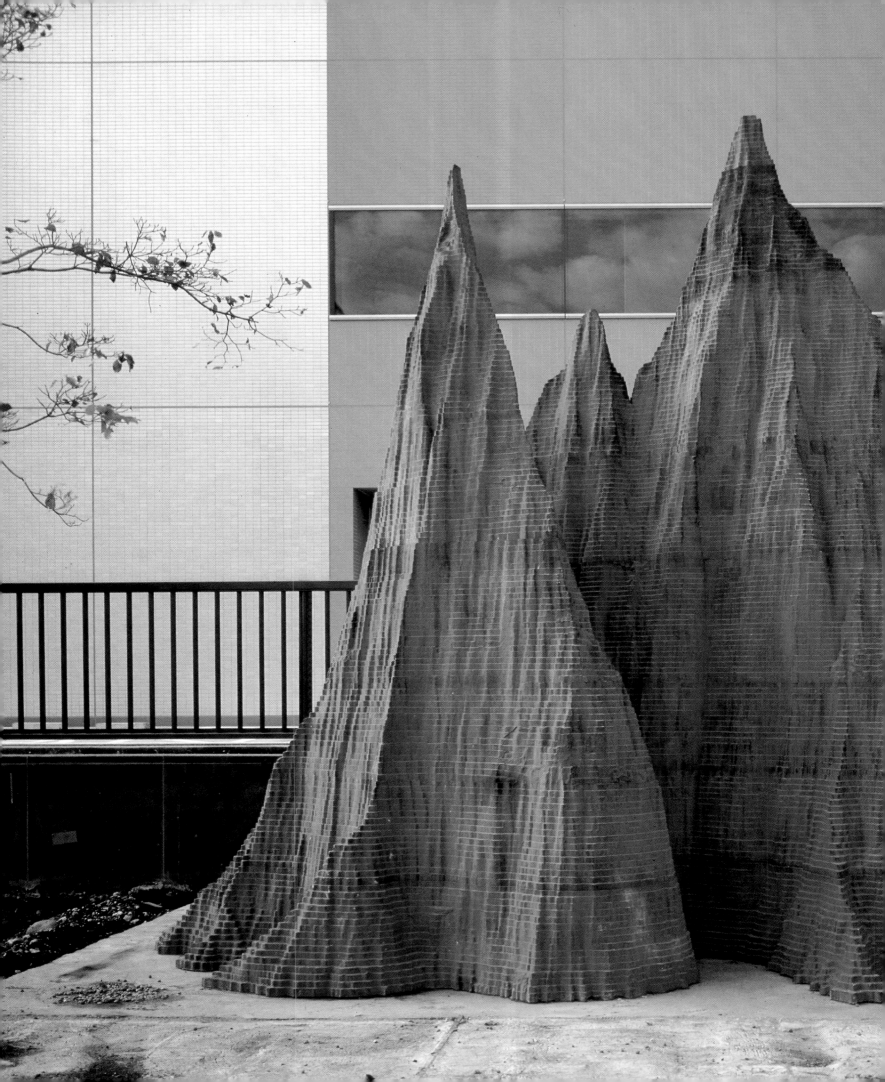

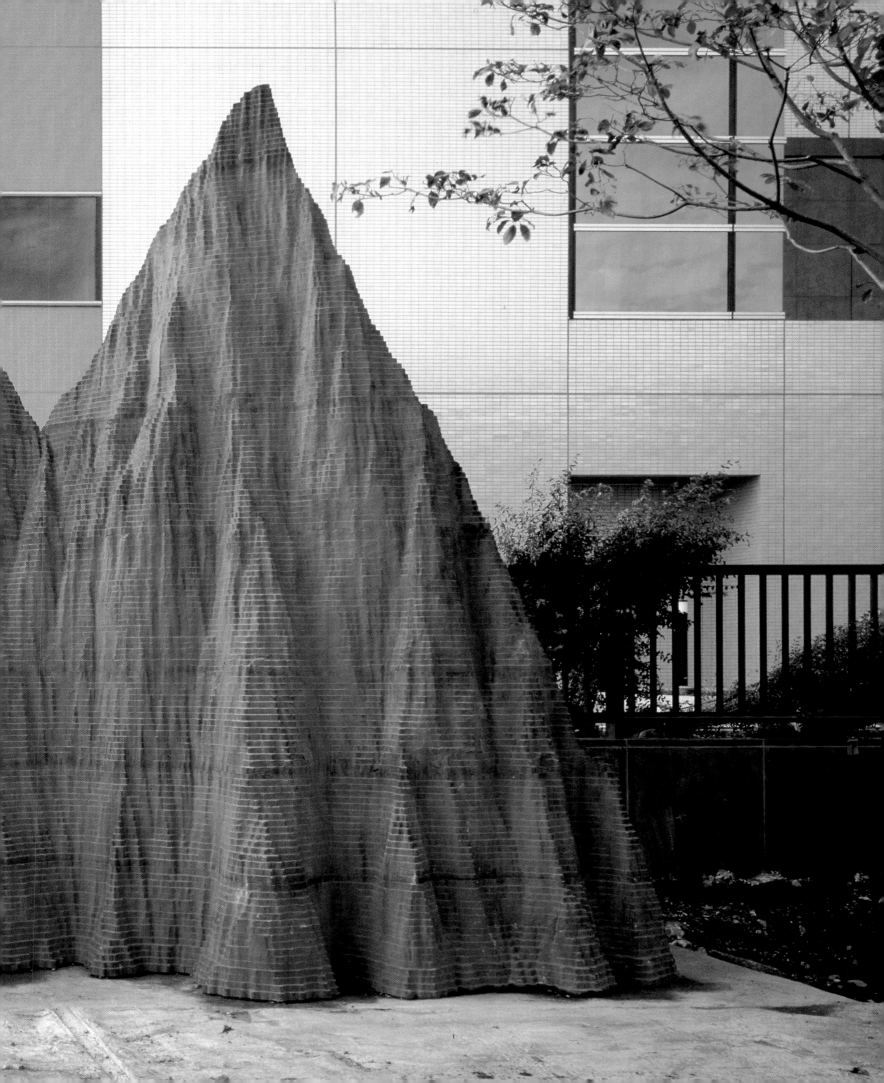

188

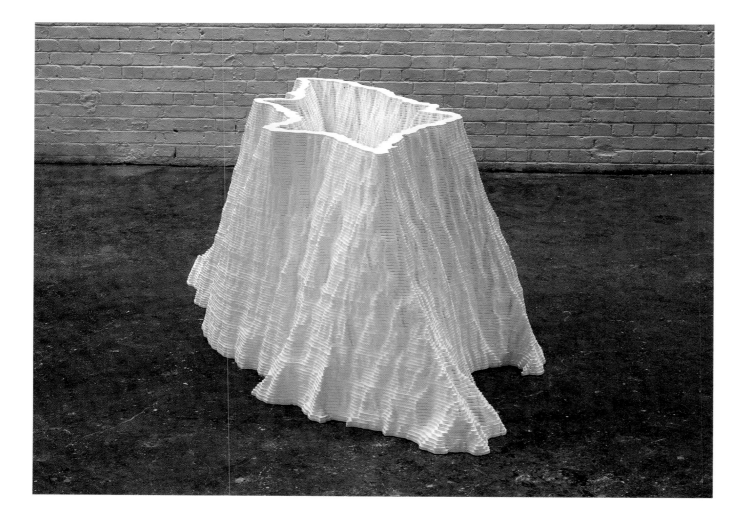

p. 186-187
Mountain, 1994 Untitled, 1994

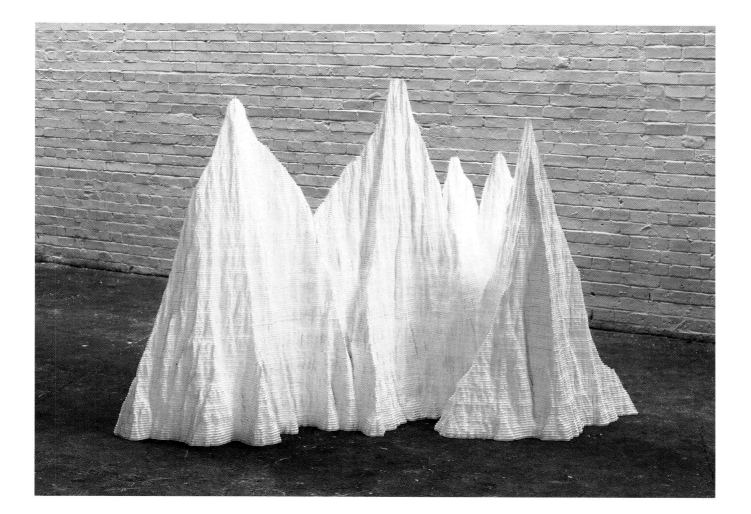

189

Untitled, 1994

190

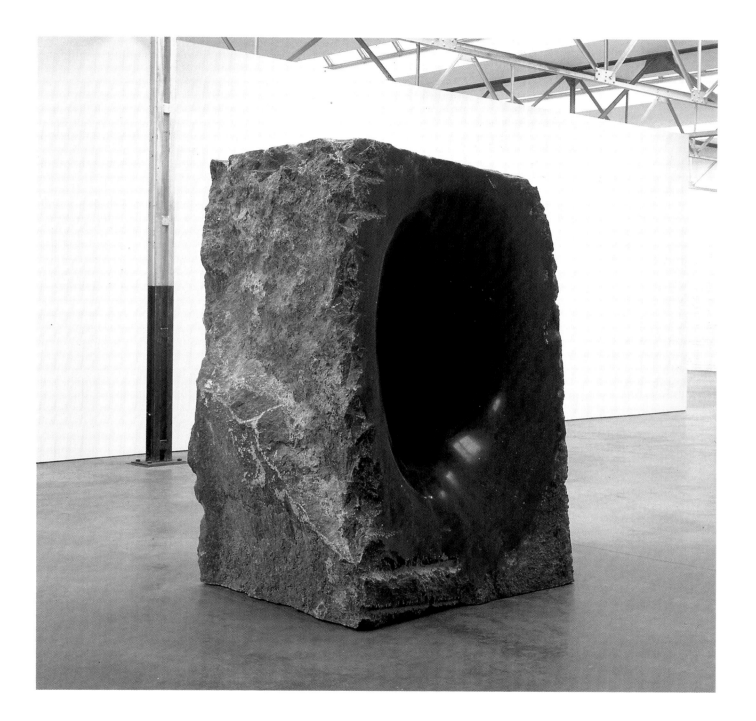

Untitled, 1994-95

192

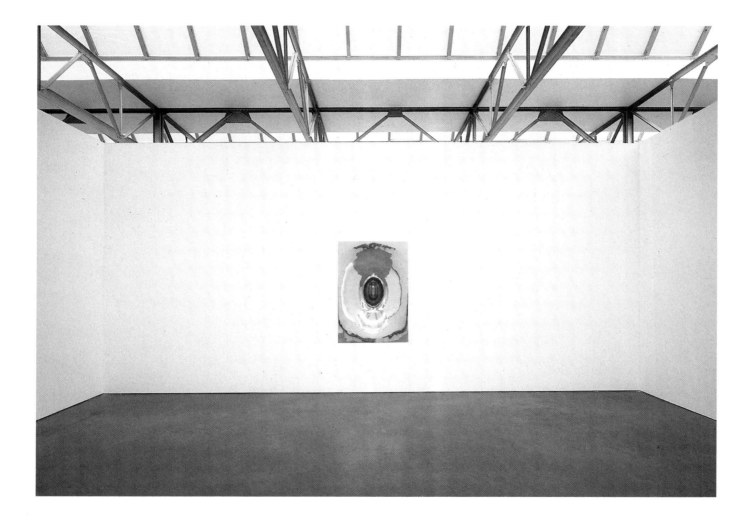

Untitled, 1995

193

Untitled, 1995

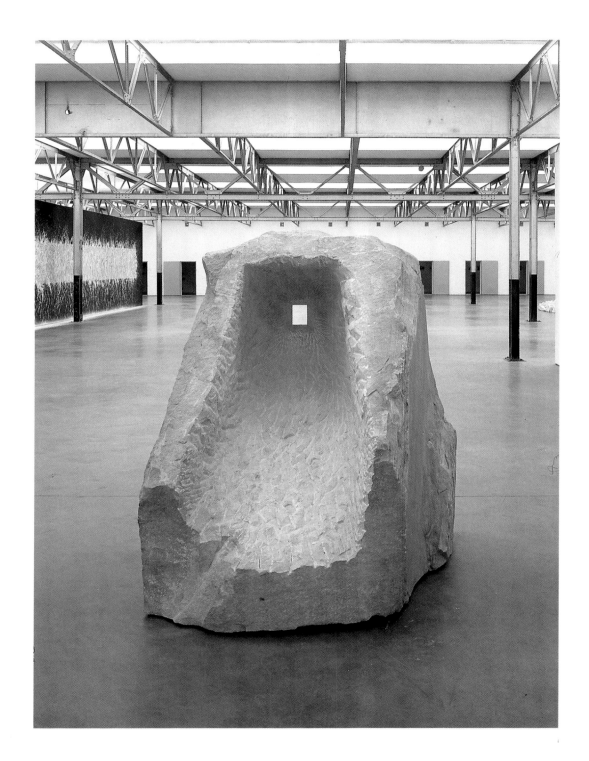

Untitled, 1994-95

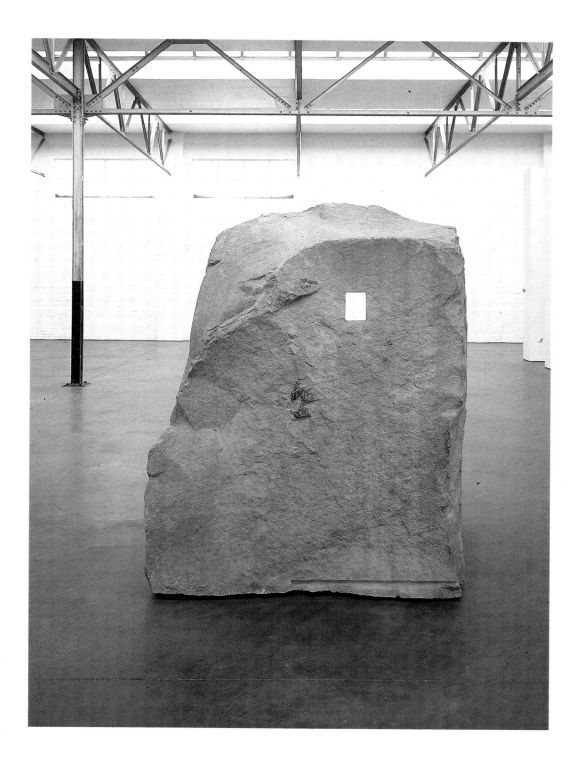

195

Untitled, 1994-95

196

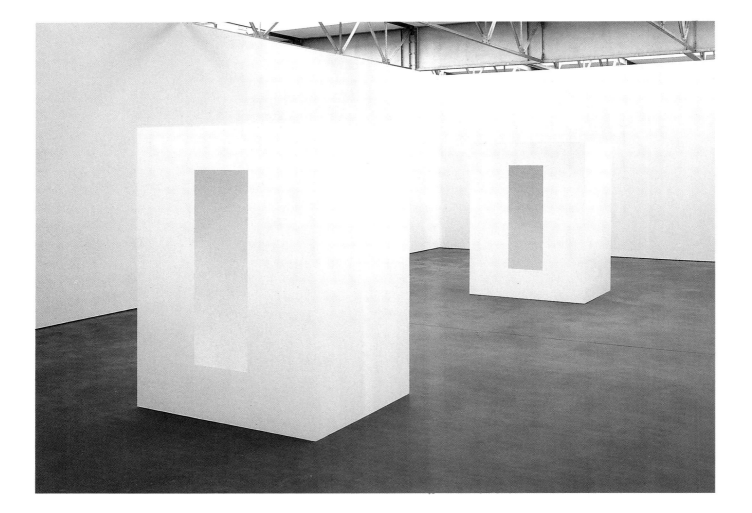

Untitled Installation, 1994-95

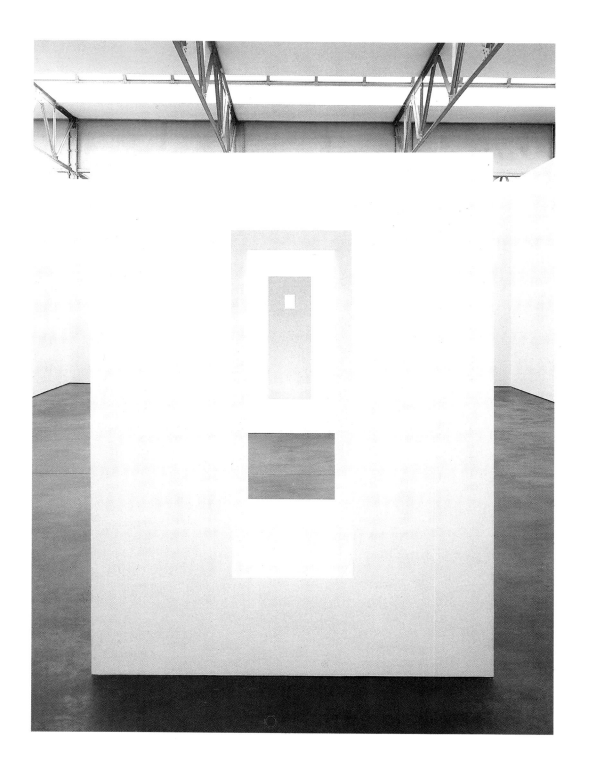

Untitled Installation, 1994-95

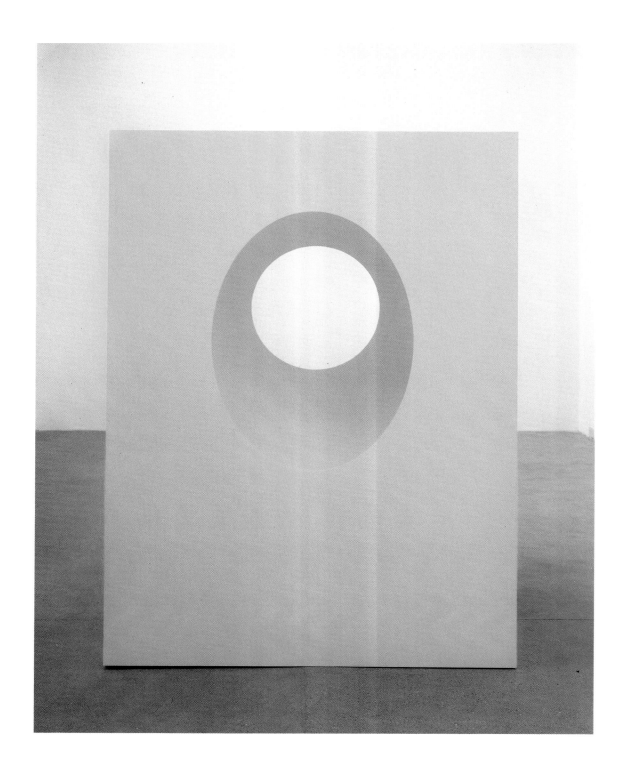

White Dark III, 1994-95

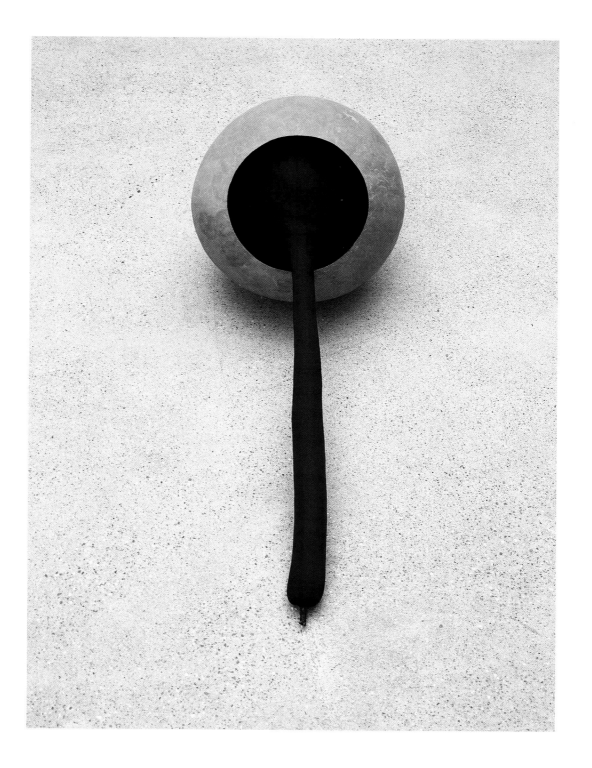

Untitled, 1995

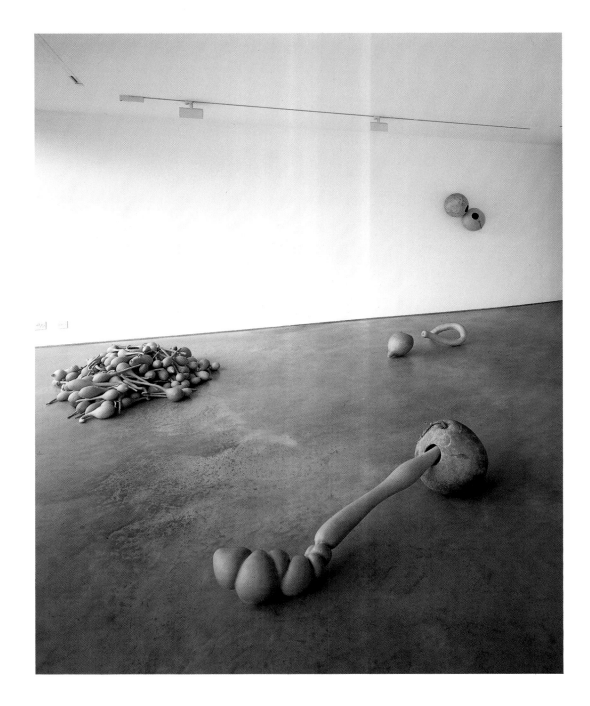

Untitled, 1995

Untitled, 1995

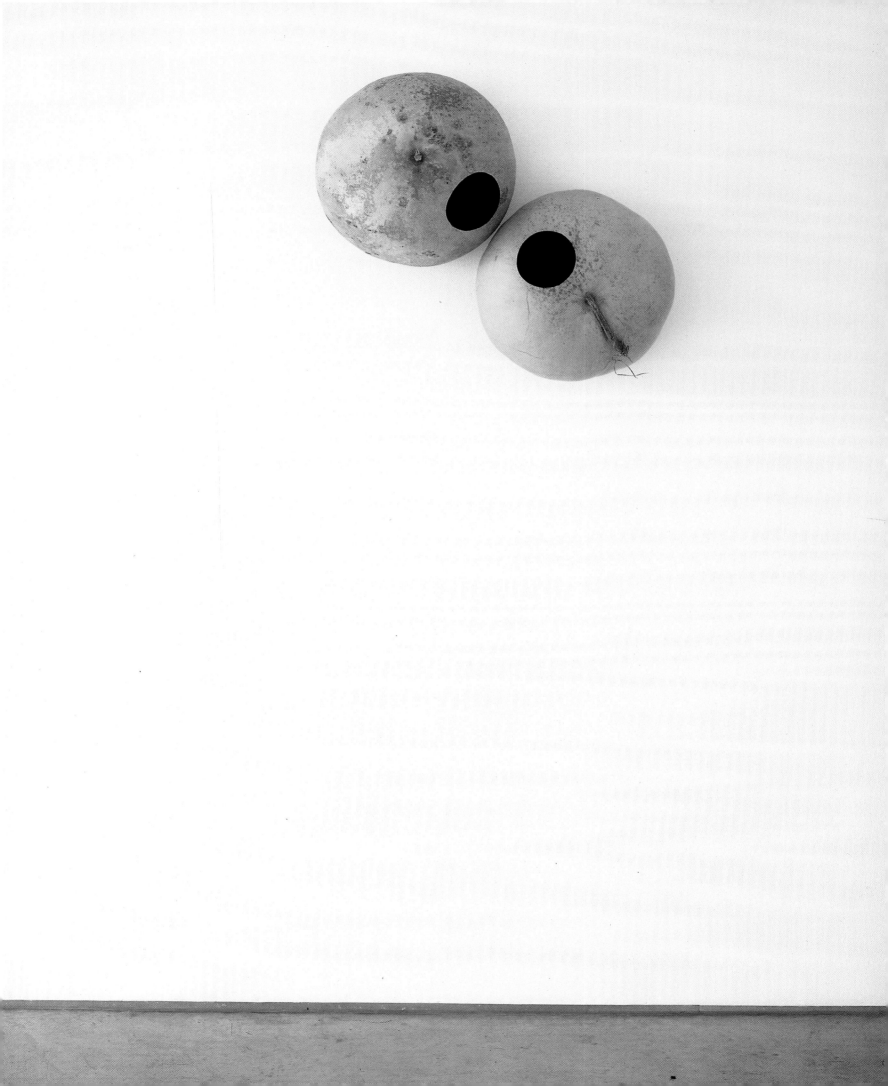

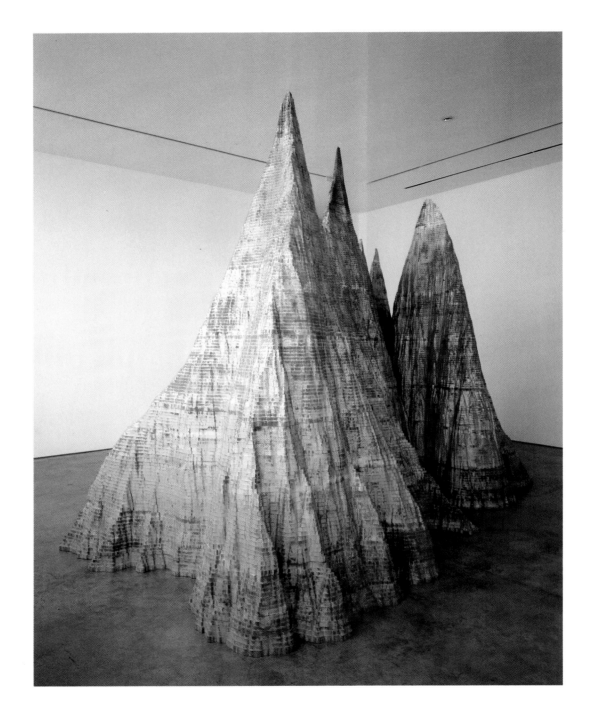

Mountain, 1995

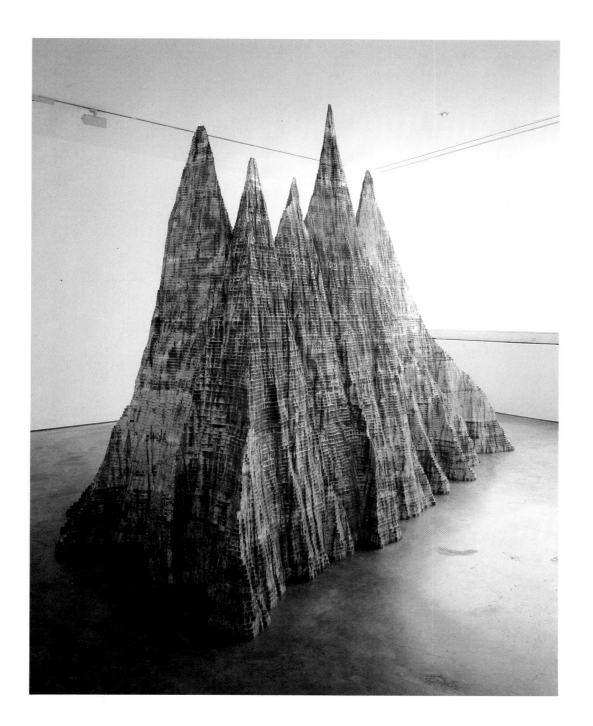

Mountain, 1995

204

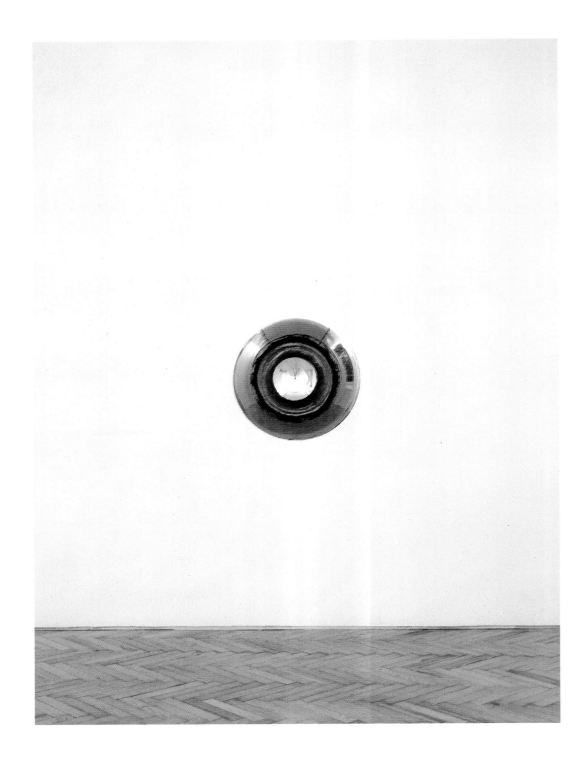

Turning the World Upside Down, 1995

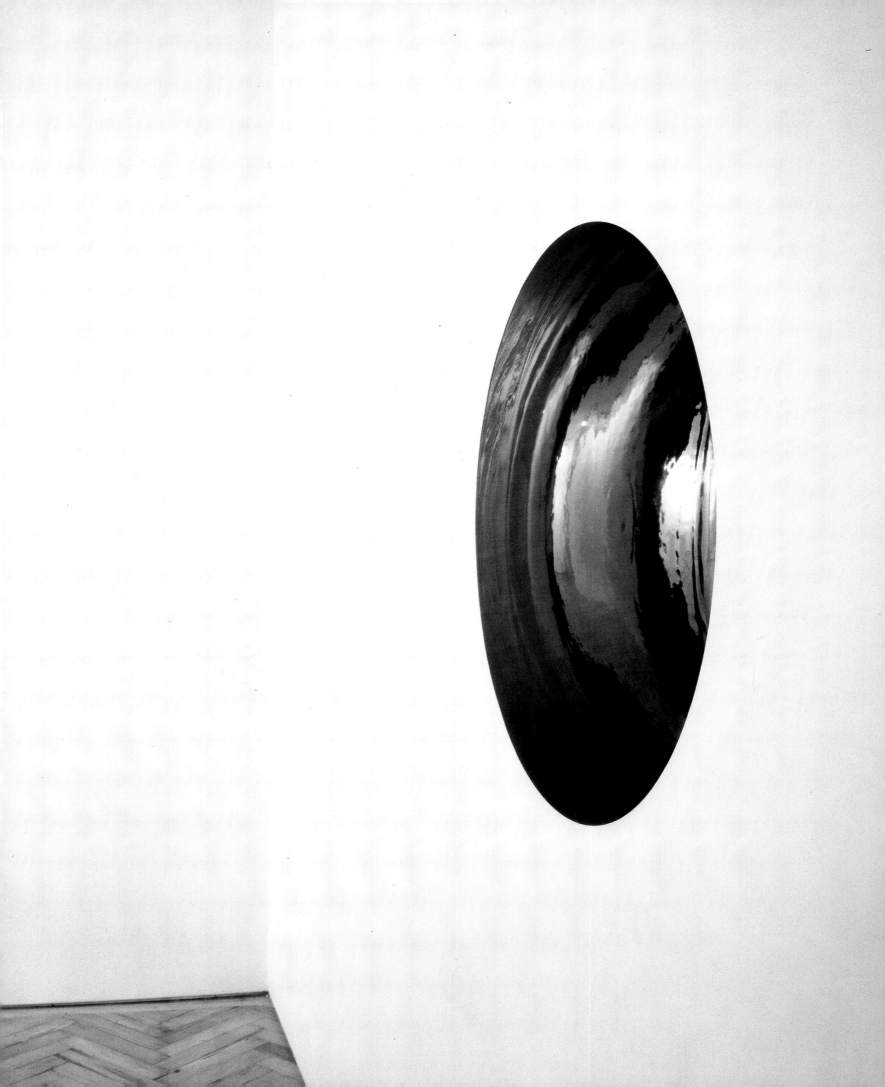

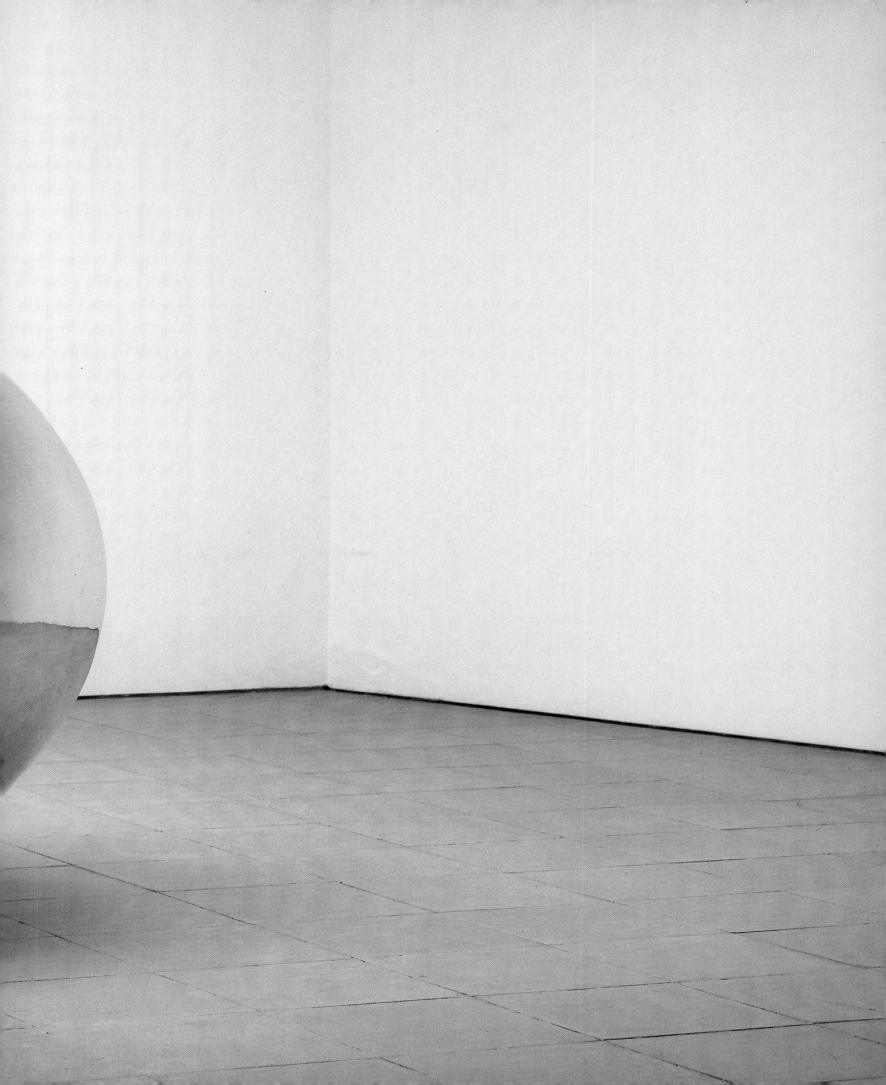

208

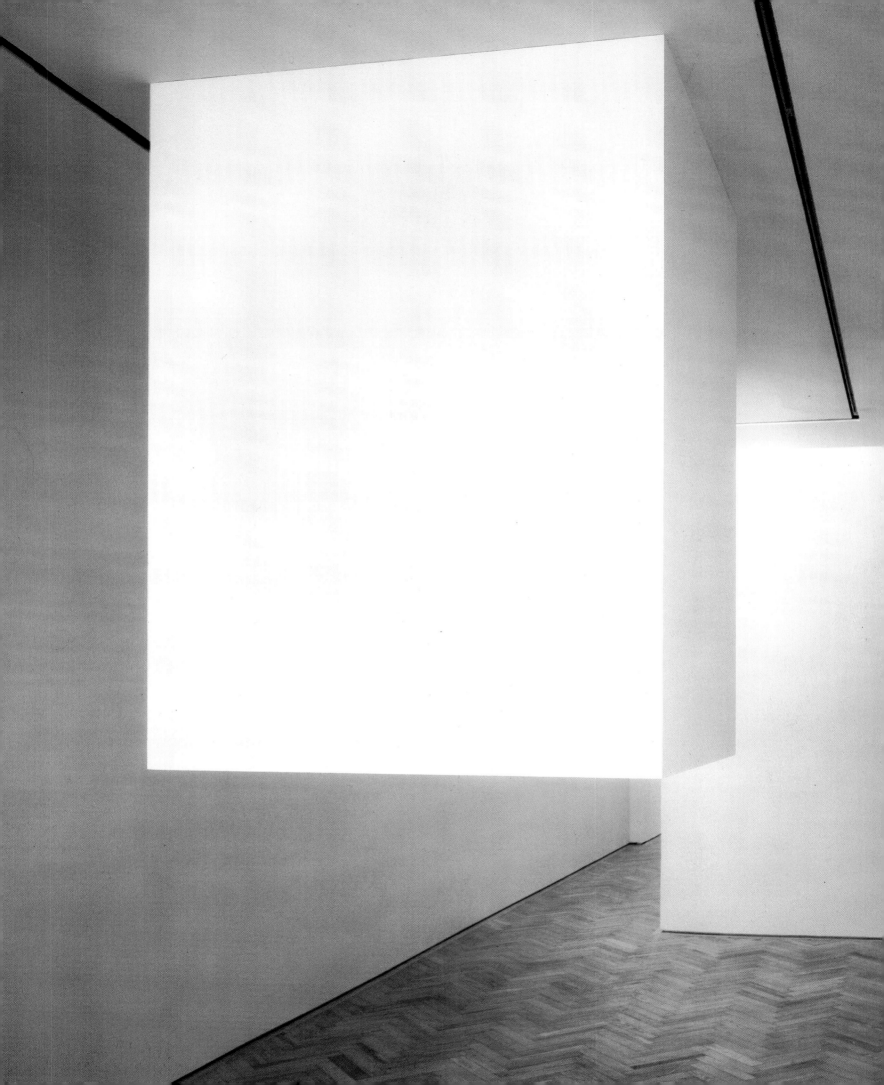

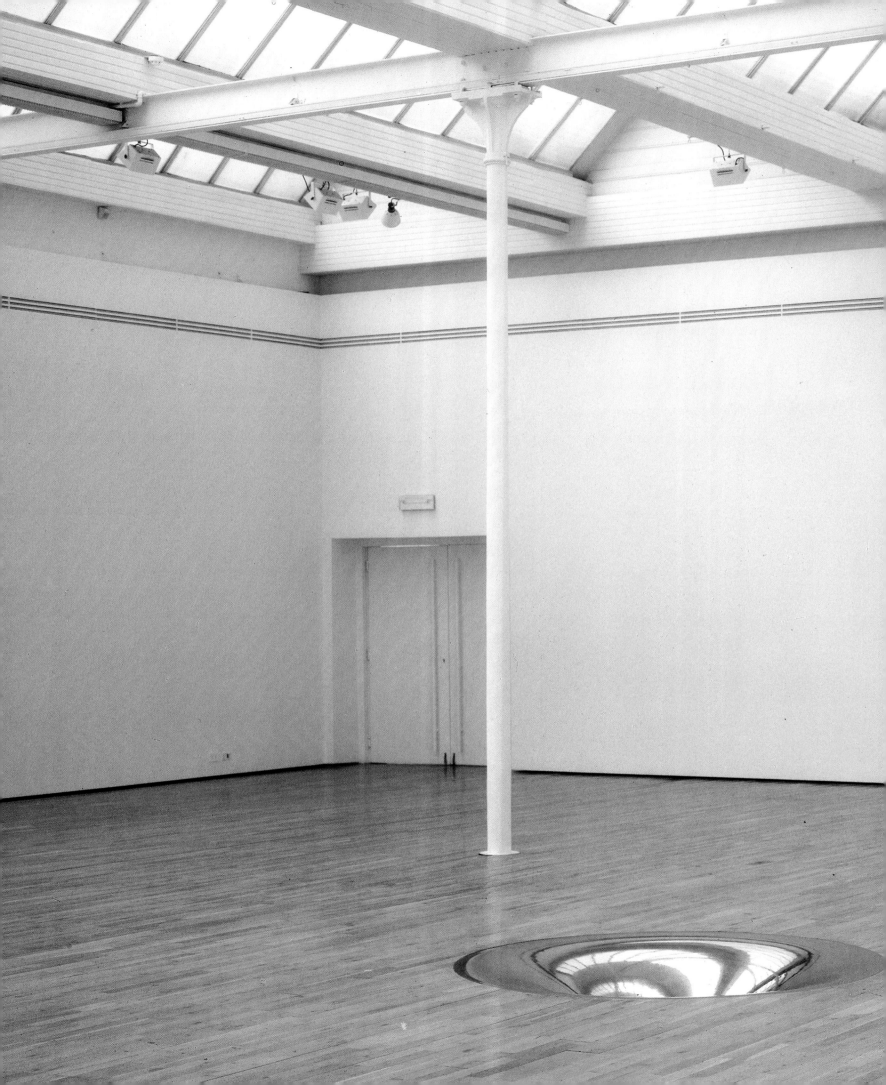

212

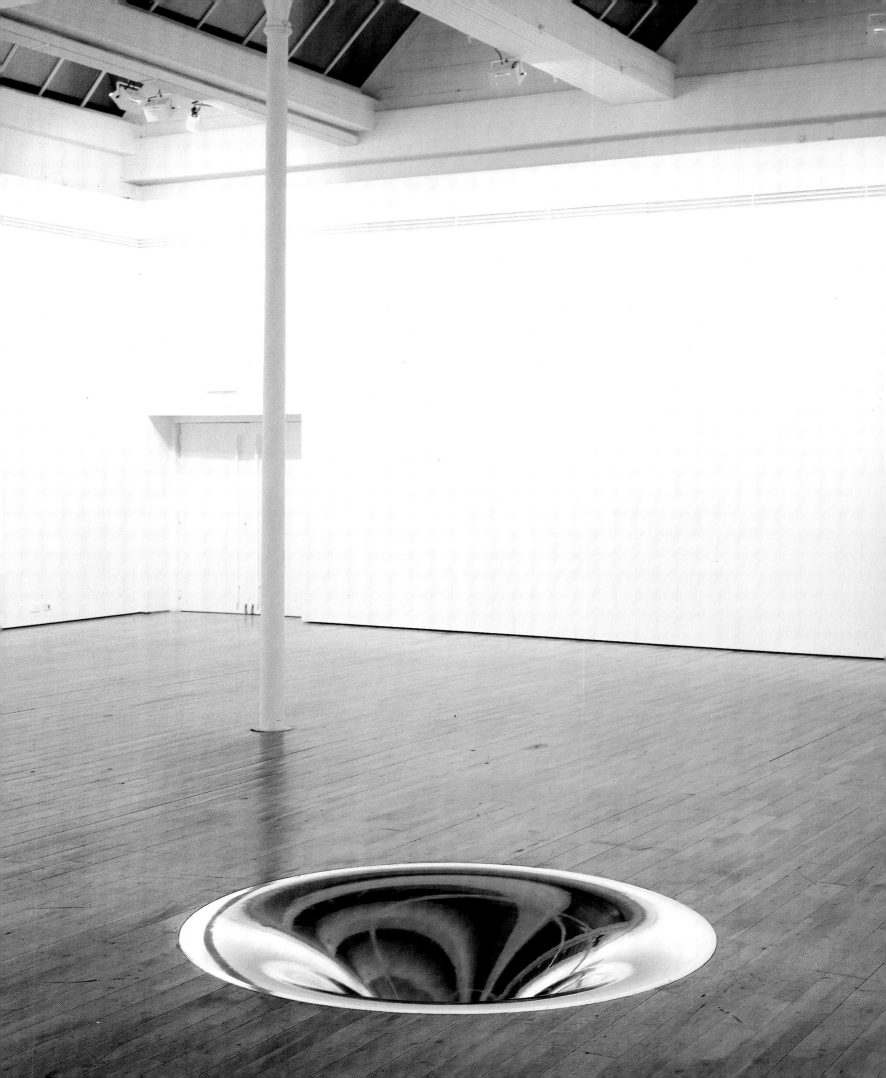

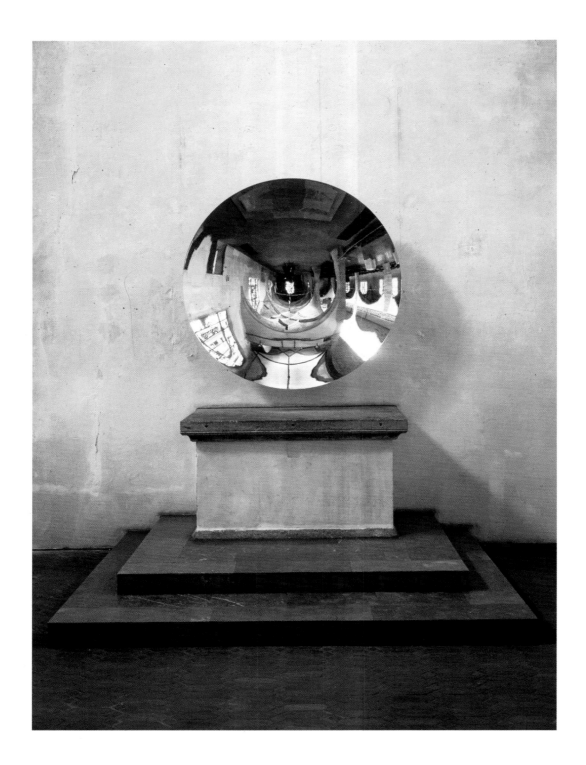

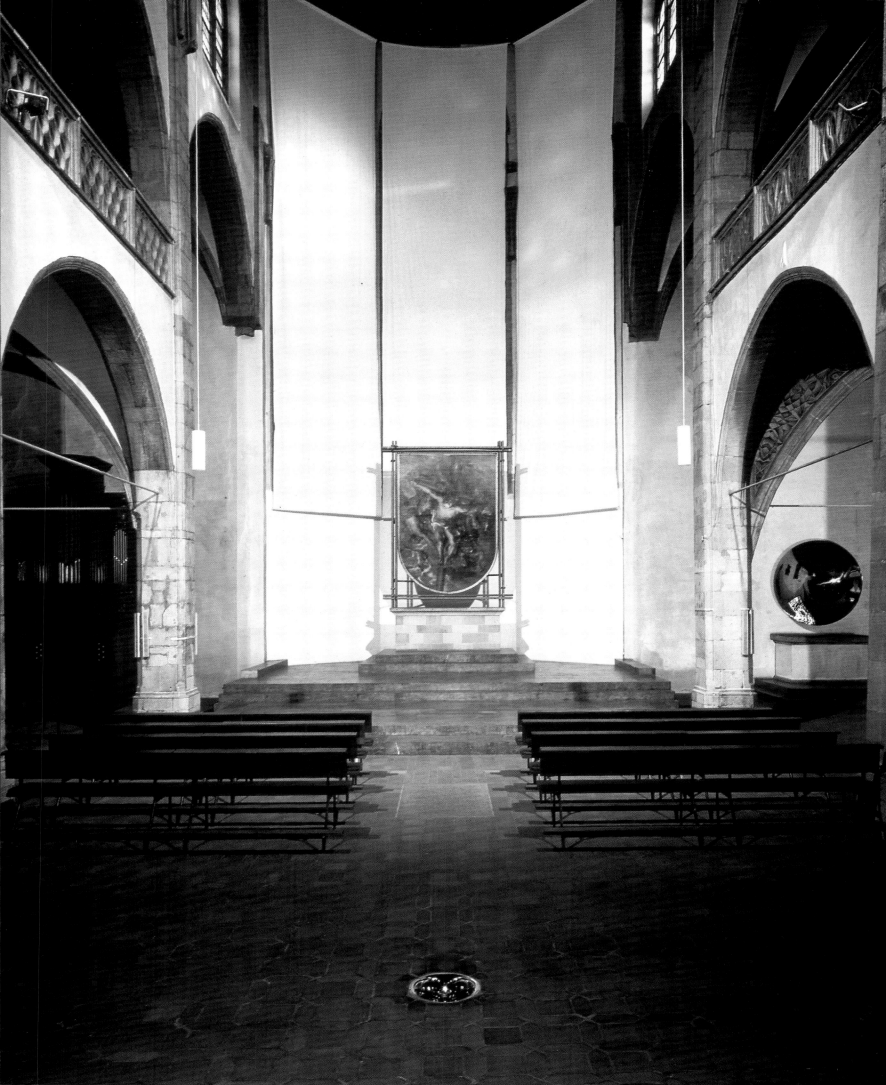

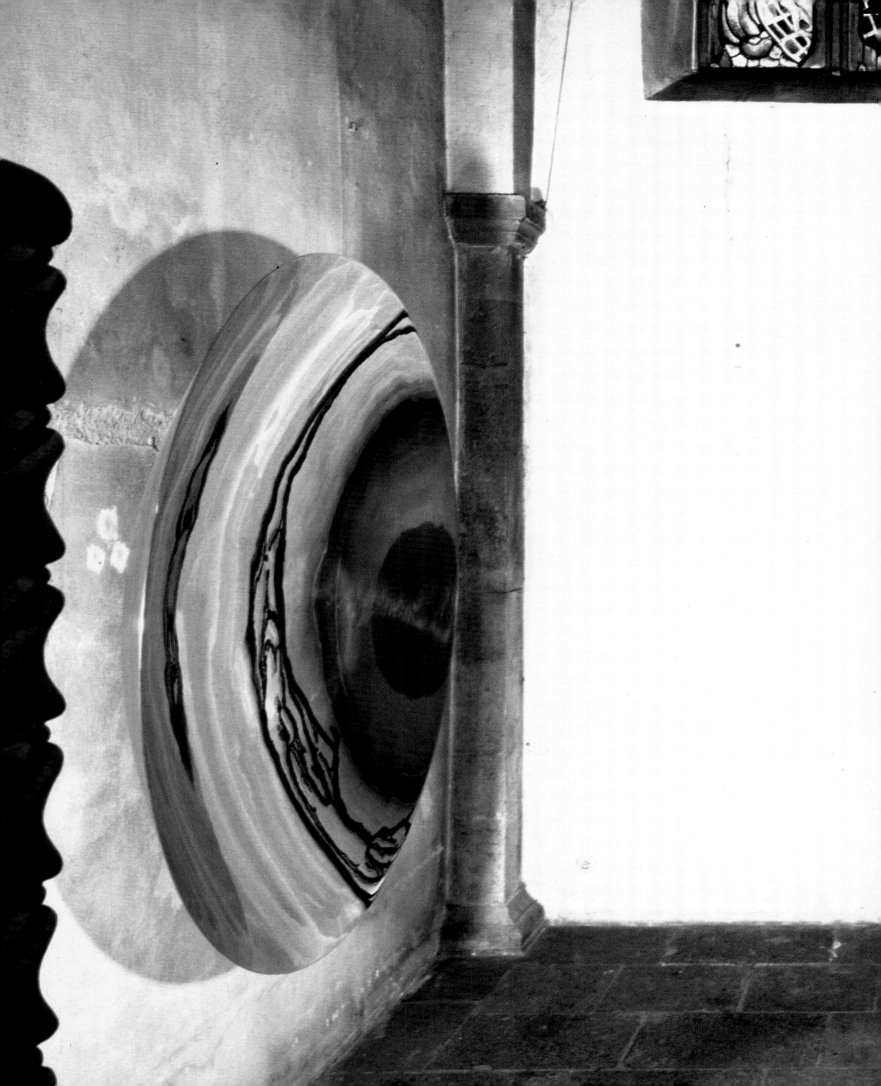

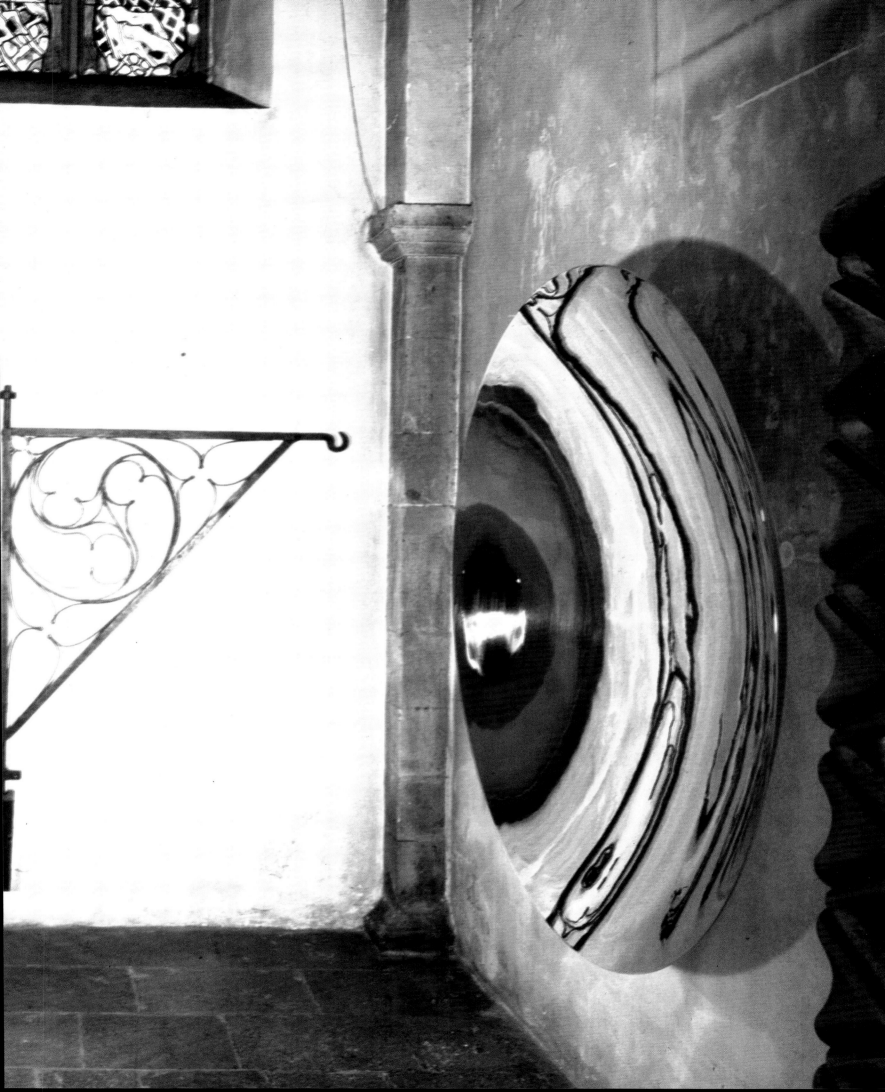

218

p.216-217
Untitled, 1996

Untitled, 1996

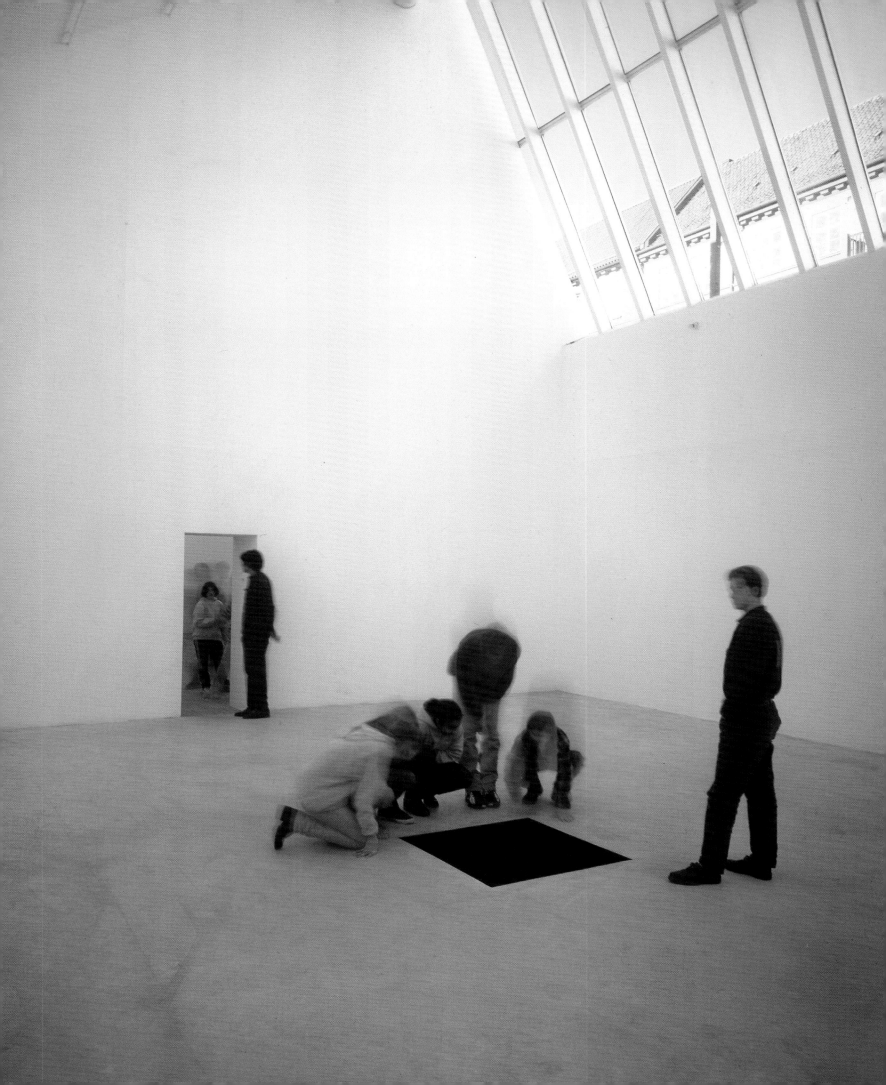

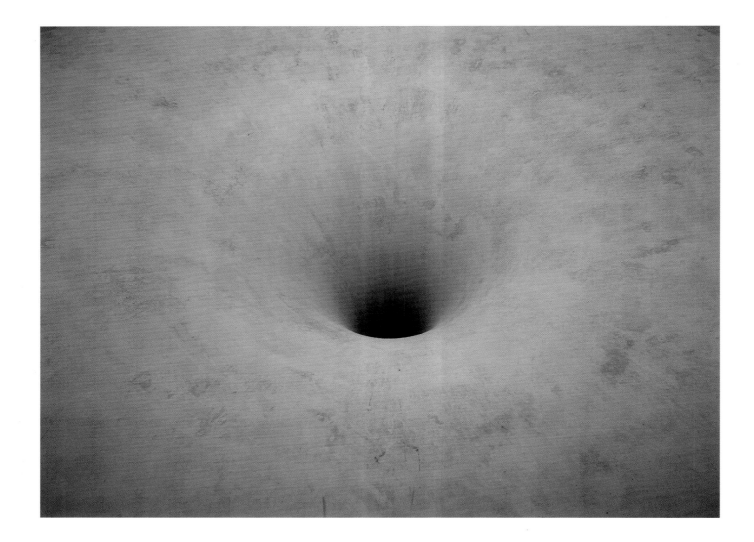

Untitled, 1996

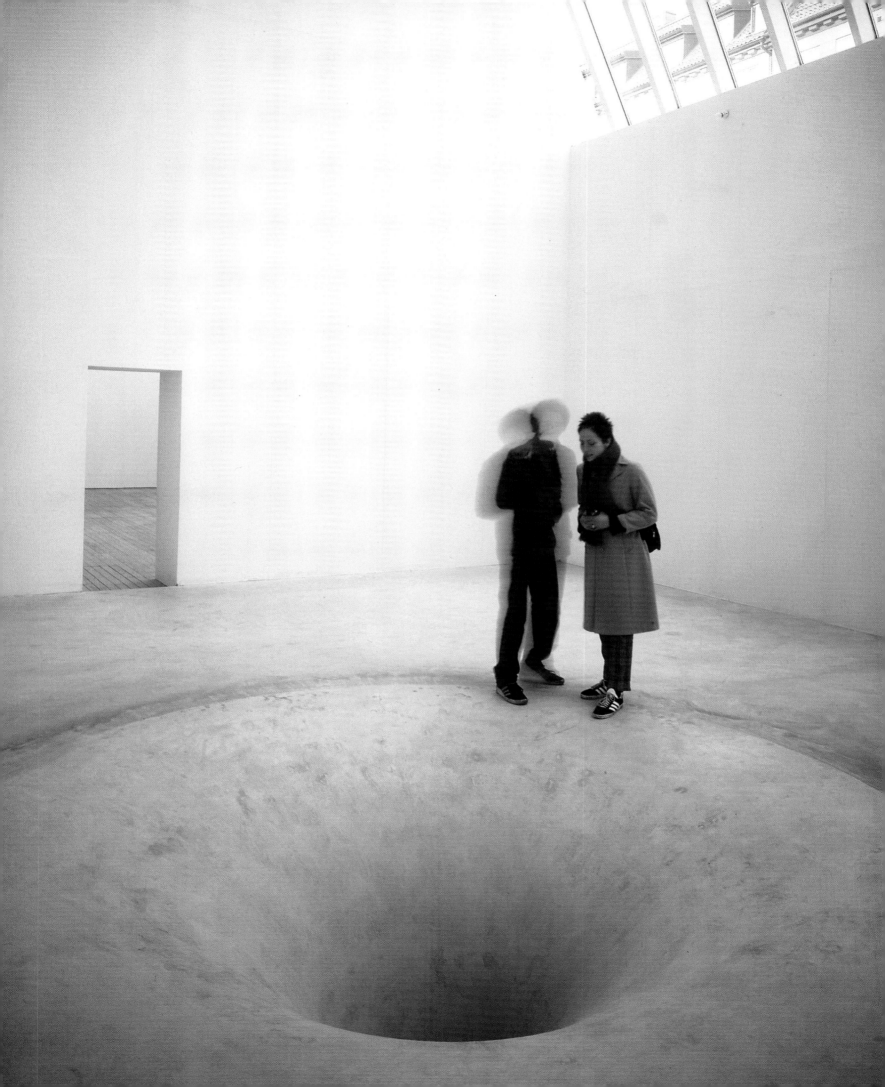

Foreground: Untitled, 1997
background: Untitled, 1997

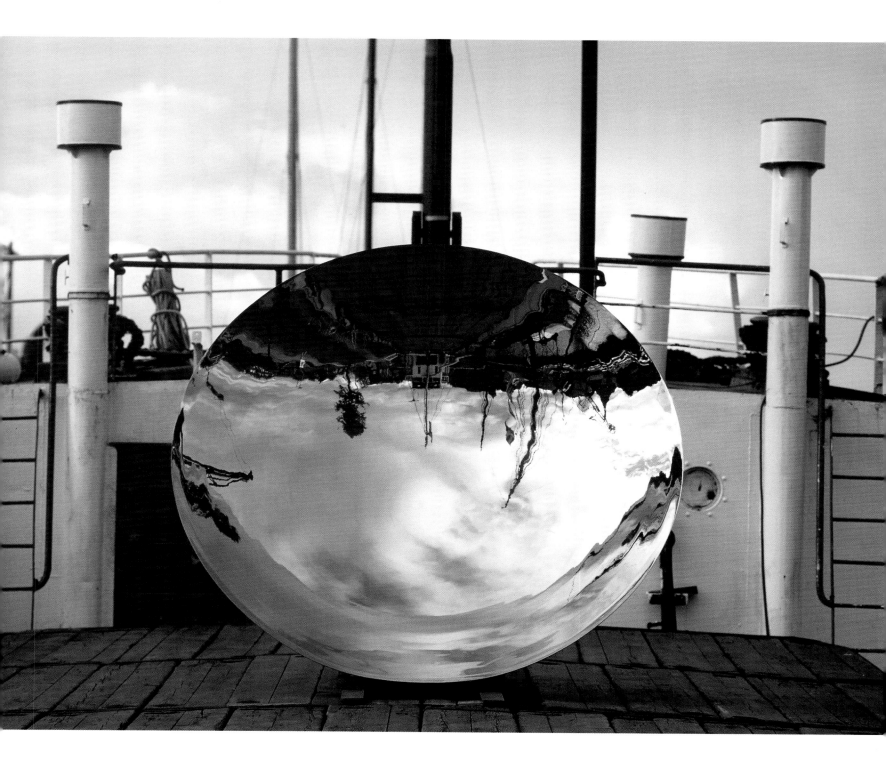

Untitled, 1997

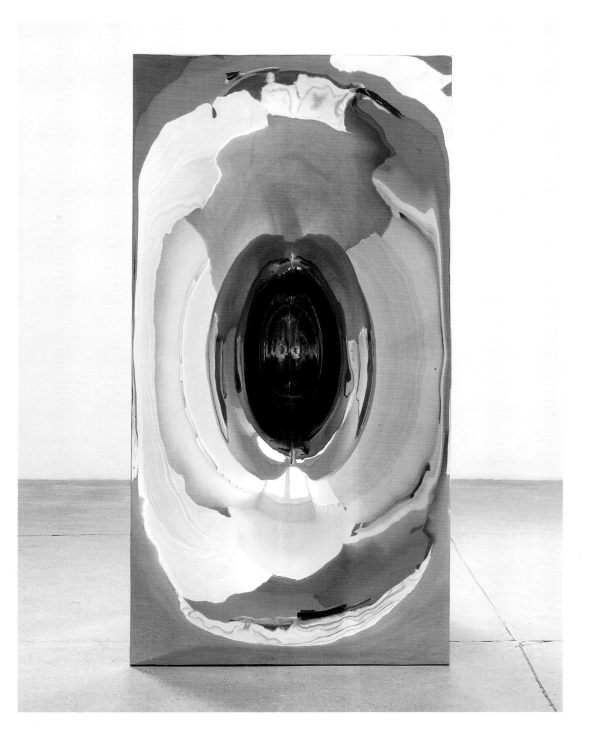

Untitled, 1997

Making the World Many, 1997

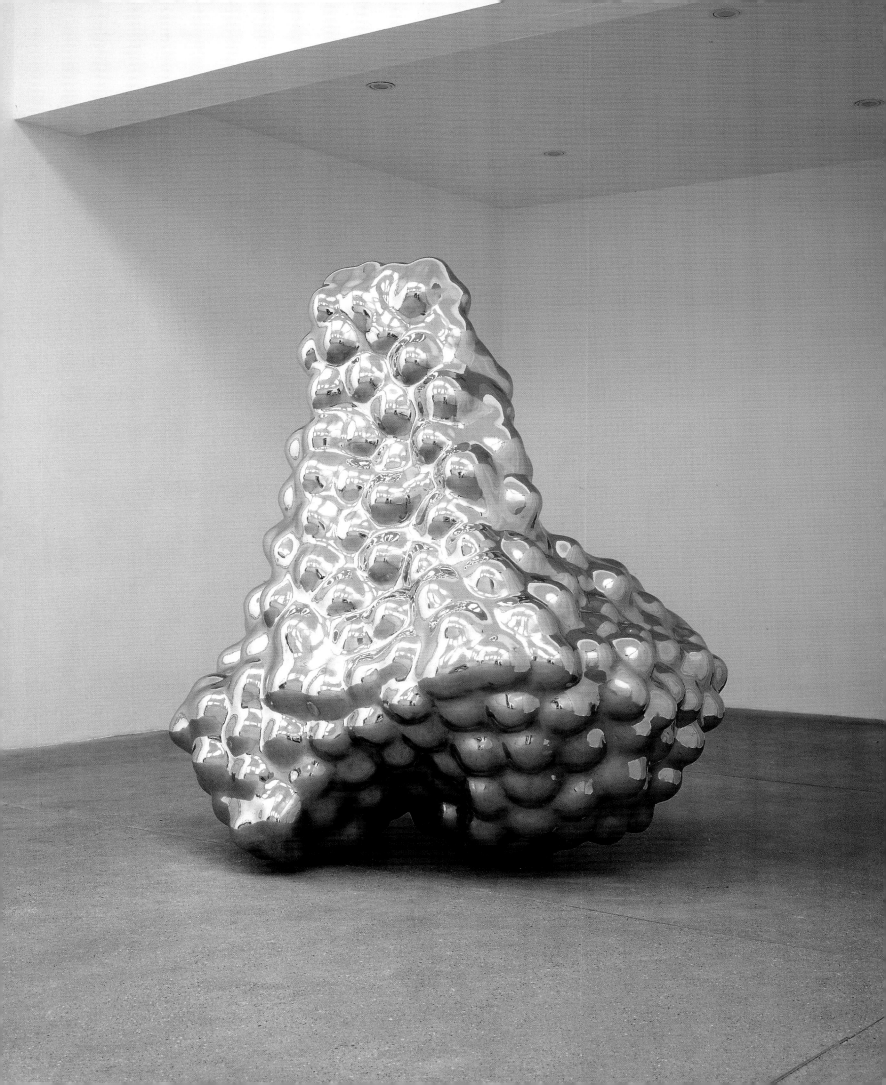

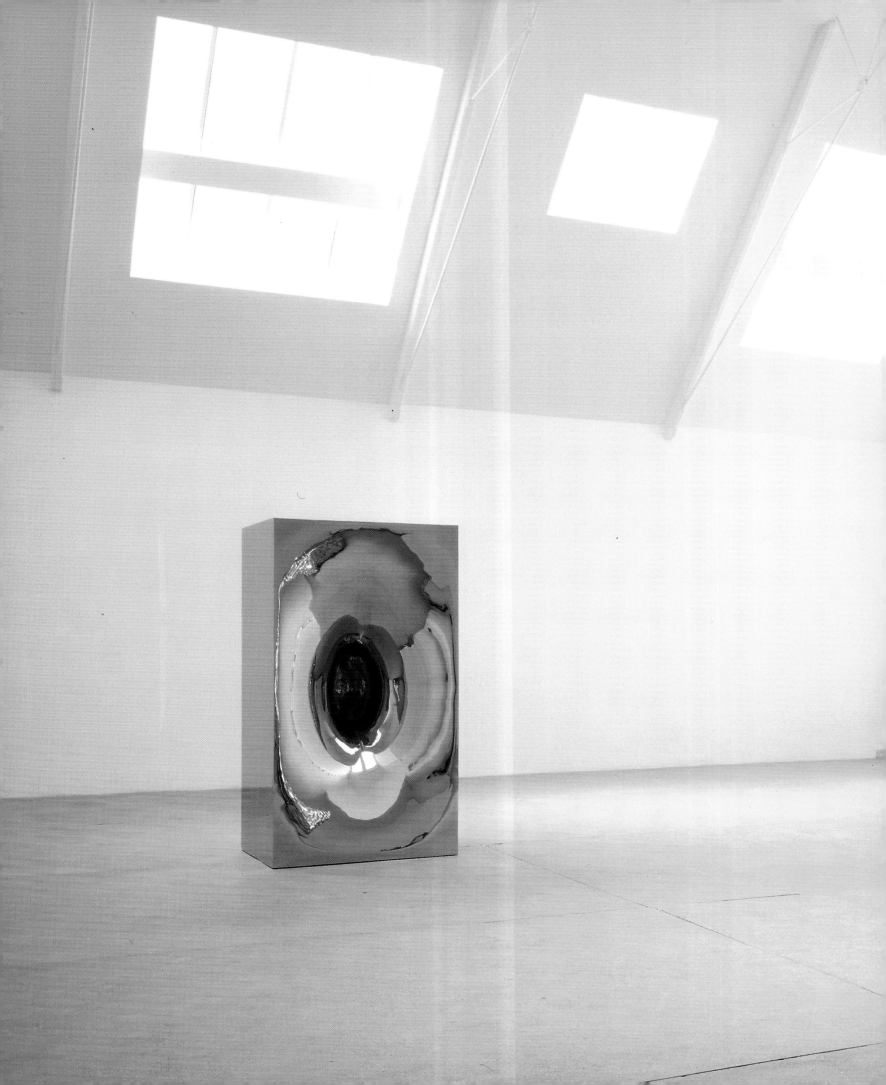

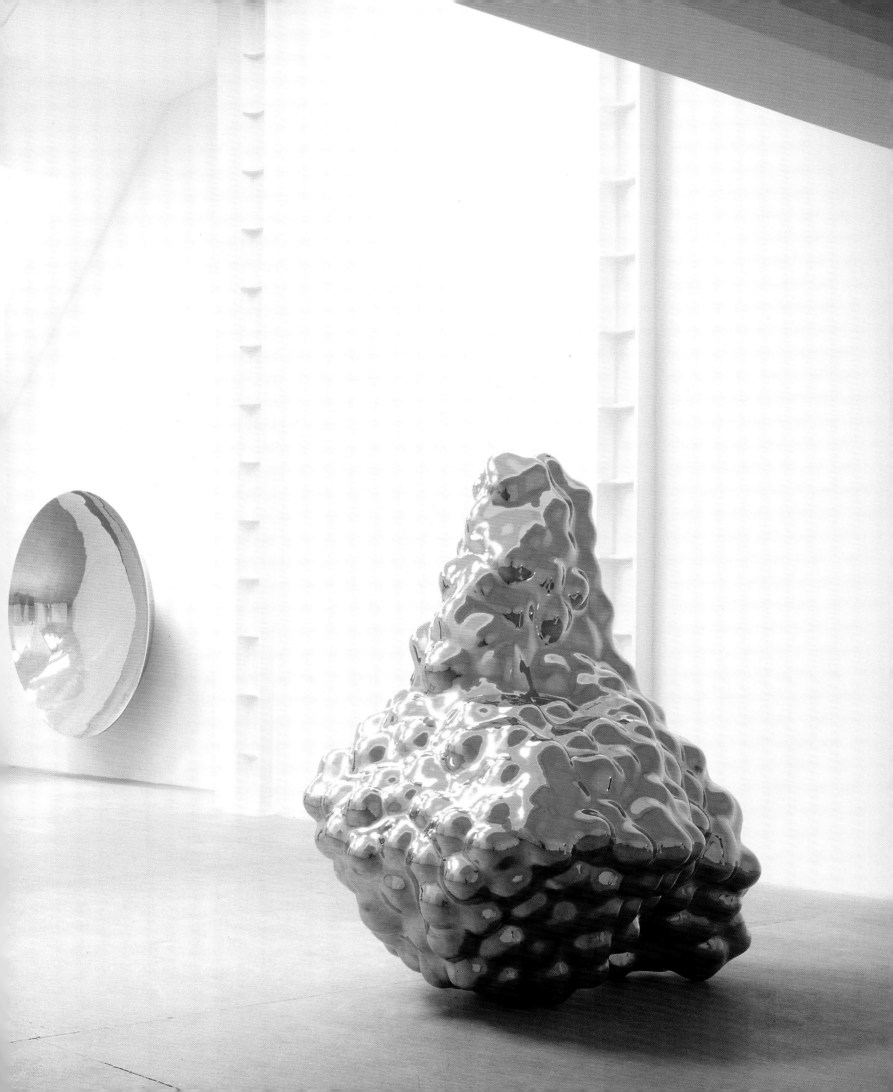

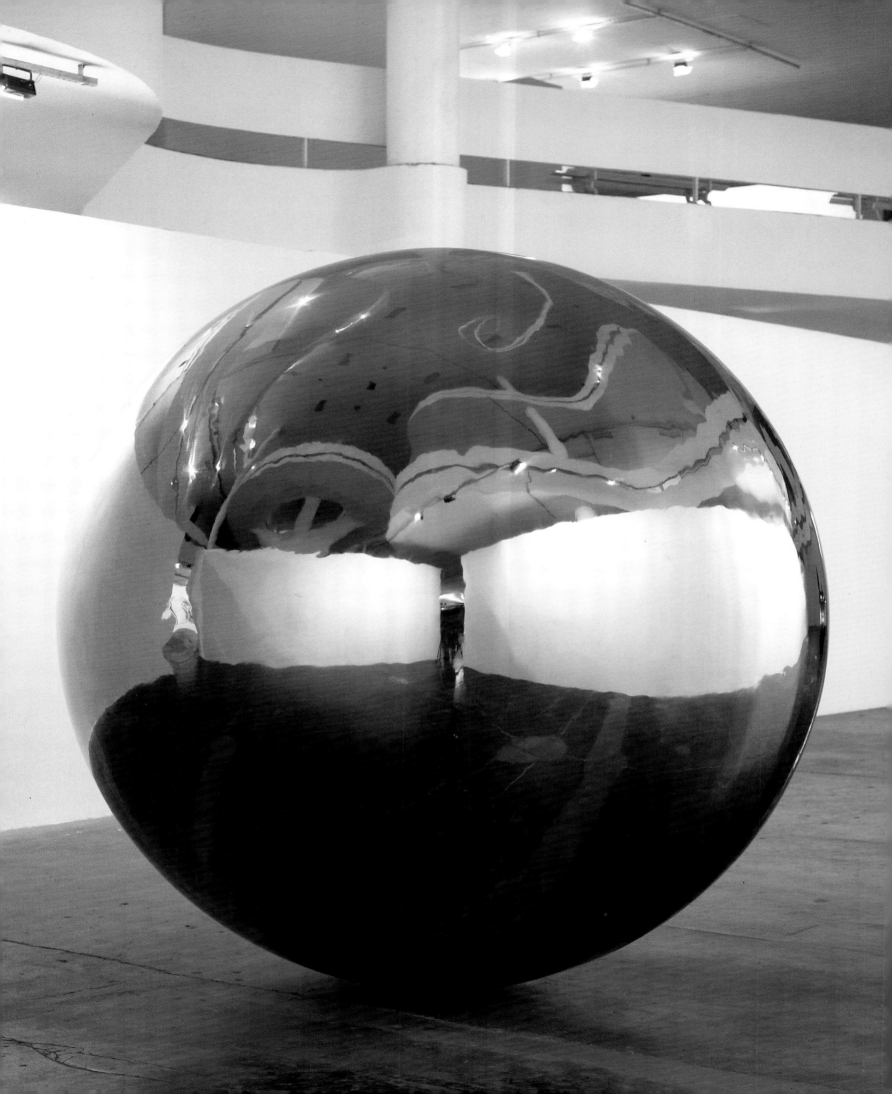

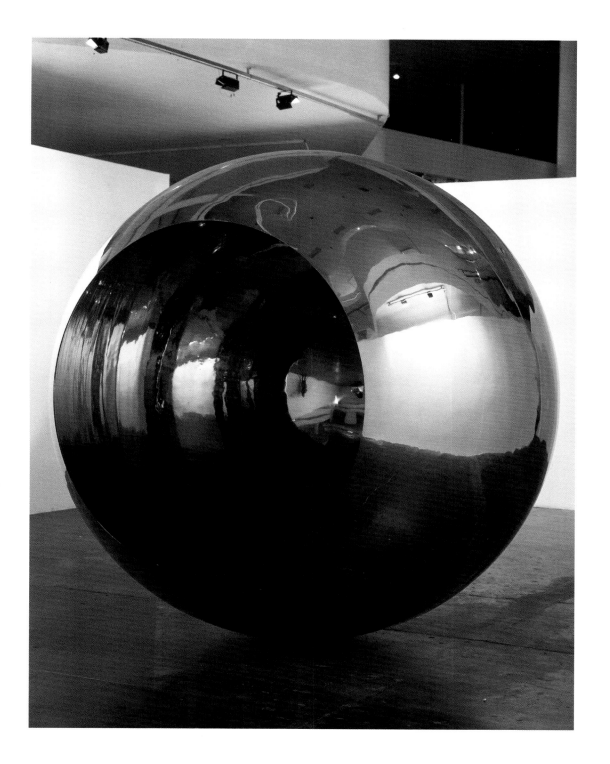

Left to right: Untitled, 1997, Untitled, 1997,
Making the World Many, 1997

Turning the World Upside Down III,
(front and back view), 1996

230

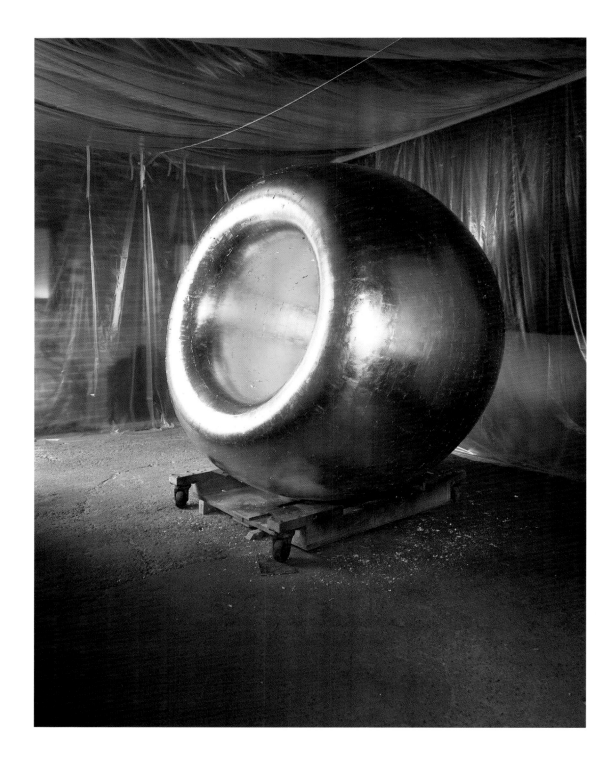

Untitled, 1997

Untitled, 1997

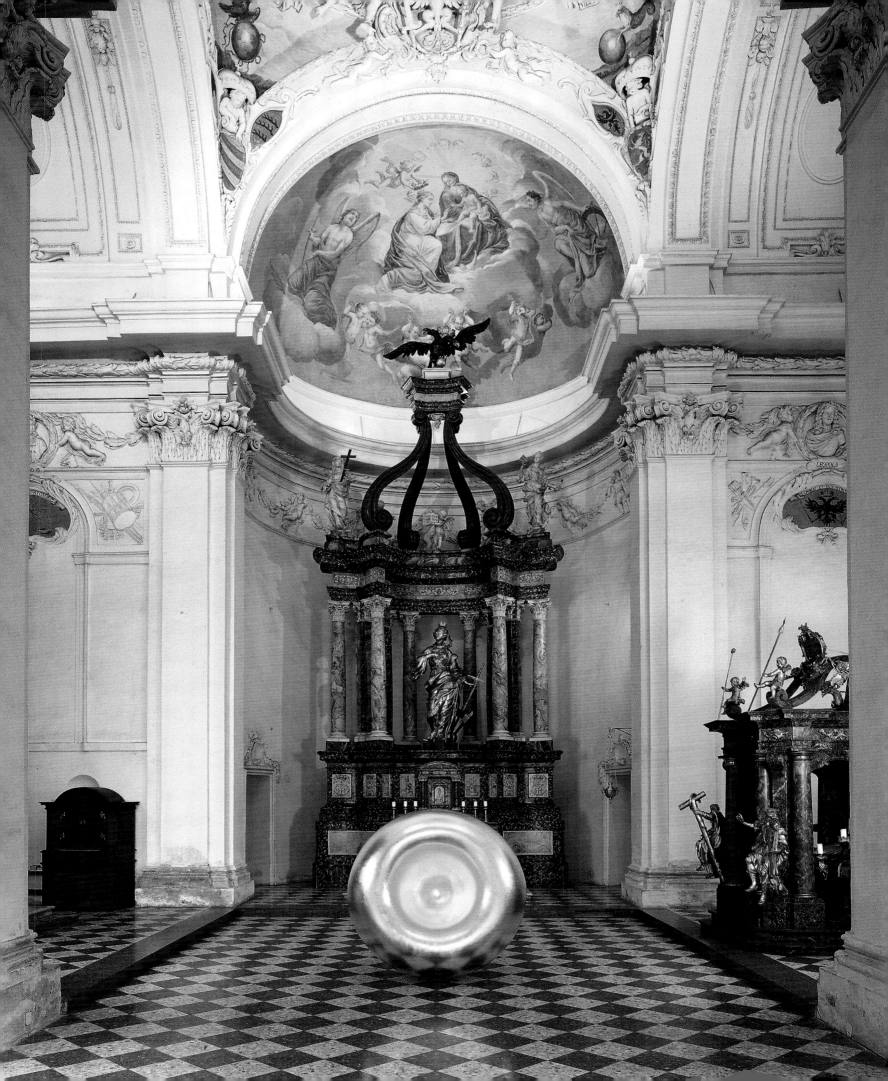

232

Untitled, 1997

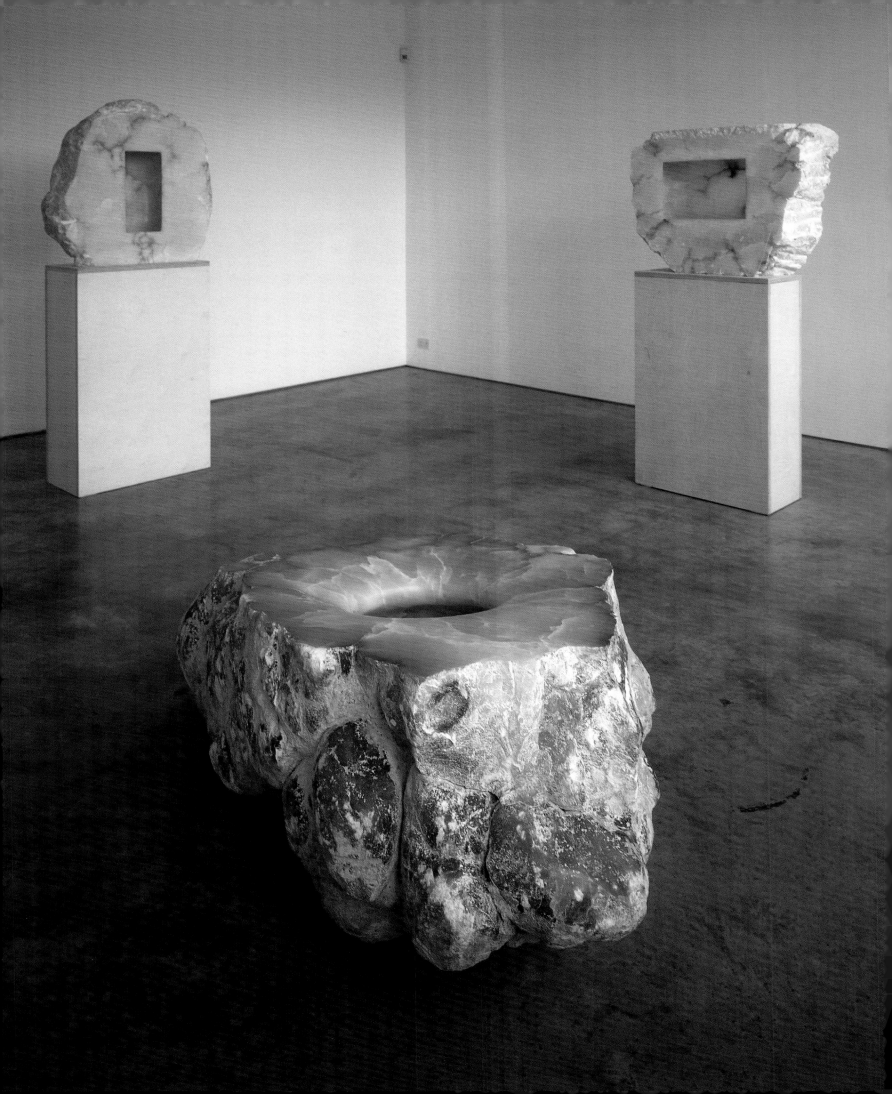

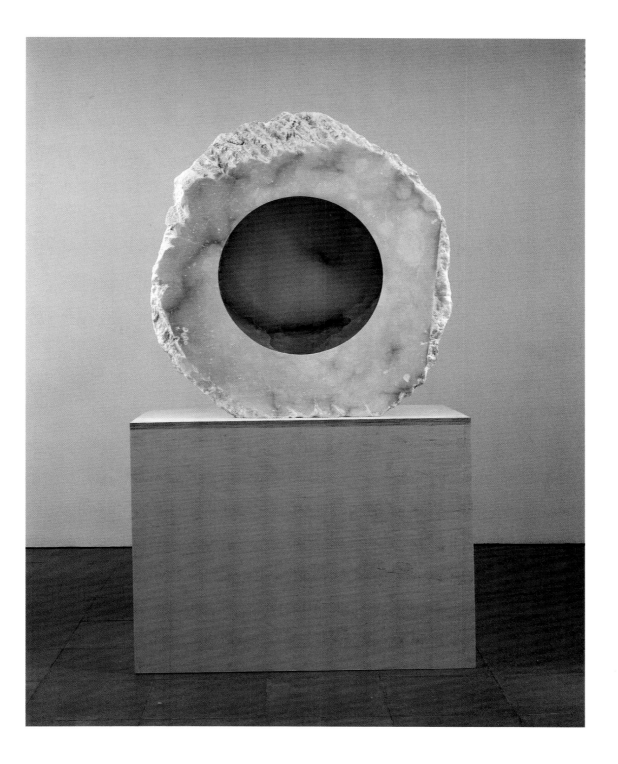

No. 1, No. 2, No. 3, 1997 No. 5, 1997

p.236-237
No. 7, 1997

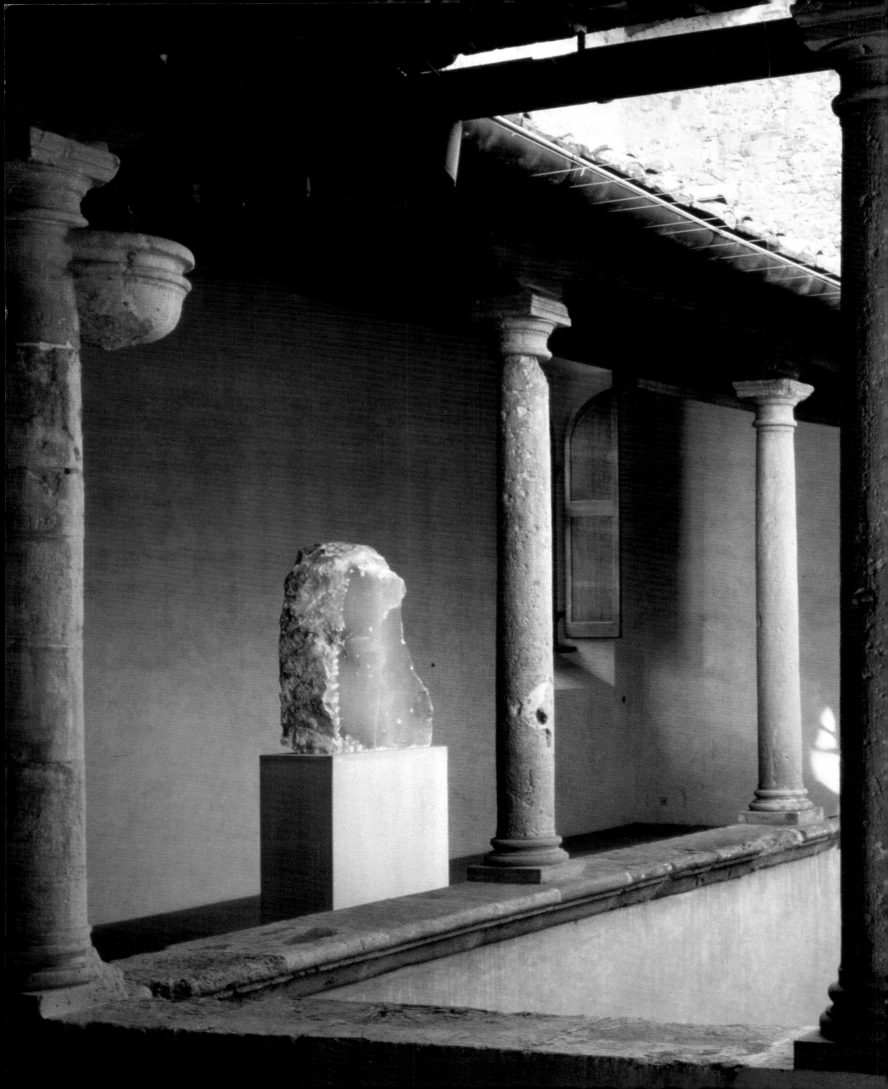

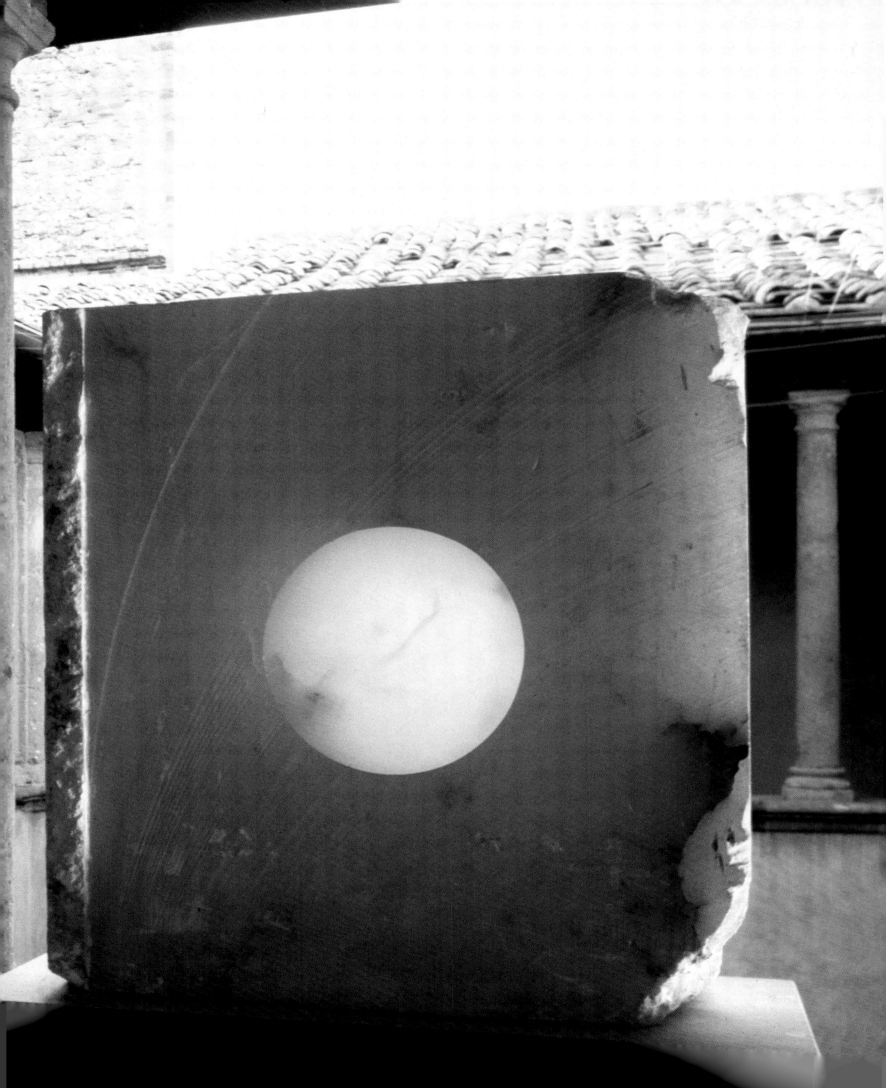

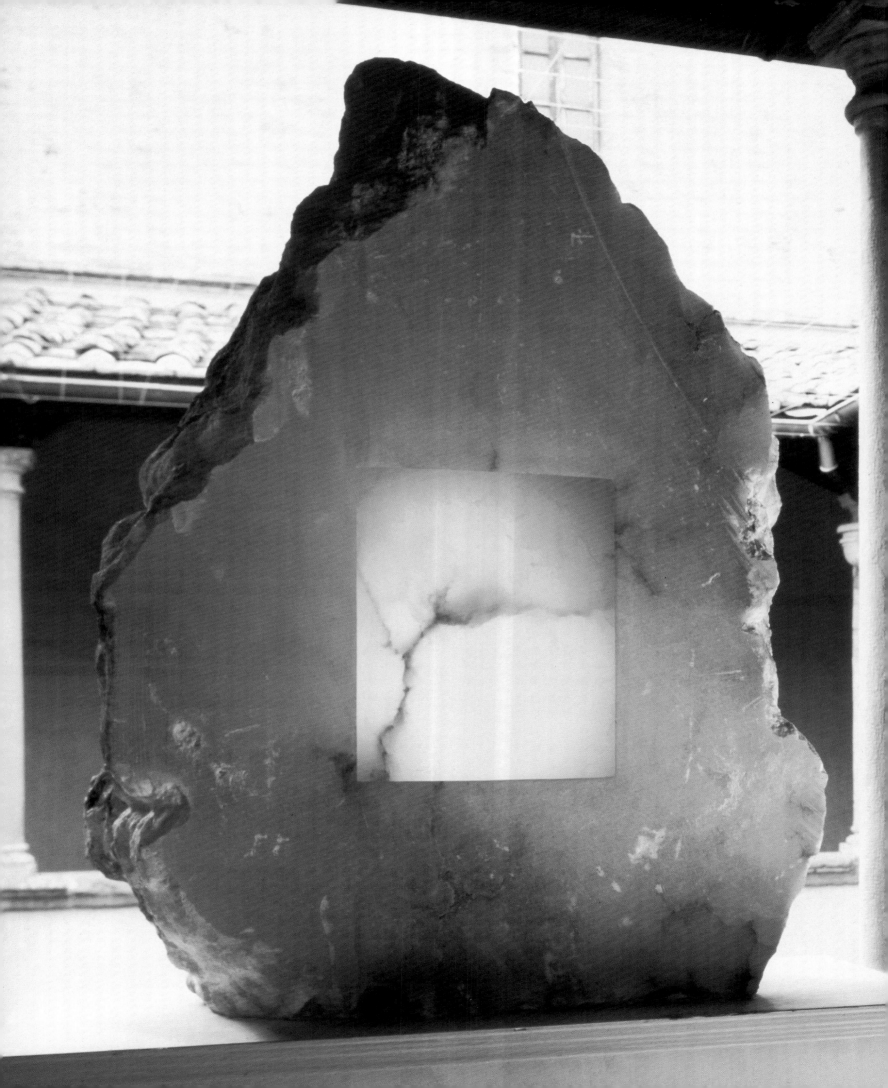

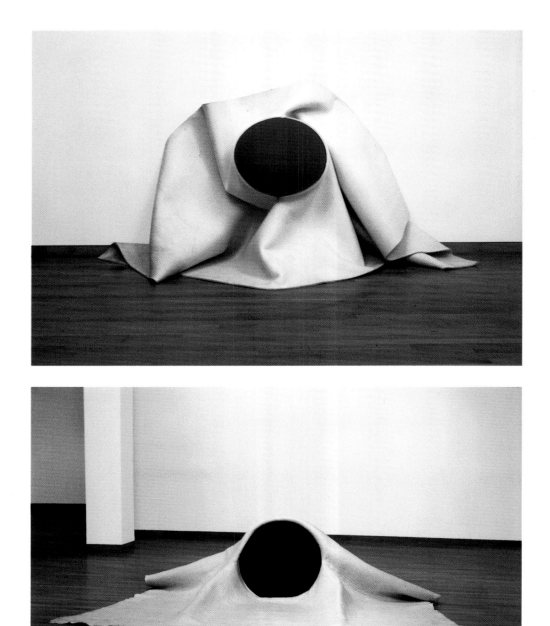

240

Untitled, 1997
Cloak, 1997

Body to Body, 1997

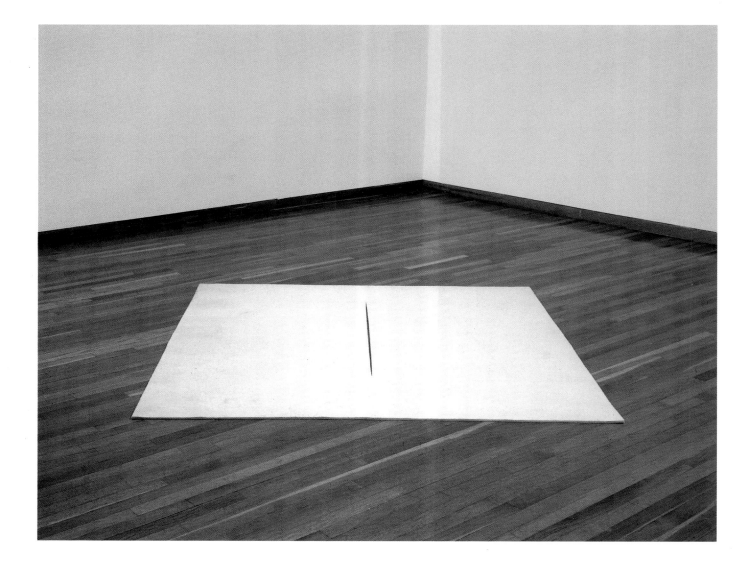

Untitled, 1997

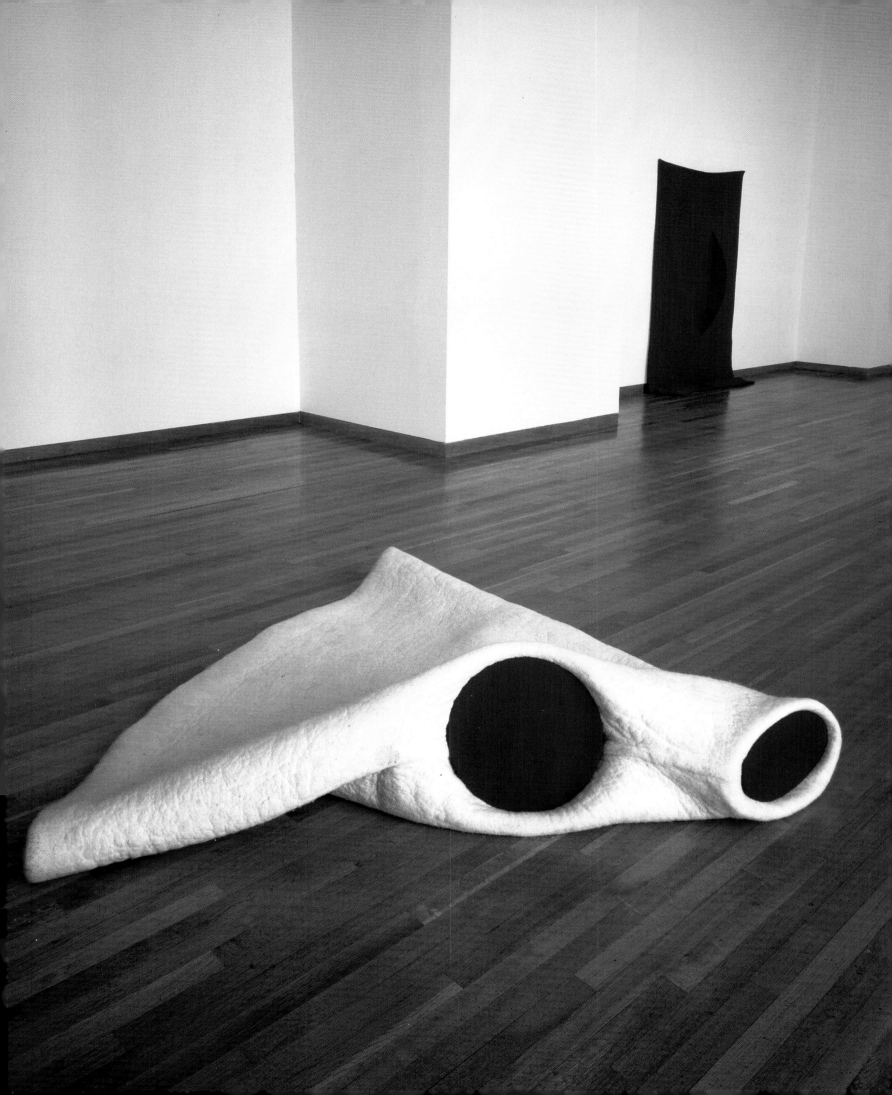

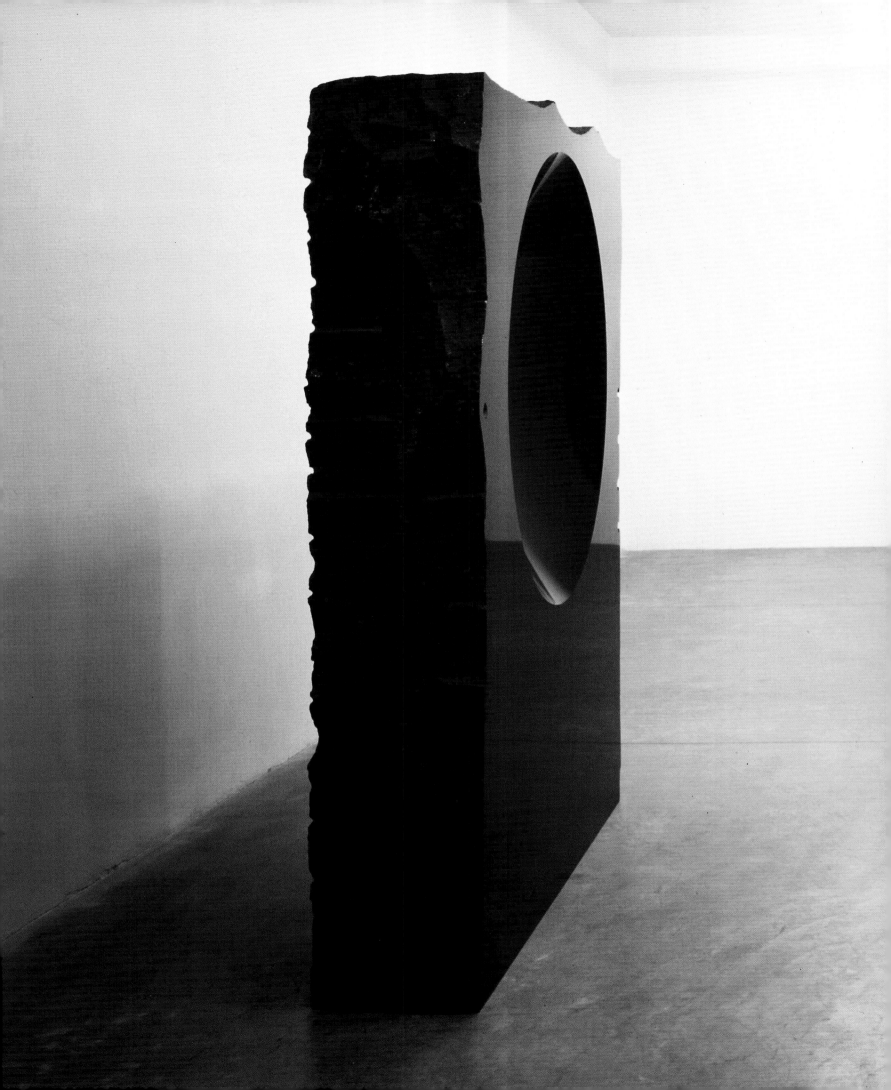

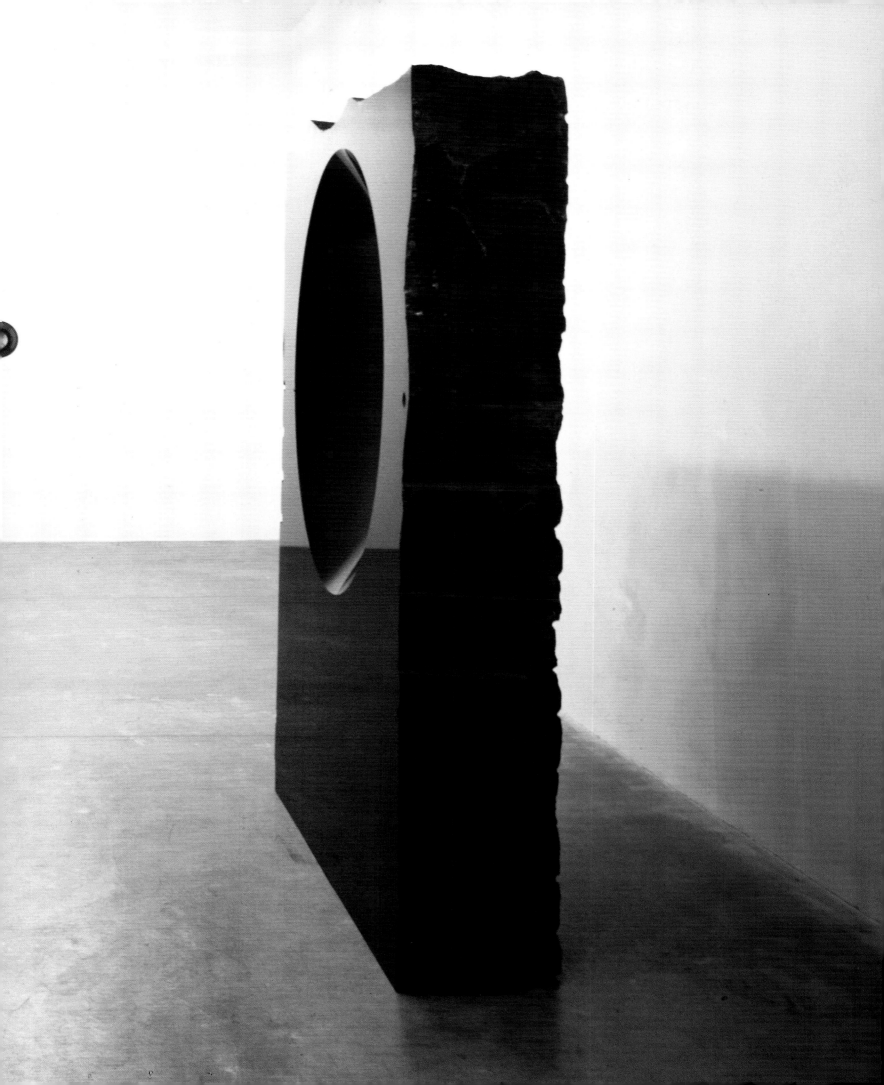

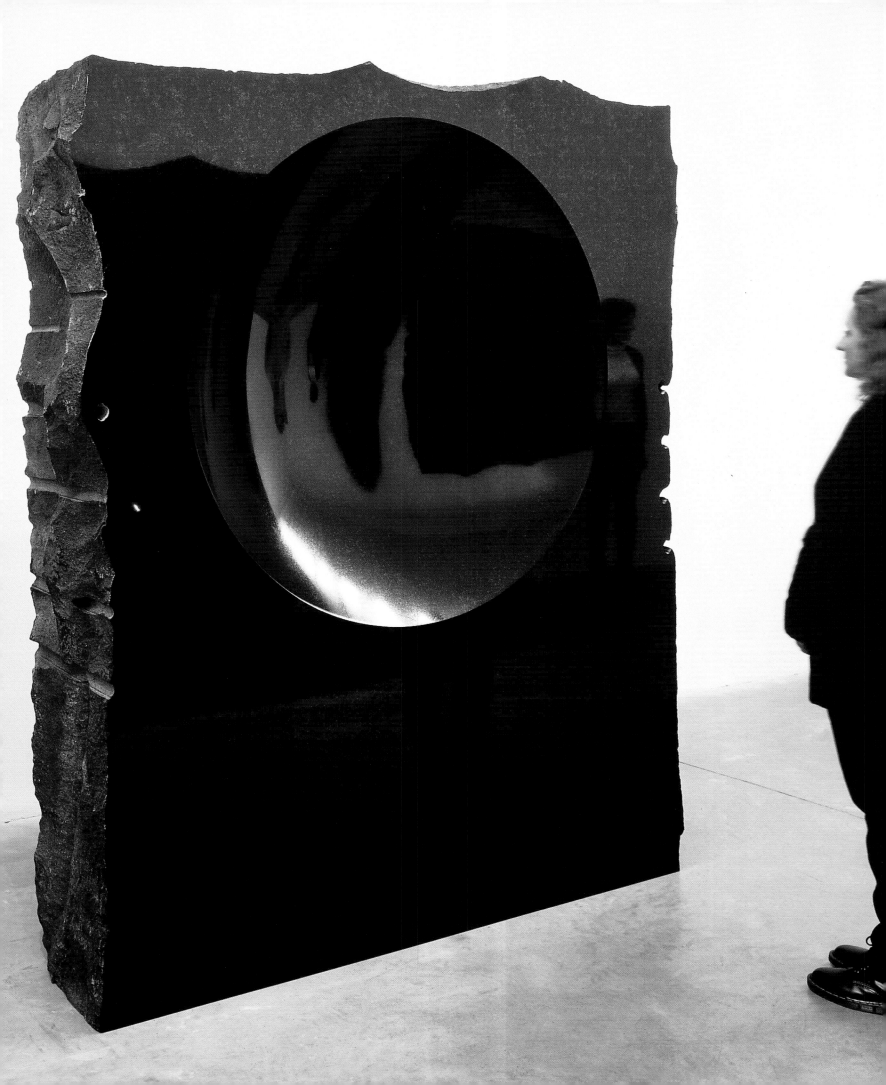

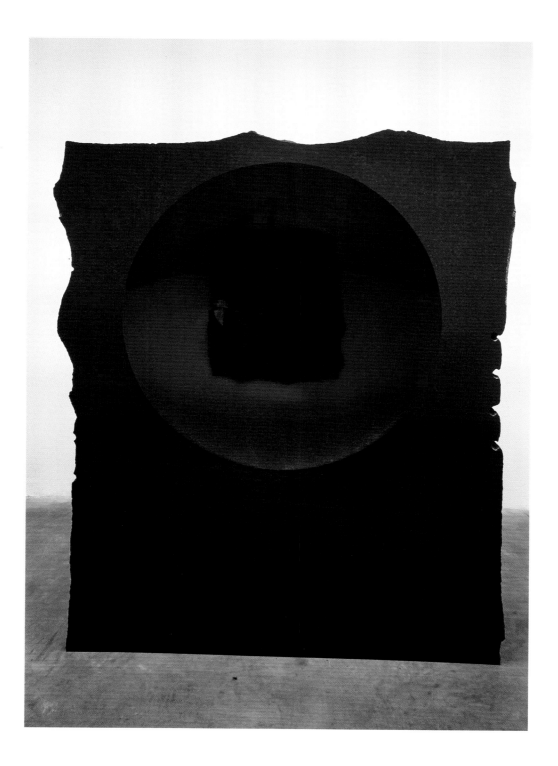

247

p.244-245
Untitled, 1997

p.246-247
Untitled, 1997 *(detail)*

p.248-249
background: White Dark III, 1995
front left: White Dark VI, 1998
front right: White Dark I, 1995

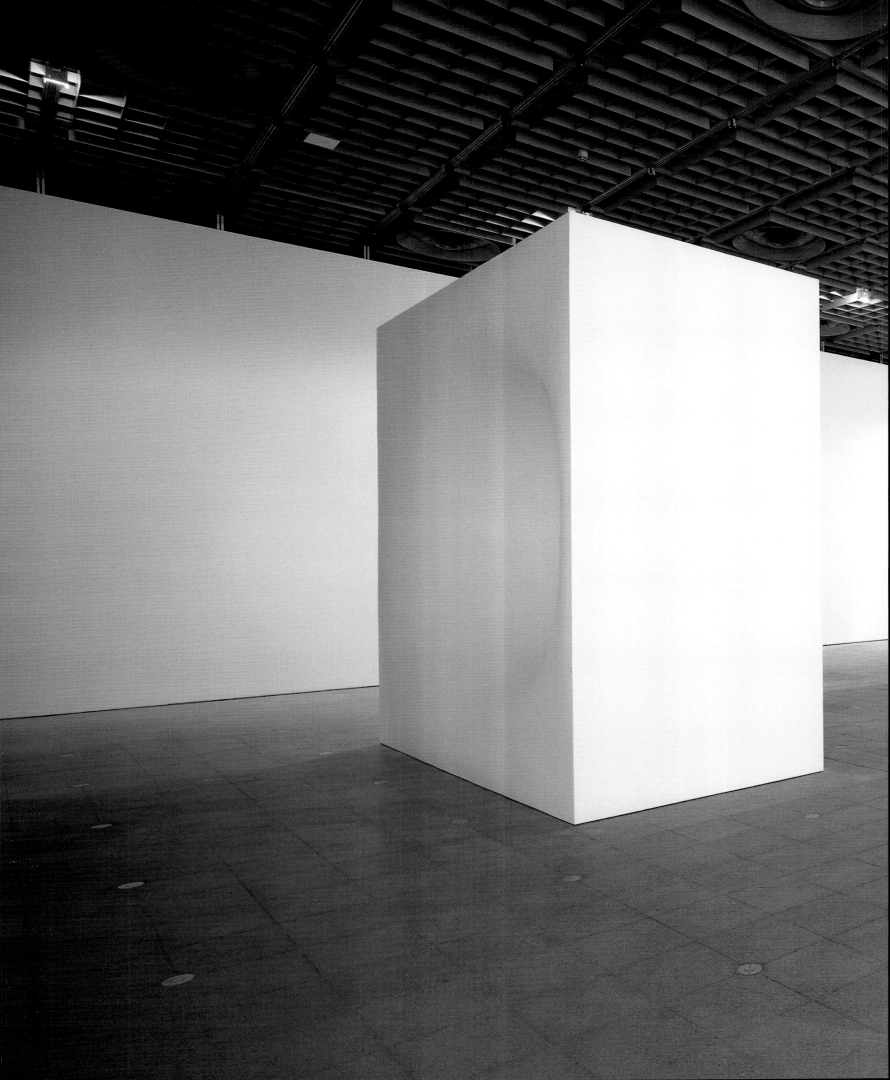

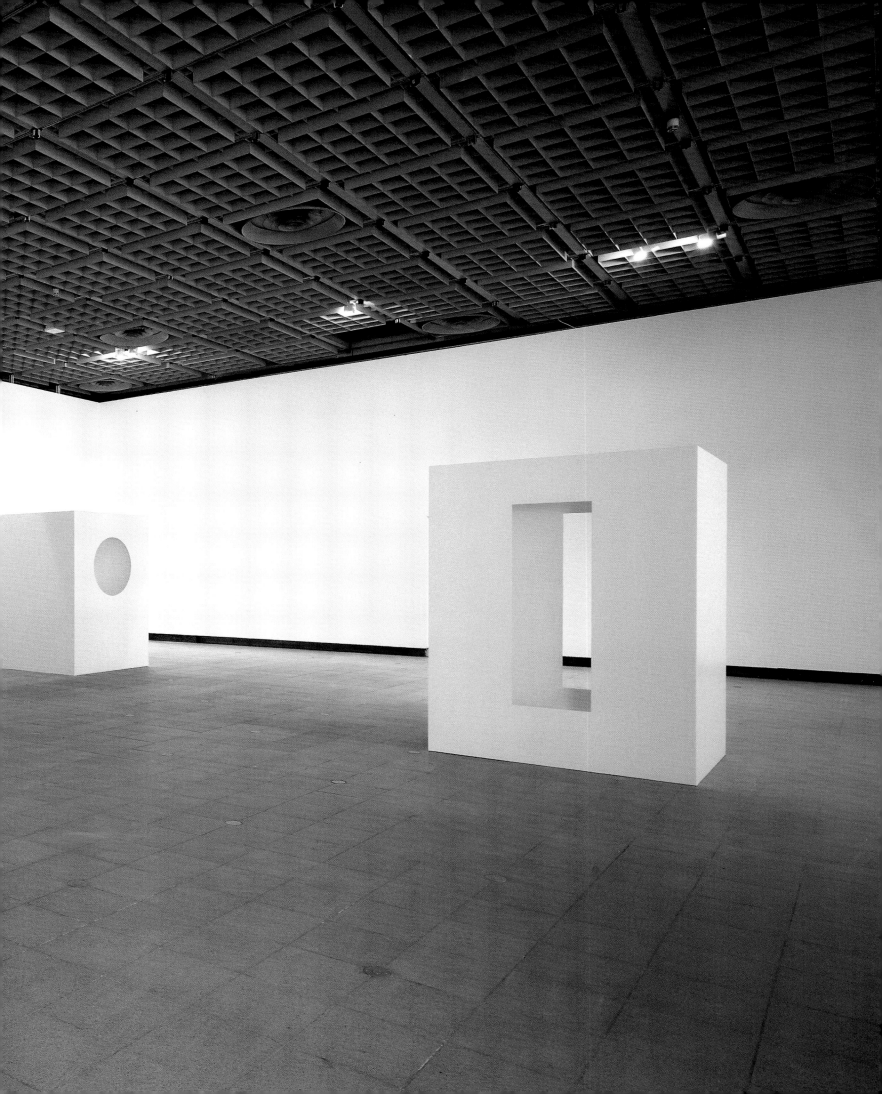

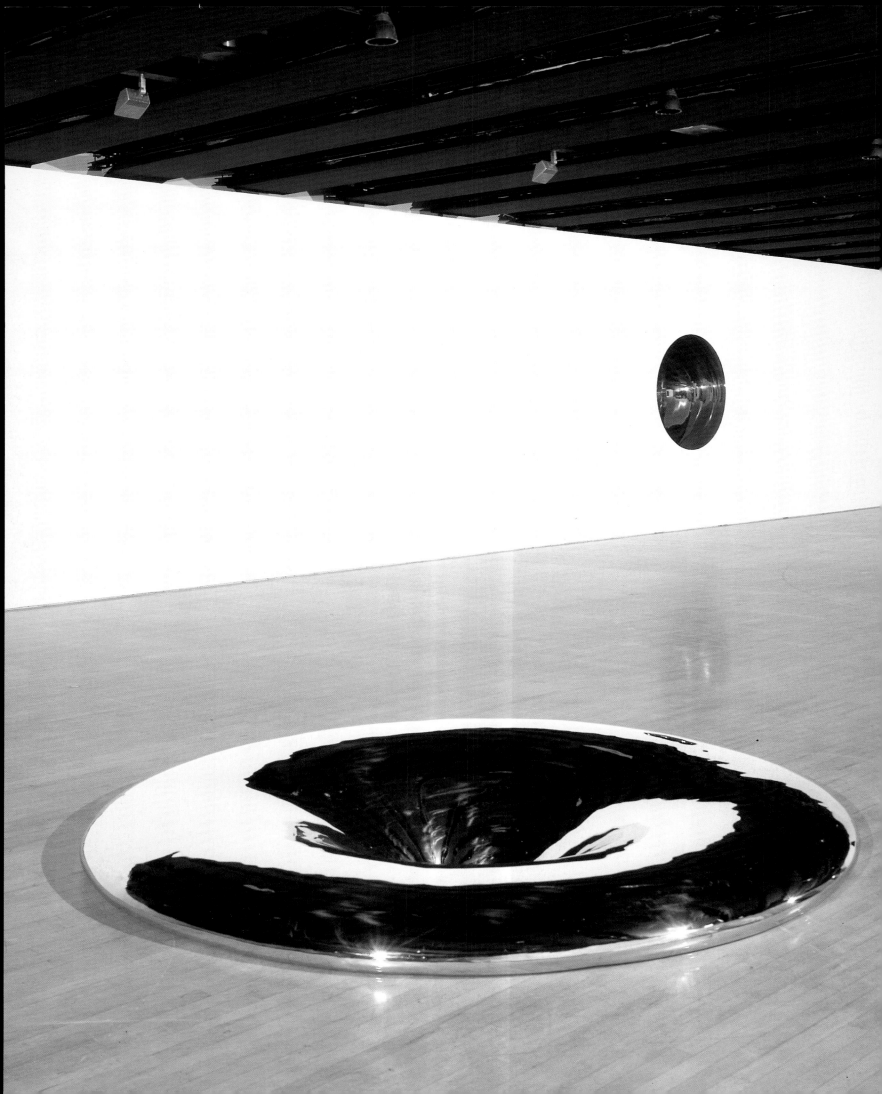

252

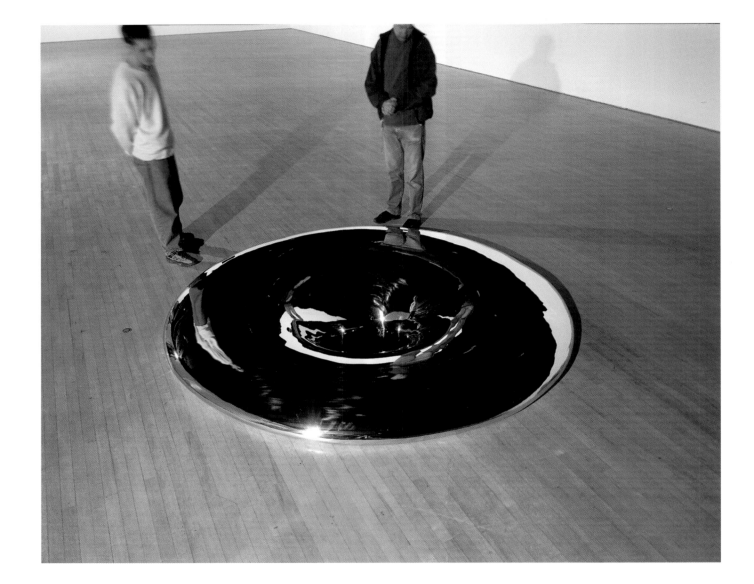

p.250-251
foreground: Suck, 1998
back left: Iris, 1998
back right: My body your body, 1993 Suck, 1998

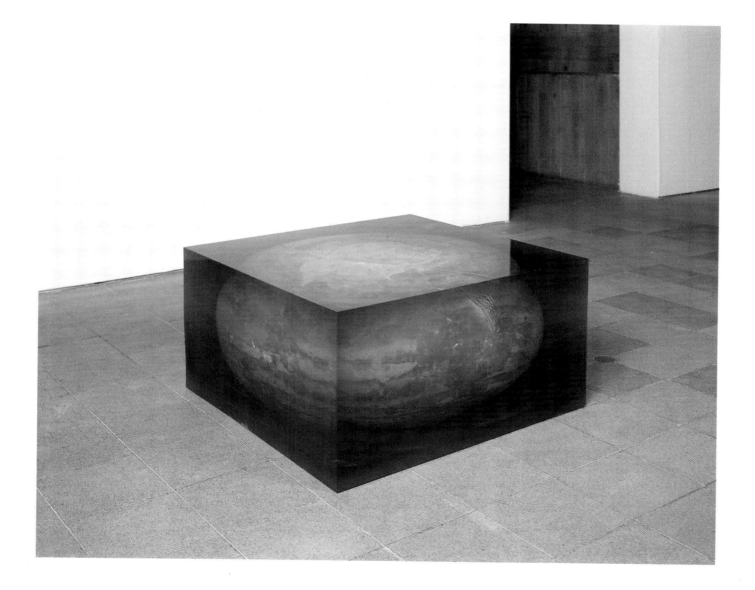

253

Reason Space, 1998

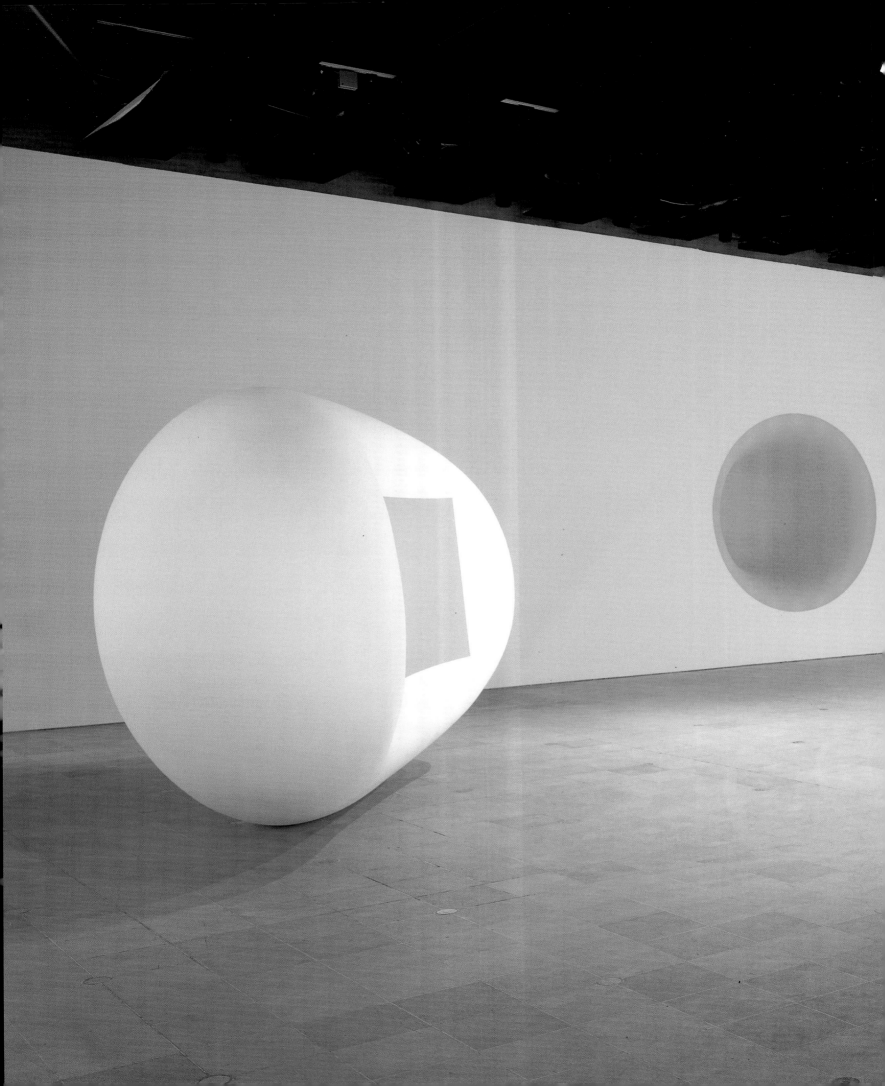

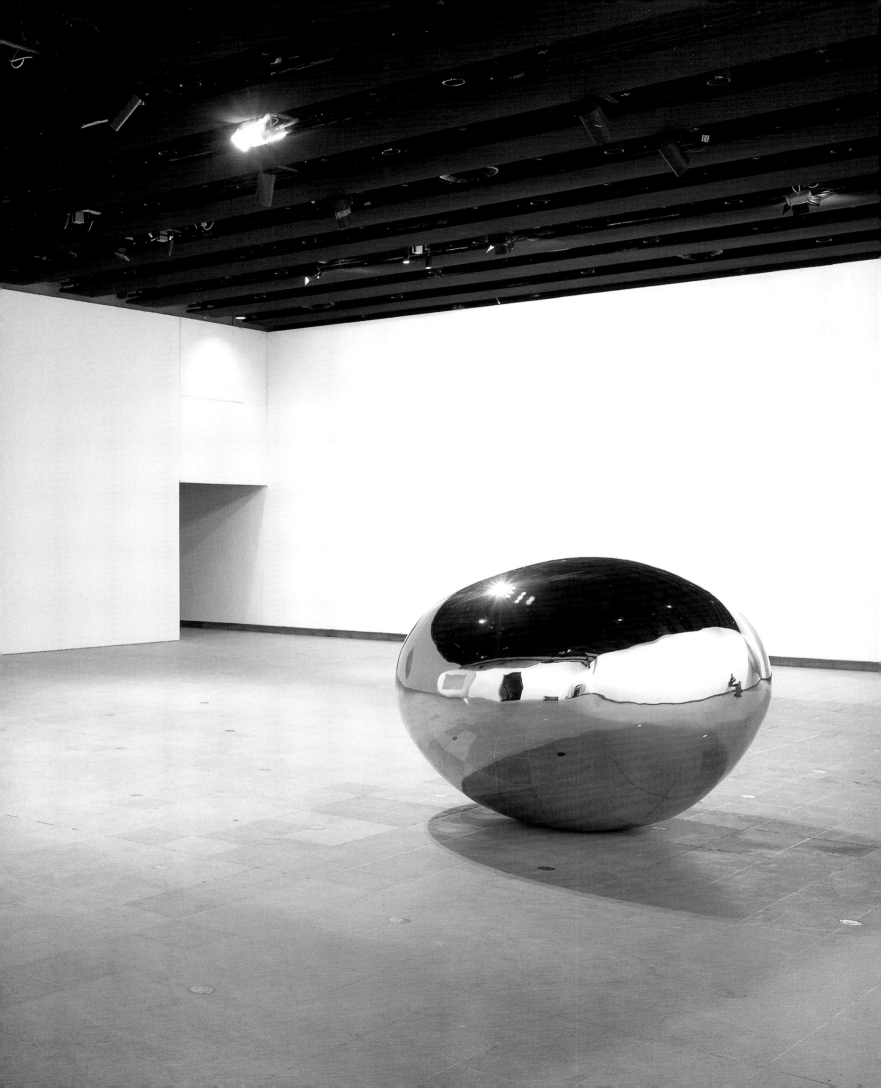

256

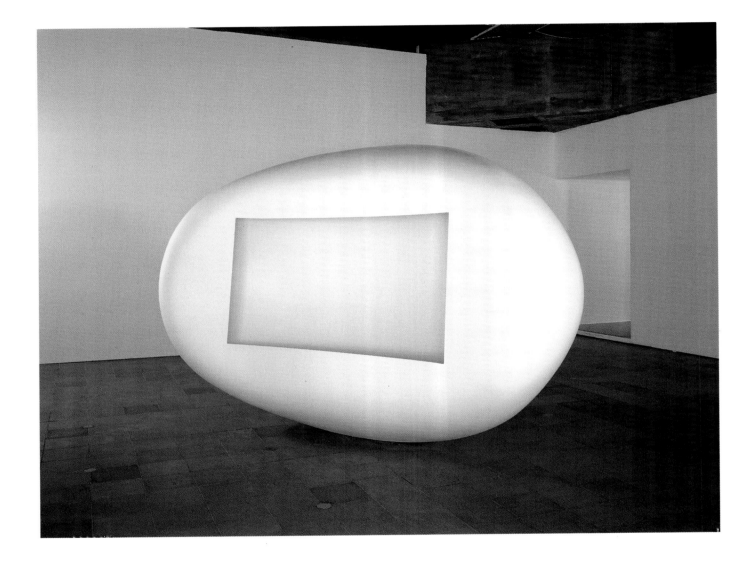

p.254-255
background: Yellow, 1998
front left: Untitled, 1998
front right: Turning the World Inside Out, 1995

Untitled, 1998

Yellow, 1998

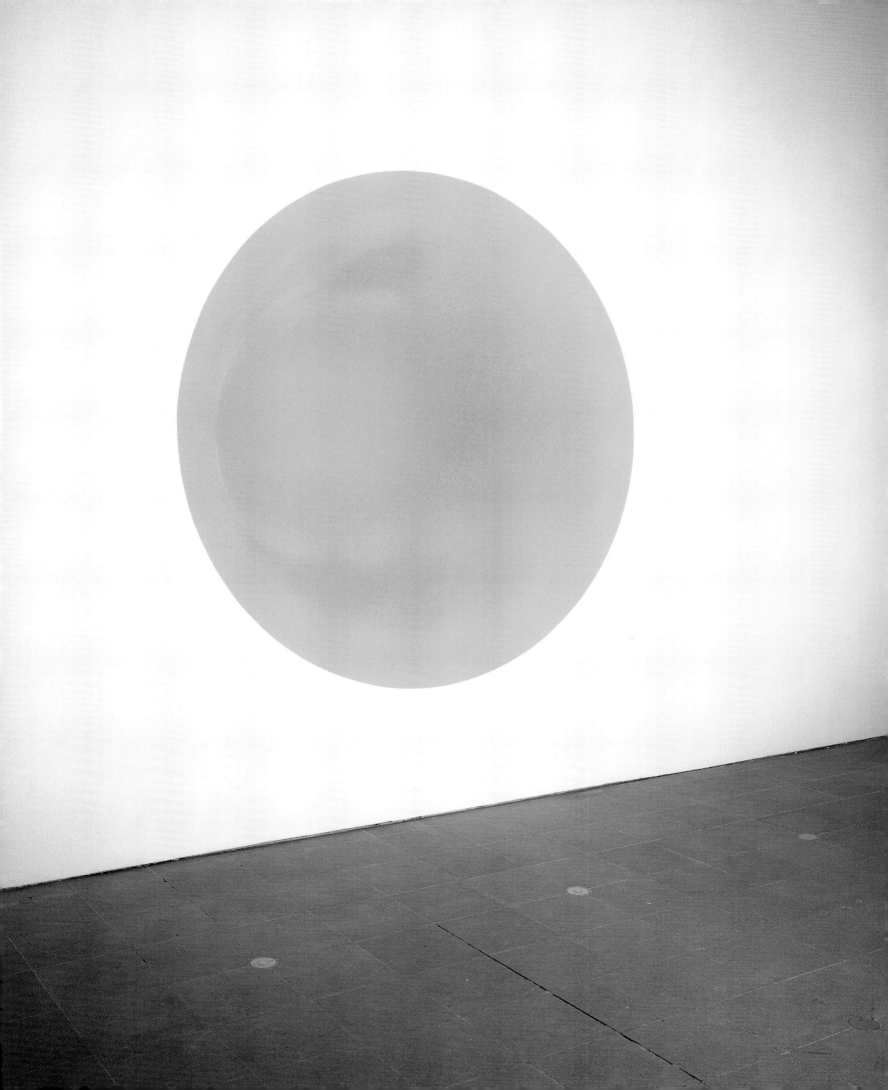

p.259-263
At the Edge of the World, 1998

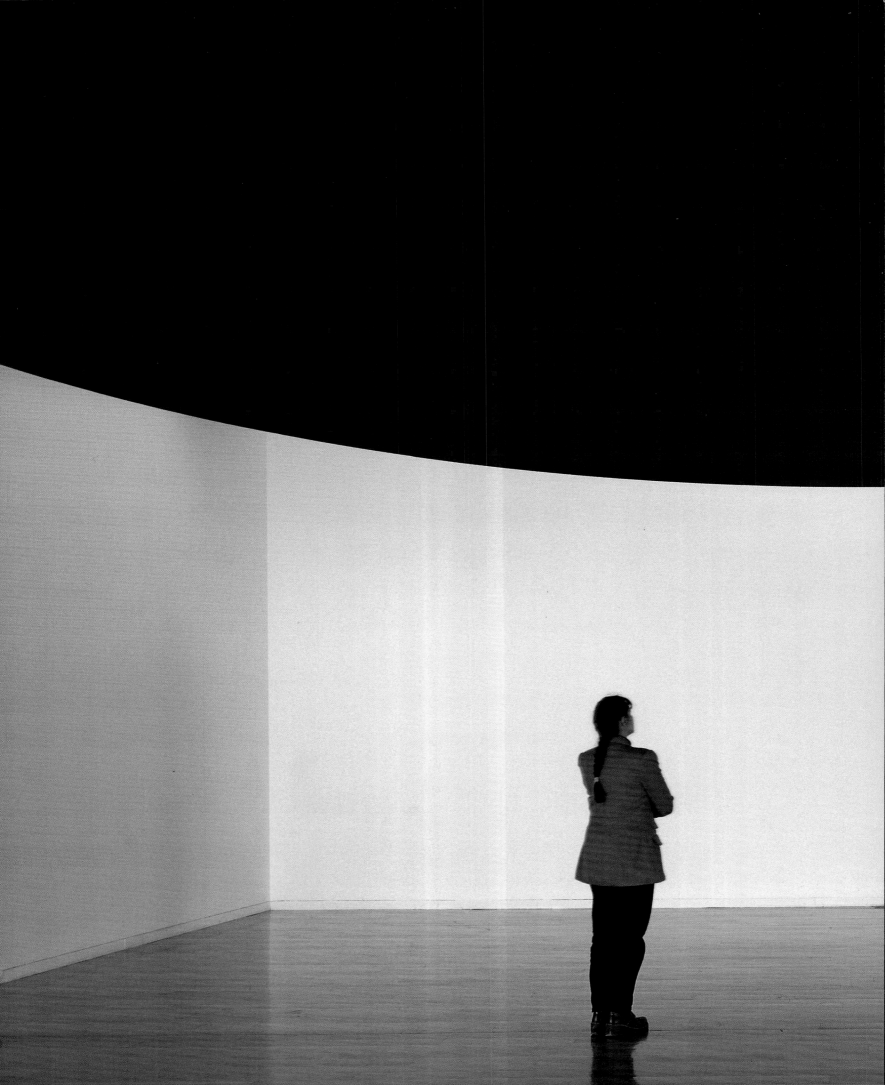

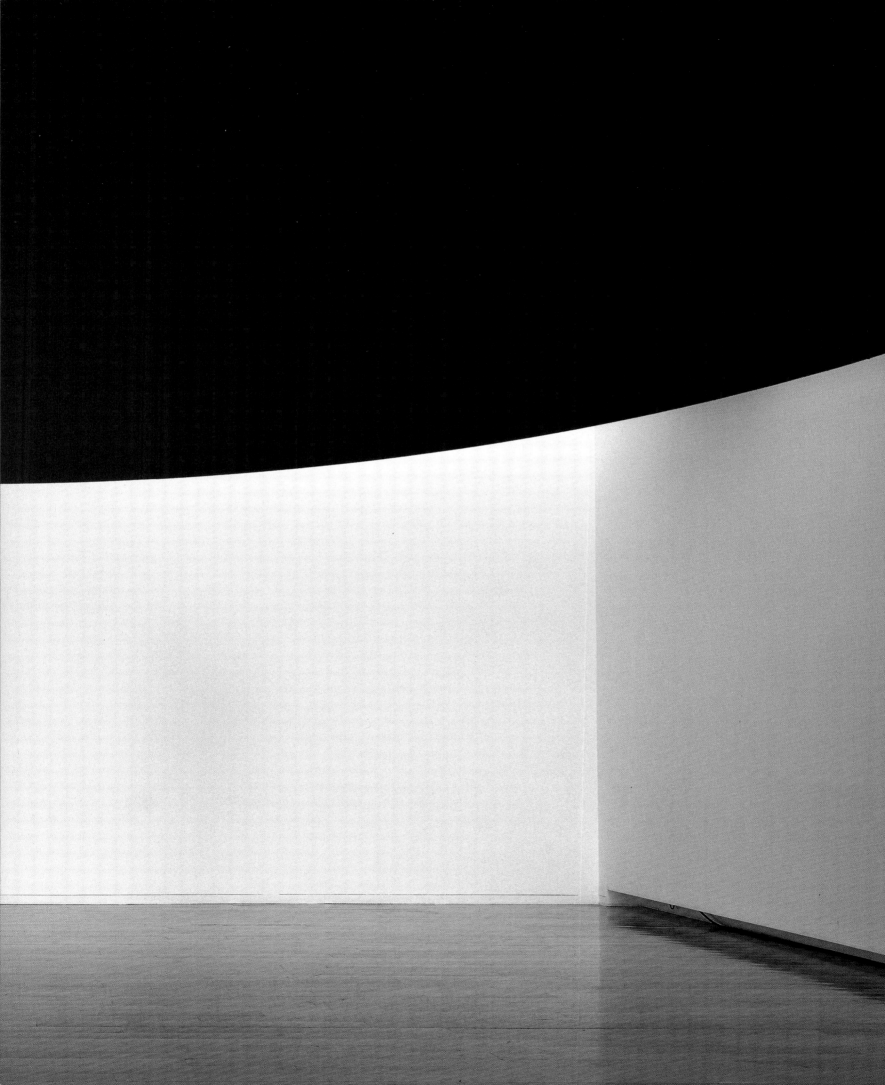

List of Works

pp. 2-3
Untitled, 1977
Steel, curtain, chalk, electricity, paint

p. 5
Untitled, 1975
Paint, plaster, chalk, steel
270x120x15.2 cm

pp. 6-7
Untitled Installation, 1977-78
Silk, plaster, paint, electric motor, mixed media
900x600x450 cm

pp. 8-9, 10, 11, 13
1000 Names, 1979-80
Mixed media, pigment
Dimensions variable
Installation: studio of the artist, London

pp. 14-15, 16-17, 18-19, 20-21
1000 Names, 1979-80
Mixed media, pigment
Dimensions variable
Installation: studio of the artist, London

p. 23
1000 Names, 1980
Bonded chalk
Dimensions variable

pp. 24-25
1000 Names, 1979-80
5 elements
Mixed media, pigment
74x71.5x71.5 cm (overall)

p. 27
1000 Names, 1980
Bonded chalk
Diam 130x70 cm
Private collection, London
Installation: Starkmann Library Services, London, 1991
Photo O. Vaering, Oslo

p. 29
1000 Names, 1980-81
Wood, gesso, pigment
102x102x102 cm
Private collection, Geneva

p. 31
1000 Names, 1981
5 elements
Mixed media, pigment
200x100x30 cm; 41x75x28 cm; 15x20x68 cm; 25x78x28 cm; 10x56x56 cm
Installation: "Prefiguration," Centre d'art contemporain, Chambéry, 1982

p. 33
1000 Names, 1979-80
Mixed media, pigment
38x30x28 cm

p. 34
1000 Names, 1979-80
Wood, gesso, pigment
63.5x51x30.5 cm
Collection Celine and Heiner Bastian, Berlin

p. 35
1000 Names, 1979-80
Wood, chalk
50.8x38x50.8 cm

pp. 36-37, 38-39
1000 Names, 1981
5 elements
Wood, gesso, pigment
122x183x183 cm (overall)
Museo National Centro de Arte Reina Sofia, Madrid

p. 41
1000 Names, 1979-80
Mixed media, pigment
h 183 cm c.
Collection Sol LeWitt, Chester

pp. 42-43
1000 Names, 1979-80
Mixed media, pigment
left element: 28x91.5x91.5 cm;
right: 18x91.5x91.5 cm

pp. 45, 46, 47, 49
Part of the Red, 1981
5 elements
Earth, resin, pigment
Collection Rijksmuseum Kröller-Müller, Otterlo

pp. 50-51, 52-53
To Reflect an Intimate Part of the Red, 1981
5 elements
Mixed media, pigment
200x800x800 cm (overall)
Collection of the artist, London
Photo Andrew Penketh, London

p. 55
As if to Celebrate I Discovered a Mountain Blooming with Red Flowers, 1981
3 elements
Wood, cement, polystyrene, pigment
107x305x305 cm (overall)
Tate Gallery, London

p. 57
1000 Names, 1982
Earth, pigment
Stedelijk Museum, Amsterdam

p. 59
White Sand, Red Millet, Many Flowers, 1982
4 elements
Wood, cement, pigment
101x241.5x217.4 cm (overall)
Collection Arts Council, South Bank Centre, London

pp. 60-61, 62-63
Red in the Centre, 1982
5 elements
Earth, pigment
Walker Art Gallery, Liverpool

p. 65
1000 Names, 1982
Mixed media, pigment
Private collection, Paris

p. 67
Untitled, 1983
Mixed media, pigment
120x80x20 cm
Contemporary Art Society, London

pp. 68-69
Black Earth, 1983
4 elements
Polystyrene, cement, earth, acrylic, pigment
259x271.5x236 cm (overall)

Collection Carol and Arthur Goldberg, New York

p. 71
Pot for Her, 1985
Wood, gesso, pigment
100x275x175 cm
Private collection, Switzerland
Photo Gareth Winters, London

p. 73
Hole and Vessel II, 1984
Polystyrene, cement, earth, acrylic, pigment
95x163x109 cm
Collection G.S. Elliott, Chicago
Photo Eeva Inkeri

pp. 74-75
Six Secret Places, 1983
6 elements
Mixed media, pigment
115x425x60 cm (overall)
Collection of the artist, London
Photo Gareth Winters, London

p. 77
1000 Names, 1985
Wood, gesso, pigment
125x50x70 cm
Private collection, London
Photo Gareth Winters, London

p. 78
Mother as a Mountain, 1985
Wood, gesso, pigment
140x275x105 cm
Walker Art Center, Minneapolis, T.B. Walker Acquisition Fund, 1987
Installation: studio of the artist
Photo Gareth Winters, London

p. 79
Place, 1985
Wood, gesso, pigment
90x80x80 cm
Private collection
Photo Gareth Winters, London

p. 80
Dark, 1986
4 elements
Wood, polystyrene, gesso, fibreglass, cloth, pigment
25.5x25.5x53.5 cm; 66x66x94 cm; 63.5x68.5x71 cm; 305x62x77.5 cm
Allbright-Knox Museum, Buffalo

p. 81
Untitled, 1986
3 elements
Fibreglass, wood, pigment
h max 300 cm
Private collection, United States of America
Photo Sue Ormerod, London

p. 83
Here and There, 1987
Limestone, pigment
90x246.5x160 cm
Centro d'arte contemporanea Luigi Pecci, Prato
Photo Gareth Winters, London

p. 85
Wound, 1988
Limestone, pigment
308x432x331 cm (overall)

265

Private collection, Zurich
Photo Susan Ormerod, London

p. 87
I, 1987
Limestone, pigment
59x63x95 cm
Collection David Michael Winton,
Minneapolis
Photo Susan Ormerod, London

p. 89
At the Hub of Things, 1987
Fibreglass, pigment
163x141x150 cm
Hirshhorn Museum and Sculpture Garden,
Washington
Photo Susan Ormerod, London

p. 91
Blood Stone, 1988
2 elements
Limestone, pigment
211x83.8x61 cm; 83.8x89x109.2 cm
Private collection, Turin
Photo Sue Ormerod, London

pp. 92, 93
Adam, 1988-89
Sandstone, pigment
119x102x236 cm
American Fund for the Tate Gallery, Courtesy
of Edwin C. Cohen (To A., A., A., and J.) on
loan to The Tate Gallery, London
Photo Larry Lame, New York

pp. 94-95, 96-97
Void Field, 1989
20 elements
Sandstone, pigment
Dimensions variable
Installation: British Pavilion, XLIV Biennale
Internazionale d'Arte, Venice, 1990
Photo Graziano Arici, Venice

p. 99
Void Field, 1989
12 elements
Sandstone, pigment
Dimensions variable
Installation: Palacio Velázquez, Parque del
Retiro, Centro de Arte Reina Sofia, Madrid, 1991
Photo Gareth Winters, London

pp. 101-103
Void Field, 1989
16 elements
Sandstone, pigment
Dimensions variable
Photo Gareth Winters, London

pp. 104-105, 107, 108, 109
Angel, 1990
11 elements
Dimensions variable

pp. 104-105, 107, 111
It is Man, 1989
Installation: Le Magasin, Centre National
d'Art Contemporain, Grenoble, 1990-91
Photo Georg Rehsteiner, Vufflens-le-Chateau

p. 108
Angel, 1990
Slate, pigment
61x264x113 cm
Photo Georg Rehsteiner, Vufflens-le-Chateau

p. 109
Angel, 1990
Slate, pigment
66x234x130 cm
Photo Georg Rehsteiner, Vufflens-le-Chateau

p. 111
It is Man, 1989-90
Sandstone, pigment
241x127x114 cm
Museo National Centro de Arte Reina Sofia,
Madrid
Photo Susan Ormerod, Gareth Winters, London

p. 113
Tomb, 1989
Slate, pigment
48.5x136x392 cm
Installation: Tel Aviv Museum of Art,
Tel Aviv, 1993
Photo Meidad Suchowolski, Tel Aviv

pp. 114, 115
Madonna, 1989-90
Fibreglass, pigment
Diam 284.5x155 cm
Museo National Centro de Arte Reina Sofia,
Madrid
Photo Susan Ormerod, Gareth Winters, London

p. 117
The Healing of St. Thomas, 1989
Mixed media
Dimensions variable
San Diego Museum of Contemporary Art,
La Jolla
Photo Georg Rehsteiner, Vufflens-le-Chateau

p. 119
Mother as a Void, 1989-90
Fibreglass, pigment
213x210x203 cm
Fukuoka Art Museum, Fukuoka

pp. 120-121
Untitled, 1990
Triptych
Fibreglass, pigment
Diam 250x167 cm each
Installation: Kunstverein, Hannover, 1991
Photo Robert Hausser, Mannheim

pp. 122-123
Three Witches, 1990
3 elements
Limestone, pigment
192x113x89 cm; 202x125x88 cm;
204x110x90 cm
National Gallery of Canada, Ottawa
Installation: Kunstverein, Hannover, 1991
Photo Robert Hausser, Mannheim

pp. 124, 125, 126-127
Untitled, 1990
7 elements
Limestone
h 125 cm c.
Installation: Le Magasin, Centre National
d'Art Contemporain, Grenoble, 1990-91
Photo Georg Rehsteiner, Vufflens-le-Chateau

p. 129
Pot, 1991
Sandstone, pigment
Diam 152.4x156.2 cm
Installation: Kunstverein, Hannover, 1991
Photo Robert Hausser, Mannheim

p. 131
The Earth, 1991
Fibreglass, pigment
Dimensions variable
Installation: Palacio Velázquez, Parque del
Retiro, Centro de Arte Reina Sofia, Madrid, 1991
Photo Gareth Winters, London

pp. 132-133
Untitled, 1991
Marble
174x93x90 cm
Installation: Winchester Cathedral, 1995
Photo Stephen White, London

pp. 135, 137
Untitled Installation, 1991
Mixed media
Dimensions variable
The Sixth Japan Ushimado International Art
Festival, Ushimado

pp. 138-139, 140, 141
Dragon, 1992
11 elements
Sandstone, pigment
Dimensions variable
Installation: Art Tower Mito, Mito-shi, 1992-93
Photo Hirosuke Yagi, Nagoya

p. 143
Endless Column, 1992
Mixed media
Dimensions variable
Installation: San Diego Museum
of Contemporary Art, La Jolla, 1992
Photo Philipp Rittermann, San Diego

pp. 144, 145, 146, 147
Building for a Void, 1992
Project for Expo '92, Seville
In collaboration with David Connor
Concrete, stucco
h 15 m; long axis: 8 m 400 cm;
short axis: 6 m 900 cm
Photo John Edward Linden, London

p. 148
Building for a Void, 1992
Project for Expo '92, Seville
In collaboration with David Connor
Axonometry, Section BB
Rendering by Nicholas Alderson

p. 149
Building for a Void, 1992
Project for Expo '92, Seville
In collaboration with David Connor
Axonometry
Rendering by Nicholas Alderson

p. 151
In the Presence of Form II, 1993
Portland stone
175x201x122 cm
Heide Park and Art Gallery, Victoria, Australia
Photo Stephen White, London

p. 153
Untitled, 1992
Mixed media
Dimensions variable

p. 154, 155
Descent into Limbo, 1992
Project for Documenta IX, Kassel, 1992
Concrete, stucco

6x6x6 m
Photo Dirk De Neef, Gent

p. 157
Untitled, 1993
Plaster, pigment
189.5x76.5x166 cm
Photo Stephen White, London

pp. 158-159
Eyes Turned Inward, 1993
2 elements
Fibreglass, pigment
155x155x135.5 cm (overall)
Collection Fundacion Berardo, Lisbona
Installation: Tel Aviv Museum of Art, 1993
Photo Meidad Suchowolski, Tel Aviv

p. 160
Entrances to *Untitled*, 1992
(p. 161) and *Untitled*, 1992 (p. 163)
Installation: "De Opening," De Pont
Foundation for Contemporary Art, Tilburg,
1992

pp. 160, 161
Untitled, 1992
Fibreglass, acrylic, pigment
Diam 100 cm
Photo Hans Biezen

p. 163
Untitled, 1992
Polystyrene, aluminium, fibreglass, acrylic,
pigment
Dimensions variable, diam 220 cm
De Pont Foundation for Contemporary Art,
Tilburg
Photo Hans Biezen

p. 165, 166, 167
When I am Pregnant, 1992
Mixed media
Dimensions variable
De Pont Foundation for Contemporary Art,
Tilburg
Installation: De Pont Foundation for
Contemporary Art, Tilburg, 1995

p. 168, 169, 170
Untitled, 1992
Sandstone, pigment
241x150x119 cm
Collection Fondazione Prada, Milan

pp. 168, 170, 171
Untitled, 1992
Sandstone, pigment
230x122x103 cm
Installation: De Pont Foundation
for Contemporary Art, Tilburg, 1995

p. 173
Untitled, 1993
Fibreglass, pigment
Photo Dan Barsotti

p. 175
Black Stones, Human Bones, 1993
2 elements
Marble
131x163x171.5 cm, diam 90 cm
Installation: "The Siege," Obidos, 1993
Photo Jose Manuel Costa Alves

pp. 176-177
Untitled Installation, 1993

Dimensions variable
Installation: Barbara Gladstone Gallery,
New York, 1993-94

p. 179
Untitled, 1993
Sandstone
165x92x145 cm
Installation: Barbara Gladstone Gallery,
New York, 1993-94

p. 181
My Body Your Body, 1993
Fibreglass, pigment
Dimensions variable;
element: 248x103x205 cm
Photo Attilio Maranzano, Rome

pp. 182-183
Oblivion, 1994
Limestone
142x98x114 cm; 142x98x145 cm;
122x132x122 cm
Installation: "Asian Art Now," Hiroshima
City Museum of Contemporary Art,
Hiroshima, 1994

p. 185
Oblivion, 1994
Limestone
142x98x145 cm
Installation: "Asian Art Now," Hiroshima
City Museum of Contemporary Art,
Hiroshima, 1994

pp. 186-187
Mountain, 1994
Cast iron
285x420x210 cm
Commission: Municipality of Tachikawa,
Japan
Photo Anzai

p. 188
Untitled, 1994
Fibreboard, paint
89x120x241 cm
Vancouver Art Gallery, Vancouver
Photo Andrew Penketh, London

p. 189
Untitled, 1994
Fibreboard, paint
156.6x125x248 cm
Private collection, Turin
Photo Andrew Penketh, London

p. 191
Untitled, 1994-95
Kilkenny limestone
202.5x140x125 cm
De Pont Foundation for Contemporary Art,
Tilburg
Installation: De Pont Foundation for
Contemporary Art, Tilburg, 1995

pp. 192, 193
Untitled, 1995
Aluminium
149x98x99 cm
Installation: De Pont Foundation for
Contemporary Art, Tilburg, 1995

pp. 194, 195
Untitled, 1994-95
Limestone
188x150x175 cm

Installation: De Pont Foundation for
Contemporary Art, Tilburg, 1995

pp. 196, 197
Untitled Installation, 1994-95
Wood, paint
206x152.6x127.8 cm; 206x152.3x127.2 cm
Installation: De Pont Foundation for
Contemporary Art, Tilburg, 1995

p. 198
White Dark III, 1994-95
Wood, fibreglass, paint
206x152.6x127.8 cm
Photo John Riddy, London

p. 199
Untitled, 1995
2 elements
Gourds, acrylic pigment
25.5x26.5x71.5 cm
Photo Stephen White, London

p. 200
Untitled, 1995
Gourds
32x140x115 cm
Installation: Lisson Gallery, London, 1995
Photo John Riddy, London

p. 201
Untitled, 1995
Gourds, pigment
55x67x32 cm
Collection Fondazione Prada, Milan
Installation: Lisson Gallery, London, 1995

pp. 202, 203
Mountain, 1995
Fibreboard, paint
317.5x249x404.5 cm
Private collection, Brussels
Installation: Lisson Gallery, London, 1995
Photo John Riddy, London

pp. 204, 205
Turning the World Upside Down, 1995
Stainless steel
120x120x120 cm
Installation: Fondazione Prada, Milan, 1995

pp. 206-207
Turning the World Inside Out, 1995
Cast aluminium
148x184x188 cm
Photo John Riddy, London

p. 209
Cloud, 1995
Wood, fibreglass, paint
205.7x152.4x126.9 cm
Installation: Fondazione Prada, Milan, 1995

pp. 210-211, 213
Turning the World Inside Out II, 1995
Chromium-plated bronze
145x185x185 cm
Installation: Fondazione Prada, Milan, 1995

p. 214
Untitled, 1996
Stainless steel
196x196x42 cm
Installation: Kunst-Station St. Peter, Cologne,
1996
Photo Wim Cox, Cologne

p. 215
Back: *Untitled*, 1996
Stainless steel
196x196x42 cm
Front: *Untitled*, 1995
Stainless steel, 139x39x27 cm
Installation: Kunst-Station St. Peter, Cologne,
1996
Photo Wim Cox, Cologne

p. 216-217
Untitled, 1996
Stainless steel
2 elements
195.8x195.8x41.4 cm
Installation: Kunst-Station St. Peter, Cologne,
1996
Photo Wim Cox, Cologne

p. 219
Untitled, 1996
Wood and pigment
Installation: "Betong", Malmö Konsthall, 1996
Photo Gerry Johansson

p. 220, 221
Untitled, 1996
Concrete
Installation: "Betong", Malmö Konsthall, 1996
Photo Gerry Johansson

p. 222
Foreground: *Untitled*, 1997
Background: *Untitled*, 1997
Installation: "Follow Me. Britische Kunst an
der Unterelbe," MS Greundiek, Stadthafen,
Stade, 1997
Photo Dick Reinartz, Buxehude

p. 223, 222 (background)
Untitled, 1997
Stainless steel
243x243x60 cm
Installation: "Follow Me. Britische Kunst an
der Unterelbe," MS Greundiek, Stadthafen,
Stade, 1997
Photo Dick Reinartz, Buxehude

p. 224
Untitled, 1997
Stainless steel
197.5x99.5x99.5 cm
Photo Stephen White, London

p. 225
Making the World Many, 1997
Stainless steel
217x143x173 cm
Photo Stephen White, London

p. 226-227
Left to right: *Untitled*, 1997
Stainless steel
197.5x99.5x99.5 cm
Untitled, 1997
Polished stainless steel
250x250x60 cm
Making the World Many, 1997
Stainless steel
217x143x172 cm
Photo Stephen White, London

p. 228, 229
Turning the World Upside Down III, 1996
Stainless steel
250x250x225 cm
Collection Deutsche Bank, London
Installation: 23rd International Biennal of São

Paulo, Brazil, 1996
Photo: Fernando Chaves, São Paulo

p. 230
Untitled, 1997
Photograph during fabrication
GRP and gold leaf
200x200x160 cm
Photo Stephen White, London

p. 231
Untitled, 1997
GRP and gold leaf
200x200x160 cm
Installation: "Entgegen", Mausoleum am
Dom, Graz, 1997
Photo Christian Jungwirth, Austria

p. 232, 233
Untitled, 1997
Alabaster
295x175x128 cm
Installation: Chiesa di San Giusto and
Pinacoteca Civica, Volterra, 1997
Exhibition organised by Galleria Arte
Continua
Photo Attilio Maranzano, Rome

p. 234
No. 5, 1997
Alabaster
135x126x60 cm
Installation: Lisson Gallery, London, 1998
Photo John Riddy

p. 235
Left to right: *No. 1*, 1997
Alabaster
96x95x34 cm
Centre: *No. 3*, 1997
Alabaster
67x117x166 cm
No. 2, 1997
Alabaster
80x112x28 cm
Installation: Lisson Gallery, London, 1998
Photo John Riddy

p. 236-237
Untitled, 1997
Alabaster
96x70x29 cm
Installation: Chiesa di San Giusto and
Pinacoteca Civica, Volterra, 1997
Photo Attilio Maranzano, Rome

p. 238-239
No. 7, 1997
Alabaster
73x68x29 cm
Installation: "Arte Continua", Chiesa di San
Giusto and Pinacoteca Civica, Volterra, 1997
Photo Attilio Maranzano, Rome

p. 240
Untitled, 1997
Felt, wool and fibreglass
137x285x74 cm
Installation: The High Museum of Art,
Atlanta, 1997.
Photo T.W. Meyer, Atlanta

p. 240
Cloak, 1997
Felt and pigment

86.5x335x274 cm
Installation: The High Museum of Art,
Atlanta, 1997.
Photo T.W. Meyer, Atlanta

p. 241
Body to Body, 1997
Wool and fibreglass
292x147x275 cm
Installation: The High Museum of Art,
Atlanta, 1997.
Photo T.W. Meyer, Atlanta

p. 242
Untitled, 1997
Felt
2x185.5x185.5 cm
Installation: The High Museum of Art,
Atlanta, 1997.
Photo T.W. Meyer, Atlanta

p. 243
Red holes to..., 1997
Felt and wool
44.5x183x188 cm
Installation: The High Museum of Art,
Atlanta, 1997.
Photo T.W. Meyer, Atlanta

p. 244, 245
Untitled, 1997
Granite
2 elements
220x180x42 cm each
Installation: Galleria Massimo Minini,
Brescia, 1998
Photo Attilio Maranzano, Rome

p. 246-247
Left: *Untitled*, 1997, detail
Granite
2 elements
220x180x42 cm each
Installation: Galleria Massimo Minini,
Brescia, 1998
Photo Attilio Maranzano, Rome

p. 248-249
Background: *White Dark III*, 1995
Wood, fibreglass and paint
206x152.6x127.8 cm
Front left: *White Dark VI*, 1998
Fibreglass and wood
300x300x200 cm
Front right: *White Dark I*, 1995
Wood, fibreglass and paint
206x152.6x127.8 cm
Installation: "Anish Kapoor,"
Hayward Gallery, London, 1998
Photo John Riddy, London

p. 250-251
Foreground: *Suck*, 1998
Stainless steel, 270x270 cm
Back left: *Iris*, 1998
Stainless steel
200x200 cm
Back right: *My Body Your Body*, 1993
Fibreglass and pigment, 248x103x205 cm
Installation: "Anish Kapoor,"
Hayward Gallery, London, 1998
Photo John Riddy, London

p. 252
Suck, 1998
Stainless steel
270x270 cm
Installation: "Anish Kapoor,"

Hayward Gallery, London, 1998
Photo John Riddy, London

p. 253
Reason, Space, 1998
Perspex
64x145x165 cm
Installation: "Anish Kapoor,"
Hayward Gallery, London, 1998
Photo John Riddy, London

p. 254-255
Background: *Yellow*, 1998
Fibreglass and pigment
245x245x140 cm
Front left: *Untitled*, 1998
Fibreglass
243x335x162 cm
Front right: *Turning the World Inside Out*, 1995
Cast aluminium, 148x184x188 cm
Installation: "Anish Kapoor,"
Hayward Gallery, London, 1998
Photo John Riddy, London

p. 256
Untitled, 1998
Fibreglass
243x335x162 cm
Installation: "Anish Kapoor,"
Hayward Gallery, London, 1998
Photo John Riddy, London

p. 257
Yellow, 1998
Fibreglass and pigment
245x245x140 cm
Installation: "Anish Kapoor,"
Hayward Gallery, London, 1998
Photo John Riddy, London

p. 259-263
At the Edge of the World, 1998
Fibreglass and pigment
500x800x800 cm
Installation: Centro Galego de Arte
Contemporanea, Santiago de Compostela,
1998
Photo John Riddy, London

268

Biography

1954	Born, Bombay, India
1973-77	Hornsey College of Art, London
1977-78	Chelsea School of Art, London
1979	Taught at Wolverhampton Polytechnic
1982	Artist-in-Residence, Walker Art Gallery, Liverpool
1990	Premio Duemila at XLIV Biennale Internazionale d'Arte, Venice
1991	Turner Prize
1997	Awarded an Honorary Fellowship at the London Institute
	Lives and works in London

Exhibition History

Information regarding *Solo Exhibitions* listed
in sequence, according to city, exhibition site,
title of exhibition, length of exhibition, data
provided in catalogue (if one exists; for
complete information on catalogues see
bibliography, section *Books, Solo Exhibitions
Catalogues*) and in texts contained therein.
There follows a complete list of exhibited
works and a selection of the most important
reviews.
Information regarding the title, date, technique
and size (height, width, depth in cms.)
is supplied for each piece listed.
The measurements of works comprising
different elements indicate overall size, unless
otherwise specified. Pieces featured in more
than one exhibition are described in detail only
for the first exhibition; afterwards, they are
accompanied by a brief description and an
asterisk.
For *Group Exhibitions*, the criterion and the
sequence according to which information is
supplied is the same, but only the titles of
works created for a particular exhibition
appear in the square brackets.

Solo Exhibition

1980

Paris, Patrice Alexandre.
Works in exhibition: *1000 Names*, 1979–80, five elements, mixed media, pigment, 74x71.5x71.5 cm; *1000 Names*, 1979–80, mixed media, pigment, 35.5x22.9x33 cm; *1000 Names*, 1979–80, two elements, mixed media, pigment, 28x200x91.5 cm.

1981

London, Coracle Press, 3 April–1 May.
Works in exhibition: *1000 Names*, 1979–80* [Alexandre 1980, two elements]; *1000 Names*, 1981, mixed media, chalk, 70x130 cm; *1000 Names*, 1981, five elements, wood, chalk, pigment, 122x183x183 cm.

1982

Liverpool, Walker Art Gallery, 13 March–18 April.
Works in exhibition: *As if to Celebrate I Discovered a Mountain Blooming with Red Flowers*, 1981, five elements, wood, cement, polystyrene, pigment, 107x305x305 cm.

London, Lisson Gallery, 19 May–12 June.
Works in exhibition: *White Sand, Red Millet, Many Flowers*, 1982, four elements, wood, cement, pigment, 101x241.5x217.4 cm; *Red in the Centre*, 1982, earth, pigment, dimensions variable; *Red in the Centre II*, 1982, earth, pigment, dimensions variable; *1000 Names*, 1982, earth, pigment; six untitled drawings, mixed media on paper.
- William Feaver, "Charred remains," «The Observer,» London, 30 May 1982;
- Caroline Collier, "Anish Kapoor," «Arts Review,» London, 4 June 1982, pp. 289–290;
- Michael Newman, "Anish Kapoor," «Art Monthly,» no. 58, London, July–Aug. 1982, p. 15;
- John Coleman, "Anish Kapoor, Lisson Gallery," «Flash Art International,» no. 110, Milan, 1983.

1983

Rotterdam, Galerie 't Venster, 21 Jan.–23 Feb. (organised by The Rotterdam Arts Council). Catalogue with text by Michael Newman.
Works in exhibition: *1000 Names*, 1980; *1000 Names*, 1980; *1000 Names*, 1981; *To Reflect an Intimate Part of the Red*, 1981, five elements, mixed media, pigment, 200x800x800 cm c.; *As if to Celebrate I Discovered a Mountain Blooming with Red Flowers*, 1981*; *1000 Names*, 1982; *Three*, 1982, four elements, wood, cement, earth, pigment, 91.5x91.5x91.5 cm c. each; *1000 Names*, 1982; *1000 Names*, 1982.
- Paul Groot, "Anish Kapoor: 't Venster Gallery," «Flash Art International,» no. 112, Milan, May 1983, pp. 70–71.

Liverpool, Walker Art Gallery, "Feeling into Form," 16 March–17 April. Catalogue with text by Marco Livingstone. Traveled to Villeurbanne, Lyon, Le Nouveau Musée, 20 May–5 July.
Works in exhibition: *1000 Names*, 1981, two elements, wood, cement, polystyrene, pigment, 30x30x30 cm c. each; *Three*, 1982*; *Red in the Centre*, 1982, five elements, earth, pigment; *Tongue*, 1982, wood, cement, polystyrene, pigment, 61x91.5x91.5 cm c. each; *Full*, 1983, five elements, wood, cement, polystyrene, pigment, four elements 91.5x91.5x91.5 cm c., one element 107x61x107 cm c.; *Six Secret Places*, 1983,

Studio of the artist, London, 1983

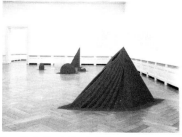

Kunsthalle Basel, Basel, 1985

mixed media, pigment, 115x425x60 cm; *1000 Names*, 1983, wood, cement, polystyrene, pigment, 107x107x107 cm c.; *1000 Names*, 1983, two elements, wood, cement, polystyrene, pigment.

London, Lisson Gallery, 22 Oct.–19 Nov.
Works in exhibition: *Untitled*, 1983, mixed media, gold leaf, 70x70x70 cm; *1000 Names*, 1983, mixed media, 38x38x38 cm; *1000 Names*, 1983, mixed media, gold leaf, 45x55x31 cm; *1000 Names*, 1983, mixed media, 120x80x20 cm; *1000 Names*, 1983, mixed media, 35x30x48 cm; *Hole and Vessel*, 1983, mixed media, pigment, 240x150x60 cm; *1000 Names*, 1983, mixed media, 45x30x45 cm; *1000 Names*, 1983, mixed media, 55x18x45; *Six Secret Places*, 1983, mixed media, 115x425x60 cm; *1000 Names*, 1983, mixed media, 50x50x60 cm; *Untitled*, 1983, mixed media, 70x70x70 cm; *1000 Names*, 1983, mixed media, 39x39x39 cm.
- Amanda Baillieu, "Strange Monoliths," «LAM Magazines,» Oct. 1983;
- Sarah Kent, "Review," «Time Out,» London, 3–9 Nov. 1983;
- Richard Cork, "Lucid Form," «Evening Standard,» London, 3 Nov. 1983;
- Mary Rose Beaumont, "Anish Kapoor, Lisson Gallery," «Arts Review,» London, 11 Nov. 1983;
- Caroline Collier, "Anish Kapoor at the Lisson Gallery," «Studio International,» no. 1003, Dec. 1983, p. 51;
- John Coleman, "Anish Kapoor, Lisson Gallery," «Flash Art,» no. 115, Milan, Jan. 1984, p. 39.

1984

New York, Barbara Gladstone Gallery, 3–31 March.
Works in exhibition: *Black Earth*, 1983, four elements, polystyrene, cement, earth, acrylic, pigment, 259x571.5x236 cm; *Chant of Blue*, 1984, three elements, polystyrene, cement, earth, acrylic, pigment, 129.5x272x213.5 cm; *Half*, 1984, polystyrene, cement, earth, pigment, diam 170x96.5 cm; *1000 Names*, 1984, polystyrene, cement, earth, pigment, 70x70x84 cm; *1000 Names*, 1984, polystyrene, cement, earth, pigment, 33x30.5x84 cm; *Half*, 1984, polystyrene, cement, earth, pigment, 86.3x104x45.7 cm; *Untitled*, 1984, polystyrene, cement, earth, pigment, 101.6x106.6x137.2 cm; *1000 Names*, 1984, polystyrene, earth, cement, wood, pigment, 40.6x38x35.3 cm; *Hole and Vessel*, 1984, polystyrene, cement, earth, pigment, 92.2x162.2x110 cm.
- Dan Cameron, "Anish Kapoor," «Arts Magazine,» March 1984, p. 4;
- John Russell, "Anish Kapoor," «The New York Times, Weekend Section,» New York, 23 March 1984;
- D.J., "Anish Kapoor," «Currents,» no. 39, New York, April 1984;
- Ellen Handy, "Anish Kapoor," «Arts Magazine,» May 1984, p. 44;
- Nancy Princenthal, "Anish Kapoor, Barbara Gladstone," «Artnews,» New York, Summer 1984, p. 189;
- Kenneth Baker, "Anish Kapoor at Barbara Gladstone," «Art in America,» no. 72, New York, Oct. 1984, pp. 189–190.

1985

London, Lisson Gallery, 4–23 Sept.
Works in exhibition: *In Search of the*

Mountain II, 1985, wood, chalk, pigment, 100x45x65 cm; *Pot for Her*, 1985, wood, chalk, pigment, 100x275x175 cm; *1000 Names*, 1985, wood, chalk, pigment 125x50x70 cm; *Mother as a Mountain*, 1985, wood, chalk, pigment, 145x200x145 cm; *Place*, 1985, wood, chalk, pigment, 90x80x80 cm; *The Pot is a God I*, 1985, wood, chalk, pigment, 45x80x80 cm; *The Pot is a God II*, 1985, wood, chalk, pigment, 55x45x40 cm; three untitled drawings, 1985, mixed media on paper.
- Sarah Kent, "Anish Kapoor," «Time Out,» London, 19–25 Sept. 1985;
- Caroline Collier, "Forms a hole can take...: Anish Kapoor, London, Lisson Gallery," «Studio International,» vol. CXCVIII, no. 1010, pp. 43–44;
- Marina Vaizey, "A new star carves out a sculpture for our time," «The Sunday Times,» London, 8 Sept. 1985;
- William Packer, "The age of discardment," «Financial Times,» New York, 19 Sept. 1985.

Basel, Kunsthalle, 6 Oct.–10 Nov. Catalogue with texts by Jean-Christophe Ammann, Alexander von Grevenstein, Ananda Coomaraswamy. Traveled to Eindhoven, Stedelijk Van Abbemuseum, 3 May–8 June 1986.
Works in exhibition: *To Reflect an Intimate Part of the Red*, 1981*; *Six Secret Places*, 1983*; *Untitled*, 1983, mixed media, h 152 cm c.; *Untitled*, 1985, mixed media, 254x114.5x114.5 cm; *In Search of the Mountain II*, 1985*; *Pot for Her*, 1985*; *1000 Names*, 1985*; *Mother as a Mountain*, 1985*; *Place*, 1985, mixed media, 90x80x80 cm; *The Pot is a God I*, 1985*; *The Pot is a God II*, 1985*; six untitled drawings, 1985, mixed media on paper.
- Siegmar Gassert, "Tisch und Stuhl und Kreis und Kugel und Muschel," «Basler Zeitung,» Basel, 7 Oct. 1985;
- "'Noli me tangere' und 'Beruhren gestattet'," «Basellandschaftliche Zeitung,» Liestal, Switzerland, 9 Oct. 1985;
- P.B., "Neues aus Amerika und Indien," «Der Bund,» Bern, 10 Oct. 1985;
- Roman Hollenstein, "Von Johns und Artschwager bis Kapoor," «Neue Zurcher Zeitung,» Zurich, 10 Oct. 1985;
- Susan Moser–Ehinger, "Auf den Skulpturen liegt leuchtend farbiges Pulver," «Südkurier Konstanz,» Konstanz, Germany, 11 Oct. 1985;
- Susan Moser–Ehinger, "Zum Berühren und Nichtberühren," «Solothurner Zeitung,» Solothurn, Switzerland, 12 Oct. 1985;
- Max Wechsler, "Werke Richard Artschwager und Anish Kapoor," «Vaterland,» Luzern, 16 Oct. 1985;
RD., "Der lange und der endlose Weg," «Nordschweiz,» Basel, 16 Oct. 1985;
- Anneliese Zwez, "Zwei Pole: Intellektuelle Konzepte un sinnliche Strahlkraft," «Aargauer Tagblatt,» Aargau, Switzerland, 17 Oct. 1985;
- Guy Curdy, "Illusion et Couleur," «Le Démocrate,» Delémont, Switzerland, 19 Oct. 1985;
- Philippe Mathonnet, "Poudre aux yeux et faux bois!," «Journal de Genève,» Geneva, 19 Oct. 1985;
- "Faszination der Gegensätze," «Basler Az.,» Basel, 25 Oct. 1985;
- "Das Kunstwerk als Wahrnehmungsgegenstand," «Bünder

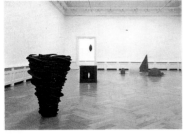
Kunsthalle Basel, Basel, 1985

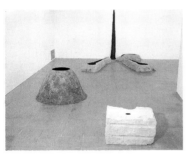
Lisson Gallery, London, 1988

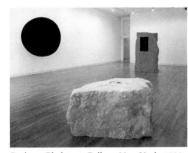
Barbara Gladstone Gallery, New York, 1989

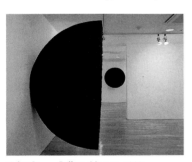
Kohji Ogura Gallery, Nagoya, 1989

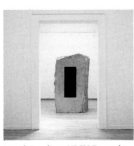
British Pavilion, XLIV Biennale Internazionale d'Arte, Venice, 1990

Zeitung,» Chur, Switzerland, 7 Nov. 1985.

1986
Oslo, Kunstnernes Hus. Catalogue with texts by Arne Malmedal and Lynne Cooke. Works in exhibition: *1000 Names*, 1981* [Coracle Press 1981, 70x130 cm]; *To Reflect an Intimate Part of the Red*, 1981*; *Place*, 1985*; *1000 Names*, 1981, five elements, mixed media, dimensions variable.

New York, Barbara Gladstone Gallery, 3–31 May.
Works in exhibition: *Untitled*, 1986, polystyrene, chalk, cloth, pigment, 75x75x45.7 cm; *Untitled*, 1986, polystyrene, chalk, cloth, pigment, 73.5x73.5x61 cm; *Dark*, 1986, polystyrene, chalk, fibreglass, cloth, pigment, 305x317.5x266 cm circa; *A Flower, a Drama like Death*, 1986, three elements, polystyrene, chalk, cloth, pigment, 56x355x152.5 cm; *Untitled*, 1986, wood, cloth, chalk, pigment, 123.2x123.2x66 cm; *Place*, 1985*; *Blue Flower*, 1986, polystyrene, cloth, chalk, pigment, 50.8x50.8x50.8 cm.
- John Russell, "Bright Young Talents: Six Artists with a Future," «The New York Times,» Section 2, New York, 18 May 1986, pp. 1, 31;
- "Anish Kapoor, Barbara Gladstone," «Artforum,» New York, Nov. 1986.

Amherst, University Gallery, Fine Arts Center, University of Massachusetts, "Anish Kapoor: Recent Sculpture and Drawings," 1 Nov.–14 Dec. Catalogue with text by Helaine Posner.
Works in exhibition: *1000 Names*, 1980, wood, chalk, pigment, 53.5x10x37 cm; *Black Earth*, 1983*; *Hole and Vessel*, 1984*; *Place*, 1985*; *Blue Flower*, 1986*; *A Flower, a Drama like Death*, 1986*; seven untitled drawings, 1984–86, mixed media on paper.

1987
Sydney, Ray Hughes Gallery, "Anish Kapoor: on Paper 1975–1987." Catalogue with interview by Richard Cork. Traveled to Brisbane, Museum of Modern Art.
Works in exhibition: seventy-nine untitled drawings, 1975–87, mixed media on paper.

1988
London, Lisson Gallery, 11 April–7 May.
Works in exhibition: *Painting No. 1*, 1986, earth, oil, pigment on wood, 177x122 cm; *Painting No. 2*, 1987, earth, oil, papier mâché on wood, 178x122 cm; *Painting No. 3*, 1987, sawdust, earth, acrylic on wood, 177x122 cm; *At the Hub of Things*, 1987, fibreglass, pigment, 163x141 cm, diam 150 cm; *Virgin*, 1987–88, microcrystalline wax, fibreglass, pigment, h 110 cm, diam 168 cm; *Body*, 1988, microcrystalline wax, mixed media, h 110 cm, diam 173 cm; *I*, 1987, limestone, 59x63x95 cm; *Wound*, 1988, limestone, pigment, 308x432x331 cm; *Sky*, 1988, earth, mixed media, 48x206x122 cm.
- Marina Vaizey, "Shaping up to Abstracts," «The Sunday Times,» London, 17 April 1988;
- David Lee, "Anish Kapoor, Lisson Gallery," «Arts Review,» London, 22 April 1988;
- Rupert Martin, "The Journey from an Earthly to a Heavenly Body," «Flash Art International,» Milan, Summer 1988, p. 159.

1989
New York, Barbara Gladstone Gallery, 1–29 April.
Works in exhibition: *Adam*, 1988–89, sandstone, pigment, 120.6x104x238.5 cm; *Void*, 1988–89, fibreglass, pigment, 205.5x205.5x115.5 cm; *Untitled*, 1989, limestone, pigment, 194.5x200.5x77.5 cm; *Moonstone*, 1989, slate, pigment, 129.5x105.5x37 cm.
- Peter Schjeldahl, "Earthy but Housebroken," «7 Days,» New York, 19 April 1989;
- Eleanor Heartney, "Anish Kapoor," «Tema Celeste,» English edition, no. 21, July–Sept. 1989;
- Stephen Westfall, "Anish Kapoor, Barbara Gladstone Gallery," «Flash Art,» no. 147, Summer 1989;
- "Anish Kapoor, Barbara Gladstone Gallery," «Arts Magazine,» Sept. 1989, p. 98;
- «Arts Magazine,» Oct. 1989, p. 46.

Nagoya, Japan, Kohji Ogura Gallery, 9 Sept.–14 Oct. (in collaboration with Lisson Gallery, London). Catalogue with text by Pier Luigi Tazzi.
Works in exhibition: *Virgin*, 1987–88*; *Void*, 1989, fibreglass, pigment, 121.9x121.9x91.4 cm; *Mother as a Ship*, 1989, fibreglass, pigment, 215.9x119.3x106.6 cm; *1000 Names*, 1979–80, wood, chalk, 76x76x38 cm.

London, Lisson Gallery, "Void Field," 1 Dec.1989–4 Jan. 1990.
Works in exhibition: *Void Field*, 1989, sixteen elements, sandstone, pigment, dimensions variable; *Angel*, 1989, slate, pigment, 245x150x42 cm.
- Andrew Graham–Dixon, "Pride and Prejudice," «The Independent,» London, 5 Dec. 1989;
- Richard Dorment, "Vexed questions of colour," «Daily Telegraph,» London, 9 Dec. 1989;
- William Feaver, "Voices from the void," «The Observer,» London, 10 Dec. 1989, p. 44;
- Marina Vaizey, "Why elementality does not tell the whole story," «The Sunday Times,» London, 10 Dec. 1989;
- William Packer, "Sculptor with the best of both worlds," «Financial Times,» London, 12 Dec. 1989;
- Sarah Kent, "Anish Kapoor," «Time Out,» London, 13 Dec. 1989;
- Richard Cork, "Airy as a rock," «The Listener,» London, 14 Dec. 1989, p. 42;
- David Lillington, "Anish Kapoor," «Arts Review,» vol. XLI, no. 25, London, 15 Dec. 1989, pp. 889–890;
- Giles Auty, "Anish Kapoor at Lisson Gallery," «Spectator,» London, 16 Dec. 1989, p. 35;
- Mark Currah, "Anish Kapoor, Lisson Gallery," «City Limits,» London, 21 Dec. 1989, p. 109;
- Noemi Smolik, "Anish Kapoor, Lisson, London," «Noema,» Jan. 1989–Feb. 1990, pp. 66–67;
- Andrew Renton, "Art," «Blitz,» London, 1 Feb. 1990, p. 28;
- Marjorie Allthorpe–Guyton, "Anish Kapoor, Lisson Gallery," «Artforum,» New York, March 1990, pp. 175–176;
- Andrew Renton, "Anish Kapoor, Lisson," «Flash Art International,» Milan, no. 151,

March–April 1990, pp. 151–152;
- William Feaver, "Anish Kapoor," «Artnews,» New York, April 1990, p. 179.

1990
Venice, Giardini di Castello, English Pavilion, XLIV Biennale Internazionale d'Arte, "Anish Kapoor," 27 May–30 Sept. (organised by British Council). Catalogue with texts by Thomas McEvilley and Marjorie Allthorpe–Guyton.
Works in exhibition: *The Healing of St. Thomas*, 1989, mixed media, dimensions variable; *Void Field*, 1989*; *It is Man*, 1989–90, sandstone, pigment, 241x127x114 cm; *Madonna*, 1989–90, fibreglass, pigment, diam 284.5x155 cm; *Black Fire*, 1990, fibreglass, pigment, anthracite, 315x508x180 cm; *A Wing at the Heart of Things*, 1990, two elements, slate, pigment, 28x353x270 cm, 25x295x320 cm.
- "XLIV Venice Biennale 1990," «Visual Arts News,» no. 31, Jan. 1990, p. 1;
- Marjorie Allthorpe–Guyton, "Original sites. The sculpture of Anish Kapoor," «Artscribe,» May 1990, pp. 50–52;
- Penelope Curtis, "Sculpture on the threshold," «The Antique Collector,» May 1990, pp. 66–73;
- Sarah Kent, "Mind over matter," «20/20,» no. 14, May 1990, pp. 36–40;
- Louisa Buck, "Pigments of the imagination," «Sunday Correspondent,» London, 13 May 1990, pp. 10–14;
- Ann Hindry, "Champs de pierre d'Anish Kapoor," «Beaux Arts,» June 1990, pp. 64–77;
- Lisa Licitra Ponti, "Journey to Venice," «l'Arca,» July–Aug. 1990;
- John Kemp, "Stones of Venice: Anish Kapoor at the Biennale," «Modern Painters,» vol. III, no. 2, Summer 1990, pp. 44–46;
- Doris Van Drateln, "Anish Kapoor, Ein Gespräch," «Kunstforum,» vol. CIX, Aug.–Oct. 1990, pp. 304–315;
- Bojana Pejić, "What will become of our sensitive skin...," «Artforum,» vol. XXIX, no. 1, New York, Sept. 1990, pp. 130–132;
- Domenico Scudero, "XLIV Venice Biennale," «Tema Celeste,» Syracuse, Nov.–Dec. 1990.

New York, Barbara Gladstone Gallery, "Drawings," 18 Sept.–6 Oct.
Works in exhibition: twenty-one untitled drawings, 1987–90, mixed media on paper.
- Gregory Galligan, "Steamed-up mirrors and boogie-woogies," «Art International,» no. 14, Spring–Summer 1990;
- Michael Brensen, "Anish Kapoor," «The New York Times,» New York, 28 Sept. 1990;
- Justin Spring, "Anish Kapoor, Barbara Gladstone Gallery," «Artforum,» New York, Dec. 1990, p. 137;
- "New York in Review," «Arts Magazine,» Dec. 1990.

London, Tate Gallery, "Anish Kapoor. Drawings," 3 Oct.–10 Feb. 1991. Catalogue with text by Jeremy Lewison.
Works in exhibition: seventy-four untitled drawings, 1984–90, mixed media on paper.
- "Anish Kapoor's twin peaks," «Bazaar,» no. 15;
- John Russell Taylor, "Shapes and assemblies," «The Times,» London, 3 Oct. 1990;

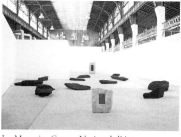

Le Magasin, Centre National d'Art
Contemporain, Grenoble, 1990

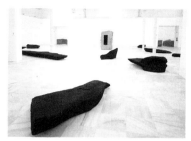

Palacio Velázquez, Parque del Retiro,
Centro de Arte Reina Sofía, Madrid, 1991

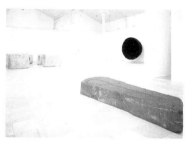

Palacio Velázquez, Parque del Retiro,
Centro de Arte Reina Sofía, Madrid, 1991

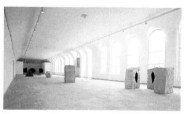

Kunstverein Hannover, Hannover, 1991

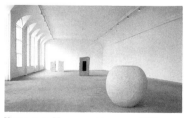

Kunstverein Hannover, Hannover, 1991

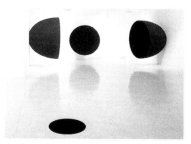

San Diego Museum of Contemporary Art,
La Jolla, 1992

- William Feaver, "Prize wake for timeless values," «The Observer,» London, 7 Oct. 1990;
- Marina Vaizey, "Seeing what comes naturally," «The Sunday Times,» London, 14 Oct. 1990;
- Sarah Kent, "Anish Kapoor," «Time Out,» London, 17 Oct. 1990;
- Stephanie du Tan, "Pigments of the imagination," «The Journal of Art,» vol. III, no. 2, London, Nov. 1990, pp. 31–33;
- Clair Frankel, "Watch where you walk at Tate," «International Herald Tribune,» 17 Nov. 1990;
- Bert Steevensz, "Anish Kapoor," «Metropolis M,» Feb. 1991, p. 48.

Grenoble, Le Magasin, Centre National d'Art Contemporain, 23 Nov.–19 Jan. 1991 (in collaboration with The British Council). Works in exhibition: *Tomb*, 1989, slate, pigment, 48.5x136x392 cm; *The Healing of St. Thomas*, 1989*; *It is Man*, 1989–90*; *Madonna*, 1989–90*; *Three Witches*, 1990, three elements, limestone, pigment, 192x113x89 cm, 202x125x88 cm, 204x110x90 cm; *Untitled (Seven Stones)*, 1990, limestone, dimensions variable; *Angel*, 1990, eleven elements, slate, pigment, dimensions variable; *Untitled*, 1990, Portland stone, 111x94x77 cm.
- Sylvie Perrard, "Quand la pierre devient immatérielle," «Dauphiné Libéré,» 22 Nov. 1990;
- Suzanne Engelson, "Du matériel à l'immatériel... A Grenoble," «Le Gutemberg,» 29 Nov. 1990;
- F.B., "Dark Heart," «The Art Newspaper,» no. 3, London, Dec. 1990;
- Philippe Gonnet, "L'essence de la matière," «Dauphiné Libéré,» 4 Dec. 1990;
- Nelly Gabriel, "Anish Kapoor, magicien et illusioniste," «Lyon Figaro,» Lyon, 4 Dec. 1990;
- Daniel Dobbels, "Kapoor: la forme de l'ineffable," «Libération,» 8 Dec. 1990;
- Geneviève Praplan, "Le désir et la croyance," «La Suisse,» 11 Dec. 1990;
- Bernadette Bost, "Le bleu de l'inconnu," «Le Monde Rhône-Alpes,» 15 Dec. 1990;
- Qg–T.T.D., "Les délices de Kapoor, non sans pigment," «Lyon Libération,» Lyon, 20 Dec. 1990;
- Jean Pagneux, "Les grands cimetières sous la lune," «L'Humanité,» 21 Dec. 1990;
- Claude Guilloteau, «Affiches de Grenobles et du Dauphiné,» 28 Dec. 1990;
- "L'art du silence," «La Suisse,» 31 Dec. 1990;
- J.J.No.,"Le trou noir du trou," «Grenoble Bimensuel,» Grenoble, 18 Dec. 1990–18 Jan. 1991;
- Philippe Piguet, "Monolithes et monochromes," «La Croix,» 15 Jan. 1991;
- "Anish Kapoor at Le Magasin," «Flash Art International,» Milan, vol. XXIV, no. 156, Jan.–Feb. 1991, p. 147;
- Gloria Picazo, "Anish Kapoor," «Lapiz,» no. 75, Madrid, Feb. 1991.

1991

Madrid, Centro de Arte Reina Sofia, Palacio de Velázquez, 2 Feb.–17 April (in collaboration with The British Council). Catalogue (Spanish edition exhibition catalogue for XLIV Biennale Internazionale d'Arte, Venice, 1990).

Works in exhibition: *Void Field*, 1989*; *Tomb*, 1989*; *Madonna*, 1989–90*; *It is Man*, 1989–90*; *Three Witches*, 1990*; *Untitled*, 1990* [Le Magasin 1990, 111x94x77 cm]; *Angel*, 1990*; *Untitled (Seven Stones)*, 1990*; *The Earth*, 1991, mixed media, 102x102x91 cm.
- C.I. de Bustos, "Torres, Lupertz, Brossa y Kapoor: cita de la ultimas tendencias en el CARS," «ABC Magazine,» 5 Feb. 1991, p. 50;
- "El Reina Sofia, en plena actividad," «El Punto,» 12 Feb. 1991, p. 18;
- "Torres, Lupertz, Kapoor y Brossa, en el Reina," «El Punto,» 14 Feb. 1991, p. 19;
- Juan Manuel Bonet, "Lupertz y Kapoor, dos voces europeas de los ochenta," «ABC Magazine,» 14 Feb. 1991, p. 126;
- F. Calvo Serraller, "Hacia el esplendor," «El Pais Magazine,» Madrid, 17 Feb. 1991, pp. 4–5;
- Maria Lluïsa Borràs,"Anish Kapoor exhibe esculturas de origine cromatismo en el palacio Velázquez," «La Vanguardia,» 18 Feb. 1991, p. 35;
- "Anish Kapoor, la escultura y el presente," «El Punto,» 8 March 1991;
- Pablo Llorca, "Literatura complicada, obra sencilla," «Diario 16,» 8 March 1991, p. 42.

Cologne, Feuerle Gallery, "Anish Kapoor & Ban Chiang," 15 Feb.–28 March. Catalogue with text by Angel Garcia. Works in exhibition: *Void*, 1990, fibreglass, pigment, 92x92x78 cm; *Angel*, 1991, slate, pigment, 70x160x95 cm; *Void*, 1991, fibreglass, pigment, 93x129x95; five untitled drawings, 1987–90, mixed media on paper.
- Cornel Bierens, "Urformen der Kulturen," «Kolner Stadtanzeiger (KSTA),» Cologne, 21 March 1991;
- Beate Eickhoff, "Anish Kapoor und Gefäße der Ban–Chiang Kultur," «Kunstforum,» May–June 1991, pp. 365–366.

Hannover, Kunstverein, 10 May–14 June (in collaboration with The British Council). Catalogue.
Works in exhibition: *Tomb*, 1989*; *It is Man*, 1989–90*; *Mountain*, 1989–90, fibreglass, earth, pigment, diam 208x182.8 cm; *Untitled*, 1990, three elements, fibreglass, pigment, diam 250x 167 cm each; *Three Witches*, 1990*; *Untitled*, 1991, sandstone, pigment, diam 152.4x156.2 cm.

Ushimado, "The Sixth Japan Ushimado International Art Festival".
Works in exhibition: *The Earth*, 1991*; *Untitled*, 1991, mixed media, dimensions variable.

1992

La Jolla, San Diego Museum of Contemporary Art, 1 Feb.–5 July. Catalogue with texts by Lynda Forsha and Pier Luigi Tazzi.
Works in exhibition: *The Healing of St. Thomas*, 1989*; *Untitled*, 1990, three elements, fibreglass, pigment, c. 250x170 cm each; *Angel*, 1990, eight elements, slate, pigment, dimensions variable; *Untitled*, 1991, marble, 174x90x93 cm; *In the Presence of Form*, 1991, sandstone, 173x114x181 cm; *Pillar of Light*, 1991, sandstone, 152x153x143 cm; *The Earth*, 1991*; *When I am Pregnant*, 1992, mixed media, dimensions variable; *Untitled*, 1993, mixed media, pigment, dimensions variable, element: 19x14.3x1.3 cm.

Traveled to Des Moines, Des Moines Art Center, 30 Jan.–25 April 1993; Ottawa, The National Gallery of Canada, 18 June–19 Sept. 1993. Works in exhibition: *The Healing of St. Thomas*, 1989*; *Angel*, 1990*; *Three Witches*, 1990*; *Untitled*, 1990*; *In the Presence of Form*, 1991*; *Untitled*, 1991*; *Pillar of Light*, 1991*; *When I am Pregnant*, 1992*; The Power Plant, Toronto, 19 Nov. 1993–2 Jan. 1994. Works in exhibition: *Pillar of Light*, 1989*; *The Healing of St. Thomas*, 1989*; *Angel*, 1990*; *Untitled*, 1990*; *In the Presence of Form*, 1991*; *Untitled*, 1991*; *When I am Pregnant*, 1992, mixed media, dimensions variable.
- Priscilla Lister, "Anish Kapoor: Contradictions say something," «San Diego Daily Transcript,» San Diego, 29 Jan. 1992;
- Susan Freudenheim, "Creating art from a diverse heritage," «San Diego County Los Angeles Times,» 30 Jan. 1992;
- Ann Jarmusch, "Dark and dangerous," «San Diego Tribune,» San Diego, 31 Jan. 1992;
- Robert L. Pincus, "Kapoor's fame far exceeds his ego," «The San Diego Union Tribune,» San Diego, 2 Feb. 1992;
- Kenneth Baker, "Between a rock and a soft place," «San Francisco Chronicle,» San Francisco, 26 Feb. 1992;
- Robert L. Pincus, "Sublime case of the blues," «San Diego Union-Tribune,» San Diego, 5 March 1992;
- Peter Clothier, "Metaphor or metaphysics, Jackie Winsor and Anish Kapoor," «Artspace,» Los Angeles, May–June 1992, pp. 44–49;
- Joseph Newland, "Spirit forms, Anish Kapoor at the Museum of Contemporary Art, San Diego," «Artweek,» 18 June 1992;
- Judith Christensen, "Anish Kapoor, San Diego Museum of Contemporary Art," «Sculpture,» July–Aug. 1992, p. 64;
- "San Diego, Kapoor at the MCA," «Flash Art International,» Milan, Vol. XXV, no. 166, Oct. 1992, p. 118;
- Jim Duncan, "Sculptor's granite caves pulls meditative viewers," «Des Moines Business Record,» Des Moines, 25 Jan. 1993;
- Eliot Nusbaum, "From floating stones to hollow tubes," «The Register,» Des Moines, Feb. 1993;
- Colette Tougas, "Anish Kapoor," «Parachute,» April–June 1993, pp. 30–31;
- Nancy Beale, "Two sculptors, two views of life," «The Ottawa Citizen,» Ottawa, 20 June 1993;
- Gillian MacKay, "British sculptor," «Canadian Art,» Summer 1993, p. 11;
- Nancy Beale, "Triple play at the National Gallery," «The Ottawa Citizen,» Ottawa, 20 June 1993;
- Nancy Beale, "Summer shows provide feast for all tastes," «The Ottawa Citizen,» Ottawa, 30 June 1993;
- Kate Taylor, "Healing visions carved in stone," «Globe and Mail,» Toronto, 5 July 1993;
- Ann Duncan, «The Gazette,» Ottawa, 16 July 1993;
- Lynda Forsha, "Anish Kapoor, Museum of Contemporary Art, San Diego," «Flash Art International,» Milan, Vol. XXVI, no. 168, Jan.–Feb. 1993, p. 132.

Madrid, Galeria Soledad Lorenzo, 28 April–30 May. Catalogue with text by José-

Lisson Gallery, London, 1993

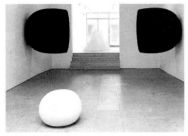

Lisson Gallery, London, 1993

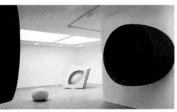

Tel Aviv Museum of Art, Tel Aviv, 1993

The High Museum of Art, Atlanta, 1997

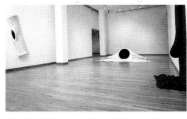

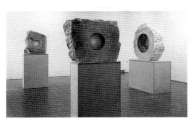

Lisson Gallery, London, 1998

274

Miguel Ullán.
Works in exhibition: *Angel*, 1990, slate, pigment, 64x114x114 cm; *Untitled*, 1990–92, Forest of Dean sandstone, pigment, 195x107x88.9 cm; *Void*, 1991–1992, fibreglass, pigment, diam 165 cm c.; *When I am Pregnant*, 1991–92, mixed media, diam 127x31.75 cm; *Untitled*, 1991–92, marble, 136.5x91.5x65.4 cm.
- Fietta Jarque, "La cultura monolítica europea ha dejado de existir, según el escultor Anish Kapoor," «El Pais,» Madrid/Barcelona, 27 April 1992;
- F. Calvo Serraller, "El arte del vacío," «El Pais,» Madrid/Barcelona, 27 April 1992;
- Betriz Pottecher, "Se ha puesto el gallo incierto, hombre," «El Mundo,» Madrid, 2 May 1992;
- Pablo Jiménez, "Anish Kapoor, entre el objeto y la pintura," «ABC de las artes,» Madrid, 8 May 1992;
- Fietta Jarque, "La experiencia de Anish Kapoor.'Cuando estoy embarazado'," «Guia de "El Pais",» Madrid, 8 May 1992;
- Jose Ramon Danvila, "Anish Kapoor, lo espiritual en la creación," «El Punto de las Artes,» Madrid, 8–14 May 1992, p. 5;
- Marcos R. Barnatán, "Un misterioso aerolito azul,"«El Mundo–Magazine,» Madrid, 9–10 May 1992;
- Ramón F. Reboiras and Miguel Fernandez, "La danza del cosmos," «Cambio 16,» Madrid, 10 May 1992, pp. 124–127;
- Rosa Olivares, "Anish Kapoor," «Lapiz,» no. 87, Madrid, May–June 1992, p. 74;
- Magdala Perpinyà, "Anish Kapoor, la irradiació del buit," «Papiers d'Art,» June–Aug. 1992, p. 19.

Los Angeles, Stuart Regen Gallery, Sept.–Oct.
Works in exhibition: *Untitled*, 1990* [Le Magasin 1990, 111x94x77 cm]; *Void*, 1992, fibreglass, pigment, 92x92x76.2 cm; *When I am Pregnant*, 1992*; *Untitled*, 1992, mixed media, dimensions variable.
- Susan Kandel, "The push and pull of Kapoor's metaphors," «Los Angeles Times,» Los Angeles, 9 Oct. 1992;
- Ralph Rugoff, "Depth of Field. Anish Kapoor's erotic pigments," «Los Angeles Weekly,» Los Angeles, 9–15 Oct. 1992.

1993
London, Lisson Gallery, 16 April–20 May.
Works in exhibition: *Icon*, 1992–93, mixed media, dimensions variable; *Passage*, 1993, sandstone, pigment, 169x172x134 cm; *Untitled*, 1993, mixed media, dimensions variable; *Untitled*, 1993, mixed media, dimensions variable; *In the Presence of Form II*, 1993, Portland stone, 175x201x122 cm; *Untitled*, 1993, mixed media, dimensions variable; *Eyes Turned Inward*, 1993, two elements, fibreglass, pigment, 155x155x135.5 cm each; *Bright Mountain*, 1993, fibreglass, paint, 140x231x147 cm; *Portrait of Light Picture of Space*, 1993, wood, paint, 198.5x107x5.2 cm; *Untitled*, 1993, plaster, pigment, 189.5x76.5x166 cm; three untitled drawings, 1993, mixed media on paper.
- Roger Bevan, "Kapoor at Lisson with stage designs," «The Art Newspaper,» London, April 1993;
- Celia Lyttelton, "Anish Kapoor," «Interiors,» London, April 1993;
- Martin Gayford, "Watch this space,"

«Telegraph Magazine,» London, 10 April 1993, pp. 50–51;
- Richard Cork, "The shapeliness of things to come," «The Times,» London, 23 April 1993;
- Sarah Kent, "Shaping up," «Time Out,» London, 28 April 1993;
- Giles Auty, "Shock tactics," «Spectator,» London, 1 May 1993;
- William Feaver, "New life out of old wood," «The Observer,» London, 2 May 1993;
- John McEwen, "Anthony Green, Anish Kapoor, Alison Wilding, David Nash, and Sutherland," «The Sunday Telegraph,» London, 2 May 1993;
- William Packer, "Never had it so good," «Financial Times,» London, 4 May 1993;
- Richard Dorment, "Body of work that cries out to be touched," «Daily Telegraph,» London, 5 May 1993;
- Simon Grant, "Anish Kapoor, Lisson Gallery," «What's On In London,» London, 12 May 1993;
- Leslee Wills, "Anish Kapoor, Lisson Gallery," «The Weekly Journal,» London, 13 May 1993;
- David Batchelor, "Anish Kapoor," «Galeries Magazine,» Paris, Summer 1993, p. 136;
- Marta Dalla Bernardina, "Lo spettatore e l'opera," «Segno,» no. 126, Summer 1993;
- Jeffrey Kastner, "Anish Kapoor, Lisson," «Flash Art International,» Milan, Vol. XXVI, no. 171, Summer 1993, p. 122;
- Keith Patrick, "Anish Kapoor, Lisson Gallery, London," «Art Line, International Art News,» vol. V, no. 8, Summer 1993;
- Claudia Peres, "Sculture da meditazione," «Casa Vogue,» Milan, July–Aug. 1993, pp. 54–57;
- "Anish Kapoor, Lisson," «Artnews,» New York, Oct. 1993, pp. 174–175.

Tel Aviv, Tel Aviv Museum of Art, 2 Sept.–6 Nov. Catalogue with text by Nehama Guralnik and a conversation between Anish Kapoor and Homi Bhabha.
Works in exhibition: *Tomb*, 1989*; *Angel*, 1990*; *When I am Pregnant*, 1992*; *Untitled*, 1992, sandstone, 188x107x67 cm; *Untitled: Void*, 1993, fibreglass, pigment, 155x155x135.5 cm; *Passage*, 1993*; *Untitled*, 1993* [Lisson 1993, 189.5x76.5x166 cm]; *Eyes Turned Inward*, 1993*.
- Felice Maranz, "Searching for the sacred Place," «The Jerusalem Report,» Jerusalem, 7 Oct. 1993.

New York, Barbara Gladstone Gallery, 27 Nov. 1993–15 Jan. 1994.
Works in exhibition: *Bright Mountain*, 1993*; *Untitled*, 1993, fibreglass, pigment, diam 166.4x152.4 cm; *Untitled*, 1993, sandstone, 132x81x107 cm; *Untitled*, 1993, sandstone, 81x94x119 cm; *Untitled*, 1993, sandstone, 92x109x145 cm; *Untitled*, 1993, sandstone, 165x92x145 cm.
- "Exporama: Anish Kapoor," «Artpress,» no. 188, Paris, Feb. 1994, p. 72;
- Carol Kino, "Spiky peaks and shadowy voids," «Artnews,» New York, March 1994, p. 133;
- Donald Kuspit, "Anish Kapoor," «Artforum,» vol. XXXII, no. 7, New York, March 1994, pp. 83–84.

1994
Ljubljana, Mala Galerija, Moderna Galerija

Ljubljana, 13 May–12 June. Catalogue with text by Zdenka Badovinac.
Works in exhibition: *The Healing of St. Thomas*, 1989; *Untitled*, 1990–92, Forest of Dean sandstone, pigment, 195.5x107x88.9 cm; *Void*, 1991–92, fibreglass, pigment, diam 165.1x119.4 cm.

Nagoya, Kohji Ogura Gallery, "Echo," 21 Sept.–29 Oct. (in collaboration with Lisson Gallery, London).
Works in exhibition: *Echo*, 1993, five elements, wood, patinated bronze, ceramic, acrylic, gouache, musical mechanism, 9x12.5x12.5 cm, 17x29.5x21 cm; diam 26x39.5, 10x28x24.5 cm, diam 14.5x24 cm; thirteen untitled drawings, 1985–94, mixed media on paper.
- "Anish Kapoor," «Bijutsu Techo,» Japan, Jan. 1995, pp. 185–182.

1995
Tilburg, DePont Foundation, 11 March–2 July. Catalogue with text by Francesco Bonami.
Works in exhibition: *When I am Pregnant*, 1992*; *Untitled*, 1992, sandstone, pigment, 230x122x103 cm; *Untitled*, 1992, sandstone, pigment, 241x150x119 cm; *Untitled*, 1994–95, Kilkenny limestone, 202.5x140x125 cm; *Untitled*, 1994–95, limestone, 188x150x175 cm; *Untitled*, 1994–95, limestone, 180x136x100 cm; *Untitled*, 1994–95, wood, paint, 206x152.3x127.2 cm; *Untitled*, 1994–95, wood, paint, 206x152.6x127.8 cm; *Untitled*, 1995, aluminium, 149x98x99 cm; sixteen untitled drawings, 1994–95, mixed media on paper.
- Tony Godfrey, "Maastricht and Tilburg, the Bonnefanten Museum; Anish Kapoor," «The Burlington Magazine,» London, June 1995, pp. 407–408.

Tokyo, Nishimura Gallery.
- "Anish Kapoor", «Bijutsu Techo», Japan, 1 Jan. 1995, pp. 185-182;
- Hideto Akasaka, "Anish Kapoor", «GQ Japan», May 1995.

Milan, Prada Milanoarte, 25 Nov. 1995–4 Jan. 1996. Catalogue/book by Germano Celant.
Works in exhibition: *Untitled*, 1992, sandstone, pigment, 241x150x119 cm; *Turning the World Upside Down*, 1995, stainless steel, 120x120x120 cm; *Cloud*, 1995, wood, fibreglass, paint, 205.7x152.4x126.9 cm; *Turning the World Inside Out II*, 1995, chromium-plated bronze, 145x185x185 cm.
- "Anish Kapoor alla Fondazione Prada," «Flash Art,» No.194, Milan, Oct./ Nov. 1995, p. 56;
- Silvia Robertazzi, "Première," «Elle Decor,» Milan, Nov. 1995;
- S.D.O., "Kapoor o la pienezza del vuoto," «Il Giornale dell'Arte,» Turin, Nov. 1995;
"Pure spirit," «L'Uomo Vogue,» Milan, Nov. 1995;
- Angela Vettese, "Dentro gli ambigui vuoti di Anish Kapoor," «Il Sole 24 Ore,» Milan, 26 Nov. 1995;
- Francesco Somaini, "Le forme oscure di Anish Kapoor," «Il Giorno,» Milan, 26 Nov. 1995;
- L. Go., "Le sculture di Kapoor, mago dello spaesamento," «Il Messaggero,» Rome, 26 Nov. 1995;
- Marco Meneguzzo, "I 'buchi neri' di

Kapoor," «Avvenire,» Rome, 26 Nov. 1995;
- "Anish Kapoor", «Abitare,» Milan, Dec. 1995;
- "Rocce metafisiche", «Interni,» Milan, Dec. 1995;
- L. Cab., "le Mostre," «Arte,» Milan, Dec. 1995;
- Rachele Ferrario, "A me gli occhi," «Arte in,» Dec. 1995, pp. 80-81;
- Luciana Baldrighi, "Il mondo 'a parte'," «Il Giornale,» Milan, 1 Dec. 1995;
- Giovanni Bai, "Abissi di pietra e di metallo le sculture-sogno di Kapoor," «L'Indipendente,» Milan, 3 Dec. 1995;
- Roberto Di Caro, "Non voglio più fare l'indiano," «L'Espresso,» Rome, 3 Dec. 1995, pp. 160-162;
- Raffaella Guidobono, "Kapoor l'anarchico," «Lombardia oggi,» 3 Dec. 1995;
- Walter Guadagnini, "Meditazioni sul vuoto," «Repubblica,» Rome, 4 Dec. 1995;
- "Alba, Nutella e salame", Panorama, Milan, 7 Dec. 1995;
- Mario Perazzi, "Anish Kapoor. I mille volti della scultura," «Amica,» Milan, 9 Dec. 1995, pp. 119-126;
- Simona Chiappella, "Anish Kapoor in Italia," «Il Resto del Carlino,» Bologna, 14 Dec. 1995;
- Luigi Cavadini, "Anish Kapoor, Milano, Fondazione Prada," «Il Corriere del Ticino,» 15 Dec. 1995;
- Francesca Borrelli, "Verso lo splendore del buio," «Il Manifesto,» Rome, 16 Dec. 1995;
- Astrid Vinatzer, "Pietra scolpita, rito della natura," «Alto Adige,» 16 Dec. 1995;
- G. Marz, "Piovono pietre, senza alcun rumore," «L'Opinione,» 17 Dec. 1995;
- Isabella Fava, "Quadri animati. L'arte e il cinema," «Il Manifesto,» Rome, 22 Dec. 1995;
- Marco Vallora, "Kapoor, poeta dell'ipnosi," «La Stampa,» Turin, 22 Dec. 1995;
- Ilaria Giaccone, David Bianco, "Nella pelle dell'universo," «Il Manifesto,» Rome, 23 Dec. 1995;
- Carlo Alberto Bucci, "L'arte nelle pause delle parole," «L'Unità,» Rome, 27 Dec. 1995;
- Manuela Gandini, "Un'anti-scultura fatta di non materia e strani buchi neri," «Il Giorno,» Milan, 28 Dec. 1995;
- Roberto Sanesi, "Quattro passi nel vuoto con lo scultore stregone," «Il Corriere della Sera,» Milan, 30 Dec. 1995;
- Ada Masoero, "Vibrazioni vertiginose," «Mondo Economico,» 1 Jan. 1996;
- "Anish Kapoor at the Fondazione Prada," «Flash Art» no. 186, Milan, Jan.-Feb. 1996, p. 39;
- Giorgio Verzotti, "Anish Kapoor. Fondazione Prada," «Flash Art,» no. 187, Milan, March-April 1996, pp. 121-22.

London, Lisson Gallery, 6 Nov. 1995–6 Jan. 1996
Works in exhibition: Mountain, 1995, fibreboard and paint, 317.5x249x404.5 cm; Turning the World Inside Out, 1995, cast aluminium, 148x184x188 cm; Untitled, 1995, fibreglass and pigment, diam. 202.5 cm; Untitled I - VI, 1995, gourds and paint, individual dimensions variable;White Dark I, 1995, wood, fibreglass and paint, 206x152.6x127.8 cm;White Dark II, 1995, wood, fibreglass and paint, 206x152.6x127.8 cm;White Dark III, 1995, wood, fibreglass and paint, 206x152.6x127.8 cm;White Dark IV, 1995, wood, fibreglass and paint, 206x152.6x127.8 cm; 15 etchings/Edition of 30, 20 sets & 10 broken sets, plate size 28x35 cm, portfolio case designed by Kapoor.
- Sarah Kent, "Gourd Times," «Time Out,»

London, 15 Nov. 1995;
- Michael McNay, "Anish Kapoor," «The Guardian,» London, 18 Nov. 1995;
- "Falling for hole truths," «Hampstead & Highgate Express,» 24 Nov. 1995;
- Rosanna Negrotti, "Anish Kapoor," «What's On in London,» London, 13 Dec. 1995, p. 17;
- Dalia Manor, "Anish Kapoor, Lisson Gallery," «Art Monthly,» no. 193, London, Feb. 1996, pp. 38-39.

1996
Turku, Finland, Aboa Vetus & Ars Nova, "Anish Kapoor. Sculptures," 21 Jan.–14 April.
Works in exhibition: Void Field, 1989, cumbrian sandstone and pigment, 10 parts; Angels, 1990, sandstone and pigment, 10 parts.

Cambridge, University of Cambridge, Kettle's Yard, "Anish Kapoor. Two Sculptures," 13 Jan.–25 Feb.
Works in exhibition: White Dark II, 1995, wood, fibreglass and paint, 206x152.6x127.8 cm; White Dark III, 1995, wood, fibreglass and paint, 206x152.6x127.8 cm.

Brescia, Galleria Massimo Minini, 22 March-25 May.
Works in exhibition: Untitled, 1991, marble, 174x93x90 cm; Untitled, 1995, bronze, 149x98x99 cm; Untitled, 1994, fibreboard and paint, 66x106x245 cm; Untitled (XVII), 1996, gourds and paint, 2 parts, 34x35.5x35 cm, 29x34x34 cm; Six drawings, 1996, mixed media on paper, 67.5x54.5 cm each.
- f.lor., "Dentro i 'buchi neri' di Kapoor," «Giornale di Brescia,» Brescia, 21 March 1996;
- "Kapoor, nel vuoto si fa la fusione dei sessi," «Arte,» Milan, April 1996, p. 146;
- Enrico Crispolti, "I misteri dello spirito," «AD,» Milan, no. 180, May 1996, p. 240;
- Ariella Giulivi, "Anish Kapoor, Massimo Minini," «Tema Celeste,» no. 57, Summer 1996, p. 72.

San Francisco, Freddie Fong Contemporary Art, "Gourd Project 1993-95," 2-25 May.

Köln, Kunst-Station Sankt Peter, 16 Nov. 1996-2 Feb. 1997. Catalogue with texts by Claudia von Blücker, Heinrich Heil, Friedhelm Mennekes.
Works in exhibition: Untitled, 1996, stainless steel, two parts, diam. 195.8x41.4 cm each; Untitled, 1996, stainless steel, diam. 196x42 cm; Wounds and Absent Objects, 1996, edition of 5, wood and pigment, diam. 37x17.5 cm; Untitled, 1996, chromed bronze, diam. 39x27 cm; Untitled, 1995, aluminium and pigment, diam. 13x13 cm; Untitled, 1996, fabric, 100x100x2 cm.
- Thomas Illmaier, "Zur Gegenwart erwachen," «Ursache/Wirkung», no. 15, Vienna, Winter 96/97.

1997
Atlanta, The High Museum of Art, "Changing Spaces," 11 Aug.–28 Sept. (in collaboration with The Fabric Workshop, Pennsylvania). Traveled to Detroit, The Detroit Institute of Arts, 8 Nov. 1997-4 Jan. 1998.
Works in exhibition: Body to Body, 1997, wool and fibreglass; 292x147x275 cm; Cloak, 1997, felt and pigment, 86.5x335x274 cm; India, 1997, wool and plaster, 221x147x35.5 cm; Untitled, 1997, felt, wool and fibreglass, 137x285x74 cm; Plug, 1997, felt and wool,

185.5x63.5x28 cm; Red Holes to..., 1997, felt and wool, 44.5x183x188 cm; Red Proverb, 1997, wool, 77.5x77.5x77.5 cm; Untitled, 1997, felt, 185.5x185.5x2 cm.

Volterra, Chiesa di San Giusto and Pinacoteca Civica, "Arte all'arte," 14 Sept.-2 Nov. (organised by Galleria Arte Continua). Catalogue with texts by Jan Hoet, Giacinto Di Pietrantonio.

1998
Santiago de Compostela, Centro Galego de Arte Contemporanea, "At the Edge of the World," 15 Jan.-15 March.
Works in exhibition: At the Edge of the World, 1998, fibreglass and pigment, 500x800x800 cm.
- KG-A, "Celestial void," «Tate Magazine,» London, Spring 1998.

London, Lisson Gallery, 23 Jan.-28 Feb.
Works in the exhibition: No. 1, 1997, alabaster, 96x95x34 cm; No. 2, 1997, alabaster, 80x112x28 cm; No. 3, 1997, alabaster, 67x117x166 cm; No. 4, 1997, alabaster, 79x100x30 cm; No. 5, 1997, alabaster, 135x126x60 cm; No. 6, 1997, alabaster, 90x80x29 cm; No. 7, 1997, alabaster, 73x67x28.5 cm; No. 8, 1997, alabaster, 120x76x29 cm; Wounds and Absent Objects, 1998, edition of 9, pigment and gelatine on polyester base dry mounted on aluminium, 53.5 x 44.5 cm.
- "Anish Kapoor," «The Times», London, 17 Jan. 1998;
- Helen Sumpter, "My art on Blair's wall," «The Big Issue,» London, 19 Jan. 1998;
- "Miuccia Prada on... Anish Kapoor," «Evening Standard,» London, 22 Jan. 1998;
- Andrew Lambirth, "Kapoor: master of the sexuality within," «The Indipendent,» London, 27 Jan. 1998;
-Suman Bhuchar, "Man with a mission to make time stand still," «The Herald Tribune,» 8 Feb. 1998;
- Sarah Kent, "Anish Kapoor," «Time Out,» London, 11 Feb. 1998;
- L.B. "Anish Kapoor," «The Art Newspaper,» London, Feb. 1998.

Brescia, Galleria Massimo Minini, 28 Feb.–12 April.
Works in exhibition: Untitled, 1997, swedish granite, two parts, 220x180x42 cm each; No. 10, 1998, alabaster, two parts, 125x59x23 cm each; Untitled, 1998, terracotta with platinum glaze, diam. 43 cm.
- Fausto Lorenzi, "Lo scultore ipnotico," «Giornale di Brescia,» Brescia, 21 Feb. 1998, p. 11;
- Angela Vettese, "Marmi, mutazioni e omini monocromi," «Il Sole-24 Ore,» Milan, 22 Feb. 1998;
- Mauro Corradini, "Kapoor, viaggio nell'Altrove," «Brescia oggi,» Brescia, 15 March 1998, p. 10;
Cloe Piccoli, "Fede e passione," «D.,» suppl. to «La Repubblica,» Rome, 17 March 1998, p. 122;
Anna Maria Di Paolo, "Con Kapoor un viaggio nell'anima," «BresciaSet,» Brescia, 26 March 1998;
- "Anish Kapoor," «Galleria,» Reggio Emilia, March 1998, p. 34;
- "Italianish Kapoor," «Il Giornale dell'Arte,» Turin, April 1998.

New York, Barbara Gladstone Gallery, 9 April-22 May.
Works in exhibition: Turning the World Upside Down No. 4, 1998, polished stainless steel, diam 200 cm; Almost Human, 1998, Kilkenny limestone, 208x178x51 cm.
- Holland Cotter, "Anish Kapoor," «The New York Times,» New York, 8 May 1998, p. E33;
- Donald Kuspit, "Anish Kapoor: Icon and Illusion," «Artnet,» www.arnet.com/magazine/features/kuspit/kuspit-9-98.htm.

London, Hayward Gallery, 30 April-14 June. Catalogue with texts by Homi K. Bhabha, Pier Luigi Tazzi.
Works in exhibition: Suck, 1998, stainless steel, diam 270 cm; Iris, 1998, stainless steel, diam 200 cm; Yellow, 1998, fibreglass and pigment, 245x245x140 cm; White Dark VI, 1998, fibreglass and pigment, 300x300x200 cm; Double Mirror, 1997-98, stainless steel, two parts, diam 200 cm each; At the Edge of the World II, 1998, fibreglass and pigment, diam 800 cm.
- DF, "Preview. Anish Kapoor," «Artforum,» New York, Jan. 1998, p. 53;
- Andrew Lambirth, "Space invader," «RA. Royal Academy Magazine,» London, March 1998;
- Andrew Lambirth, "Embrace the void," «Indipendent Saturday Magazine,» «The Indipendent,» London, 25 April 1998, pp. 32-36;
- Isabel Carlisle, "Into the wild blue yonder," «New Statesman,» London, 1 May 1998;
- Adrian Searle, "Don't look up...," «The Guardian,» London, 5 May 1998, pp. 10-11;
- Richard Cork, "Face to face with our fear of fly," «The Times,» London, 5 May 1998;
- Tim Hilton, "It's all in what the eye cannot see," «The Indipendent on Sunday,» London, 10 May 1998, pp. 22-23;
- William Packer, "Now you see it, now you don't," «Financial Times,» London, May 12 1998, p. 19;
- Brian Sewell, "Talking up a load of spherical objects," «Evening Standard,» London, 14 May 1998, pp. 28-29;
- Oberto Gili, "The Big Question," «Vogue,» May 1998, pp. 174-178.

271

Group Exhibition

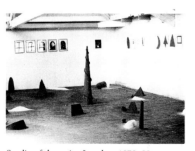

Studio of the artist, London, 1979–80

Galerie Paul Maenz, Cologne, 1984

1974
London, Serpentine Gallery, "Art into Landscape 1," 21 Sept.–20 Oct.

1975
London, Royal Academy of Art, "Young Contemporaries."

1978
Manchester, Whitworth Art Gallery, "Northern Young Contemporaries."

1979
Cambridge, Fitzwilliam Museum, "Tolly Cobbold: Eastern Arts, 2nd National Exhibition."

London, Whitechapel Art Gallery, "Whitechapel Open," Summer.

1980
Nottingham, Midland Group Gallery, "New Sculpture."

1981
London, Institute of Contemporary Art, "Objects & Sculptors: Richard Deacon, Antony Gormley, Anish Kapoor, Peter Randall-Page." Catalogue with texts by Lewis Biggs, Iwona Blazwick and Sandy Nairne. Traveled to Bristol, Arnolfini Gallery.
[*Part of the Red*, 1981, five elements, earth, resin, pigment, dimensions variable].
- William Feaver, "An Air of Light Relief," «The Observer,» London, 26 June 1981.

London, Serpentine Gallery, "Summer Show," 12 Sept.–11 Oct.

London, Whitechapel Art Gallery, "British Sculpture in the 20th Century. Part 2: Symbol and Imagination 1951–80," 27 Nov. 1981–24 Jan. 1982. Catalogue edited by Sandy Nairne and Nicholas Serota with texts by various authors.
[*As if to Celebrate I Discovered a Mountain Blooming with Red Flowers*, 1981, five elements, wood, cement, polystyrene, pigment, 107x305x305 cm].

1982
Venice, Cantieri Navali della Giudecca, XL Biennale Internazionale d'Arte, "Aperto 82. Prima sezione-Tempo." Catalogue with text by Tommaso Trini.

Luzern, Kunstmuseum Luzern, "Englische Plastik Heute/British Sculpture Now," 11 July–12 Sept. Catalogue with texts by Martin Kunz, Michael Newman, *et al.*

Paris, Musée d'Art Moderne de la Ville de Paris and other seats, "XIIème Paris Biennale," 2 Oct.–14 Nov. Catalogue with texts by Georges Boudaille, Andrea Rose, *et al.*

Chambéry, Centre d'Art Contemporain, "Prefiguration."

London, Lisson Gallery, "London/New York 1982."

Oxford, Museum of Modern Art, "India: Myth and Reality."

Edinburgh, Fruitmarket Gallery, "Objects and Figures. New Sculpture in Britain," 20 Nov. 1982–8 Jan. 1983 (organised by The Scottish Arts Council). Catalogue.

1983
Rennes, C'est Rien de le Dire, "Douceur de l'Avant-Garde," 7–29 Jan. Catalogue.

Gibellina, Museo Civico d'Arte Contemporanea, "Tema Celeste," 22 Jan.–30 March. Catalogue with text by Demetrio Paparoni.

Syracuse, Centro d'Arte Contemporanea, "La Trottola di Sirio," 29 Jan.–26 March (organised by The British Council). Catalogue with text by Demetrio Paparoni.

Southampton, John Hansard Gallery, "Figures and Objects," Feb.–March. Catalogue with text by Michael Newman.

Rotterdam, Rotterdamse Kunststichting, "Beelden/Sculpture 1983," 13 May–22 June. Catalogue with text by Paul Hefting.

Helsinki, "Finland Biennale."

Amsterdam, Van Krimpen Gallery, "Sculpture 1983," 28 May–25 June.

London, Hayward Gallery and Serpentine Gallery, "The Sculpture Show," 13 Aug.–9 Oct. (organised by The Arts Council of Great Britain). Catalogue with texts by Kate Blacker, Fenella Crichton, Paul de Monchaux, Nena Dimitrijevic, Stuart Morgan, Deanna Petherbridge, Bryan Robertson, Nicholas Wadley.
- Waldemar Januszczak, "Three into two won't go," «The Guardian,» London, 16 Aug. 1983;
- John Russell Taylor, "Playing into the hands of those who pour scorn," «The Times,» London, 16 Aug. 1983;
- Edward Lucie-Smith, "Back in touch with the emotions," «The Sunday Times,» London, 21 Aug. 1983;
- Mary Rose Beaumont, "The Sculpture Show," «Arts Review,» Sept. 1983.

London, Tate Gallery, "New Art," 14 Sept.–23 Oct. Catalogue.

Turin, Galleria Giorgio Persano, "Costellazione." Curated by Demetrio Paparoni.

Graz, Neue Galerie, "Eros Mythos Ironie," 17 Sept.–23 Oct. Catalogue with texts by Achille Bonito Oliva, Andrej Medved, Klaus Honnef, *et al.*

São Paulo, XVII Bienal de São Paulo, "Transformations: New Sculpture from Britain," 14 Oct.–18 Dec. (organised by The British Council). Catalogue with texts by Lewis Biggs, Lynne Cooke, Mark Francis, John McEwen, Stuart Morgan, Nicholas Serota, John Roberts. Traveled to Rio de Janeiro, Museu de Arte Moderna, 20 Jan.–20 Feb. 1984; Mexico City, Museo de Arte Moderna, 15 March–15 May 1984; Lisboa, Fundação Calouste Gulbenkian, 1984.

1984
New York, Museum of Modern Art, "An International Survey of Recent Painting and Sculpture," 17 May–19 Aug. Catalogue with text by Kynaston McShine.
- John Russell, "Art: inaugural show is survey of new work," «The New York Times,» New York, 18 May 1984.

Cologne, Galerie Paul Maenz, "Anish Kapoor and Bill Woodrow," 6–30 June.

Dublin, the Guinness Hop Store, "ROSC '84." Catalogue.

Birmingham, Birmingham Museum and Art Gallery and Ikon Gallery, "The British Art Show: Old Allegiances and New Directions 1979–1984," 2 Nov.–22 Dec. (organised by The Arts Council of Great Britain). Catalogue with texts by Jon Thompson, Alexander Moffat and Marjorie Allthorpe-Guyton. Traveled to Edinburgh, Royal Scottish Academy, 19 Jan.–24 Feb.1985; Sheffield, Mappin Art Gallery, 16 March–4 May 1985; Southampton Art Gallery, 18 May–30 June 1985.

1985
"Sculptors' Drawings" (organised by The Scottish Arts Council). Traveled to Aberdeen, Artspace Galleries; Ayr, Lyth, Stirling, Stromness, Glasgow; Athen, Dracos Arts Centre.

Perth, Art Gallery of Western Australia, "The British Show" (organized by The Art Gallery of New South Wales and by The British Council), 19 Feb.–24 March. Catalogue with texts by John Roberts, Lewis Biggs, Graham Beal, Stuart Morgan, *et al.* Traveled to Sydney, Art Gallery of New South Wales, 23 April–9 June; Brisbane, Queensland Art Gallery, 5 July–11 Aug.; Melbourne, The Exhibition Hall; Wellington, New Zeland, National Art Gallery.
- Ted Snell, "Relevance strikes a blow for the British," «The Australian,» Perth, 21 Feb. 1986.

Tubingen, Kunsthalle, "7000 Eichen," 2 March–14 April. Catalogue edited by Heiner Bastian. Traveled to Bielefeld, Kunsthalle, 2 June–11 Aug.

Boston, Institute of Contemporary Art, "Currents," 3 April. Catalogue with text by David Joselit.

Paris, "Nouvelle Biennale de Paris." Catalogue with texts by Georges Boudaille, Stuart Morgan, *et al.*

Bologna, Galleria Comunale d'Arte Moderna and other seats, "Anniottanta," 4 July–30 Sept. Catalogue with texts by Renato Barilli, Flavio Caroli, Concetto Pozzati, Claudio Spadoni, Lynne Cooke, *et al.*

Bristol, Arnolfini Gallery, "Who's Afraid of Red, Yellow and Blue?," 31 Aug.–6 Oct.

State University of New York, Neuberger Museum, "Three British Sculptors."

Tournus, l'Abbaye de Tournus, "20 Sculptures du FRAC Rhône-Alpes."

Chicago, Donald Young Gallery, "Anish Kapoor and Bill Woodrow." [*Mother as a*

Mountain, 1985, wood, chalk, pigment, 145x200x145 cm].

Dublin, Douglas Hyde Gallery, "The Poetic Object: Richard Deacon, Shirazeh Houshiary, Anish Kapoor," 21 Nov.–21 Dec. Catalogue with text by Richard Francis. Traveled to Belfast, The Arts Council Gallery, 9 Jan.–1 Feb. 1986.
- Aidan Dunne, "Ambiguous objects just being themselves," «The Sunday Press,» 24 Nov. 1985;
- Bruce Arnold, "Close look at new British sculpture," «The Independent on Sunday,» London, 24 Nov. 1985;
- Brian Fallon, "'The Poetic Object' at TCD," «The Irish Times,» Dublin, 28 Nov. 1985.

1986
Madrid, Palacio de Velázquez, "Entre el objeto y la imagen. Escultura Britanica contemporanea," 28 Jan.–30 April (organised by The British Council and Ministerio Español de Cultura). Catalogue with texts by Lewis Biggs and Juan Muñoz. Traveled to Barcelona, Centre Cultural de la Caixa de Pensions, "Entre l'objecte i la imatge," 3 June–17 July 1986. Catalogue.

Humlebaek, Louisiana Museum of Modern Art, "Skulptur-9 Kunstnere fra Storbrittanien," 1 March–20 April. Catalogue.

Arnhem, Holland, Park Sonsbeek, "Sonsbeek '86. International Sculpture Exhibition," 18 June–14 Sept. Catalogue in two volumes with texts by G. F. Boreel, Saskia Bos, Antje von Graevenitz, Marianne Brouwer and statements by the artists [*Pot for Her*, 1985, pigment, mixed media, 269x104x104 cm; *Untitled*, 1986, three elements, wood, chalk, h max 300 cm].

Buffalo, Albright-Knox Art Gallery, "General Idea, Anish Kapoor, Melissa Miller," 12 July–24 Aug. Catalogue with text by Helen Raye.

Frankfurt, Frankfurter Kunstverein and Schirn Kunsthalle Frankfurt, "Prospect '86. Eine internationale Austellung aktueller Kunst," 9 Sept.–2 Nov. Catalogue.

New York, Lang & O'Hara Gallery, "Inaugural Exhibition."

Paris, Galerie Gabrielle Maubrie, "Dessins de Sculpteurs," 24 Sept.–24 Oct.

1987
Stockholm, Liljevalchs Konstall, "British Art of the 1980s," 10 April–24 May (organised by The British Council). Catalogue with text by Lynne Cooke. Traveled to Tampere, Sara Hildén Art Museum, "Britannia. Paintings and Sculptures from the 1980s," 16 June–23 Aug. 1987.

Long Island, P.S. 1, The Institute for Art and Urban Resources, "Juxtapositions: Recent Sculpture from England and Germany," 26 April–21 June. Catalogue with texts by Alanna Heiss, Joshua Decter, Denys Zacharopoulos.

London, Serpentine Gallery, "Vessel," 5 Sept.–11 Oct. [*Here and There*, 1987,

Cotswold sandstone, pigment, 90x246.5x160 cm].

Antwerpen, Museum Van Hedendaagse Kunst, "Inside/Outside." Catalogue.

Düsseldorf, Kunsthalle, "Similia-Dissimilia," curated by Rainer Crone. Catalogue with text by Cornelia Lauf. Traveled to New York, Columbia University, 4 Dec. 1987–30 Jan. 1988; Sonnabend Gallery and Leo Castelli Gallery, 5–22 Dec.

Brussels, Musée d'Art Moderne, "Viewpoint. L'art contemporain en Grande Bretagne," 18 Dec. 1987–31 Jan. 1988 (in collaboration with The British Council). Catalogue with an interview by Richard Cork.

1988
Prato, Centro per l'arte contemporanea Luigi Pecci, "Europa oggi/Europe now," 25 June–20 Oct. Catalogue with texts by Amnon Barzel, Achille Bonito Oliva, Bruno Corà, Helmut Draxler, Antje van Gravenitz, Joseph Kosuth, Donald Kuspit, Jean-Hubert Martin, Beatrice Merz, Carlo Bertelli, Gillo Dorfles, Knud Jensen, Peter Ludwig, Thomas M. Messer, Giuseppe Panza di Biumo, *et al.*

Nürnberg, Kunsthalle, "Fourth International Drawing Triennale," 1–23 Oct. Catalogue with text by David Reason.

Lyon, Musée St. Pierre, "La Couleur seule. L'Experience du Monochrome," 7 Oct.–5 Dec. Catalogue with texts by Thierry Raspail, Maurice Besset, Thomas McEvilley, Thierry de Duve, *et al.* [*Mother as a Void*, 1988, fibreglass, pigment, 205x205x230 cm].

Le Havre, Musée des Beaux-Arts André Malraux; Rouen, École d'Architecture de Normandie; Évreux, Musée de l'Éveche, "Britannica," 15 Oct.–12 Dec. Catalogue with texts by Catherine Grenier, Françoise Cohen and Lynne Cooke. Traveled to Antwerpen, Museum Van Hedendaagse, Jan.–March 1989; Labege Innopole, Centre Regional d'Art Contemporain, March–May 1989.
- F. Bataillon, "Britannica," «Artpress,» no. 131, Dec. 1988, p. 64.

Liverpool, Tate Gallery, "Starlit Waters. British Sculpture: An International Art 1968–88." Catalogue with texts by Martin Kunz, Charles Harrison, Lynne Cooke.

Pittsburgh, The Carnegie Museum of Art, "Carnegie International." Catalogue with text by Kellie Jones. [*Blood Stone*, 1988, two elements, limestone, pigment, 211x83.3x61 cm, 83.8x89x109.2 cm].

Montreal, Musée d'art contemporain de Montréal, "British Now: sculpture et autres dessins." Catalogue with text by Sandra Grant Marchand.

1989
Paris, Galerie Le Gall Peyroulet, "Anish Kapoor, Wolfgang Laib, Richard Long," 6 June–22 July.

1990
Chicago, The Art Institute of Chicago, "Affinities and Intuitions. The Gerald

S. Elliott Collection of Contemporary Art," 12 May–29 July. Catalogue curated by Neal Benezra, with texts by Lynne Cooke, Mark Rosenthal, *et al.*

Tokyo, Setagaya Museum, "British Art Now: A Subjective View," 25 Aug.–7 Oct. (organised by The British Council). Catalogue with texts by H. M. Hughes, J. Shioda, A. Graham-Dixon, A. Obigane. Traveled to Fukuoka, Fukuoka Art Museum, 1990; Nagoya, Nagoya City Art Museum, 1990; Tochigi, Tochigi Prefectural Museum of Fine Arts, 1991; Hyogo, Hyogo Prefectural Museum of Modern Art, 1991; Hiroshima, Hiroshima City Museum of Contemporary Art, 1991.

Otterlo, Holland, Rijksmuseum Kröller-Müller, "Dujourie, Fortuyn, Houshiary, Kapoor," 14 Sept.–29 Oct. Catalogue with text by Marianne Brouwer [*Untitled*, 1990, triptych, fibreglass, pigment, diam 250x167 cm each].

Gstaad, Switzerland, Galerie Saqqarah, "Heroes of Contemporary Art," 17 Nov. 1990–15 Jan. 1991. Catalogue with text by Akim Monet. Traveled to Cologne, TransArt Exhibitions Kreishaus.

London, Frith Street Gallery, "Works on paper," 23 Nov.–22 Dec.

Brussels, Galerie Isy Brachot, "Made of Stone," 19 Dec. 1990–26 Jan. 1991. Catalogue.

1991
Kyoto, Gallery Shirakawa.

Fréjus, Fondation Daniel Templon, "La sculpture contemporaine après 1970," 4 July–29 Sept. Catalogue with texts by C. Ratcliff, P. Cabanne, D. Dobbels, S. Gohr, D. Paparoni, C. Smulders.

Malmö, Rooseum, "Trans/Mission," 27 Aug.–27 Oct. Curated by Lars Nittve. Catalogue with texts by Lars Nittve, Dick Hebdige.

London, Tate Gallery, "The 1991 Turner Prize: An Exhibition of Work by the Four Shortlisted Artists," 6 Nov.–8 Dec. Catalogue with text by Sean Rainbird.
- Iain Gale and Dalya Alberge, "Youth and beauty?," «The Independent,» London, 16 July 1991;
- Richard Dorment, "A prize turnabout," «Daily Telegraph,» London, 16 July 1991;
- Tom Lubbock, "Shortlist short on ideas," «The Independent on Sunday,» London, 21 July 1991;
- Stuart Morgan, "The Turner Prize," «Frieze,» London, Oct. 1991, pp. 4–8;
- Richard Dorment, "A winner in a class of his own," «Daily Telegraph,» London, 27 Nov. 1991;
- Roger Bevan, "Controversy over the Turner Prize short-list," «The Art Newspaper,» no. 12, London, Nov. 1991, p. 3;
- Sarah Kent, "Prize Fighters," «Time Out,» London, Nov. 1991;
- "Turner Prize for Anish Kapoor," «Indian Weekly,» Dec. 1991;
- Roger Bevan, "Anish Kapoor wins Turner Prize," «The Art Newspaper,» London, 14 Jan. 1992.

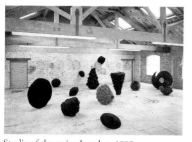

Studio of the artist, London, 1985

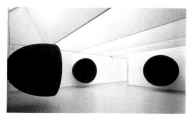

Rijksmuseum Kröller-Müller, Otterlo, 1990

The Hague, Haags Gemeentemuseum, "Rhizome," 26 Nov 1991.–19 Jan. 1992. Catalogue.
- Els van der Plas, "Rhizome, a rootstock that offers no hold, Haags Gemeentemuseum," «Kunst and Museum Journal,» no. 4, pp. 60–62.

Milan, Studio Oggetto, "Il limite delle cose nella Nuova Scultura Inglese," Nov.–Dec. Catalogue with texts by Enrico Pedrini, Emilio Stabilini.

Fukuoka, Fukuoka Art Museum, "Anish Kapoor and Abstract Art in Asia."

1992
New York and San Francisco, Crown Point Press, "Prints by Sculptors. Anish Kapoor and Jane Provisor."
- B.A.M., "Anish Kapoor, Jannis Provisor-Crown Point Press," «Artnews,» New York, April, pp. 119–120;
- David Bonetti, "Risk-taking artists find their Crowning Point," «The San Francisco Examiner,» 27 May 1992.

Kassel, "Documenta IX," 13 June–20 Sept. Catalogue in three volumes with texts by Wolfram Bremeier, Jan Hoet, Denys Zacharopoulos, Bart De Baere, Pier Luigi Tazzi, Claudia Herstatt, Joyce Carol Oates, Jacques Roubaud, Cornelius Castoriadis, Heiner Muller, Paul Robbrecht, Hilde Daem. [*Descent into Limbo*, 1992, concrete, stucco, 600x600x600 cm].
- "Documenta IX images," «Artefactum,» Antwerpen, Sept.–Nov. 1992;
- Grazia Toderi, "The light of the sun will reveal it," «Flash Art International,» vol. XXV, no. 166, Milan, Oct. 1992, p. 134.

University of North Texas Art Gallery, "The New British Sculpture. Selected works from the Patsy R. and Raymond D. Nasher Collection." Catalogue.

London, Whitechapel Art Gallery, "Whitechapel Open," 19 June–28 Aug.

Tilburg, De Pont Foundation for Contemporary Art, "De Opening," 13 Sept. 1992–31 Jan. 1993. Catalogue. [*Untitled*, 1992, fibreglass, acrylic, pigment, diam 100 cm; *Untitled*, 1992, polystyrene, aluminium, fibreglass, acrylic, pigment, diam 220 cm].

Brussels, Centre de Conférences Albert Borschette, "New Voices, New Works for the British Council Collection," 23 Sept.–Dec. (organised by The British Council). Catalogue with text by Gill Hedley.

Verona, Foro per l'Arte Contemporanea, "Anish Kapoor invita Gary Woodley," 17 Oct.–29 Nov. Catalogue with texts by Erno Vroonen, Paolo Gambazzi.
- Jos van den Bergh, "Anish Kapoor, Gary Woodley," «Artefactum,» Antwerpen, Dec. 1992–Jan. 1993, pp. 55–56.

Amsterdam, Stedelijk Museum.

Mito-shi Ibaraki, Japan, Art Tower Mito, "Another World," 21 Nov. 1992–7 March 1993. Catalogue with text by Yoko Hasegawa. [*Dragon*, 1992, eleven elements, limestone, pigment, dimensions variable].

1993
Derby, Derby Museum and Art Gallery, "British Sculpture from the Arts Council Collection" (organised by The Arts Council of Great Britain). Catalogue with text by James Roberts.
- Clare Henry, "Terrific sculptures but none by Scots," «Glasgow Herald,» Glasgow, 28 May 1993;
- Andrew Gibbon Williams, "Parts for art's sake," «The Sunday Times (Scottish Section),» 30 May 1993.

Venice, Giardini di Castello, Padiglione Italia, XLV Biennale Internazionale d'Arte, "Punti dell'arte. Aureo," 14 June–10 Oct. Catalogue (vol. I) with texts by Arthur C. Danto and Tommaso Trini. [*My Body Your Body*, 1993, fibreglass, pigment, dimensions variable, element: 248x103x205 cm].
- Alison Sarah Jacques, "Anish Kapoor, the distance between 'here' and 'there'," «Flash Art Daily,» Venice, June 1993;
- Thomas McEvilley, "Venice the Menace," «Artforum,» vol. XXXII, no. 2, New York, Oct. 1993.

Venice, Collezione Peggy Guggenheim, XLV Biennale Internazionale d'Arte, "Art Against Aids." Catalogue (vol. II) with text by John Cheim, Diego Cortez, Carmen Gimenez, Klaus Kertess.

Venice, Isola di San Lazzaro degli Armeni, Monastero Mechitarista. "Trésors de voyage" (supported by La Biennale di Venezia). Catalogue (vol. II) with text by Adelina von Fürstenberg.

New York, Leo Castelli Gallery, "Sculpture."

Sheffield, Graves Art Gallery, "Body of Drawings" (organised by The South Bank Centre). Traveled to Coventry, Mead Art Gallery.

Óbidos, Portogallo, Bienal Internacional de Óbidos, "Cerco," 9 Oct.–27 Nov. Catalogue. [*Black Stones, Human Bones*, 1993, two elements, marble, 131x163x171.5 cm, diam 90 cm].

Vienna, Architectur Zentrum, "Magazin," 22 Nov.–13 Dec.

1994
Cologne, Hohenthal und Bergen, "Punishment and Decoration," 8 April–28 May. Catalogue with text by Michael Corris.

London, Tate Gallery, "Sculptors' Drawings," 5 July–30 Oct.

Hiroshima, Hiroshima City Museum of Contemporary Art, "Asian Art Now," 18 Sept.–6 Nov.

S. Antonino di Susa (Turin), Stabilimento Radiomarelli, "Collezione Re Rebaudengo-Sandretto," 24 Sept.–18 Nov.

St. Petersburg, Russian Museum, "A Changing World: Fifty Years of Sculpture from the British Council Collection," 17 Oct.–28 Nov. Catalogue. Traveled to Moscow, New Tretyakov, 28 April–26 May 1995; Prague, Castle Riding Hall, 27 June–1 Oct. 1995.

1995
Helsinki, Museum of Contemporary Art, "Ars '95 Helsinki," 11 Feb.–28 May.

Edinburgh, Scottish National Gallery of Modern Art, "Contemporary British Art in Print," 25 Feb.–30 April. Catalogue. Traveled to New Haven, Yale Center for British Art, 2 Dec. 1995–4 Feb. 1996.

Dublin, The Irish Museum of Modern Art, "British Art of the 1980s & 1990s. Works from The Weltkunst Collection," 18 May–5 Oct.
- Brian Fallon, "British sculpture here and now," «The Irish Times,» Dublin, 18 May 1995.

Modena, Galleria Civica, Palazzo dei Giardini, "Arte inglese d'oggi nella raccolta Re-Rebaudengo Sandretto," 21 May–30 July. Curated by Flaminio Gualdoni and Gail Cochrane. Catalogue with text by Flaminio Gualdoni.

Santiago de Compostela, Auditorio de Galicia, "De Henry Moore ós anos 90. Escultura británica contemporánea," 3 June–25 July. Catalogue. Traveled to Oporto, Fundacão Serralves, 7 Sept.–5 Nov.

Santa Fe, Museum of Fine Arts and SITE, "Longing and Belonging: From the Faraway Nearby," 14 July–8 Oct.
- Charles Dee Mitchell, "Introducing SITE Santa Fe," «Art in America,» vol. LXXXIII, no. 10, pp. 44–47.

London, Lisson Gallery, "Ideal Standard Summertime," 17 July–30 Sept.
- "Ideal Standard Summertime," «The Guide,» «The Guardian» weekly supplement, London, 22 July 1995, p.6;
- Sarah Kent, "Summer Frieze," «Time Out,» no. 1301, London, 26 July–2 Aug. 1995, p. 50;
- Rosanna Negrotti, "Ideal Standard Summertime," «What's On In London,» London, 9 Aug. 1995, p. 21;
- Iain Gale, "Iain Gale on exhibitions", «The Independent,» London, 11 Aug. 1995;
- Tim Hilton, "Abstract expressions", «The Independent on Sunday,» London, 13 Aug. 1995;
- Richard Cork, "Summer brings cold comfort," «The Times,» London, 15 Aug. 1995;
- Martin Gayford, "The subject is anything", «The Daily Telegraph,» London, 16 Aug. 1995;
- Linda Talbot, "Threads of many ideas," «Hampstead & Highgate Express,» London, 18 Aug. 1995;
- Philip Sanderson, "Ideal Standard Summertime", «Art Monthly,» no. 189, London, Sept. 1995, pp. 37-38;
-0 Estelle Lovatt, "Ideal Standard Summertime", «Southern Cross,» 13 Sept. 1995, p.13

London, Flowers East, "British Abstract Art Part II: Sculpture," 5 Aug.–3 Sept. 1995.
- Martin Gayford, "The subject is anything,"

«The Daily Telegraph,» London, 16 Aug. 1995.

Paris, Centre national d'art et de culture Georges Pompidou, Grande Galerie, "Fémininmasculin. Le sexe de l'art", 24 Oct. 1995-12 Feb. 1996. Catalogue with texts by Kathy Acker, François Barré, Marie-Laure Bernadac, Bice Curiger, Thierry de Duve, Denis Hollier, Gilbert Lascault, Jean-Jacques Lebel, Rosalind Krauss, Bernard Marcadé, Thomas McEvilley, Angelica Pabst, Juan Antonio Ramírez, Robert Storr, Michael Taylor, Marina Warner, Sarah Wilson.

1996
Montreal, Galerie Samuel Lallouz, "Dessins et maquettes de sculpteurs/Drawings and maquettes by sculptors," 13 Jan.-10 Feb.

Philadelphia, Philadelphia Museum of Art, 17 March-26 May. Catalogue with texts by Martha Chahroudi, Susan Dackernan, John Ittmann, Ann Percy, Innis Owe Shoemaker.

Annandale-on-Hudson, New York, Center for Curatorial Studies, Bard College, "Dissonant Wounds: Zones of Display/Metaphors of Atrophy."

Dublin, The Irish Museum of Modern Art, "Works on Paper from the Weltkunst Collection of British Art of the 80s and 90s," 30 March-16 June. Catalogue with texts by Richard Cork, Penelope Curtis, Declan McGonigle.
- Brian Fallon, "British sculpture here and now", «Irish Times,» Dublin, 18 May 1996.

Paris, Jeu de Paume, "Un siècle de sculpture anglaise," 6 June-15 Sept. Catalogue with texts by Daniel Abadie, Véronique Béranger, Alan Bowness, Ester Coen, David Cohen, Richard Cork, Penelope Curtis, Jonathan Fineberg, Claude Gintz, Marco Livingstone, Tomàs Llorens Serra, Ieoh Ming Pei, Stuart Morgan, Hélène Pinet, Marcelin Pleynet, Ben Read, Bryan Robertson, Gilles A. Tiberghien.
- Roger Bevan, "British beef goes to France", «The Art Newspaper,» London, May 1996;
- Ann Hindry, "Histoires anglaises," «Art Press,» no. 214, Paris, June 1996, pp. 19-28;
- Paul Levy, "British Artists Teach Franch a Lesson," «Wall Street Journal,» London, 28 June 1996;
- Yves Abrioux, "A Century of British Sculpture," «Untitled,» no. 11, London, Summer 1996, pp. 6-7;
- Éric de Chassey, "Entretien avec Daniel Abadie, directeur de la galerie nationale du Jeu de Paume," «Beaux Arts Magazine,» Paris, pp. 6-9.

Villeurbanne, Le Nouveau Musée, "Collections du Castello di Rivoli," 14 June-21 Sept.

23rd International Biennal of São Paulo, Brazil, 1996

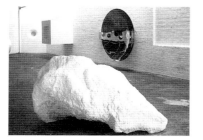

Studio of the artist, London, 1997

Santa Monica, Angles Gallery, "Anish Kapoor, Barry X Ball," 28 June-7 Sept.

São Paulo, "23rd International Biennial of São Paulo". 5 Oct.-8 Dec. Catalogue.
- Monica Maia, "Kapoor estuda espaço que terá na Bienal," FSP, São Paulo, 6 Feb. 1996;
- Geórgia Lobacheff, "Kapoor Busca o Melhor Espaço," Jornal de Tarde, São Paulo, 6 Feb. 1996;
- Mônica Maia, "Kapoor estudia espaço que terá na, Bienal," Folha de São Paulo, São

Paulo, 6 Feb. 1996;
- Celso Fioravante, "Anish Kapoor vem à Bienal com aço, pedra e pigmento," Ilustrada, São Paulo, 10 Aug. 1996;
- Antonio Gonçalves Filho, "Bienal vai ter sala de Anish Kapoor," Visuais, São Paulo;
- Claudia Izique, "Viagem ao reino da invenção," Correeio Braziliense, Brazil, 20 Oct. 1996;
- Mariãngela Guimarães, "Labirinto contemporãneo," Gazeta do Povo, Curitiba, 20 Oct. 1996;
- Mona Thomas, "Les années 80-90, jeunes sculptures anglaises," Beaux Arts Magazine, Paris, pp. 48-55.

Ljubljana, Slovenia, "Moderner Galerija Ljubljana for the Museum of Modern Art, Saraijevo."

Paris, Galerie Lucien Durand, "Multiples," 20 Sept.-2 Nov.

Malmö, Malmö Konsthall, "Betong," 9 Nov.1996-26 Jan. 1997.
[Untitled, 1996, concrete; Untitled, 1996, wood and pigment].

1997
London, Institute of Contemporary Arts, "Belladonna," 24 Jan.-12 April. Traveled to Colchester, First Sight, 22 April-31 May.

Graz, Mausoleum am Dom, "Entgegen", 24 Jan.-12 April. Catalogue with texts by Tatjana Beljalewa, Kai-Uwe Hemken, Werner Hofmann, Alois Kölbl, Gerhard Larcher, Monika Leisch-Rohsmann, Simona Mehnert, Friedhelm Mennekes, Johann Baptist Metz, Helmut A. Müller, Johannes Rauchenberger, Manfred Richter, Günter Rombold, Alex Stock, Peter Strasser, Rainer Volp, Saskia Wendel, Jean-Pierre Wils, Erich Witschke, Matthäus Woschitz.
[Untitled, 1997, GRP and gold leaf, 200x100x160 cm].

Marrakech, Madrasa Ibn Youssef, "Meditations", 15 March-5 April.

London, Hayward Gallery, "Material Culture. The object in British Art of the 1980s and 90s," 3 April-18 May.
- Jane Burton. «The Express,» London, 1 April 1997;
- John O'Reilly. "The object of seeing," «The Independent Long Weekend,» London, 5 April 1997;
- Philip Hensher, "Object Lessons," «Mail On Sunday; Night and Day,» London, 6 April 1997;
- Richard Shone. "Material Witness," «The Observer Review,» London, 6 April 1997;
- Richard Cork. "Intimations," «The Times,» London, 8 April 1997;
- Adrian Searle. "Isn't it offal?," «The Guardian,» London, 8 April 1997;
- Martin Gayford. "Poppet Green is alive and well," «The Spectator,» London, 10 April 1997;
- Waldemar Januszczak. "A true reflection of the age," «The Sunday Times,» London, 13 April 1997;
- Richard Dorment. "Hypnotic power of the object," «The Daily Telegraph,» London, 23 April 1997;
- Marina Vaizey. "An Enduring Inspiration,"

«Art Quarterly,» no. 30, Summer 1997;
- John Slyce. "Material Culture: The Object in British Art," «Flash Art International,» vol. XXX, no. 195, Milan, Summer 1997, p. 75.

Stadthafen Stade, MS Greundiek, "Follow Me. Britische Kunst an der Unterelbe", 6 Sept.-31 Oct. Catalogue with texts by Stephan Berg, Dieter-Theodor Bohlmann, Hans-Eckard Dannenberg, Beate-Christine Fiedler, Klaus Frerichs, Antony Gormley, James Hall, Heidi Kwastek, Tim Marlow, Susan Mayerhofer, Gerd Meier-Linnert, Gerd Mettjes, Marc Quinn, Bettina Roggmann, Eckhard Schneider, Hans-Georg Schröder, Ulrike Schuck [Untitled, 1997, stainless steel, 243x243x60 cm; Untitled, 1997, iron, 250x270x270 cm].

"Changing Spaces", The Detroit Institute of Arts.

1998
Stockholm, Moderna Museet, "Wounds: Between Democracy and Redemption in Contemporary Art," 14 Feb.-19 April. Catalogue with texts by Massimo Cacciari, Michael Corris, Alain Cueff, David Elliott, Paul Groot, Michael Newman, Marcelo E. Pacheco, Bojana Pejic, Gertrud Sandquist, Nancy Spector, Gilane Tawadros, Pier Luigi Tazzi.

Stockholm, Stockholm Konsthall, "Spatiotemperal," Magasin 3, opened 25 March.

Lisbon, Culturgest, Caixa General de Depositos, "The Art of the 80s," 12 May–31 Aug. Catalogue with texts by Dan Cameron, Maria de Corral, José Gil, Alexandre Melo.

Lisbon, Fundação Calouste Gulbenkian, "Towards Sculpture," 28 May-2 Sept. Catalogue with texts by Rui Sanchez, George Molder.

"Prime", Dundee Contemporary Arts, Dundee.

Collaborations

1992

Seville, Expo'92. *Building for a Void*.
Architectural collaboration with David Connor.
- "Anish Kapoor/David Connor," «SD. Art and Public Space,» 1992;
- "Journey to the centre of a void," «The Independent,» London, 8 January 1992;
- David Cohen, "Anish Kapoor," «Sculpture,» Washington, January–February 1992, pp. 30–37;
- Roger Bevan, "American art-less in Seville: Britain fields four sculptors," «The Art Newspaper,» no. 17, London, April 1992;
- Giles Tremlett, "Seville's Expo '92," «The Times,» London, 12 August 1992.

1993

London, Queen Elizabeth Hall. *River Run*.
Stage design for dance performance. A collaboration with Laurie Booth and Hans Peter Kuhn.
- Judith Mackrell, "Rock and Roll. The rising fall of Laurie Booth," «Vogue,» London, February 1993;
- Jacqui Bealing, "Putting a spring into dancer's steps," «Brighton Evening Argus,» East Sussex, 15 March 1993;
- Sophie Constanti, "Laurie Booth, Queen Elizabeth Hall," «The Guardian,» London, 29 March 1993;
- Judith Mackrell, "Laurie Booth's *River Run*, with designs by Anish Kapoor, at Queen Elizabeth Hall," «The Independent,» London, 31 March 1993;
- "Main Chance," «Sheffield Telegraph,» Sheffield, 14 May 1993;
- Nicholas Dromgoole, "Preferable to prison?," «The Sunday Telegraph,» London, 4 April 1993;
- Jann Parry, "Dance," «The Observer,» London, 4 April 1993;
- Anne Sacks, "Calm in an arctic limbo," «The Independent on Sunday,» London, 4 April 1993;
- Jane King, "Meaningless meanderings," «The Morning Star,» London, 18 April 1993;
- "Dance, sound and sculpture," «Somerset County Gazette,» Taunton, 23 April 1993;
- Cathy Brown, "Rare treat in store for dance fans at famous concert hall," «What's On In London,» London, May 1993.

1994

Echo. A group of five sculptures which incorporate music mechanisms.
A collaboration with the composer Brian Elias.

Writings, Statements, and Projects for Periodicals and Catalogues by the Artist
"The works are about sensuality...," in *Sonsbeek 86*, exhibition catalogue, Utrecht, Veen/Reflex, 1986, p. 328.

Anish Kapoor, Sylvie Primard, Pier Luigi Tazzi. "Mother as a Mountain," project for «Artforum,» New York, September 1989, pp. 126–131.

Interviews
Demetrio Paparoni. "Spazio di Dio, spazio della Terra," «Tema Celeste,» no. 6, Syracuse, 1985, pp. 46–49.

Richard Cork. In "Anish Kapoor: Works on Paper 1975–1987," exhibition catalogue, Sidney, Ray Hughes Gallery, 1987.

Mileta Prodanovic. "Anish Kapoor, Razgovor," «Moment,» no. 15, July-September 1989, pp. 16–18.

Ameena Meer. "Anish Kapoor," «BOMB,» no. 30, Winter, 1989–90, pp. 38–43.

Akio Obigane. "Anish Kapoor," «Atelier,» no. 755, January 1990, pp. 2–24.

Paul Taylor. "Anish Kapoor," «Interview,» New York, June 1990, p. 93.

"Anish Kapoor interviewed by Douglas Maxwell," «Art Monthly,» London, May 1990, pp. 6–12.

Doris Van Drateln. "Anish Kapoor, Ein Gespräch," «Kunstforum,» vol. CIX, August–October 1990, pp. 304–315.

Caroline Smulders. "Anish Kapoor. Vers la dématérialisation de l'objet," «Artpress,» no. 152, Paris, November 1990, pp. 16-21.

Stephanie du Tan. "Pigments of the Imagination," «The Journal of Art,» vol. III, no. 2, London, November 1990, pp. 31–33.

Yoshiko Ikoma. "Anish Kapoor: Interview," «Crea,» no. 5, 1991.

Constance Lewallen. "Interview with Anish Kapoor, Japan, September, 1990," «View,» vol. VII, no. 4, San Francisco, Fall 1991, pp. 2–32.

Pablo Llorca. "Anish Kapoor, 'Mi madre are judía; mi padre, hindú; mi nana, cristiana; mi profesor, budista'," «Diario 16,» Madrid, 10 May 1992.

Alison Sarah Jacques. "Anish Kapoor, the distance between 'here' and 'there'," «Flash Art Daily,» Venice, June 1993.

Francesco Bonami. "Jumping into the Void," «Flash Art International,» vol. XXVII, no. 179, Milan, Nov.–Dec. 1994, pp. 81–82.

Sherry Gaché. "Interview. Anish Kapoor," «Sculpture,» vol. XV, no. 2, Washington DC, February, pp. 22-23.

Marianne MacDonald, "The colour issue," «Observer Life,» London, 12 April 1998, pp. 4-8.

Olga Spiegel. "'El gran reto del arte consiste en ser íntimo y, de algún modo, absoluto y apasionado'," «La Vanguardia,» 17 May 1998, p. 69.

Books, Solo Exhibition Catalogues
Anish Kapoor. Beeldhouwwerken, Rotterdam, Galerie 't Venster, 1983. Text by Michael Newman.

Feeling into Form, Liverpool, Walker Art Gallery and Lyon, Le Nouveau Musée, 1983. Text by Marco Livingstone.

Anish Kapoor, Basel, Kunsthalle, 1985. Texts by Jean-Christophe Ammann, Alexander von Grevenstein, Ananda Coomaraswamy.

Anish Kapoor, Oslo, Kunstnernes Hus, 1986. Texts by Arne Malmedal, Lynne Cooke.

Anish Kapoor: Recent Sculpture and Drawings, Amherst, University Gallery, Fine Arts Center, University of Massachusetts, 1986. Text by Helaine Posner.

Anish Kapoor: Works on Paper 1975–1987, Sydney, Ray Hughes Gallery, 1987.

Anish Kapoor, Nagoya, Japan, Kohji Ogura Gallery and London, Lisson Gallery, 1989. Text by Pier Luigi Tazzi.

Anish Kapoor. British Pavilion, XLIV Venice Biennale, London, The British Council, 1990. Texts by Thomas McEvilley, Marjorie Allthorpe-Guyton.

Marco Livingstone, ed. *Anish Kapoor*, Kyoto, Art Random, Kyoto Shoin International, 1990.

Anish Kapoor. Drawings, London, Tate Gallery, 1990. Text by Jeremy Lewison.

Anish Kapoor, Madrid, Centro de Arte Reina Sofia and The British Council (Spanish edition exhibition catalogue XLIV Biennale Internazionale d'Arte), 1991.

Anish Kapoor, Hannover, Kunstverein and The British Council, 1991.

Anish Kapoor & Ban Chiang, Cologne, Feuerle, 1991. Text by Angel Garcia.

Anish Kapoor, San Diego Museum of Contemporary Art, 1992. Texts by Lynda Forsha, Pier Luigi Tazzi.

Anish Kapoor, Madrid, Galeria Soledad Lorenzo, 1992. Text by José-Miguel Ullán.

Anish Kapoor, Tel Aviv, Tel Aviv Museum of Art, 1993. Introduction by Nehama Guralnik and a conversation between Anish Kapoor and Homi Bhabha.

Anish Kapoor, Ljubljana, Moderna Galerija, 1994. Text by Zdenka Badovinac.

Anish Kapoor, De Pont Foundation, Tilburg, 1995.

Germano Celant, *Anish Kapoor*, Milan, Fondazione Prada/Edizioni Charta, 1995 (English edition ed. Thames and Hudson, London, 1995).

Articles and Essays About the Artist
Michael Newman. "Le drame du désir dans la sculpture d'Anish Kapoor," «Artpress,» no. 70, Paris, May 1983, pp. 31–33.

Patrick Kinmouth. "Anish Kapoor's Shades of Meaning," «Vogue,» August 1983, pp. 104–107.

Michelangelo Castello. "Se il vero prende corpo," «Tema Celeste,» vol. I, Syracuse, November 1983, pp. 12–15.

Robin Dutt. "Anish Kapoor," «New Life,» no. 346, 18 November 1983.

"Sculptor Anish Kapoor," «Art Gallery,» December 1984–January 1985, p. 33.

Lynne Cooke. "Mnemic Migrations," «Louisiana Revy,» no. 2, March 1986, pp. 28–32.

"Anish Kapoor," «Lapiz,» Madrid, no. 42, 1987, p. 57.

Kosme Maria de Barañano. "Anish Kapoor-Towards the Point of Origin," «Lapiz,» no. 78, Madrid, June 1991, pp. 28–35.

Liliane Touraine. "Anish Kapoor. De la modification pour principe à un symbolisme de l'universal," «Artefactum,» vol. VIII, no. 38, April-May 1991, pp. 9–11.

Farida Cooper. "Anish Kapoor," «Society,» Bombay, January 1992, pp. 50–55.

Marta Dalla Bernardina. "Erotismo e trascendenza nella scultura di Anish Kapoor," «Palazzo Ruini,» Reggio Emilia, October–November–December 1992, pp. 4–5.

David Cohen. "Anish Kapoor," «Sculpture,» Washington, January-February 1993, pp. 30–37.

Geraldine Norman. "Sculptor creates fibreglass vision," «The Independent,» London, 10 May 1993.

"Anish Kapoor," «Art Watching (Freestyle),» vol. XLV, no. 666, Winter 1993.

John K. Grande. "Anish Kapoor," «Espace,» no. 25, Montreal, Fall 1994, pp. 27–32.

Christopher Hume. "Anish Kapoor's Mountain," «The Toronto Star,» Toronto, 26 August 1995, Section L1-L3.

Tatsumi Shinoda, "Sculptor Kapoor chooses Japan for new approach," «Asahi Evening News,» Japan, 23-24 September 1995.

Tasneem Mehta, "The Importance of Being Anish Kapoor," «The Art News Magazine of India,» vol. I, no. 2, Mumbai, Aug/Oct 1996, pp. 36-41.

Celia Lyttleton, "Anish Kapoor," «The Now Art Book,» Japan, 1996.

Paolo Cecchetto, "Anish Kapoor," «Juliet Art Magazine,» no. 81, Trieste, February/March 1996.

Andrew Lambirth, "Kapoor: Master of the sexuality within," «The Independent,»

281

London, 27 Jan. 1998.

L.B, "Anish Kapoor, Q & A," «The Art Newspaper,» February 1998.

General Reference Books, Catalogues and Articles

Andrea Rose. "Odd Couples," «London Magazine,» London, September 1982, pp. 107–113.

Michael Newman. "New Sculpture in Britain," «Art in America,» September 1982, pp. 104–114, 177, 179.

Michael Newman. "Figuren und Objekte. Neue Skulptur in England," «Kunstforum,» no. 62, June 1983, pp. 22–35.

Hayward Annual, exhibition catalogue (with a conversation between Stuart Morgan and Kate Blacker), London, Hayward Gallery, South Bank Centre, 1983.

Michael Newman. "Discourse and Desire: Recent British Sculpture," «Flash Art International,» no. 115, Milan, January 1984, pp. 48–55.

Elisabeth Vedrenne. "L'illusion du désir," «Décoration Internationale,» Paris, no. 85, October 1985, pp. 41–44.

Paul Bonaventura. "An Introduction to Recent British Sculpture," «Artefactum,» September–October 1987.

Richard Cork. «Kunstschrift,» 1987, p. 224.

Terry A. Neff, ed. *A Quiet Revolution: British Sculpture Since 1965*, London, Thames & Hudson, 1987.

Edward Lucie-Smith. *Sculpture since 1945*, London, Phaidon Press, 1987.

Sarah Jane Checkland. "No critics please, they're British," «The Times,» London, 2 October 1990.

William Feaver. "View down the grant-aid road," «The Observer,» London, 30 December 1990.

Jan Donia, ed. *Surrogaat/Surrogate. 15 years of Galerie 't Venster from Kiefer to Koons.* Texts by Jan Donia, Wofgang Max Faust, Rotterdam, SDU Uitgeverij, 1990.

Hans Gercke, ed. *Blau: Farbe der Ferne,* exhibition catalogue, Heidelberg, Wunderhorn, 1990.

Kenneth Baker. "Sculptors Go Two-Dimensional,"«The San Francisco Chronicle,» San Francisco, 20 February 1991.

Paul Overy. "Lions and Unicorns: The Britishness of Postwar British Sculpture," «Art in America,» September 1991.

Henry Meyric Hughes. "Art Exports," «Art Review Yearbook,» London, 1991, pp. 32–34.

Francesca Borelli. "Sculture che sigillano il secolo," «Wimbledon,» Rome, February 1992, pp. 71–74.

Roger Bevan. "New contemporary art fair opens in Japan," «The Art Newspaper,» London, March 1992.

Geraldine Norman. "Eighties for sale," «The Independent on Sunday,» London, 3 May 1992.

Raghubir Singh. "Banaras Transformed," «Sunday,» Calcutta/London, 1–7 November 1992, pp. 86–89.

Kate Bernard. "Which way to Turner?," «The Sunday Times,» London, 25 July 1993.

Jeremy Isaacs. "A sense of the future," «Modern Painters,» London, July 1993.

Martin Gayford. "Forms that rhyme," «Sunday Telegraph,» London, 5 September 1993.

Colin Glaedell. "Still Tough at the Top," «Art Monthly,» London, June 1994, pp. 177–178.

Fiona Giannulis. "Soul Mates," «The Telegraph Magazine,» London, 23 July 1994.

"Artistas Extranjeros Adquisiciones, Donaciones y Daciones," «La Revista del Museo, Museo Nacional Centro de Arte Reina Sofia,» Madrid, July 1994, pp. 20–23.

Simon Corbin. "Sculptors' Drawings," «What's On in London,» London, 24 August 1994, p. 19.

F.F. "Per la regina e per i Re," «Il Giornale dell'Arte,» no. 126, Turin, October 1994.

"Luis Monreal, Director of La Caixa, Has a National Sized Budget to Spend," «The Art Newspaper,» International Edition, London, vol. V, no. 41, October 1994.

Adrian Searle. "We Know You are in There," «The Independent,» London, 4 November 1994.

"Die 100 Grobten," «Capital,» no. 11, Cologne, November 1994, pp. 173–174.

Pilar Corrias. "Looking to the future: contemporary art in London," in *The Society of Londra Art Dealers (1994/95 Yearbook & Directory of Members)*, London, 1994, pp. 44–45.

"Old Masters and Young Pretenders," «Time Out Visitors Guide 1994,» London, 1994, pp. 33–36.

Nicolas De Oliveira, Michael Petry, Nicola Oxley, eds. *Installation Art*, London, Thames & Hudson, 1994.

Patricia Bickers. "La sculpture britannique: générations et tradition," «Artpress,» no. 202, Paris, May 1995, pp. 31–39.

Jonathan Fineberg. *Art since 1940. Strategies of Being*, Englewood Cliffs, Prentice Hall, 1995.

Brandon Taylor. *Avant-Garde and After. Rethinking Art Now*, New York, Abrams, 1995, p. 84.

Sophie Bowness and Clive Phillpot, ed.

Britain at the Venice Biennale 1895-1995, London, The British Council, 1995.

Keith Patrick. "The complex web," «RA Magazine,» no. 48, London, Autumn, 1995, pp. 24-25.

Suman Buchar. "The tingle factor," «The Telegraph Magazine,» Bombay, 27 August 1995, pp. 5-11.

"Key Notes," «The Full Score,» London, Autumn 1995, p. 4.

Edward Lucie-Smith. "Critic's Diary," «Art Review,» London, October 1995, pp. 8–9.

Piero Deggiovanni. "Arte Inglese Oggi," «Tema Celeste,» no. 53-54, Autumn 1995, p. 88.

Takeshi Sakurai. "Metamorphosis of Gourd,"Ryusei, Japan, November 1995.

Contemporary Art at Deutsche Bank London, London, Deutsche Bank, 1996.

Barbara A. Macadam. "British Impressions," «Artnews,» no. 3, New York, March 1996, p. 67.

Meenakshi Shedde. «The Art News Magazine of India,» vol. I, no. 2, Mumbai, April/June 1996, p. 58.

Martin Gayford. "Confusing for les rosbifs," «The Daily Telegraph,» London, 12 June 1996.

Frank Whitford. "Albion market undersold", «Sunday Times,» London, 16 June 1996.

William Feaver. "Impudence is bliss," «The Observer,» London, 23 June 1996.

Richard Cork. "A brilliant century taken out of context," «The Times,» London, 25 June 1996.

Anish Kapoor. "Dedication of the Sho'ah Memorial," «LJS News,» London, December 1996.

Thomas Illmaier. "Eintauchen in eine andere Welt," «Junge Freiheit,» no. 50, December 1996.

Thomas Illmaier. "Zur Gegenwart Erwachen," «Ursache/Wirkung,» Vienna, no. 15, Winter 1996.

Von Bernd Klempnow. "Nur eine Wand aus Sandstein trennt Leben und Tod," «Prisma,» 21 August 1996.

«London Magazine,» vol. XXXVII, no. 3 & 4 August-September 1997, p. 163.

Sarah Kent. "Hell's belles," «Time Out,» February 1997.

Adrian Searle. "It came from Planet Blah," «The Guardian,» 4 February 1997, p. 14.

Steve Beard. «Arena,» March 1997.

Mark Sladen. «Art Monthly,» March 1997, p. 204.

"Critic's Choice," «Time Out,»
London, 12 February–9 April 1997.

David Lister. "When the art world painted
the city of dreams bright red," «The
Independent,» London, 16 June 1997, p. 20.

Balraj Khanna. "Passage from India," "Artists
& Illustrators," October 1997, pp. 43-45.

Helen Sumpter. "My art on Blair's wall,"
«The Big Issue,» 19 January 1998.

Richard Ingleby. "Leaving no stone unturned,"
«The Independent,» London, 24 January
1998.

Printed by Leva spa, Sesto San Giovanni
for Edizioni Charta